GREGORY GEORGES, LARRY BERM AND CHRIS MAHER

50 FAST DIGITAL CAMERA TECHNIQUES

WILEY

Wiley Publishing, Inc.

50 Fast Digital Camera Techniques

Published by
Wiley Publishing, Inc.
909 Third Avenue

New York, NY 10022

www.wiley.com

Copyright © 2003 by Wiley Publishing, Inc., Indianapolis, Indiana

Library of Congress Control Number: 2002114779

ISBN: 0-7645-2500-X

Manufactured in the United States of America

10 9 8 7 6 5 4 3 2 1

1V/RS/QT/QT/IN

Published by Wiley Publishing, Inc., Indianapolis, Indiana
Published simultaneously in Canada

PREFACE

This book has been written to be a *fun* book to read and one that can be used as a continual source of valuable information for taking better photographs with a compact digital camera. If you enjoy photography and you have, or plan to have a compact digital camera, this book is for you. If you do not yet have a compact digital camera, this book can still be valuable to you because it will help you learn which camera features are likely to be important to you, thus enabling you to buy the right camera for your needs the first time.

Not all that long ago, skilled professionals like woodworkers, jewelers, sculptors, and other creative or skilled professionals learned their trade by becoming an apprentice. As an apprentice, you learned the body of knowledge you needed for your profession by working right next to a master on real projects. If you were learning to be a furniture maker, you might first build a small, simple piece of furniture, and then build increasingly larger and more complex pieces until you knew what you needed to know to make just about any kind of furniture you wanted to make.

Undoubtedly, being an apprentice and working with a master was a real luxury that is not often available today. However, the notion of working with a master on specific projects is the basis of this book and others in this series. The premise is that you can effectively and quickly learn how to take great photos by following step-by-step techniques — just as you would do if you were working as an apprentice next to a master photographer. After you've successfully completed twenty or thirty techniques in this book, you'll be amazed at the "body of knowledge" you will have gained and how much better your photos will be.

ACKNOWLEDGMENTS

Many, many people have contributed in one way or another to make this book. First on the list of those to be thanked are those readers of my prior books who have helped me to be able to write about digital photography and take pictures — full-time! For too many years, I have worked to make a living, without really enjoying the work. I am now able to enjoy my passion for photography everyday — and make a living from that passion! "Thanks" also go to the Wiley team that have published this book, and to my book agent, Carole McClendon of Waterside. It has been a pleasure to work with Larry Berman and Chris Maher, my two co-authors — "thank you" for the expertise you have added to this book. Butch Fowler, John Wyman, and my daughter Lauren Georges also deserve a special "thanks" for helping me to understand what material needed to be in the book and how to present it — a most valuable bit of insight.

 — *Gregory Georges*

I would like to start off by thanking my co-author Gregory for giving me the opportunity to participate in this project. I'd like to thank all the manufacturers who came through when we needed products to photograph and write about. I would also like to thank my family and friends who agreed to change plans on a moment's notice and pose for photographs when I needed them as subjects. Lastly, I'd like to thank my wife Mary who put up with my eating many meals in front of the computer while working on this project.

 — *Larry Berman*

The focused energy that is needed to create a really good book is only possible when a supportive environment is present. My co-authors provided that support, and more. Gregory's guiding hand in style and concept, and Larry's enthusiasm and ideas helped make this book the functional guide that it is.

 — *Chris Maher*

CONTENTS AT A GLANCE

CONTENTS

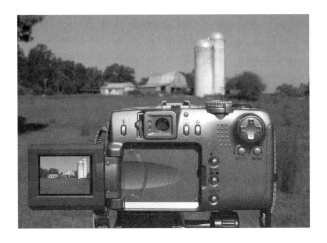

CHAPTER 2: TAKING PICTURES 33

TECHNIQUE 6
FIGURING OUT WHAT TO SHOOT 35

TECHNIQUE 7
COMPOSING YOUR SHOTS 41

TECHNIQUE 8
SELECTING FOCAL LENGTH 47

TECHNIQUE 9
GETTING THE EXPOSURE YOU WANT 53

CHAPTER 3: USING ADVANCED FEATURES 69

CHAPTER 4: CHOOSING ACCESSORIES 95

CHAPTER 6: PHOTOGRAPHING NATURE 165

CHAPTER 7: "SCAPE" PHOTOGRAPHY 191

CHAPTER 8: TAKING STILL-LIFE, ART, AND AUCTION PHOTOS 217

TECHNIQUE 38
USING OFF-CAMERA FLASH FOR STILL-LIFE PHOTOS 219

TECHNIQUE 39
MAKING PHOTOS FOR ONLINE AUCTIONS 223

TECHNIQUE 40
SHOOTING "FLAT" FINE ART 229

TECHNIQUE 41
TAKING A PHOTO OF AN AUTOMOBILE 235

CHAPTER 9: CREATIVE PHOTOGRAPHY 239

CHAPTER 10: MOVING UP TO A DIGITAL SLR 267

TECHNIQUE 47
PHOTOGRAPHING FLOWERS WITH A MACRO RING LIGHT 269

TECHNIQUE 48
SHOOTING LANDSCAPE PHOTOS WITH A TELEPHOTO LENS 273

TECHNIQUE 49
ISOLATING A FLOWER FROM ITS BACKGROUND 277

TECHNIQUE 50
PHOTOGRAPHING SPORTS ACTION 281

INTRODUCTION

Today's compact digital cameras have a simple side, and they have a complex side. If you shoot in one of the many "auto" modes, they can be simple and easy to use, and you will generally get reasonably good photos. However, most compact digital cameras are loaded with sophisticated features that you can learn to use effectively — and you can use them to get outstanding photos! Even understanding how to use a half-dozen of these more sophisticated features can dramatically improve your picture-taking skills.

How do you currently shoot? Do you usually shoot with one of the auto modes? Are you aware of, and do you use many of the more sophisticated features your camera offers? Do you really understand the relationship between ISO setting, f-stop, and shutter speed? Do you change shooting modes based upon the subject you are shooting? Do you use several different metering modes, change focal points, or use exposure lock? If not, you will be excited to see how much your picture-taking skills will improve after you read and put into practice even a few of the fifty techniques that you will find in this book.

WHAT KIND OF CAMERA SHOULD YOU HAVE TO COMPLETE THE TECHNIQUES IN THIS BOOK?

Unlike most of the photography books on the market, this book has been written specifically for those using compact digital cameras — not film cameras, or digital SLR cameras. It has *not* been written for one specific brand or model of camera; rather, it has been written for *all* compact digital cameras. In this book, you learn how to take specific kinds of photographs using specific camera features. Often, when you read about a camera feature in this book, you will have to read the documentation that came with your camera to see whether your camera has that feature and how it has been implemented on your camera. The combination of this book and the documentation that came with your camera will be all that you need to consistently take good photographs.

You can purchase compact digital cameras for as little as $70 and for as much as $1,300 or more. At the time this book was published, some of the better cameras in terms of features and the quality of pictures they create were available for under $800.

WHAT DIGITAL CAMERA SHOULD YOU BUY?

One of the most frequently asked questions on digital photography forums and in e-mails sent to the authors is, "What digital camera should I buy?" Another common and even more difficult question to answer is, "Which digital camera is the *best* digital camera?" If you look throughout this book, you will not find the answer to either of those questions. The only person that can answer them is you — after you have a good understanding of the kinds of pictures you want to take, some knowledge about various camera features, and a budget. Then and only then can you determine which camera you should get and which one is *best for you*.

 After you have a budget and an idea of the features you want in a camera, take a few minutes to visit Phil Askey's Digital Photography Review Web site (`www.dpreview.com`). This incredibly useful resource offers unbiased reviews on just about every digital camera that has ever been made. You can even view actual photos that were taken with most camera models. Besides the reviews and detailed specs, you can join one of the many forums and learn more about the cameras you are considering from those who are already using them.

HOW SHOULD THIS BOOK BE USED?

This book is not one that you must sit and read from page one through to the end. You should read the first three or four chapters — then you can choose the techniques that you are most interested in reading when you can go out and shoot to practice what you have learned. In preparation for shooting photos of a specific subject, you can also read one or more of the techniques on related topics to help you take better photos. Technique 1 suggests that you complete a detailed two-page worksheet that will force you to learn about all the features that are available on your camera. The effort you take to complete this worksheet will be well worth the time it takes. You can use Technique 5 as a "pre-shoot" checklist to make sure you know your camera well enough to shoot an important event or to simply remind you what you should check before you shoot to avoid using the wrong settings. The rest of the techniques you can read as you choose.

A FEW WORDS ABOUT THE PHOTOS USED IN THIS BOOK

Most of the 50 techniques in this book starts with an "original" and an "edited" photo. The first photo is the original photo as it was saved by the camera. The second photo is one that has been digitally edited with Adobe Photoshop or Adobe Photoshop Elements 2.0. You can find the original image file and the edited image file for all fifty techniques on the companion CD-ROM. Having these photos allows you to see them yourself on your computer screen and to read the shooting data that is stored in each image file.

 One of the things many photographers do not realize is that most photographs are not exposed properly — whether they were taken with a film camera or a digital camera. When you drop off your film at a photo-processing lab, the lab technicians are the ones

who do all the work of correcting color casts, fixing image contrast, or improving exposure. When you shoot digitally, *you* are responsible for those fixes! No matter how good you get with your digital camera, just about every photo you take can be improved with some digital image editing as you will notice when comparing the "original" photos with the "edited" images in this book.

Editing digital photos is a huge topic in itself and so it has been excluded from this book. If you want to learn more about how to edit your digital photos, consider purchasing *50 Fast Digital Photo Techniques* or *50 Fast Photoshop 7 Techniques*; both books were written by Gregory Georges, one of the authors of this book. You can learn more about these books on the author's Web site at www.reallyusefulpage.com.

CHAPTER 1

GETTING FAMILIAR WITH YOUR CAMERA

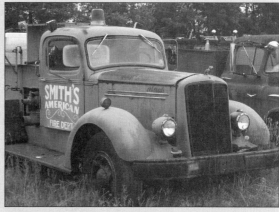

Today's digital cameras are both rich in features and highly capable of helping you get good photos when used in one of many "auto" modes — without requiring you to know much about your camera *or* photography. However, learning how to use your digital camera and its many features will enable you to get even better photos and do things you never even imagined could be done. In Technique 1, you will first get familiar with *your* camera. You will then learn how to select important image-quality settings in Technique 2. Technique 3 helps you learn how to select an appropriate shooting mode. Being able to review photos is a significant benefit of digital camera, and Technique 4 shows you how to get the most from the review features on your camera. Technique 5 will help you learn how to change settings quickly so that you don't miss getting the photos you want due to wrong settings.

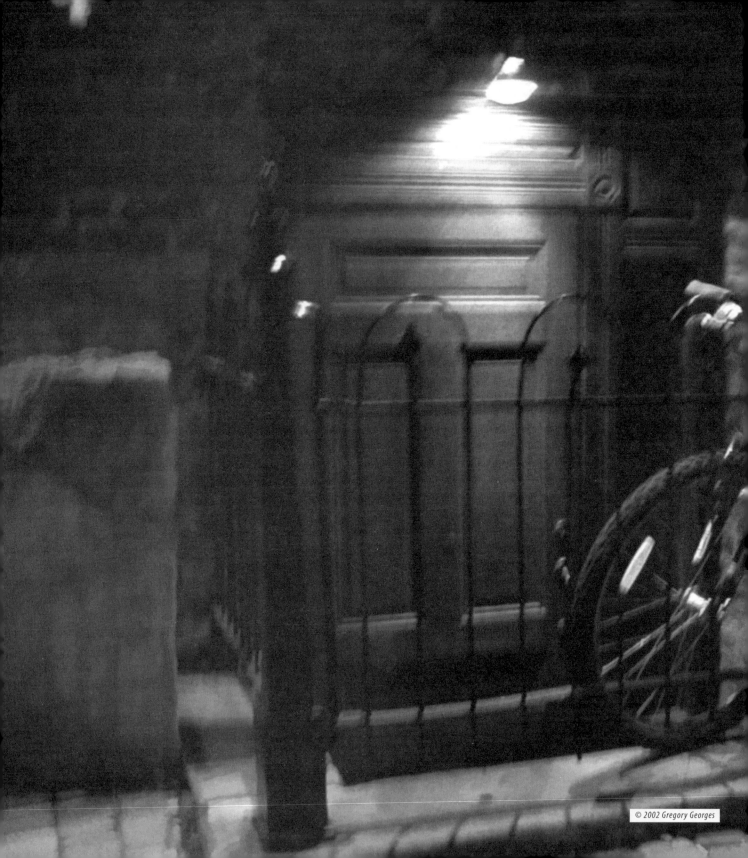

LEARNING ABOUT YOUR CAMERA

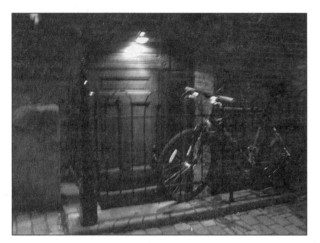

1.1 *Original image* © 2002 Gregory Georges

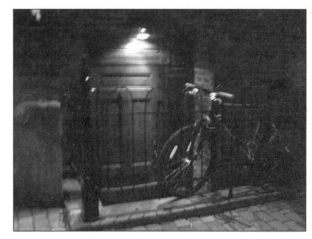

1.2 *Edited image* © 2002 Gregory Georges

"Back Door to the Club" Nikon CoolPix 950, hand-held, zoom set to 50mm (35mm equivalent), f/2.6 @ 1 second, ISO 320, 1,600 x 1,200 pixels, 866KB .jpg

I f you were to come upon the scene shown in the photo in **Figure 1.2**, which shows the back door to a nightclub in Richmond, Virginia; what camera settings would you use? If you did not have a tripod, would you even consider taking a photo of this scene, which has such a low light level? Would you trust automatic focus to focus in the dim setting? Would you use a low or high ISO setting? What exposure mode would you use? Would you consider using other features your camera offers, such as noise reduction, exposure bracketing, a built-in flash, or maybe even a "vivid" image effect? Or would you simply shoot in "auto" mode and hope for the best?

Because you are reading this book, it is a good bet that you're fairly serious about photography, and about taking the best photos that you can take. Many factors contribute to your ability to get the photos that you want. The features your camera has, when to use them, and how to properly use them are three of the most important things you can learn to improve your picture-taking skills.

Although this technique *twice* recommends the obvious — that you read the written documentation that came with your camera — it also provides a valuable digital camera feature and specification checklist that can help you learn more about *your* digital camera. By now, you may be thinking to yourself, "Thanks, but I'll just skip this technique and move on to the next one!" However, please don't because you'll have much more success with the rest of the techniques if you spend an hour or more doing the exercises that are suggested in this technique.

Incidentally, the photo shown in **Figure 1.2** has been edited with Adobe Photoshop Elements 2.0. The intent of the editing was to further increase color saturation and overall contrast. Because the camera was hand-held (instead of being mounted on a tripod), it is slightly out of focus, making the image soft, which adds to the dreamlike feel of the photo. When printed with an Epson 1280 printer, this photo made a nice print on a fine art paper such as Epson's Archival Matte paper.

STEP 1: READ (OR GLANCE THROUGH) YOUR MANUAL

Most digital camera users have proven over and over that they can take good pictures without reading most of the written documentation that came with their camera; some never read any of it at all — ever! Not reading the documentation that came with your camera when you get the camera is okay. Not reading it at all just means that you won't be able to take advantage of many cool and useful features your camera offers. Not only does reading the manual help you to more fully enjoy your camera, but it also enables you to take better pictures. It is also quite likely that you will be more than compensated for your investment in time because your effort may help you avoid missing good shots of those important events that you get only one chance to shoot.

If you're somewhat familiar with cameras, then when you first get your camera, just go shoot with it. You bought it for taking pictures, so take them. After you have taken a couple dozen pictures so that you have a basic understanding of what your camera can do and where some of the controls are, then read your manual. Using your camera first helps make reading the manual easier and more useful than if you were to just pick up the manual and read it.

As the cost of printing manuals increases and as product life cycles shorten, digital camera vendors are increasingly providing some or all of the written documentation in electronic form on a CD-ROM. To read the documentation, you usually need to have Adobe Acrobat Reader installed. This free software application is more often than not included on the CD-ROM provided by your camera vendor. After installing Acrobat Reader, you can read the documentation on your computer screen. **Figure 1.3** shows a screenshot of Adobe Acrobat Reader displaying a page from the manual for an Olympus Camedia C-720 Ultra Zoom digital camera.

1.3

STEP 2: SHOOT A FEW PHOTOS

After you have had a reasonably good read of the documentation that came with your camera, shoot a few more photos. Take a few photos of nearby objects, such as your foot, the pet at the other end of the room, books on the bookshelves, or any people who may be walking by. Try using a few different settings. Flip through the menus on your LCD monitor if you have one. Take a photo with a built-in flash if you have one. If you're inside, walk outside and take a few more photos.

STEP 3: COMPLETE THE CAMERA FEATURES & SPECIFICATIONS FORM

If you're just getting started with photography, if you have only used a simple point-and-shoot camera, or even if you have a reasonable amount of experience with your digital camera, you're likely to find filling out the form shown in **Figure 1.4** to be useful. You can find this form in both Microsoft Word and Rich Text Format (a format that is viewable in a simple text editor) in the **/chapter-images/chap01/01** folder on the companion CD-ROM. After opening the form in Microsoft Word or a text editor, print it out on

TIP

If your camera vendor provides an electronic version of the documentation (for example, .pdf or .doc file format), consider printing out pages with key information such as menu settings, information displayed on the LCD monitor, or descriptions of shooting mode icons. Place these reference pages in your camera bag for easy reference. If you just get printed documentation, check the vendor's Web site because you may be able to find electronic versions along with updated documentation, drivers, or additional software.

your printer. Notice that on the right side of the form is a column for writing the page number of the manual where you can find the feature discussed. Completing this form helps you learn about the features your camera offers as well as any limitations it has.

STEP 4: READ YOUR MANUAL AGAIN

"Yeah right," you're probably saying out loud to yourself. Read the manual again — fat chance! You're not likely to read the manual again right away, but as you use your camera or when you have not used your camera for a while, you will find that going back and looking over the manual periodically is useful. Today's digital cameras are complex and feature-rich and learning how to use all the features takes time and effort. Even if your objective is not to learn all about your camera, a periodic glance at the manual helps you to learn more about those features that you often use.

One of the reasons I enjoy reading manuals is that I always seem to find "surprise" features. "Surprise" features are features that I didn't know about, but that can help me take great photos in new ways. I have known many people who have had a digital camera for months and were not able to get the photos that they wanted. When I point out a feature that they have on *their* camera — that makes it easy for them to get the shots they always wanted — they are both surprised and pleased! That is all you will hear from me about reading manuals for now.

Later in this chapter and throughout the book, you learn more about the features listed on the form shown in **Figure 1.4** and how to use many of them. For now, just concentrate on getting the correct information on the form and note the page number where you can find more information in the documentation that came with your camera.

Digital Camera Features / Specifications Checklist

Manufacturer: _____ Model #: _____ Page #

Serial Number: _____

Image Characteristics
Maximum Resolution: _____ x _____ pixels Megapixels: _____ _____

Other Resolutions: _____, _____, _____, _____ _____

Compression Level settings: o Yes o No Settings: _____ _____ _____

Image Formats: JPEG quality settings: _____ _____
TIFF: o Yes o No 16-Bit RAW Acquire: o Yes o No _____

ISO Sensitivity Settings: Auto o Yes o No _____ _____

White Balance Settings: Auto o Yes o No _____ _____

Other Exposure modes (sepia, B&W, etc.): _____ _____

Photo Storage Media
Image Storage Media: o Compact Flash o SmartMedia o Floppy Disk o CD-ROM _____
o Memory Stick o: xD-Picture Card o: Other_____ Maximum Capacity: ___ MB _____

View Finder / LCD
LCD: o Yes o No _____
View Finder: o Yes o No View Finder Adjustment: o Yes o No _____

Image Review
Image Review Modes: _____ _____
Histogram: o Yes o No Playback Zoom: o Yes o No Video Out: o Yes o No _____

Lens
Lens Aperture: o Fixed o Optical Zoom : _____ mm to _____ mm _____

Digital Zoom: o Yes o No Range: _____X to _____ X _____

Shutter speeds: _____ to _____ Maximum Manual Shutter Speed: _____ seconds _____

F-stops: _____ to _____ Increments: o 1/2 o 1/3 o 1 stop _____

1.4

Metering

Metering Modes: o Evaluative/Matrix o Center-weighted o Spot o Other: _____ _____

Exposure Compensation: o Yes o No _____

Increments: o 1/2 o 1/3 o 1 Range (Stops): _____ _____

Exposure Modes (auto, shutter-priority, portrait):_____ _____

Manual Mode : o Yes o No _____

Auto Exposure Bracketing: o Yes o No _____

Focus Features

Auto Focus Settings (continuous, 1-point, 3-point):_____ _____

Focal Points: _____ Selectable: o Yes o No _____

Manual Focus: o Yes o No Focus Range: _____ inches to Infinity _____

Macro Mode: o Yes o No Macro Focus Range: _____ inches to _____ inches _____

Continuous Shooting: o Yes o No FPS: _____ _____

Flash

Built-in Flash: o Yes o No Flash Shoe: o Yes o No Sync Socket: o Yes o No _____

Flash Compensation: o Yes o No _____

Flash Modes (auto, red-eye, etc.): _____ _____

Battery

Battery type: _____ Rechargeable: o Yes o No Proprietary: o Yes o No _____

Other Features

Video Mode: o Yes o No Movie Size(s): _____ _____

Movie Clip Maximum Time: _____ seconds Sound: o Yes o No _____

Self Timer: o Yes o No Maximum Shutter Time: _____ _____

Remote Shutter Control: o Yes o No _____

Connection to Computer: o Yes o No _____

Connection Type: o Serial o USB 1.0 o USB 2.0 o USB FireWire _____

Time Lapse Shooting: o Yes o No Panorama Mode: o Yes o No _____

Printer Capabilities: o DPOF o Direct Print o Other: _____ _____

Other Features:

Available Accessories

List optional accessories: _____

CHOOSING IMAGE QUALITY SETTINGS

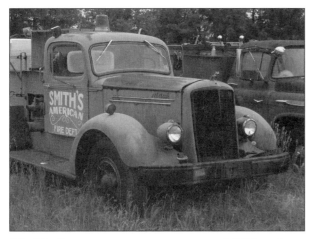

2.1 *Original image* © 2000 Gregory Georges

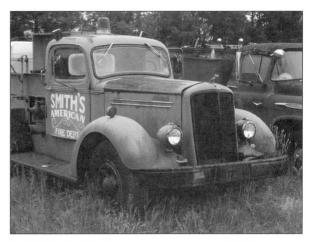

2.2 (CP 2.2) *Edited image* © 2000 Gregory Georges

In Technique 1, you learned about a multitude of features that are available on *your* digital camera. Many of these features are user controlled, and depending upon what you want to shoot, how you plan on using the images, and where you shoot, one setting can be a much better choice than another. In this technique, you learn how to choose the most appropriate setting for seven of the more important and common "image-quality" settings and how to make sure your digital photo storage media is ready to use.

As you go through the steps in this technique, consult the form you completed in Technique 1 and the documentation that came with your digital camera. Be aware that you may have a digital camera that does not have one or more of the settings mentioned in this technique. Also, you may find that your camera has useful settings not mentioned here that you can set, too.

STEP 1: SET DATE AND TIME

The world is full of VCRs set to the wrong time and wrong date. They are owned by people who either don't know how to set them, or by people who don't need to set them. Unlike VCRs, where a correct date and time is not often needed, setting the date and time correctly on your digital camera is more than worthwhile.

Each time you take a picture with your digital camera, a digital image file is written to the digital photo storage media in your camera. This file contains the "picture," plus it contains "metadata." *Metadata* is a fancy term that means data or information about the picture. Most digital camera vendors conform to an industry standard; the cameras write this metadata in the EXIF format in each picture file.

In addition to writing precise time and date data, most cameras also write dozens of camera settings used for each photo, too! This means you can read these settings while the digital photos are in your camera, or later when you open up an image file with any one of many software applications that allow you to read the f-stop, the shutter speed, the exposure mode, whether you used a flash or not, as well as lots of other information that you can use to learn how to shoot better photos. EXIF data can also become

useful when you begin managing your digital image collection with an image management application such as Cerious Software's ThumbsPlus (`www.cerious.com`), or ACD System's ACDSee (`www.acdsystems.com`).

Providing that you set the date and time correctly, you can sort all your photos by date and time, or even search for photos taken on a specific day and at a specific time. If you don't set the date and time on your digital camera, you'll miss out on this valuable capability.

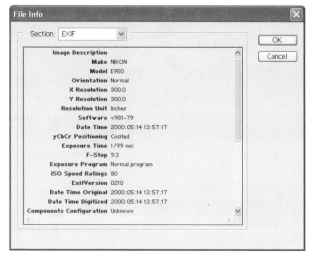

2.3

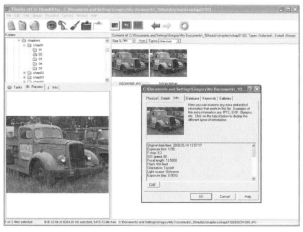

2.4

TIP

To read EXIF data, you must first open the image in an application that can read EXIF data. For example, after opening the image shown in **Figure 2.1** using Adobe Photoshop Elements 2.0, you can view the EXIF data by choosing File ➢ Info and clicking on the EXIF tab to get the dialog box in **Figure 2.3**. **Figure 2.4** shows the EXIF data shown in the properties dialog box in ThumbsPlus 5.0. **Figure 2.5** shows the complete list of EXIF data that can be found in the image file.

Original date/time: 2000:05:14 13:57:17

Exposure time: 1/99

F-stop: 9.3

ISO speed: 80

Focal length: 13.5000

Flash: Not fired

Orientation: Top-left

Light source: Unknown

Exposure bias: 0.0000

Metering mode: Spot

Exposure program: Normal

Digitized date/time: 2000:05:14 13:57:17

Modified date/time: 2000:05:14 13:57:17

Image description:

Scene type: Photograph

User comment:

Compression: 6

Camera make: NIKON

Camera model: E950

X resolution: 300.0000

Y resolution: 300.0000

Resolution unit: Inches

Camera version: v981-79

Colorspace: sRGB

File source: DSC

2.5

STEP 2: SET IMAGE RESOLUTION

In digital photography, not only are you faced with the traditional trade-offs between shutter speed and aperture size, but you also must choose from among a number of settings that determine file size (which ultimately is a trade-off between files that take less space to store and less computer processor cycles to edit) and image-quality. The five major factors determining image file size are image resolution, image format, compression level, ISO setting, and the subject. You can control the first four of those five factors with user-selectable settings that allow you to optimize image file size with image-quality to meet your needs.

Almost all digital cameras offer user-changeable settings for image resolution. For example, the Canon PowerShot G2 has a maximum image size of 2,272 × 1,704 pixels. It also has image resolution settings of 1,600 × 1,200, 1,024 × 768, and 640 × 480. **Table 2-1** shows each image resolution setting, the total pixel count, the percentage decrease in pixel count, the optimal print size, and the approximate file size.

So, the question remains: What image resolution setting should *you* use? The answer depends entirely on what you plan to do with the image, how much in-camera storage and computer storage space you have, and how important image-quality is to you. Image resolution is costly in terms of file size — the higher the resolution, the more space required to store a single digital photo, and the more computer processor cycles required to edit it.

If you want to be able to make the best *and* largest print possible, you will always want to use the highest image resolution setting your camera offers. If you have a 4- or 5-megapixel or larger camera, you may not always want to use the highest image resolution setting if you intend to only print 4" × 6" photos. Choosing a lower image resolution allows you to get more images on your digital photo storage media,

TABLE 2-1

CANON G2 IMAGE RESOLUTION SETTINGS

¾MAGE RESOLUTION	TOTAL PIXELS	% OF MAXIMUM IMAGE SIZE	PRINT SIZE	APPROXIMATE FILE SIZE
2,200 x 1,704	3,748,800	100%	10.7" x 8"	1.6MB
1,600 x 1,200	1,920,000	51%	6.7" x 5"	0.89MB
1,024 x 768	786,432	16%	4.3" x 3.2"	0.43MB
640 x 480	307,200	6%	2.7" x 2"	0.2MB

* Using 240DPI printer setting

** Using .jpg format and compression set to Super Fine

and these smaller image files require less computing power than larger images would.

Additionally, smaller images require less storage and backup space on your hard drive or removable media. So, when possible, a lower resolution setting is a good choice. To learn more about the different resolutions and their resulting file sizes, and the number of images that you can store on a specific digital photo storage media card, check the documentation that came with your camera — vendors usually provide a table with this information.

One reason against using any image resolution other than the maximum size is that a larger image may allow you to crop an image to show exactly what you want. **Figure 2.6 (CP 2.6)** shows a photo of a five-lined skink that was taken with a Canon PowerShot G2 at the maximum resolution of 2,200 × 1,704 pixels. Although the full-size image makes the skink look very small, the square in the figure shows that the skink and all of his beautiful blue tail won't fit in an 800 × 600 pixel image (see **Figure 2.7 (CP 2.7)**), which is a very large image for a Web page or for display on a computer screen. If a smaller resolution image had been used, this cropping would not have been possible and the resulting image would feature a tiny skink.

With that information as a guide, set your image resolution on your camera to meet your requirements.

Image resolution settings are usually changed via a menu, or a button that changes the setting that is shown on an LCD.

WARNING

After you learn how to change the image resolution setting, be careful! I once drove with a photographer friend for several hours to get to a remote place where we had heard there were rare butterflies. After several hours of shooting these rare butterflies in the hot sun, my friend noticed that he had far more room on his digital photo storage media than he should have had considering the number of photos that he had already taken. A quick look at the image resolution setting showed why. A day earlier he changed the setting to shoot images for a Web page and he had forgotten to change the settings to the maximum image resolution! All of his wonderful shots of these rare butterflies were unprintable because he had been shooting 1,536 × 1,024 pixel images — not nearly enough for the 8" × 10" prints that he wanted to make!

STEP 3: SET FILE FORMAT

Depending on your camera model, you can likely choose from two or more different file formats. Three basic types of file formats are offered on compact-level digital cameras: .jpg, .tif, or a proprietary "raw" format. The most frequently used format is the .jpg format, which is a compressed file format. To make the image file smaller, a mathematical algorithm is applied that simplifies the image, thereby making it smaller. Simplifying an image also means that there is some decrease in image-quality.

Proprietary "raw" formats are file formats that are unique to a single vendor, such as Nikon's .nef format, or Canon's .crw format. Both are compressed, "raw" file formats. Unlike non-raw formats, where an image is taken and the camera processes it to get optimal results, a *raw* format image file is written to the digital photo storage media as it was captured on the image sensor without any additional processing. The advantage to these raw files is that you can use special software to adjust the original image parameters, such as white balance, contrast, sharpening, saturation, and so on. Because both .nef and .crw file formats have the additional advantage of also being compressed files, they take less storage space than an uncompressed file such as .tif, which is a common uncompressed file format found on digital cameras.

On those occasions where you want to maximize image-quality and you have plenty of digital photo storage media space, you should select either a .tif format or a proprietary format if one is available on your digital camera. Besides being compressed, some of the proprietary files use 16-bit images instead of 8-bit images — meaning that they contain much more picture information, which can be useful if you edit the image with an image editor that can work with 16-bit images. The downside of using a proprietary format is that you may need special software to convert the images so that you may view them or use them in other applications. Also, these image files can be very large.

So, pick the .jpg format unless you are seeking to get the best possible image-quality that your camera can produce *and* you plan on and are prepared to use an image editor to edit a .tif or proprietary image file. Be aware that the choice between a .jpg format and an uncompressed format like .tif is a decision between a relatively small file and a much larger file! Image-quality can be better but not necessarily significantly better.

For example, the same photo of a barn shot with a Canon PowerShot G2 using the "best" (least compressed) .jpg setting is 1.6MBs. The same image shot in Canon's "raw" format (.crw) is 3.3MBs; when it's

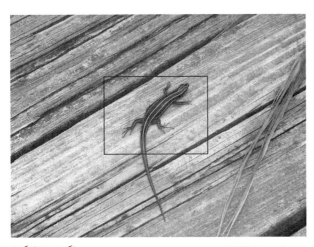

2.6 (CP 2.6) © *2002 Gregory Georges*

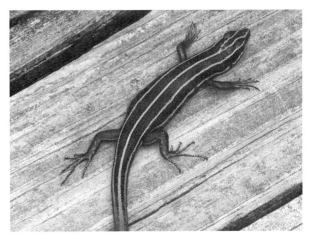

2.7 (CP 2.7) © *2002 Gregory Georges*

opened up as a 16-bit image, it's a whopping 22.2MBs! If you would like to compare these images, you can find them in the folder **/chapter-images/ chap01/02** named **barn-jpg1.jpg**, **barn-RAW.crw**, and **barn-RAW.tif**. The **barn-RAW.tif** file has already been converted from its .crw format using Canon's RAW Image Converter software shown in **Figure 2.8**. If you don't have software that can read .crw files, you won't be able to open the **barn-RAW.crw** file.

STEP 4: SET COMPRESSION LEVEL

If you chose the .jpg format in Step 3, you may want to check to see whether your camera allows you to choose different compression levels. A moderate amount of JPEG compression can dramatically reduce file size while only slightly reducing image-quality; in fact, you may not notice any image degradation at all relative to a non-compressed or .tif "raw" format. As compression level increases, file size decreases, as does image-quality to some extent. Once again, you are faced with the trade-off between file size and image-quality. On those occasions where you have limited photo storage capacity, you may want to increase the compression level so that you

have room to take more photos. Otherwise, you should use a setting that applies the least amount of image compression.

STEP 5: SET ISO SENSITIVITY

In Technique 3, you learn about the trade-offs between shutter speed and f-stop. The third variable that determines the amount of light that exposes the image sensor (the equivalent counterpart to film in a film camera) is the ISO setting. In earlier days, the ISO setting was known as the ASA film speed. You could then, and you can now, still purchase film that has ISO (or ASA) ratings from 50 to 800 or even 1,600 or 3,200. The higher the ISO rating, the more sensitive the image sensor is to light. Changing the ISO sensitivity setting is like so many of the other settings on a digital camera — it offers trade-offs. Some trade-offs you may like, and some, depending on what you want to achieve, you won't like. The lower the ISO sensitivity (50 or 100), the less digital noise (the equivalent to "grain" when using a film camera) you will have. As the ISO rating goes up, your photos will have more digital noise.

You can make a decision on what ISO setting to use by asking yourself four questions:

■ Do you want to avoid having digital noise in your photo, or might it be considered a "feature" of your photo?
■ Does your scene or subject have enough light to use a low ISO setting?
■ How much digital noise does your digital camera create at different ISO settings?
■ Can you stop movement in the image and shoot without camera movement to avoid blurring the image, or is an intentional blur with a lower ISO setting something that you want?

Before making a final decision on which ISO settings are too "grainy" for your photos, shoot a few shots

2.8

with different ISO settings and compare them your-self. After you've answered these questions, you will know what ISO setting to use.

STEP 6: SET FILE NUMBERING "ON"

One more useful feature many digital cameras offer is an automatic file (and sometimes folder) numbering feature. You realize how valuable this feature can be after you start storing and archiving your digital photos. If you have the option, I recommend that you set automatic file numbering to "On." When this feature is on, image files will be sequentially numbered — even when you remove the digital photo storage media and use a new one. The camera remembers the number of the last photo regardless of which digital photo image media was in the camera last.

If you don't have, or you don't use this feature, you will find that you have files with the exact same file-name! Each time you remove a card and download the images to your computer, the digital camera starts numbering at 1 again. This means that you have to rename files if you want to put them in the same folder with another file with the same name. Additionally, sequentially numbered files just make keeping track of when you shot particular photos easy.

TIP

Generally, you should use the lowest ISO setting possible to get the most "digital-noise-free" and highest-quality photo that can be taken with your camera. The use of a tripod can help you to use a lower ISO setting by allowing you to shoot with a slower shutter speed, which allows a lower ISO rating. Digital noise is not always bad; if you can't avoid it, use it as a design feature. Many photographers intentionally use high-ISO-rated settings or film speeds to add grain to their images.

STEP 7: SET IMAGE SHARPNESS AND CONTRAST

Digital photos are inherently "soft" as opposed to being "sharp," because the image is represented by pixels, or "dots," instead of a smooth tonal range like analog or traditional photos. But that's okay because you can sharpen an image and increase contrast in many ways. You can sharpen a photo by "editing" it with an image editor such as Adobe Photoshop 7 or Adobe Photoshop Elements 2.0, or if your digital camera has an "in-camera sharpening process," you can turn it on to increase the perception that an image is sharp. Likewise, you may find your digital camera has an "in-camera contrast" feature, too.

Before you use either of these features, you need to carefully consider how you intend to use your photos, and you ought to experiment with the features before using them to shoot photos for an important event. If you don't plan on using an image editor to sharpen your photos, you may find that the sharpness and contrast features in your camera help you get better prints when you print on some printers. Should you plan on using an image editor to edit your photos, I suggest that you not use either of these features because you'll have much more control over your image in your image editor.

STEP 8: FORMAT DIGITAL PHOTO STORAGE MEDIA

In the prior seven steps you learned about many important settings that you need to set before you begin shooting. Besides setting these and possibly other settings, you also ought to consider formatting your digital photo storage media in your camera — as formatting will erase all images remaining on the card.

If you use a digital photo storage media reader to download your digital photos to your computer, the media card will appear as one more "hard drive" to your computer's operating system. This means that you can rename a folder or images, delete or add files,

or even format your photo storage media card with your computer. However, if you use your computer to add, change, or delete files on your photo storage media card, your digital camera may not recognize these files or changes or possibly even be able to read and write to the media. After you download photos to your computer, you should format the photo storage media card with your digital camera by selecting **Format** in one of the menus. This formatting ensures that your camera will have access to all the storage space contained on the media.

> **WARNING**
>
> You should *always* format your digital photo storage media with your digital camera. This is the best way to make sure that your media is able to store your photos as you expect and as the camera expects! Making changes to, or formatting a photo storage media card with, your computer can cause problems that could cost you either storage space or lost photos. To prevent any problems and to keep your digital photo storage cards ready for recording, format them with your digital camera.

CHOOSING AN APPROPRIATE SHOOTING MODE

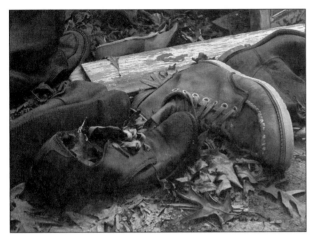

3.1 *Original image* © 2000 Gregory Georges

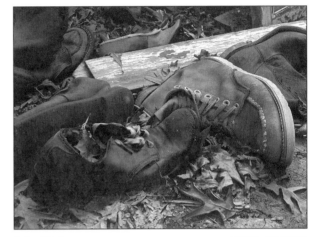

3.2 *Edited image* © 2000 Gregory Georges

If you came upon the old leather work boots, shown in **Figure 3.2**, what shooting mode would you use? Would you select one of the automatic modes like shutter-priority or aperture priority? Or, would you choose one of the other modes your camera offers? In this technique, you learn how to choose from among the various exposure modes your camera offers to get a photo that matches your vision of the photo you want.

STEP 1: DETERMINE OBJECTIVES

Before you can choose an appropriate exposure mode, you must first determine what you want the photo to look like! It sounds simple, but visualizing how a photo should look before you take it is a skill that must be acquired. Those who have it take better photos than those who don't have it. If you don't have it yet, don't worry; keep reading and keep shooting.

All cameras (whether they are digital or film) expose either an image sensor or film with light. Light entering the camera is controlled in three important ways: the amount of time the shutter is open, the size of the lens opening, and the ISO setting. The role of the ISO setting was discussed earlier in Technique 2. The larger the lens opening, the faster the light exposes the image sensor or film. The corollary is the smaller the lens opening, the longer the shutter will have to be open in order to allow the same amount of light in to expose the sensor or film.

The size of the lens opening (or aperture) is referred to as the f-stop. Most compact-level digital cameras have f-stops ranging between f/2.0 and f/11.0. Understanding f-stops can be a bit confusing because the number is actually the denominator of a fraction with 1 as the numerator. In other words, f/2.0 is really 1/2.0 (or 1/2) and f/8.0 is really 1/8.0 (or 1/8). These fractions represent the opening size; so, f/2.0 is a larger opening than f/8.0.

> **NOTE**
>
> Larger aperture numbered (f/8.0 or f/11.0) result in more depth-of-field than smaller aperture numbers (f/2.8 or f/4.0). Longer shutter speeds (1/60th or 1/30th) are more likely to be blurred than shorter shutter speeds (1/250th or 1/400th). When shooting low-light scenes, increasing the ISO setting (say, from 50 ISO to 200 ISO) allows the image sensor to capture more light more quickly, allowing the use of a faster shutter speed, or a smaller aperture setting. But this increased ISO setting increases the amount of digital noise. These are the fundamental trade-offs of *all* cameras, film or digital.

When thinking about this concept, you may wonder why photographers care so much about which combination of f-stop and shutter speed they use if different combinations result in the same level of light entering the lens. We care because a small opening results in more depth-of-field than a large opening. *Depth-of-field* is a term that describes the area from near to far that is in focus; in other words, it describes how much of the image is in focus.

Furthermore, because a smaller opening requires that the lens be open longer to get the same amount of light as a larger opening, an image has an increased chance of being blurred if the camera or the subject moves during exposure. In this case, a camera support would be recommended. So, the trick is to get the proper depth-of-field and the desired degree of image sharpness with the available light.

The photo of the old work boots shown in **Figure 3.2** is a good example of having to deal with the trade-offs between f-stop and shutter speed — you'll find you can't always choose the settings you want. Because the objective was to have as much of the photo as possible be in focus, the choice of f-stop was near the maximum f-stop available on the Nikon CoolPix 950, such as f/11.0. However, because no tripod was available and not much light was in the barn where the boots were laying, the smallest f-stop that could be used was f/2.9. This setting was just about the worst setting that could be used to maximize the depth-of-field, but it worked! If a tripod had been available, the camera could have been set to f/8.0 and the photo would have been entirely in focus.

Figure 3.3 shows a photo of a small frog. The objective here was exactly the opposite of the photo of the old work boots — it was to have as shallow a depth-of-field as possible. Notice how the right eye of the frog is clearly focused and the left eye and everything further from it is blurred. Likewise, the foreground leaves are also blurred. Given the chance to shoot this photo again, I would try to shoot with a slightly

smaller f-stop (for example, f/8.0 instead of f/4.0) so that both eyes would be in focus. The problem then would have been to hold the camera still enough to avoid causing image blur due to camera movement at the resulting slower shutter speed.

You should also now understand the importance of deciding what your photo should look like before shooting. Otherwise, how will you optimally set the camera settings? You can shoot with an automatic setting, or you can choose your settings carefully for each shot you take. Often, many of photography's trade-offs and limitations make getting the photo that you want challenging and that is why some photographers are better than others. The good ones learn to envision a shot, and choose the best settings based upon the constraints and trade-offs that face all photographers.

With that quick and possibly overly simplistic overview of f-stop and shutter speed, the discussion of the resulting effects that different combinations can have on image blur (due to subject movement or to the photographer's inability to hold the camera still while shooting), and the nuances of depth-of-field, you can understand the challenges of capturing a photo as you envision it!

3·3 © 2001 Gregory Georges

STEP 2: CHOOSE BETWEEN AN AUTOMATIC OR CREATIVE EXPOSURE MODE

In an effort to compete, as well as provide lots of control to users of digital cameras, camera vendors have created a wide variety of different exposure modes. All of these modes fall into one of four categories: automatic, creative, manual, or special.

When you use an automatic mode, the camera chooses *both* f-stop and shutter speed for you based upon its attempt to optimize exposure for a particular type of subject. Besides choosing f-stop and shutter speed, some automatic setting modes also control the ISO setting based upon the available light, or white balance. They can automatically turn on a built-in flash if it is needed, or make other settings for you automatically. One drawback of using *some* automatic modes is they do not let you modify some settings such as exposure compensation, automatic exposure bracketing, or the light metering or focus methods. A creative exposure setting allows you to choose either f-stop or shutter speed, then the camera

> **TIP**
>
> One of the advantages of conpact-level digital cameras is that they have an extremely deep depth-of-field — that is, they can be used to take photos of subjects where the entire image is in focus. This is partly due to the small image sensor size. The downside is these same digital cameras are limited in their ability to take a sharply focused subject with a soft blurred background. To get a good idea of how much control you have over depth-of-field with your camera, try shooting a row of small objects like pencils, or leaves on a bush, while varying aperture from the smallest f-stop to the largest f-stop. Then try again by varying the distance between the objects and the camera. Using a tripod for this exercise is best, if you have one.

attempts to choose the other settings for you based upon your initial choice. If there is not enough light, or there is too much light to get a good exposure, your camera may not let you even take a photo! Using a manual setting, you get to set everything yourself! Yes, that means that you can do all kinds of creative things like over- and under-exposures without having to fight with the camera in any way!

Special modes include modes optimized for doing panoramas, movies, night scenes, or other special effects. To select exposure mode, most digital cameras offer an exposure mode dial like those shown in **Figure 3.4** and **Figure 3.5**. These exposure dials are from a Canon PowerShot G2 and a Nikon CoolPix 950, respectively.

With all these choices of exposure modes, how do you decide which one to use? Because of the sophisticated and usually accurate light metering on many digital cameras, you can often get excellent results by using one of the automatic modes. Just make sure to pick one that is appropriate for your subject! For example, if you're shooting a portrait and your vision is to have a sharply focused face or faces against a soft blurred background, you can use a "portrait" mode. Most automatic portrait modes are designed to have a shallow depth-of-field, which results in a soft background. If you want an even shallower depth-of-field,

then you have to choose another exposure mode that allows you to change the aperture setting.

If you want to shoot a landscape with everything in focus, try using a landscape mode. Or, you can use one of the automatic modes or creative modes that allow you to change the aperture setting, too! The more you learn about the relationships between f-stop and shutter speed, the more you are likely to want to have control over your settings instead of leaving it up to your camera to choose for you.

WARNING

If you are using an "automatic" exposure setting, make sure to read the documentation that came with your camera to see whether it will also automatically change the ISO setting. Because significantly more digital noise exists in photos taken with the higher ISO setting, such as 400 or 800 ISO, you ought to be aware if your camera will automatically change to a higher ISO setting if there isn't enough light. If you want to avoid using these higher ISO settings, use another exposure mode, or use a flash.

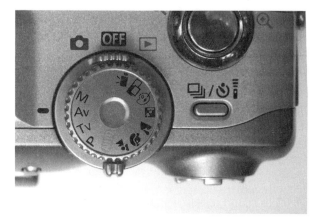

Before you go on to Step 3, carefully read the pages in the manual that came with your camera that describe each of the exposure modes on your camera. You need to understand what each mode has been designed to do and what settings you can change while in that particular mode.

STEP 3: CHOOSE F-STOP OR SHUTTER SPEED

After you've chosen a specific exposure mode, you may then need to make additional changes to either the f-stop or shutter speed. If you have chosen one of the automatic modes that selects all the settings for you, you may not be able to make any changes. If you have selected one of the creative modes, an automatic mode that allows changes, or the manual setting, now is the time to make changes to the f-stop or shutter speed to get the results you want.

WARNING

One of the common mistakes made by those new to photography is to use one of the creative modes, such as aperture priority mode or shutter priority mode, and simply shoot without considering what the current setting is! Although these modes are automatic — meaning, for example, that the aperture priority mode automatically sets the shutter speed based upon the aperture setting — you have to first select an appropriate aperture setting! The same thing applies to the shutter priority mode. You set the shutter speed to be what you want and then the camera sets the aperture to get the right exposure. If you don't choose these settings, you will simply be using the setting that the camera was last set on.

TAKING AND REVIEWING PHOTOS

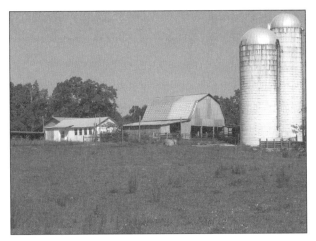

4.1 *Original image* © *2002 Gregory Georges*

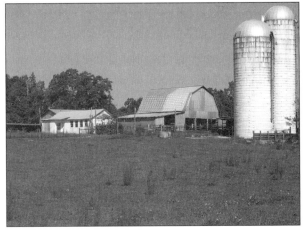

4.2 (CP 4.2) *Edited image* © *2002 Gregory Georges*

Being able to take a photo and immediately see it is one of the more significant benefits of using a digital camera. If you want to take the best possible photos, you need to learn about those features your camera offers for both "previewing" and "reviewing" photos to assess the technical as well as compositional aspects of your "just-taken" photo. After you get used to using these features, you'll have one more reason why you will want to shoot with a digital camera instead of a film camera!

The photo shown in **Figure 4.2 (CP 4.2)** was actually the third of four photos that were taken of the North Carolina farm buildings. **Figure 4.3 (CP 4.3)** shows how the camera was set up on a tripod with the LCD monitor set to "preview" the image of the farm buildings. Each time the shutter release button was pressed, a "review" screen displayed the image settings and the captured image for two seconds. Several additional shots were taken with different adjustments to the settings based upon the information on the "review" screen.

23

To make sure that one of the images was exposed properly, the Canon PowerShot G2 was put in "review" mode and the "exposure histogram" (you learn more about this in Technique 11) was examined to determine that the photo in **Figure 4.1** was the "best" shot and that it was exposed correctly. The photo in **Figure 4.2 (CP 4.2)** is the result of some basic image editing in Adobe Photoshop Elements to improve image contrast, exposure, and image sharpness.

In this technique, you learn how to get the most from the "preview" and "review" features your digital camera offers, so that you can take better photos.

STEP 1: SET PREVIEW AND REVIEW FEATURES

Digital cameras have many different features to preview and review photos. There are also many different ways in which you access these features. A "preview" feature allows you to take a look at an image on an LCD monitor before you press the shutter release button and to have a quick visual check of the camera settings and composition.

A "review" feature allows you to look back or to review an image after the photograph has been taken. Some of the new Minolta and Sony digital cameras

have gone one additional step forward — they actually allow you to view "after" image and exposure information *before* you've taken the photo! This means that you can make all the settings adjustments you want to get the photo you want, before taking a single photo!

Depending on your camera model, the differences between the preview and review features can be substantial. Once again, you should consult the documentation that came with your camera. Look for features that "replay," "preview," or "review" images. Also, check to see whether your camera offers a histogram. I have known many digital camera owners who have had their cameras for months and were not aware of the many useful features that could be used to substantially improve their photos. Don't be a part of this group! Check out your documentation.

Assuming that you have sufficient battery power and that your camera has a "review" feature, set it to display an image for a couple of seconds after a shot has been taken. This quick review is good enough to get an idea of how close you were to getting the shot you wanted. Usually, these review modes also let you read a few other important camera settings on the monitor as well as the number of photos you've taken and the number that you can take based upon current camera settings. Not every digital camera allows you to preview a photo until you change to a "preview mode," which takes you out of shooting mode.

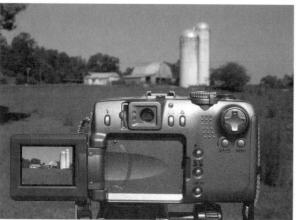

4.3 (CP 4.3) © 2002 Gregory Georges

If your camera has a review mode, you should also check to see whether it has alternative review modes. Some are simply views of the image, while other modes show shot information on the screen, too.

STEP 2: DETERMINE OBJECTIVES AND SELECT APPROPRIATE SETTINGS

Step 1 in Technique 3 discussed the importance of visualizing how you want your photo to look before you take it. After you have decided, you should then, and only then, choose the most appropriate settings to get the shot you want. Selecting focal length, exposure mode, metering mode, aperture, and shutter speed are just a few of the many settings that you are likely to want to set.

STEP 3: COMPOSE IMAGE AND TAKE PHOTO

After you have set all the necessary settings to get the photo you want, you are ready to compose your shot. Most digital cameras offer two ways to view and compose your photo — you can either view the scene on an LCD monitor, or through an optical viewfinder.

If your camera has an optical viewfinder, you need to be aware that it *may not* provide you with an accurate view of the photo that you will be taking. Most compact digital cameras with optical viewfinders have what is known as the *parallax phenomenon*. This phenomenon is due to the physical separation between the viewfinder and the lens. The closer your subject is to your lens, the less your photo is likely to look like the view you see when looking through the viewfinder. Some of the newer cameras have electronic viewfinders, or ELFs. These viewfinders are actually high-resolution LCDs and they show the same image as the LCD monitor.

Optical viewfinders do have two advantages. First, they do not consume battery power like LCD monitors, which can be important if you have limited battery power. Second, viewfinders can often be easier to use in bright daylight because light can wash out the image on an LCD monitor. If you use the viewfinder, you should also check to see whether it has a diopter adjustment to adapt to your vision.

When you've composed your shot as you want it, press the shutter button to take a photo. If you have a preview feature and it has been turned on, you should now be able to get a quick two-second view of the image you just shot.

STEP 4: REVIEW IMAGE AND CHECK SETTINGS

If you want to look more carefully at the shot you've just taken (or earlier shots, too), you probably need to change to a review mode. You usually do so using the same dial that allows you to change exposure settings. Check your documentation to learn how to change to a review mode and to learn about the various review modes that are available. Some digital cameras allow you to view up to 16 small thumbnails on the LCD monitor so that you can quickly find the photo that you want to examine. Many cameras also have options for how much shooting data is displayed on the LCD monitor in addition to the image.

Figure 4.4 (CP 4.4) shows the detailed review screen in the LCD monitor of the Canon PowerShot G2. This is just one of two display settings offered on the

4.4 (CP 4.4)

G2. From that screen, you can see that aperture was set to 1/400, f-stop was set to f/8.0, no exposure compensation was used, white balance was set to daylight, metering mode was set to evaluative, image resolution was set to the maximum resolution, and the lowest level of compression was used. You can also read the date and time, plus the image file number and folder number. Equally important is that you can also see the exposure histogram, which gives you excellent insight into how well your photo was exposed (even more so than what you can determine from looking at the image).

To determine whether your image is in focus, check to see whether your camera allows you to zoom in on the displayed photo. A zoom feature not only helps you to check an image to see whether it's in focus, but it also helps you check on subject details such as eyes to see whether they blinked or have red-eye.

As you review your images, you can also delete those that you don't want to keep. Deleting images gives you more space for more photos and it reduces

the amount of time you spend later when you download your photos to your computer.

STEP 5: SHOOT AGAIN IF NEEDED

After you have reviewed your photos, you will be able to decide whether you have the shots you want. If not, compose your picture again with new settings; then, once again, press the shutter button to take another photo. If you're not sure you have what you want, try a few other settings and take a few more photos. (In Technique 12, you learn about exposure bracketing — a great technique for ensuring that you have the exposure you want.)

TIP

To avoid having to look at a washed-out LCD monitor in bright sun, consider getting the Xtend-a-View LCD magnifying finder www.photosolve.com. It's now available with an optional rubber eyecup to make it even easier to use in bright sunlight.

WARNING

Although you may be tempted to review and delete all the photos that you think you don't want while shooting, you may end up tossing out shots that you would like to keep. As useful as the LCD monitors are, they are quite small and you may not be able to see as much as you think you can. Photos that look like they are in focus or exposed may not be. If you have enough space on your digital photo storage media, you're usually better off deleting images on your computer because you can view them full-size on your computer monitor before making any deletions.

CHANGING CRITICAL SETTINGS QUICKLY

5.1 (CP 5.1) *Original image* © 2000 Gregory Georges

5.2 (CP 5.2) *Edited image* © 2000 Gregory Georges

"The picture of a life-time." "Capturing the perfect moment." "Capturing the decisive moment." These are just a few of the many often-used phrases that vividly refer to the fleeting moment where a photo ought to be taken! So many of the perfect moments for the perfect photo are either missed, or photos are taken, but are badly taken! Many reasons exist for why the moment was not captured as it should have been. The two most common reasons are that the wrong camera settings were used, or the appropriate settings were not set quickly enough.

So, how do you avoid these problems? Learn how to reset your camera, and how to select the correct settings quickly. How do you make sure you select the right settings in time to take a photo? After you've learned about each setting, practice changing them so that you can *quickly* get the settings you want, and learn where on your camera you can check the current settings. If you know where to check the settings and can make the setting changes quickly, you are more likely to get the perfect shot.

This technique has eleven steps that take you through each of the most critical camera settings that you should know how to change instinctively. But, don't panic because it has eleven steps — this technique is more of a "pre-flight" or "pre-photo" checklist, rather than an informative technique where you'll learn how to do eleven things with your camera. Use it when you have not used your camera for a while or when you want to make sure you're ready to shoot an important event.

STEP 1: LEARN HOW TO READ CURRENT CAMERA SETTINGS

The more features your digital camera has, the more you are likely to find yourself shooting with the wrong settings; that is, unless you know how to read the settings and you're compulsive about checking them before you shoot. There is a reason why I know this!

A few years ago, I took photos at a friend's wedding, the day after I had shot still life photos inside a kitchen. Because of the incandescent lights in the kitchen, I had changed the white balance setting to incandescent. The next day; the wedding day, I shot with the incandescent light setting even though I was shooting outside in daylight. All the wedding photos had a horrible blue cast! The good news was that the images were easily fixed with Adobe Photoshop, and I was not the hired wedding photographer! Maybe, with this story in mind, and this technique, you won't have such an experience. **Figure 5.1 (CP 5.1)** shows the original wedding photo with an awful blue color cast. **Figure 5.2 (CP 5.2)** shows the photo after Adobe Photoshop Elements 2.0 was used to enhance the photo and correct the color cast.

The best way to avoid using the wrong settings is to learn where and how to read the current settings on your camera. Camera settings can be shown in more than one place. On the Canon PowerShot G2, they can be found on a display panel, as shown in **Figure 5.3**. You can check the exposure mode by looking

at the exposure mode button. You change some of the less frequently changed settings via menus on the LCD monitor like the one shown in **Figure 5.4**. You can view other settings when looking through the viewfinder.

Because of the number of settings and the lack of space to display them, you will undoubtedly have to

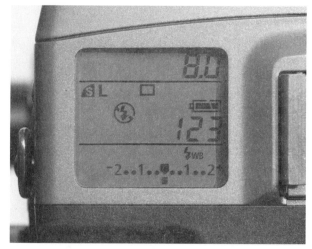

5.3 © 2002 Gregory Georges

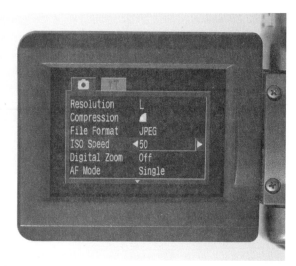

5.4 © 2002 Gregory Georges

get familiar with quite a few icons. The time you spend learning where various settings are displayed and how to change them will be well worth the effort. Take a few minutes now and find out where you can read the settings on your camera.

STEP 2: LEARN HOW TO "RESET" YOUR CAMERA

Most digital cameras have dozens of settings that can be changed, and when you change settings from their default settings, you may get unexpected results. A good way to start with the default settings is to "reset" your camera. You may have to read your manual to learn how to do this. Resetting your camera is usually as simple as selecting the right menu function and pressing a button!

STEP 3: CHANGE WHITE BALANCE SETTING

The white balance setting is an important one that you must set correctly to get photos with accurate colors. When you set the white balance setting to

> **TIP**
>
> If you experiment with different camera settings, or if you use a digital camera that is shared with others, you may want to use the reset feature to reset all the camera features to their default values each time you use the camera. Resetting the camera generally removes all settings that you may not think to check, as well as resets all other settings back to their default values. The best part about resetting your camera is that it is quick and it usually gets set to one of the automatic settings, so you usually can just shoot and get a pretty good shot.

match the light source, white will be white and all other colors will be as they should be. When the white balance setting is not correct, the photos will have an unwanted color cast, as was the case with the wedding photos shown earlier.

Most digital cameras offer an "auto white balance" setting that generally is quite good at minimizing color casts. However, you *may* find that you get better pictures when you use a specific setting to match the light source in the scene you are shooting. This is especially true if you shoot in a room with fluorescent or tungsten light; in these cases, use a fluorescent or tungsten setting to match the light source. You generally change the white balance through a menu displayed on an LCD monitor that you access with a dial or button.

Because using a correct color temperature (white balance setting) is so important, many vendors are increasing the number of available settings. For example, the Canon PowerShot G2 offers eight different white balance settings. They are Auto, Daylight, Cloudy, Tungsten, Fluorescent, Fluorescent H, Flash, and Custom. Learning about the different white balance settings offered by your digital camera, and using the most appropriate white balance setting for each photo you take, helps you get better photos.

STEP 4: CHANGE ISO SETTING

As explained earlier, ISO is a setting that determines how sensitive the digital camera is to light.

The lower the ISO setting (for example, 50 or 100), the longer it takes for the light to be recorded and, even more importantly, there will be less digital noise (similar to a film's grain). The higher the ISO setting (for example, 400 or 800), the quicker the light gets recorded and the more digital noise you will find in the resulting photos. The benefit of using a higher ISO setting is that it allows you to get a properly exposed photo in a low-light-level scene. Assuming you want to minimize digital noise, you may want to look at ways to add more light instead of changing

the ISO setting or, maybe not even take the photo at all. You can often use a lower ISO setting if you use a camera support as the extra support, which will allow you to shoot with a slower shutter speed and still avoid image blur due to camera shake.

STEP 5: CHANGE EXPOSURE MODE

Technique 3 covered the topic of how to choose and use an appropriate exposure mode. Although this setting is an easy one to make, it is one of the most important ones to choose correctly.

STEP 6: TURN FLASH ON OR OFF

Several other techniques in this book help you to learn more about using a flash. Besides just turning a flash on and off, your camera may offer many other flash-related features as well. You ought to know how to turn on any built-in flash as well as turn it off. You should also be aware that some automatic exposure modes automatically turn on the flash if extra light is needed to get a proper exposure. If you choose not to use a flash in these situations, you need to learn how to avoid using the flash by turning it off, or by changing to a more appropriate exposure mode.

STEP 7: SELECT METERING MODE

If you are not in Manual exposure mode, you are quite likely to be using one of the electronic metering modes to determine the proper exposure. Depending on what you are shooting and how you want to expose the image, one metering mode may be preferred over the other. Typical metering modes are evaluative (also called matrix or program mode), center-weighted averaging, center, or spot. You learn much more about how to pick a metering mode in Technique 13. For now, just learn what modes your camera has and how to change them.

STEP 8: SELECT FOCUS POINTS

The more skilled you become at envisioning a photograph, and then setting your camera settings to get the shot you want, the more you will want to learn about how to control focus. All photos must not necessarily be completely in focus. Great photographers are skilled at deciding what should be in focus and what should be blurred and to what degree. Choosing a focus method and focal points is essential for getting the photos you want. In Technique 10, you find out more about how to control focus. Once again, for now, take a quick look at the documentation that came with your manual and learn how you can control the focus.

STEP 9: TURN ON/OFF RED-EYE REDUCTION

When photographing people with a camera that has a built-in flash or one that is directly mounted on top on a flash shoe, the subjects in the picture will get red-eye — unless you use a red-eye reduction feature. Learn how to turn on and turn off the red-eye feature if your camera has a built-in flash. This simple setting is one you'll want to use if you're shooting people up close; nothing affects the quality as much as red eyes on an otherwise wonderful photo.

STEP 10: CHANGE EXPOSURE COMPENSATION

Throughout this book, you learn many entirely different exposure techniques to shoot the same subjects. If you're like me, and you often use exposure compensation, you will find that you will frequently put yourself at risk of taking a poorly exposed photo because you forgot to reset exposure compensation. If you use exposure compensation, make sure you learn how to adjust it and then make sure you set it back to 0 when it ought to be set to 0. Technique 12 covers exposure compensation in detail.

STEP 11: CHANGE OTHER SPECIAL SETTINGS

If you're someone who likes to use special features (like me), then you need to learn how to use them — and then make sure that you turn them off when they are no longer needed. One of my favorite features, and one that has become a common and widely used feature on many digital cameras, is the panorama mode. I've also been known to experiment with color effects and occasionally use the timed shutter-release so that I can be in the photos, too. When you use special features like these, you should make it a practice to turn them off as soon as you are through using them. Otherwise, they'll be on when you don't want them to be and you may miss getting the photo that you want.

So, are you ready for a quick test to see whether you're ready to shoot an important event? If so, then do the following:

- Quickly set your camera to a shooting mode suitable for shooting portraits.
- Turn on the flash to get some "fill flash," a small amount of light to supplement the existing light.
- Make sure you turn on the red-eye reduction feature.
- Set ISO to 100 to minimize digital noise.
- Set white balance for shooting with flash.
- Quickly review your settings to make sure they are set as you want and that you do not have a setting that would be contrary to your intentions!
- Now, set your camera to an exposure mode suitable to shoot a landscape on a tripod in late evening light.
- Set ISO to the lowest setting (for example, 50 or 100) to ensure a high-quality image. Check to see that your white balance setting is appropriately set.

If you made the changes for both of these photos in less than 20 seconds, you're just about ready for the next chapter! Before you head to the next chapter,

allow me to share a quick and true story to reiterate a couple of important points. The weekend before I submitted this chapter to my editor, I attended an old car and airplane show to shoot photos and to enjoy a day away from writing. As I wandered around the airfield, I noticed that far more people were shooting with digital cameras than film cameras. I spoke to about a dozen people shooting with digital cameras and asked a few questions about the settings they were using.

One person was shooting with an incandescent light setting — outdoors in bright sunlight. "Oops!" they said. Another was pleased to have chosen the shutter speed exposure mode as he knew it was important to have a fast shutter speed, but he did not set it — he just shot using the last setting — 1/30th of a second, ensuring all his photos would be blurred. A husband who was proud to have a "wife who reads manuals," told me that she learned how to adjust exposure compensation — so he had been shooting all day with a −1 exposure compensation setting, thereby underexposing many of his photos by a full stop. Another photographer used a "one-shot" focus setting, making certain that every incoming and outgoing plane that he shot would be blurred. Four out of twelve seemed to have all the settings just right — *all of them* were using "auto exposure modes." Because it was a very bright day, even these four could have spent their day taking better photos if they knew a little more about their cameras.

The point of this story is that as you learn to use different camera features, also make sure you know when to use them, and how to turn them off. After you move away from auto modes and into the "creative picture taking" world, you have a chance to both get better photos and to *really* mess them up! In the next nine chapters, you learn much more about how to use your camera *well*.

CHAPTER

2

TAKING PICTURES

Chapter 1 helped you to get familiar with your camera and get you ready to take better pictures. This chapter offers lots of tips, ideas, and inspiration to help you make great pictures. Technique 6 offers ideas on where to go and what to shoot. Technique 7 presents composition tips that will help you make better composed photos. In Technique 8 you will learn about focal length and how to choose a lens. In Technique 9 and Technique 10, you learn techniques that cover two of the most important factors that can either make or ruin a photograph — getting the proper exposure and getting a sharply focused photo.

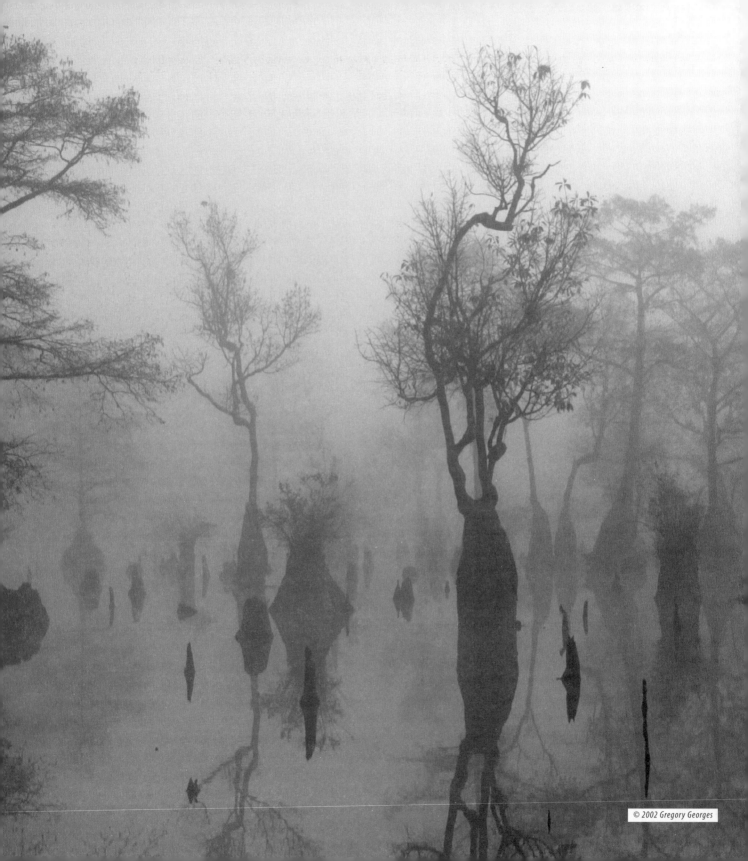

FIGURING OUT WHAT TO SHOOT

6.1 *Original image* © *2000 Gregory Georges*

6.2 (**CP 6.2**) *Edited image* © *2000 Gregory Georges*

ABOUT THE IMAGE

"Wedding Dinner Glasses"
Nikon CoolPix 950, camera
was supported by the table,
zoom set to 39mm (35mm
equivalent), f/2.6 @ 1/80th,
ISO 80, 1,600 x 1,200 pixels,
618KB .jpg

Most photography magazines and books are filled with breathtaking photos that more often than not were taken in some exotic place. Yet, you don't have to travel to Africa, take an underwater camera to the bottom of the ocean, or visit the Galapagos Islands to get good photographs. You can start in your own home or places you visit regularly, like the mall, the zoo, or even your own backyard. Getting good photographs in common places is simply a matter of learning how to see — and then composing to get interesting photos like the one of the wine glasses in **Figure 6.2 (CP 6.2)**.

Many years ago, in my first two-hour chemistry lab, all the students in the class were given a few candles and some matches. After we each lit one candle, we were shocked to find that the lab assignment was to write down 200 or more observations about a burning candle. After thirty minutes of observing and making notes, many of us were surprised to find that it was pretty easy to observe 200 or more *different* things about a burning candle.

The point of the exercise was to learn how to "see." The point of this technique is the same — only the objective of this technique is to learn how to *see creatively with a camera* by shooting a couple hundred photos while following the eight steps.

STEP 1: SHOOT INSIDE YOUR HOME

Whether you live in a small apartment, a large home in the country, or a flat twenty-nine stories up in the air, you should be able to find lots of things to shoot inside your home. The real advantage to shooting inside your home is that you're close to your computer. This means you can shoot, download your photos, examine them, shoot some more, and study those, too. This short feedback loop is an excellent way to learn how to take better pictures — quickly! I bet you'll be surprised at how much you can learn shooting a few hundred photos of objects inside your home. Try it and *see.*

My favorite subjects to shoot inside my home (excluding the three gray cats that own the place) are glass bottles, plants, and a wide variety of food products found in the kitchen. Fruit, vegetables (for example, colored bell peppers, squash, and even potatoes), olive oil bottles, and spices should all be considered as good subjects to be shot. As you shoot, look at the light and see whether you can change it by drawing a sheer curtain, adding lights, or by shooting at a different time of the day. **Figure 6.3** and **Figure 6.4** are two photos that were taken inside my home.

STEP 2: SHOOT IN YOUR BACKYARD

Because you're so familiar with your backyard, you may not deem it to be a place to go to take photographs. Or maybe you have a beautiful garden in your backyard with 200 acres of pristine forest with a pond surrounded by a waterfall and wildlife, and you know that wonderful photographs are just waiting to be

6.3 © 2002 Gregory Georges

6.4 © 2002 Gregory Georges

taken. Whatever the case, I suggest that you go out with your camera and accept the challenge to get some good shots.

To get practice assessing your photos after you've taken them and reviewed them on a computer screen, try to judge them on three standards: their technical merit, their ability to hold a viewer's interest, and how "artsy" they are. **Figure 6.5 (CP 6.5)** shows a photo of one of my gray cats and a statue in my backyard. How would you judge it?

My particularly harsh judgment rates it pretty poorly in terms of technical merit. The cat's head is a bit blurred and I would have preferred that the shot was taken with a slower ISO setting to rid the image of digital noise. Its art merits are not good either as I don't like the retainer wall or the block wall or the choice of background shrubbery. However, I thought the quick shot taken at the perfect moment of my cat attempting to "mirror" the image of the concrete cat with wings was quite captivating. Showing the photo to a few others confirmed my thought that it was interesting, so I get a few points for that photo.

After you've judged a few of your photos, open them up with software that allows you to view the EXIF data so that you can learn more about the settings you used to shoot. EXIF (Exchangeable Image File format) data is information that was recorded when the image file was created by your digital camera. When I opened the cat photo with Adobe Photoshop Elements 2.0, I learned that the shutter speed was 1/40th of a second — a bit on the slow side to hand-hold with a focal length of 100mm. That explained the blur around the cat's head. It also justified my ISO 400 setting as the blur would have even been worse with a lower ISO setting. Now the question is: "Could I have gotten a better photo using a tripod and a lower ISO setting?" We'll never know because when I went inside and got my tripod and came back, I could never get the cat to sit on the wall again! Through this example, you can understand the importance of being able to shoot, review, critique, and shoot again.

STEP 3: SHOOT IN MACRO MODE

If you feel that you have run out of things to shoot in your backyard, try shooting in macro mode. Macro mode allows you to shoot small things and make them fill up your image, as shown in **Figure 6.6 (CP 6.6)**. If your camera has a macro mode, try finding a spider, a

6.5 (CP 6.5) © 2002 Gregory Georges

6.6 (CP 6.6) © 2002 Gregory Georges

mushroom, a bright colored leaf, or another interesting subject to shoot. Techniques 30 and 31 cover the topic of taking macro photos, so I'll leave this topic for now. However, try shooting a few macro shots, because doing so gives you valuable insight that will help you with later techniques. To get good macro shots, don't be timid about getting down on your hands and knees and crawling around. Good photos are made, not taken; you have to work to make them.

STEP 4: SHOOT AT A ZOO OR BOTANICAL GARDEN

I've seen many, many good photos of wildlife and had, up until a few years ago, always assumed that they were wildlife in the wild. Over time, I've learned that many of those outstanding wildlife photos feature animals in captivity. I first believed that such photos were of a "lesser" quality than those photos taken of wildlife running free. However, because the world's wildlife population is decreasing at an alarming rate, and because it is both the volume of nature photographers and the fact that many of them have a lack of consideration for the animal's natural surroundings that contributes to the problems, I wholeheartedly recommend that you and your camera take a visit to the zoo. You may even see me there!

Rather than include photos of animals that I've taken at a zoo, or plants that I shot at a botanical garden, I suggest that you visit `www.photoblink.com`. It is a wonderful site for serious photographers who want a place to show their work, get feedback, and to become part of a group through an online forum. Seeing the photos that ordinary, everyday, non-professional, compact-level, digital camera–toting photographers display on that site is amazing! Check it out when you have at least thirty minutes to view photos and explore the site. I know you'll be impressed. The lesson here is that you, too, can shoot photos like these photographers! Professional photographers may get more great photos more often,

but even the non-professional can get one every now and then. I look forward to seeing your photos on the PhotoBlink site.

STEP 5: SHOOT PETS OR OTHER ANIMALS

I don't know for a fact, but I surmise that one of the most photographed subjects besides people are people's pets. I laugh when friends show their photos to me and they have entire folders full of pet photos — because I do, too. Every time I get a new lens or digital camera, I go looking for one of my three gray cats. **Figure 6.7** shows one of my cats with a mouse he just caught. Many tales are told about cats chasing mice. An entire cartoon series was even made about a cat chasing one mouse. Yet, have you ever seen a cat catch one? I hadn't until I shot this photo. Incidentally, my cat dropped the mouse right after I took the photo and the mouse escaped into the bushes with just a bad scare.

Out of the millions of things I could have suggested to shoot in this one of eight steps, why pick pets as a subject to shoot? Because some pets can be very patient models and odds are good that you are rather

6.7 © *2002 Gregory Georges*

fond of your pet if you have one. You'll learn that the more you enjoy your subjects, the more you will enjoy taking photos of them — and the better your photos will be! The real lesson here is to shoot things that you're passionate about. It will show in your photos.

During the past few years, I have grown increasingly passionate about shooting sports photos, great blue herons, and irises! If you have limited time to enjoy photography, you will find that when you focus on just a few different types of subjects, you get better and better at taking photos of them. You can see many photos of my favorite subjects on my Web site at `www.reallyusefulpage.com`. What are you passionate about? Now you know what to shoot.

STEP 6: SHOOT WHILE IN A MOVING CAR

Please note that the heading reads *while in* a moving car; not *while driving* a car! Please don't try shooting photos while driving as it may necessitate that an insurance agent use a digital camera to document the damage to your car! Why shoot while in a moving car? You will get an excellent sense of movement and of shutter speeds. Being able to show time or speed in a photo adds one more dimension to your photos.

As the car is moving, change shutter speeds between shots from 1/30th of a second (or even slower) all the way up to the fastest shutter speed your camera offers. One thing you can learn from this exercise is that having an image that's blurred can be okay. Not all images have to be perfectly in focus. Some image blur can add drama to a photo as it illustrates movement.

If you don't want to shoot from a moving car, you can stand at the side of a road and shoot moving vehicles. Try panning with the moving vehicle so that the vehicle is perfectly in focus and the entire background is blurred. It takes some practice to shoot fast-moving cars with a digital camera, but it is possible, and you benefit from learning the same things as you would get while shooting from a moving car.

STEP 7: SHOOT IN THE CITY

One of the reasons that so many great photographers have built their reputation from photos in New York City is because large cities are rich with photo opportunities. Take a few hours and go into a city with lots of tall buildings. You'll find it challenging to get good lighting, depending on when you visit, because the tall buildings create lots of shadows, but great photos are just waiting to be taken at every street corner. **Figure 6.8 (CP 6.8)** shows a photo of one tall office building in Charlotte, North Carolina, as a reflection

6.8 (CP 6.8) © 2002 Lauren Georges

in the glass of another building. If you have a chance, take a tripod and shoot after dark as well. The energy of big cities at night is easily captured with a digital camera.

STEP 8: SHOOT AGAIN!

Consistently taking good photos and getting the photos to look the way you want them to look takes lots of practice. You need to pre-visualize your shots, learn how to use your camera, and be at the right place at the right time. The more you shoot, the more you learn how to take great photos. Carry your camera as often as you can and shoot whenever you get a chance. When you first begin to take photos with a digital camera, you will see remarkable improvement in your picture-taking skills every couple of hundred photos that you take. Good luck and enjoy capturing the light!

COMPOSING YOUR SHOTS

7.1 *Original image* © 2000 Gregory Georges

7.2 (CP 7.2) *Edited image* © 2000 Gregory Georges

ABOUT THE IMAGE

"Excalibur Hotel-Casino" Nikon CoolPix 950 mounted on a tripod, zoom set to 111mm (35mm equivalent), f/4.0 @ 1/7th, ISO 80, 1,600 x 1,200 pixels, 718KB .jpg

The difference between a person with a camera and a photographer is that a photographer visualizes things that others don't see, then he *composes* and captures that image with the camera in a pleasing way. The vision, which is the start of a good photo, is what is really important (the camera is merely the tool to get the photo) and composition is how that vision is presented.

Learning how to compose an image is not something that happens overnight. It is not something that you can learn by following a few guidelines and rules; however, I strongly believe that learning how to think and talk about photo composition is tremendously useful. Learning some guidelines or rules that you can use as "ideas" or starting points for composing your own photos is also useful. After shooting several hundred photos while completing the following eight steps, my bet is that you will be well on your way to understanding the importance of photo composition and be able to compose better, too.

STEP 1: SHOOT USING AND VIOLATING THE "RULE OF THIRDS"

By popular usage, the "rule of thirds" must be the most commonly followed rule of photography — and the most often broken one. The idea of the "rule of thirds" is to divide your LCD monitor or viewfinder into nine areas like those found in a tic-tac-toe grid, regardless of the orientation of the photo. You then use these nine lines to help position important elements in your photo, as shown in the photo of a Maine crab shack in **Figure 7.3 (CP 7.3)**. When shooting a scene with a horizon, try shooting with the horizon line lined up with one of the grid lines.

The implication is that locating the focal point on one of these intersections is better than placing it in the center of the photograph. **Figure 7.4** shows the same subject composed with the focal point in the center and at one of the intersections. Which one do you like best? When it feels right to follow this rule, do so; otherwise, break it!

STEP 2: COMPOSE SHOTS WITH AN EMPHASIS ON LINES, SHAPES, AND PATTERNS

A well-composed photo can hold your interest exclusively due to the lines, shapes, or patterns shown, not because of the subject or scene itself. A detail of an oval ceiling in a museum is shown in **Figure 7.5**. This is a good example of the beauty of simple curves in an architectural detail that was designed by an architect intent on creating a pleasing detail. In contrast,

7.3 (CP 7.3) © 2002 Gregory Georges

7.4 © 2002 Gregory Georges

Figure 7.6 shows a very repetitive, symmetrical "cropped" view of the front of an old Ford truck. As you looked at it, did you first try to determine what it was? Then, did you begin comparing one side with the other to see whether the symmetry was perfect? If so, the photo caught your interest and that is good.

STEP 3: SHOOT TO "FRAME" YOUR SUBJECT

When possible, look at ways to "frame" your subject. You may be able to back up a few feet and have the branches of a nearby tree frame a landscape. If you shoot players in a sporting event, look for ways to frame the subject with spectators or other players. These extra people help to place the viewer in the scene. In the photo shown in **Figure 7.7 (CP 7.7)**, the viewer gets the feeling of looking through the front window of one old truck to see others. Being able to have a view inside one truck helps you to imagine what the other old trucks are like, thus giving the viewer much more information than if you were to just shoot a photo of the outsides of the trucks.

STEP 4: SHOOT TO CAPTURE OBJECTS OR BACKGROUNDS

Shoot to capture objects and backgrounds — what is the point of that you may wonder? If you already use an

7.6 © 2000 Gregory Georges

7.7 (CP 7.7) © 2000 Gregory Georges

image editor like Adobe Photoshop Elements, Adobe Photoshop 7, Paint Shop Pro, or one of the many other image editors, you already know the answer. An image editor allows you to combine parts of one image with another image.

Many times you will find an absolutely outstanding sunset or sunrise, but you aren't where you can shoot something interesting to go with the beautiful sky. At other times, you will find a great scene with a horrible sky. Maybe the sky is nothing but deep blue sky without clouds, or maybe it is the dreaded "bright white" sky that not only offers little to the scene, but makes shooting difficult as well. Using an image editor, you can take a good sky and combine it with a good scene with a bad sky! So, when you get a chance, shoot just for the objects or skies, knowing that you can use them in another photo later. **Figure 7.8** shows a photo of a sky that was later used as the background for a new image created with an old farmhouse.

When you take photos just for the objects or to be used as a background, think carefully how you should take those photos so that they will work with other photos. For example, the sky in **Figure 7.8** was rich in color, yet fairly dark. Such a dark photo might be too dark to combine with many other photos, so four

extra shots were taken with successively increased exposure to lighten the sky. You can find these extra photos on the companion CD-ROM in a folder named **/chapter-images/chap02/07/extras**.

STEP 5: SHOOT TO TIGHTLY CROP THE SUBJECT

The natural inclination is to shoot an entire subject. If the subject is a clown, the most obvious shot is of the entire clown, or the top half of the clown. Consider tightly cropping your subject as shown in the photo in **Figure 7.9**. Likewise, when taking a photo of a banjo player, also consider a tightly cropped shot of just his hand and part of the banjo, as shown in **Figure 7.10**. Sometimes, seeing less is actually more!

STEP 6: SHOOT WITH DIFFERENT CAMERA ORIENTATIONS

Much to my surprise, I rarely find beginning photographers turning their cameras 90 degrees to shoot in "portrait" mode, where the long side of a photo is vertical. You have many good reasons to shoot this way when it is appropriate. Many subjects or scenes

7.8 © 2002 Gregory Georges

7.9 © 2002 Gregory Georges

are "vertical" ones, and so you should shoot them vertically — just as some subjects are more horizontal in nature and should be shot horizontally. Besides shooting in vertical or portrait mode, you can also tilt your camera at any other angle, too. **Figure 7.11** shows a photo of a '56 Ford Thunderbird in front of a fancy home. I liked the idea of trying to shoot vertically, but I did not want the car to get too small relative to the whole picture, so I shot vertically and tilted the camera so the entire car still fit in the photo.

> **NOTE**
>
> Your choice of a camera orientation can substantially impact how your photo can or cannot be used. If you have aspirations or opportunities to have your photographs placed on the cover of a magazine, you ought to shoot vertically. Likewise, if you're shooting photos for a possible calendar, make sure you know in advance what the format will be. If in doubt, take the picture both horizontally and vertically so you have a photo to meet any requirement.

STEP 7: SHOOT USING DIFFERENT VANTAGE POINTS

The majority of the time that you view the world, it is from a point approximately five and a half feet up from the ground (depending on your height.) This view is considered to be the normal view — it's most common and familiar — and hence, it *can* be the most boring vantage point. When you shoot, consider using a different vantage point so that you shoot with a less common perspective. Try lying down on your side (to shoot from a worm's eye view) and shoot up at the subject. Or, find a way to shoot down on your subject (from a bird's eye view). The photos

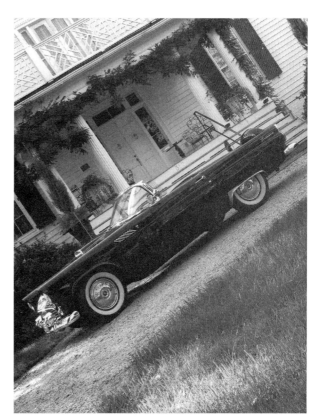

7.10 *© 2002 Gregory Georges*

7.11 *© 2002 Gregory Georges*

shown in **Figure 7.12 (CP 7.12)** and **Figure 7.13** show how much a simple change in vantage points can alter the perspective. Which one do you like most?

STEP 8: SHOOT AND DEVELOP YOUR OWN COMPOSITION IDEAS

If you completed the previous seven steps, you may have already begun to formulate your own set of ideas for composing photos. Your ideas may be based upon quality of light, the distance to the subject, the amount of distortion of the subject, the angle of view, depth-of-field, or any one of ten million other ideas. The more ideas you have and the more you shoot, the more you're likely to develop a "style" of your own and to get good photographs — photographs that are not likely to be termed "cliché photos."

Hopefully, you've enjoyed this technique and found it to be a useful one. The more you learn to previsualize each photo, the better your photos will be.

> **NOTE**
>
> Photography is becoming a passion for a rapidly growing number of people with financial resources to buy the latest and greatest digital photography gear. To make your photographs "stand apart" from the others, learn to see and shoot common subjects and scenes differently and better than other photographers. The photographer and his or her skills — *not the gear* — are still the most important factors in making great photographs.

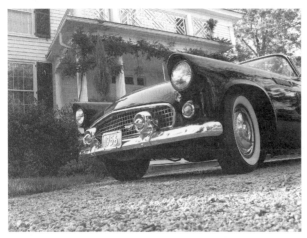

7.12 (CP 7.12) © 2002 Gregory Georges

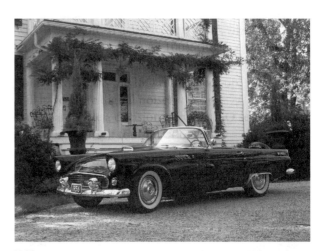

7.13 © 2002 Gregory Georges

SELECTING FOCAL LENGTH

8.1 *Original image* © 2002 Gregory Georges

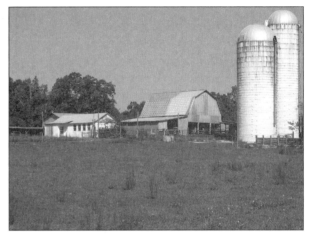

8.2 *Edited image* © 2002 Gregory Georges

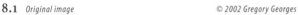

"Two Silo Farm Complex" Canon PowerShot G2 mounted on a tripod, zoom set to 102mm (35mm equivalent), f/8.0 @ 1/320th, ISO 50, 1,600 x 1,200 pixels, 866KB .jpg

Focal length, image sensor size, depth-of-field, aperture setting, magnification factor, and many other such photographic terms and concepts can be difficult to comprehend because they all are interrelated. The objective of this digital camera book is not to attempt to explain such complexities in detail; rather, it is to provide readers with enough basics and "feelings" for their cameras so that they can get good photographs. However, in order to accomplish this goal, you need to have a reasonable understanding of focal length. Plus, a good understanding of focal length will allow you to discuss photos, like the one shown in **Figure 8.2,** with others by saying, "It was shot with a 102mm lens."

STEP 1: UNDERSTANDING FOCAL LENGTH

In simple terms, focal length is similar to a magnification factor. The longer the focal length (the larger the number in millimeters), the closer it will appear that you are to your subjects, and the narrower the view will be. A short focal length allows you to see a wider-angle view and makes it appear that you are farther away from your subject.

Focal length in technical terms is the distance in millimeters between the surface of the image sensor and the center, or emergent nodal point, of the lens. It is also a number that specifies the amount of magnification you get when you look through your camera. If you have used a 35mm film camera, you may be familiar with the 28mm, 50mm, 100mm, or possibly even the 400mm lenses. If you have used several lenses with different focal lengths with your 35mm film camera, you may have developed a pretty good sense of the angle of view or the degree of magnification you get with each lens. You use this sense to pick lenses and to pick the place where you want to stand to shoot each photo.

Unfortunately, digital cameras have image sensors that are usually smaller than 35mm film. In order to project an image on a smaller area, the lens focal length must be shortened by the same proportion. This means that you will have to get familiar with an entirely new set of focal lengths — maybe even a different set for each digital camera you use!

For example, the Canon PowerShot G2 has a zoom lens with a focal length ranging from 7mm to 21mm. Canon publishes the 35mm equivalent as being 34mm to 102mm. If you divide 34mm by 7mm, or 102mm by 21mm, you get a multiplier of 4.85. Why do you care? You will only care if you are used to thinking in terms of the equivalent 35mm focal lengths and you want to know what they are. You may have noticed in the descriptions of the first photo in each of the techniques in this book that the camera's focal length has been converted to the 35mm equivalent. Also, when you read the EXIF data found in the image files, the listed focal length is the actual focal length — not the 35mm equivalent. After you have computed the multiplier for your camera, you can easily convert these actual focal lengths to the 35mm equivalent focal length if they are more meaningful to you.

Depending on your digital camera, you may have one or more ways to change focal length. Many inexpensive digital cameras have a fixed focal length lens. If you have one of these cameras and you want to be able to change focal length, you need to find out whether the vendor or any third-party lens manufacturer offers add-on lenses for your camera. If they don't, you will have to purchase a new camera to be able to change focal length.

Most compact digital cameras today come with a built-in zoom lens, which allows you to change the focal length between a minimum and maximum length. An increasing number of manufacturers also make supplemental lenses. Supplemental lenses are "add-on" lenses that you add to an existing fixed or zoom lens. You find out more about using supplemental lenses in Technique 18.

The last way to change focal length is to use a digital zoom feature if your camera offers one. You learn more about digital zoom in Step 5 of this technique.

Okay, so much for definitions. The purpose of this technique is to get you familiar with the view you get with your digital camera and any accessory lenses you may have. This familiarity is essential if you want to know where to stand and what lens or accessory lens to use to get the shot you want. It is also important to learn about the implications of using different focal lengths.

If your digital camera is a fixed focal length camera (that is, it does not have a zoom feature), then you can skip to the next technique because you will not be able to complete these steps. If you have accessory lenses such as a wide-angle, telephoto, or fisheye, then you should shoot with them also. In order to get good images that are easy to compare, you should use a tripod if you have one.

STEP 2: SHOOT WITH MINIMUM FOCAL LENGTH (WIDE ANGLE VIEW)

■ Adjust your lens for the widest possible angle of view, and then take a photograph.

The photo in **Figure 8.3** shows a photo taken with a Canon PowerShot G2 set to its minimum focal length, which provides it's maximum wide-angle view.

STEP 3: SHOOT USING MID-RANGE FOCAL LENGTH

Now adjust your lens to shoot halfway between the minimum and maximum focal length and take another photo. The photo in **Figure 8.4** shows another photo taken with a Canon PowerShot G2 set halfway between the minimum and maximum focal lengths.

STEP 4: SHOOT WITH MAXIMUM FOCAL LENGTH (TELEPHOTO MODE)

Set your lens to its maximum focal length to "zoom" in as far as possible; then take one more photo. **Figure 8.5** shows a photo with the Canon PowerShot

NOTE

If you want a panoramic photo, you are not limited by the minimum focal length that your camera offers. Many digital cameras offer "panorama" modes that make it easy to take a series of overlapping photos that you can later digitally stitch together into one single photograph. If your camera does not have a "panorama" mode, you can still shoot overlapping photos and digitally stitch them together with software made for that purpose. See Technique 36 to learn more about creating panoramic photos.

G2 set to its maximum focal length. While your camera is still set to maximum focal length, remove it from the tripod and shoot while changing the shutter speed to 1/60th of a second or even less if it is possible under the existing light conditions. Later, when you can look at the images on your computer screen, carefully look to see how the slower shutter speeds can negatively impact the image sharpness when shot with a "long" telephoto lens.

STEP 5: SHOOT USING DIGITAL ZOOM

Unlike optical zoom, which occurs as a result of the changing of the optics in your lens, digital zoom occurs *digitally*. Optical zoom maintains the image quality of the camera, whereas digital zoom uses a mathematical algorithm to magnify a portion of the image to increase image size. This process of mathematically interpolating picture information is the same as making up picture information where previously none existed. The results are that you get a magnified view — but, one that is of a much poorer quality.

Figure 8.6 shows a photo that was taken with a Canon PowerShot G2 using a *digital* zoom. If you open the image, which you can find on the companion CD-ROM, with an image editor, and zoom to 100%, you can see the results of the digital interpolation. Having the capability to capture an image with

TIP

Remember you likely will get a blurred image if you hand-hold your camera when using a slow shutter speed. What is a "slow shutter speed"? It depends on how carefully you hold the camera and the focal length of the lens you are using. It is worthwhile to make some tests to determine when you *must* use a tripod and when you can get by without one.

the extra magnification using digital zoom is wonderful — just be aware that the picture quality is considerably less good than if you used optical zoom.

STEP 6: SHOOT WITH WIDE ANGLE AND CHANGE PERSPECTIVES

Once again set your camera to the maximum wide angle. Take a few pictures of distant scenes as well as

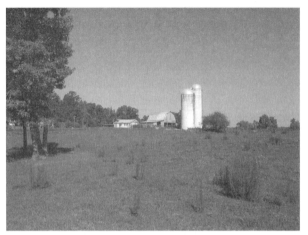

8.3 © 2002 Gregory Georges

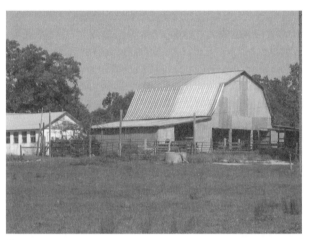

8.5 © 2002 Gregory Georges

8.4 © 2002 Gregory Georges

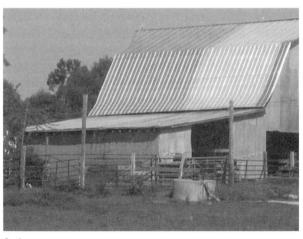

8.6 © 2002 Gregory Georges

up-close subjects, like the chessboard shown in **Figure 8.7**. Depending on the quality of your lens and on how wide an angle it is able to capture, you may find some image distortion. Notice how the

8.7 © 2002 Gregory Georges

chessboard seems to wrap under your feet. As long as you have straight lines where straight lines should be — you have a good lens.

TIP

Many lenses suffer from "barrel distortion" or the "pincushion" effect. Barrel distortion causes an image to bulge out in the middle, while pincushion distortion makes an image look like it has been squeezed in the middle. These effects are noticed most when a lens is used at maximum wide angle. If you want to correct this distortion, consider using Andromeda's LensDoc Plug-in for Adobe Photoshop (www.andromeda.com) an Adobe Photoshop plug-in–compatible applications. Not only can a plug-in correct for barreling and pin-cushioning, but you can also use it to fix a variety of other image ailments.

GETTING THE EXPOSURE YOU WANT

9.1 *Original image* © *2000 Gregory Georges*

9.2 (CP 9.2) *Edited image* © *2000 Gregory Georges*

ABOUT THE IMAGE

"After Sunset in Sedona, Arizona" Nikon CoolPix 950, hand-held, zoom set to 39mm (35mm equivalent), f/7.4 @ 1/793, ISO 80, 1,600 x 1,200 pixels, 701KB .jpg

One of the two most frequent complaints about photos is that they are not exposed properly; the other is they are "out of focus." Photography has often been described as the art of capturing light, and so learning how to get a properly exposed photo is essential — as well as challenging, as was the scene shown in the photo in **Figure 9.2 (CP 9.2)**! In this technique, you learn six steps you can take to help you get the "right" exposure — as often as is possible. Before getting into these six steps, we first need to correct a few misconceptions and give you some suggestions for finding good light.

MISCONCEPTION 1: YOU CAN ALWAYS GET THE EXPOSURE YOU WANT

Many people who are just starting with photography as well as those who have been taking photos for years believe that they should be able to *always* get a good photo. When they don't, they fault themselves or their cameras.

However, they shouldn't, because you can *always* take a photo, but you *won't always have the right light* to get the exposure you want.

Getting a well-exposed photo in some shooting conditions is simply not possible. Three of the most common problems are that the subject is bathed in too much bright light, not enough light is around to properly illuminate the subject, and too much difference exists between the brightest bright and the darkest dark. In each case, you have to accept the fact that you won't get a good photo unless you can modify the light. Sometimes you can modify light by using a flash, bouncer, diffuser, filter, or even clouds (because they can block the sun), and create the best possible shooting conditions.

Figure 9.3 shows a photo of a black 1942 Packard. Unfortunately, the day I was able to take a photo of it, the sun was very bright. After taking a few shots, I found that the shiny or bright parts of the car were captured as "blown-out" highlights and I knew that getting the quality of shot that I wanted was impossible with the bright white skies and the dark black paint on the car. Just as I was packing up my gear, I got lucky. A fairly dense cloud blocked the sun, creating a temporary, yet ideal shooting condition. I got the photo I wanted!

The photo of the shiny chrome Packard hood ornament shown in **Figure 9.4** is an example of too much bright light. When the exposure was set for the bright ornament, it was still "blown-out" to almost pure white, plus the car no longer looks black. **Figure 9.5 (CP 9.5)** shows a photo of the inside of a wonderful old church. In this case, there is not enough light to light the interior walls even with a camera mounted on a tripod and when a higher ISO setting is used. The ceiling is too high to use a camera-mounted flash. It is simply a bad environment for getting a good photo.

The photos in **Figure 9.6** and **Figure 9.7 (CP 9.7)** are good examples of a scene that requires more exposure latitude than can be captured with today's digital cameras (or film cameras either). As strange as

9.3 © 2002 Gregory Georges

9.4 © 2002 Gregory Georges

it seems, getting a good shot of a fun hole at a nearby golf course was not easy to do in the after-sunset light. **Figure 9.6** shows the results of exposing for the green grass on the fairway and the green, which results in a washed-out sky. The photo in **Figure 9.7** (**CP 9.7**) was exposed for the sky, which resulted in an overly dark fairway and green.

> ### TIP
>
> When faced with extreme exposure latitude like that found in **Figure 9.6** and **Figure 9.7 (CP 9.7)**, you can make a good exposure by combining the two photos with an image editor like Adobe Photoshop. Alternatively, you can use a graduated neutral density filter on your digital camera lens to achieve a similar effect.

If you have the flexibility to choose the time and place to shoot, ask yourself whether the lighting conditions make it possible to get a well-exposed photo, or is there a better time or place to shoot? Many times, you will just have to shoot anyway. Whenever possible, pick a time when the light will work with you, not against you.

9.6 © 2002 Gregory Georges

9.5 (CP 9.5) © 2002 Gregory Georges

9.7 (CP 9.7) © 2002 Gregory Georges

MISCONCEPTION 2: CAMERA EXPOSURE METERS ALWAYS EXPOSE PROPERLY

One other common misconception is that sophisticated modern exposure meters in digital cameras *always* give you a properly exposed photo — nothing could be farther from the truth! This isn't true for a couple of reasons. First, some scenes are inherently difficult for anything but a human brain to get correct. The most difficult scenes for automatic exposure meters to expose correctly are the "white-on-bright" or "black-on-dark" scenes. Examples include a mostly white snowman in the middle of a pure white field of snow, or a black cat sitting on a pile of coal. Logically, if you think about it, the only way a digital camera could expose these images correctly is to be able to recognize the subjects as a snowman and a cat, and know that they were white and black, respectively.

The second major reason why an exposure meter will not get a correct exposure has to do with you! You, the camera user, may not be using the exposure meter features correctly. You learn more about how to use a variety of exposure meter features correctly later in this technique and in Techniques 11, 12, and 13.

MISCONCEPTION 3: CERTAIN TYPES OF LIGHT ARE ALWAYS BAD

Have you ever been told that midday light or "high-noon" light is horrible light and that you should avoid it? Or have you been told you can't shoot in low light levels? Or, that shooting in haze or fog is awful? These examples are just a few of some of the rules that are too-often repeated that are not always correct. It is true that midday sun is usually bright, and because it is straight up overhead, few shadows are cast that you can use to emphasize detail in a subject or scene.

No question about it, shooting in deep haze or in thick fog can more often than not be more of a hindrance to getting a good photo than it can be of help. However, every time you believe that these rules apply all the time, you will miss many good opportunities to get great photos. **Figure 9.8 (CP 9.8)** shows a photo taken in the evening fog in the Great Dismal Swamp in North Carolina. Although this particular swamp offers many entirely different photographic opportunities year round, one of my favorite times is in early winter when extreme temperature changes cause lots of fog!

FINDING GOOD LIGHT

As you get better using your camera and developing your personal vision, you'll find ways to get good photos from not-so-good light conditions. Now let's

9.8 (CP 9.8) © 2002 Gregory Georges

look at a few guidelines for finding "good" light. The "golden" hours of photography are the hour around sunrise and the hour around sunset. The reason they are considered "golden" is because they can be filled with a rich warm glow of light that helps to make awesome photographs. This time is also good to shoot because the light comes in at a low level and it casts wonderful shadows — the opposite of what you find at high noon. If you want to take front-lit, side-lit, and silhouette shots, these are the best hours to get these kinds of shots, too.

Days with clear rich blue skies and a few puffy white clouds are also days where you should be photographing when you can. The blue sky is remarkably easier to shoot than that of the more common bright white sky. Depending on where you are shooting, you can have lots of "blue" days and few "white" days, or you can have the reverse. For example, the strong trade winds that always blow over the Hawaiian islands make for lots of blue days. In contrast, there are times where I did not see a blue day at all for months at a time when I lived in England. Yet, the English sky was rarely "too bright" and it generally allowed for wonderful photographs.

Moderate to violent weather conditions *can* also create superior lighting conditions. Many landscape and nature photographers have taken their best photographs in such bad or changing weather. The sky opening up after a thunderstorm, or distant lighting in an otherwise dark cloud cover make good photos even if you have to stand in the rain and hold an umbrella to protect your camera gear. Just because the weather is bad, don't stay inside. Use caution, but take advantage of the wonderful light you can find during less-than-perfect weather.

Having dismissed these few misconceptions and having considered when and where to find the best lighting conditions, you're now ready to look at a six-step process to get good exposure with a digital camera.

STEP 1: DETERMINE HOW YOU WANT YOUR PHOTO TO LOOK

There is no such thing as the "perfect" exposure, only the "perfect" exposure to capture a specific vision of a photo. "My" vision for the photo shown in **Figure 9.2 (CP 9.2)** was to expose to make the shadow in front of the mountains as black as possible and to capture as much of the detail in the white puffy clouds as possible. Someone else standing next to me may have an entirely different vision. Maybe she would want to expose to show as much detail in the mountain as possible while having a much subtler color in the sky. Once again, you learn why it is so very important to first have a vision for what you want your photo to look like. Only then can you begin to choose various camera settings to get the exposure that is "perfect" (if it is possible) for that vision.

STEP 2: SELECT AN EXPOSURE MODE

Most of today's compact digital cameras offer a variety of exposure modes. Rather than offer just a manual mode, where the user must choose every setting manually or use whatever the last setting was, they offer different exposure modes where numerous settings are optimized for a particular kind of photo. Not only do these automatic exposure modes automatically choose the right combination of shutter speed and aperture settings, but they also choose one or more other settings, too. Examples of some of the settings that may be changed automatically are auto flash, red-eye removal, continuous focus mode, type of metering mode, possible ISO setting, and more.

The advantage of having a choice of exposure modes is that they give you varying degrees of control over your camera and how it takes photos. Or you could also say some of the exposure modes provide users with guidance (camera-chosen settings) when they are not sure what settings to use. In some exposure modes, you will find that the camera won't even

let you take a picture if it thinks the exposure is not good, based upon the built-in "rules" for that exposure mode.

However, the downside of using many of the automatic modes is that they use camera-based "rules" to determine the settings without having any idea of what the subject or scene looks like. This is why you can usually choose better settings after you begin to understand what settings are available on your camera and how they work. Or you can choose one of the exposure modes that takes a first try at choosing the settings, but lets you make modifications to those settings. Following are the general descriptions of a few "generic" exposure modes. To learn about the exposure modes on your camera, you need to consult the documentation that came with your camera. More specifically, look for a table that shows what functions are available in each shooting mode, and look for descriptions of each shooting mode.

- **Auto mode:** Two kinds of "auto" modes exist — one that allows you to make changes to the settings and one that doesn't. Choose one of the auto exposure modes when you just want to get a well-exposed photo easily and without much thought. Although I'm not a big fan of using an auto exposure mode, I know many other photographers who use them almost all the time and they get excellent photographs. If you were to use an auto exposure mode for most of your shots, too, you would be quite pleased with them. Could you get better photos if you used one of the other exposure mode settings, such as aperture or shutter speed priority mode? That question is one you'll have to find out for yourself by trying after you understand the many photography variables and how to control them with your camera settings.

- **Aperture mode:** Aperture mode allows you to select the aperture setting, then the camera automatically chooses the best shutter speed to give a good exposure. If you're concerned about precisely controlling depth-of-field, this setting is good to use.

- **Shutter priority mode:** Shutter priority mode allows you to select the shutter speed setting, then the camera automatically chooses the best aperture setting to give a good exposure. This exposure mode is good to use when you're shooting moving objects or when you want to control image blur. For example, if you're shooting a moving subject where the movement can be stopped by using a shutter speed of 1/500th of a second, just set the shutter speed to 1/200th and let the camera choose the aperture setting. Or maybe you want to pan the camera with a moving subject to blur the background while getting a sharp subject. In this case, you may want to choose a shutter speed of 1/30th or 1/60th, and then let the camera choose the aperture setting.

WARNING

When you choose to use one of the automatic exposure modes, make sure you know what other settings besides shutter speed and aperture settings it will choose for you. For example, you may not want to use a flash, but you find the camera flashes when you use a portrait mode. Or you may choose an auto exposure mode and because there is not sufficient light to get a good exposure, the camera may automatically change from ISO 50 to ISO 400, which will give you a photo with considerably more digital noise. Consult the documentation that came with your camera to learn more about each exposure mode to avoid being surprised when you shoot.

■ **Other "creative" modes:** Other "creative" modes include exposure modes like portrait, sports, or landscape modes. When you choose one of these settings, you allow the camera to have the first choice of settings; then, if you don't like these settings, some of these modes allow you to manually make changes. If you're taking a portrait, using a portrait mode will get you started with "pretty good" settings for taking *one* kind of portrait. If you want to shoot creatively, you may want to try using aperture exposure mode.

When you make the move away from one of the creative modes like the sports mode to a mode such as shutter speed exposure mode, you do lose the benefit of the camera making essential settings for you. For example, if you last shot in "one-shot" focus mode and you decide to shoot a sports event with the shutter speed exposure mode, you'll have to remember to manually change to the "continuous focus" mode if your camera offers one.

■ **Manual mode:** When you want full control of all camera settings, use the manual exposure mode. Although you may not think this mode is one you will use much, you find out in later techniques that using the manual exposure mode and the histogram offer you extensive control over your camera, and in some cases, it is the only mode to use.

STEP 3: SELECT A METERING MODE

Many digital cameras have more than one metering mode. Changing between metering modes allows you to more specifically control where the camera reads the light in your scene. All digital cameras usually have one relatively sophisticated "matrix" or "evaluative" metering mode, which *generally* does an excellent job at reading and averaging light from all parts of the scene. I know many good photographers who almost always use the evaluative metering mode.

When evaluative metering doesn't work as you want it to, or when you want to have more control over where a reading of light is taken, then consider using one of the other metering modes if your camera has them. Another common mode is "center-weighted" metering. This mode does just what it says it does — it reads the light from all over the scene, but it places more importance on the light found at the center of the scene. This feature is useful when you have a subject at the middle of the image that you want to make sure you expose correctly, and the surrounding areas or background has a highly different light level.

Another useful kind of metering mode is the "spot metering" mode. Using a spot metering mode, you can read the light found on only a very small part of your scene; usually it is at the center of the scene, or some cameras allow you to set the spot metering around a selectable auto-focus point.

Although these are good recommendations for different types of "generic" metering modes, you should carefully read the descriptions of any metering modes that *your* camera has. Learning how to use these modes well greatly help you to more quickly and more accurately get the exposure you want.

If you choose to use spot metering, you may also want to learn how to use exposure lock, which is covered in detail in Technique 13. Technique 12 shows you how to use exposure compensation, and it covers exposure bracketing. Both of these techniques are essential techniques if you want to have full control of your camera's ability to control exposure.

STEP 4: SHOOT THE PHOTO AND ANALYZE THE RESULTS

■ After you've set what you think are the right camera settings, take a photo.

After looking at either a quick review image, or by looking longer at a more detailed view of the image

in a review mode, you can learn how the photo turned out relative to what you wanted. One of the most useful features to help you get a good exposure is a histogram like the one shown on the LCD monitor of a Canon PowerShot G2 shown in **Figure 9.9**. Of all the features on my digital cameras, I find the histogram to be one of the most valuable. I look at it just about every time I take a photo. To learn more about the histogram and how it can help you to get a good exposure, read Technique 11.

> **TIP**
>
> When you take the time to change to a review or playback mode, consider deleting the photos that you don't want as you review the photos you've taken. Doing so frees up space on your digital photo storage media for more photos as well as saves you time later when you download the photos to your computer and have to review all of them.

9.9 © 2002 Gregory Georges

Some digital cameras also have a detailed display mode where the overexposed parts of an image flash, showing you where the overexposure is occurring. This information can be very valuable when you have to decide how to further adjust your exposure. Check to see whether you camera offers this feature.

STEP 5: ADJUST EXPOSURE

The significant advantage of using a digital camera is that you can shoot, review the photo and the EXIF data, and then make changes to the camera settings to get the exposure you want. After you learn what additional exposure changes are needed, you can make them. Many digital cameras offer additional advanced features that help you to make these changes. Two of the most useful are exposure compensation and spot metering using exposure lock. Technique 12 covers exposure compensation in detail and Technique 13 shows you how to use spot metering and exposure lock. Both of these advanced techniques are well worth learning.

> **WARNING**
>
> When determining exposure, choose settings that prevent highlights from being overexposed. Any portion of an image that becomes pure white contains no detail. A much better approach is to expose to show detail in the highlights and use an image editor to bring some detail out of the underexposed parts of the image. Obviously, this approach would not be correct if you were trying to create a "high key" photo where the intent is to "blow out" most of the detail in an image and show only subtle shadows as shown later in Technique 45.

STEP 6: SHOOT AGAIN

If, after reviewing your prior shot, you find that you need to make some adjustment to the camera's settings, then do so, and then shoot again. You may need to repeat these steps a couple of times until you have the shot you want. Don't be conservative in how many photos you take, because it costs nothing to shoot. Shoot again, and again!

TIP

When shooting a subject or scene that changes too rapidly to be able to do the shoot-review-adjust-and-shoot-again routine, consider shooting in an auto exposure bracketing mode. In this mode, the camera automatically changes the exposure within a user-chosen set range to take three exposures after you press the shutter button. You can learn more about this feature in Technique 12.

TAKING SHARPLY FOCUSED PHOTOS

10.1 © 2000 Gregory Georges

10.2 © 2000 Gregory Georges

I n Technique 9, you learned how to avoid (as much as possible) taking badly exposed photos. In this technique, you learn how to avoid the second most common photo problem — a photo that is not "in focus" or seems to be blurred. Or, more importantly yet, you learn what variables you can control to create blurs such as for a softly focused photo, or a blurred subject or background.

The photo in **Figure 10.2** is an excellent example of how you can be shooting in all the worst possible conditions for getting a well-exposed, yet sharply focused photo. The chicken was shot inside a dimly lit barn. The objective was to use as large an aperture opening as was possible to blur out the ugly roof behind the chicken while still keeping all the chicken's face perfectly focused. Using a low ISO setting of 80 was also critical to avoid adding digital noise to the image.

Because of the low light level and the necessity of using an aperture setting of f/3.4, a shutter speed of 1/30th of a second was required, which is slow for a quick-moving subject. One further complication was the

chicken's erratic and sudden movements, which made using a tripod impossible, because the award-winning pet never ceased moving. If you have watched the movement of a chicken as it does the chicken walk and while clucking, you'll know what I mean.

After a few practice shots and a quick check on the exposure on the LCD monitor on the Nikon CoolPix 950 digital camera, the photo shown in **Figure 10.1** was taken with a flash; it is as focused as you can get!

In sharp contrast to the chicken photo is the photo of the Chincoteague pony shown in **Figure 10.3**. For this photo, the Nikon CoolPix 950's shutter speed was set to 1/47th of a second and the aperture was set to f/6.4. The speed and the movement of the horse is revealed through the well-planned blur that was achieved by panning the camera with the horse. The point here is it was a design decision to have a blurred photo — not one that was sharply focused.

FACTORS DETERMINING IMAGE SHARPNESS

Many factors determine how sharply focused or blurred a photo will be. Understanding each of these factors is important if you want to control the level of image sharpness. This technique briefly looks at seven factors you need to be aware of.

10.3 *© 2002 Gregory Georges*

- **Shutter speed setting:** Shutter speed is the amount of time that the shutter is open; a faster shutter speed (for example, 1/500th or 1/400th instead of 1/60th or 1/30th) reduces the chance of getting a blurred photo. As the shutter speed gets slower (that is, the shutter stays open longer), the better the chance for blur to occur, because the image sensor will have more of a chance to record some or all of the subject or scene in more than one place on the image — thereby causing blur.
- **Aperture setting:** As mentioned previously, you can use a fast shutter speed to minimize blur. However, there is a trade-off because shutter speed and aperture setting are inversely related. An increased shutter speed means that a larger aperture size is required to get the same exposure. A larger aperture size means a shallower depth-of-field and more chance for part of the image to be out of focus. Understanding this trade-off is essential if you want to choose the optimal settings to get a photo that meets your objectives.
- **Stillness of camera when shooting:** Another major factor determining the sharpness of an image is how still the camera is while the shutter is open. A hand-held camera set to a slow shutter speed is more likely to produce blurred images than one that is securely mounted on a tripod or other form of camera support.
- **Subject movement and distance from camera:** The speed of any moving subject and the direction it is moving is what ultimately determines what

> **TIP**
>
> Whenever you shoot with the objective of getting maximum depth-of-field and maximum image sharpness throughout the photo, use a tripod. Many photographers who value deep depth-of-field and image sharpness rarely ever shoot without using a tripod.

camera settings you must use to either freeze the movement or to allow a controlled amount of blur. The farther away a moving subject is from the camera, the less distance it moves on the image sensor, which means it will be less likely to record as being blurred than it would if it were closer to the camera.

■ **Focal length:** The longer the focal length, the closer a subject appears to be to the camera, which therefore records more movement in terms of distance on the image sensor than if a shorter focal length were used. This is why using a tripod is important when using a long focal length lens.

■ **Use of flash:** Although the most common use of flash is to add light to a subject or scene, you can also use it to "freeze" or slow the movement of a subject. Because of the short duration of the flash *light*, it can freeze motion caused by both camera shake and subject movement to create sharp images if it is the main source of light.

■ **ISO setting:** As ISO setting determines how sensitive an image sensor is to light, changing from a lower ISO setting to a higher ISO setting enables you to use a faster shutter speed, which helps minimize image blur. The downside is that a higher ISO speed setting increases the amount of digital noise shown in the photo.

> ### TIP
>
> The ISO setting determines how fast the image sensor in a digital camera records light. An ISO setting of 50 or 100 records light less quickly than a higher ISO setting of 200 or 400. Unfortunately, the higher the ISO setting, the more digital noise you will have in your image. If you're unable to shoot with a fast enough shutter speed to meet the objectives of your photo, then using the lowest ISO setting your camera offers is always best — that is, unless you want digital noise to be part of your photo.

With that background, now look at eight steps you can take to get the optimal setting you need to get the photo you want. Notice that I didn't say to get a sharply focused photo — as it is just one aspect of being able to control image sharpness or blur. Although eight steps may seem like too much to go through each time you take a photo, you'll find that you can skip most of them unless you are working on getting a particularly difficult shot.

STEP 1: DETERMINE OBJECTIVES

By now you're probably getting used to the fact that the first step in many of these techniques is to determine objectives. Until you decide how you want your photo to look, deciding how to choose the most appropriate settings is hard. Earlier in this technique the point was made that *all* blur is not bad. In fact, you can often control it in such a way that it can make an okay photo into an exceptional photo. So the first step must be how sharp or blurred do you want your photo to be?

STEP 2: CHOOSE EXPOSURE MODE

After you have determined the objectives for the photo you're about to shoot, choose an appropriate exposure mode. If your objective is to get a sharply focused image, choose an exposure mode that allows you to select a fast shutter speed, or you can choose an exposure mode that allows you to choose a maximum aperture setting (e.g. f/8.0) to maximize depth-of-field.

Besides using aperture mode or shutter speed mode, you may also want to consider shooting using sport or landscape mode if your camera has one of these modes and if it is suitable for your shot.

STEP 3: CHOOSE APERTURE OR SHUTTER SPEED SETTING

If you choose an automatic aperture mode in Step 2, make sure that you set the aperture priority setting to

give you the results you want. Likewise, if you choose shutter speed priority mode, make sure to set the shutter speed to give you the results you want. Otherwise, the settings will simply be set to the last setting that was used!

If you choose to use one of the creative exposure modes such as landscape, sports, or portrait mode, you may find that the lighting conditions will not allow you to shoot with the camera's "default" settings. If this occurs, you may have to change exposure modes to a mode that allows you to change shutter speed or aperture to get the picture that you want.

STEP 4: CHOOSE AUTO-FOCUS SETTING MODE AND FOCAL POINTS

Depending on what features your camera has, you may have several that will help you to more easily and more reliably focus on a specific subject or scene. Some digital cameras allow you to select the area in the viewfinder or LCD monitor that is used to set the focus. Also, some cameras allow you to choose between a "single shot" or "auto-focusing sequential shooting" mode. After reading this step, check the manuals that came with your camera to see which of these features your cameras has, how they work, and when they should be used.

FOCUS FRAME SELECTION

Many digital cameras allow you to choose an auto-focus frame, which is an area of the composition where the camera focuses. The default focus frame is in the center of the LCD monitor or viewfinder. This center focus frame works just fine when you want to focus on a subject that is the center of the composition. However, if you want to focus on a subject to the left or right, or anywhere else, another approach is required.

Check to see whether you can change focus frames with your digital camera. Usually, on those cameras that allow the focus frame to be changed, you get a choice of three focus frames: left, center, and right.

USING FOCUS LOCK

Many digital cameras have a focus lock button for locking the focus. This valuable feature is one that you ought to know how to use. We cover it in detail in Technique 14.

SHOT MODE

Some digital cameras allow you to choose between a "one-shot shooting mode" and a "continuous focus mode." In one-shot mode, your camera hunts to get focused once — then it locks the focus even if the subject is moving. When using a continuous focus mode, the camera continues to focus until you press the shutter button.

The one-shot shooting mode is the best choice for subjects that don't move. Using it with moving subjects is a good way to guarantee getting an out-of-focus picture. Some digital cameras will not even allow a photo to be taken when it is not focused. Use the auto-focus sequential shooting mode when you take photos of moving objects.

USING MACRO FOCUS

When taking macro (or close-up) photos while using auto-focus, a digital camera may have a hard time getting focused — this is known as *hunting*. It zooms

TIP

If your camera only has a center focus frame, or your currently selected focus frame is the center, and you want to focus on any other area of the composition, then use the focus lock feature if your camera has one. Just point your digital camera so that the area that you want to be focused is in the center of the LCD monitor or viewfinder and press the focus lock button. Then, recompose your image and shoot.

in and out until it can focus on the subject. Due to the nature of macro photography, this "hunting" can take time because the lens focuses from one extreme to the other. If you have a macro focus mode, these extremes are limited so that the "hunt" for focus takes much less time. You learn more about taking macro photos later in Techniques 30 and 31.

USING MANUAL FOCUS

Relying on auto-focus is generally okay. However, times come up where you will want to override your camera's auto-focus capabilities. Choosing a manual focus mode allows you to focus manually. Some digital cameras like the Nikon CoolPix 950 allow you to choose a manual focus mode, and then, using a ruler, set the camera the correct distance away from the subject, you can get a perfectly focused photo by making sure that the subject is exactly the correct distance from the lens.

Most LCD monitors and viewfinders found on compact-level digital cameras are not large enough for you to get an accurate view of the subject that you want to focus on. Therefore, manual focus is mostly

used for more creative things, like making soft blurred backgrounds or out-of-focus images.

STEP 5: USE CAMERA SUPPORT WHEN NEEDED

After the shutter speed setting has been determined, you can decide if a tripod or other camera support will be needed. When shooting with a 35mm film camera, a useful rule to follow is not to hand-hold your camera when the shutter speed is less than 1/focal length. However, the mathematics behind the optics in the new compact digital cameras makes this rule less useful. The wise thing to do is to experiment with your camera and learn when you ought not to shoot without using a tripod. Or, you can do as I do — shoot using a tripod whenever possible. Your pictures will often be better if you do.

STEP 6: USE A SELF-TIMER OR A SHUTTER RELEASE

When shooting macro photos, or when shooting with long focal lengths, or when using slow shutter speeds, you may find that you cause camera shake when you press the shutter release even if it is mounted on a tripod. In such cases, use a cable release if you have one. If you don't have a cable release, set the camera's self-timer to 2 or more seconds so that you don't have to press the shutter button to take a photo.

WARNING

Don't always expect auto-focus to get a precisely focused photo. Auto-focus may not work well in the following situations:

- When a subject is moving quickly
- When a close object and a far away object appear side by side in an image
- In low light level environments
- Where little contrast exists in the focus area

In these situations, you may want to shoot a couple of photos when it is possible, or even try manually focusing the camera if you have enough time.

TIP

On occasion, you may find your camera "hunting" to get focused on a subject that is dimly lit or has too little contrast. In such cases, point your camera at another part of the scene that is the same distance from the camera and use auto-focus lock if your camera has one. See Technique 14 to learn more about auto-focus lock.

STEP 7: USE FLASH

You can often use a short bright flash of light from a flash to stop image blur from camera shake or from subject movement. If you can't use the settings you want to get an image without blur, consider using a flash. See Technique 15 to learn more about using flash.

STEP 8: CHANGE ISO SETTING

If light conditions prevent you from using camera settings that allow you to shoot blur-free photos,

think about changing the ISO setting. A higher ISO setting allows the image sensor to record light more quickly, thereby enabling you to choose a faster shutter speed.

You've now reached the end of this technique and the end of this chapter. In Chapter 3, you learn how to use some of the more valuable "advanced" features that are found on most digital cameras.

TIP

Using a self-timer is a good way to avoid causing camera shake when you press the shutter button. However, in some situations the timed delay you get using a self-timer may make it hard to capture the shots when you need to capture them. In those cases, consider purchasing a cable release if you don't have one providing that one can be used with your camera.

TIP

Although changing to a higher ISO setting such as 200 ISO or 400 ISO allows you to shoot with a faster shutter speed and in a lower light level, the higher ISO setting also increases the amount of digital noise that will show in your image. Unless you choose to have digital noise, the best ISO setting is usually the lowest setting you can use.

CHAPTER 3

USING ADVANCED FEATURES

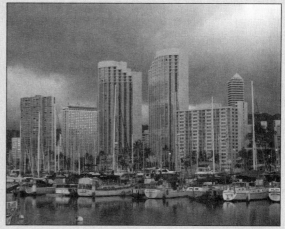

© 2002 Gregory Georges

The title of this chapter is "Using Advanced Features," but don't let the term *advanced* scare you away from learning about these useful and often essential features. Technique 11 shows you how to read a histogram to determine how close you were to getting the exposure you want. Techniques 12 and 13 cover exposure compensation, exposure lock, metering modes, and focal point selection — important features that you can use to gain more control over exposure. In Technique 14, you learn how to focus on an off-center part of the composition and to use focus lock. In Technique 15 you learn when and when not to use a built-in flash and how to get the best results if you choose to use one.

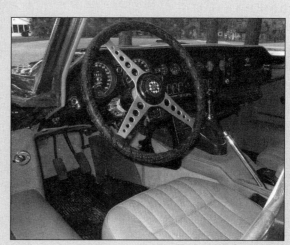

© 2002 Gregory Georges

USING THE HISTOGRAM

11.1 (CP 11.1) *Original image*

© 2002 Gregory Georges

11.2 *Edited image*

© 2002 Gregory Georges

ABOUT THE IMAGE

"Gargoyle Reading a Book" Canon PowerShot G2 mounted on a tripod, zoom set to 92mm (35mm equivalent), f/2.5 @ 1/50th, ISO 100, 1,704 x 2,200 pixels, 1.9MB .jpg

One of life's many mysteries is why so few people who use digital cameras with a histogram feature don't use the histogram. A histogram is a simple two-axis graph that allows you to judge the brightness range of an image. A quick view of the histogram and you can tell how well you have exposed the photo, and if and by how much your exposure may be off relative to what you want. It is a feature that I use just about every time I take a photo — it is one of the benefits of shooting digitally. In this technique, you learn how to get the most out of the histogram so you can decide whether or not you want to take advantage of it.

GETTING TO KNOW THE HISTOGRAM

Figure 11.3 (CP 11.3) shows the histogram (the graph inside the white square) on the LCD monitor of a Canon PowerShot G2. That particular histogram is for the photo shown in **Figure 11.1 (CP 11.1)**. The horizontal axis represents the brightness level, ranging from pure black (dark) on the left to pure white (a bright highlight) on the right. The vertical axis represents the number of pixels that exist for each brightness level.

Looking at the histogram in **Figure 11.3 (CP 11.3)**, you can learn a lot about this photo, which was taken using automatic metering. Because so few points are to the extreme right or extreme left of the graph, you know that no pure whites or pure blacks are in the photo. You can also see that most of the points are in the middle of the graph for an evenly balanced exposure.

Now take a look at what happens when the photo is overexposed by one full stop using exposure compensation (you learn about this feature in the next technique). **Figure 11.4 (CP 11.4)** shows the photo, and **Figure 11.5 (CP 11.5)** shows the resulting histogram. With a one-stop overexposure, you can see how the brightness level of the entire scene has shifted toward the right. The most important point to note about this graph is that a considerable number of pixels are "near white" or pure white. This means that little

detail, or no detail, is in that part of the image. This is one of the reasons why underexposing a digital image is better than overexposing it. Generally, you can bring some detail back into an underexposed image with an image editor like Adobe Photoshop, but bringing out detail that isn't in the image file isn't possible.

Now let's look at a third exposure of this photo, only this time it has been taken with a –2 stop exposure. **Figure 11.6 (CP 11.6)** shows the photo, and **Figure 11.7 (CP 11.7)** shows the resulting histogram. The pixels have been shifted to the left and most of the pixels now show up in the darker range, as you would expect, because the photo is now darker, with some pure black. From these three histograms, you should now have a good idea of how you can use the histogram to determine the overall correctness of exposures.

11.4 (CP 11.4) *© 2002 Gregory Georges*

11.3 (CP 11.3) *© 2002 Gregory Georges*

Many people think that they can learn as much about an image's exposure from the image displayed on the LCD monitor as they can from the histogram. That is not the case, though. When you look at an image in bright light, the LCD monitor can be washed out, making the image look lighter than it really is. When you make an exposure compensation for this lightness, you will later find out that you have underexposed your photo. When you look at the histogram to determine exposure levels, you are looking at a graph instead of just the image. Bright light will not affect your judgment of exposure when reading the histogram.

An Xtend-a-View LCD magnifying hood with a rubber eye cup from www.photosolve.com makes seeing the detail on the LCD monitor much easier when shooting in bright light.

11.6 (CP 11.6) © 2002 Gregory Georges

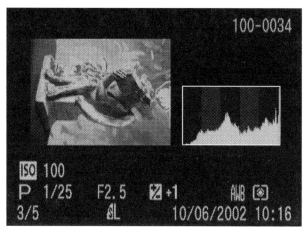

11.5 (CP 11.5) © 2002 Gregory Georges

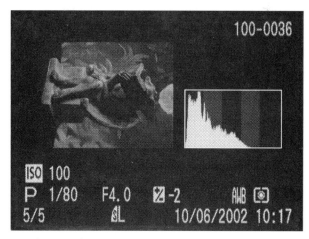

11.7 (CP 11.7) © 2002 Gregory Georges

BLINKING HIGHLIGHTS

Usually, digital cameras that have a histogram feature also have a "highlight alert" feature. This is another exceedingly useful feature. When you look at a review image, "blown-out" highlights blink in the image. A "blown-out" highlight occurs when the brightness level is at a maximum, meaning that it is pure white. If you were able to look at the LCD monitor shown in **Figure 11.5 (CP 11.5)**, you would notice that a fairly large part of the left side of the image (the lightest areas) would blink on and off, indicating "blown-out" highlights.

Ideally, the only time something in your picture should be a pure white with no tone is when it is a specular highlight. A good example of a specular highlight would be the sunlight glinting off a car bumper, or the flash of a diamond ring. All other whites should have some degree of tone to them. If you check for blinking highlights on a regular basis, you will greatly improve the printability of your difficult shots. Simply reducing exposure slightly can do wonders to return texture to white surfaces and details to the clouds in your pictures.

NOTE

In general, the more pixels that are toward the right of the histogram, the brighter (or lighter) the photo will be. The corollary is that the more pixels there are toward the left of the histogram, the darker the photo will be. There is no "perfect" histogram, because creative photographers take creative photos, which have all kinds of unlikely looking histograms. The big question is whether the histogram looks like it should, for how you want the photo to look. If not, change the camera settings and shoot again.

STEP 1: CHOOSE REVIEW AND PREVIEW SETTINGS

- Once again, you ought to read the documentation that came with your camera to learn what review and preview settings are available and what you need to do to view the histogram.

Some of the newer Minolta and Sony digital cameras allow you to see a histogram *before* a picture has been taken. This histogram is based upon the current camera settings, and an image based upon the current composition shown on the LCD monitor. This means you can make adjustments to the settings to get the photo you want the *first* time! Most other digital cameras offer a quick review of the image, but you must change to a preview mode to view the histogram — all *after* you've already taken a photo.

STEP 2: DETERMINE HOW YOU WANT THE PICTURE TO LOOK

- Yep. One of the first steps is *always* to decide how you want the picture to look. If you don't know what your photo should look like, you'll have a hard time using a histogram to decide whether you have the right exposure!

STEP 3: COMPOSE PICTURE AND PRESS THE SHUTTER BUTTON

- Compose the picture and press the shutter button to take a photo.

If you have to switch out of shooting mode into a review mode to view a histogram, you may want to change your settings and shoot a couple more photos before changing to the review mode.

STEP 4: REVIEW THE HISTOGRAM, CHANGE SETTINGS, AND SHOOT AGAIN

■ Switch to the review mode to look at the histogram.

■ Based upon what you want the picture to look like and what the histogram looks like, you can make any necessary changes to the camera settings and shoot again.

You may want to consider using the exposure compensation feature, which is covered in Technique 12, to alter the exposure and the resulting histogram.

I would really enjoy hearing more about how you use a histogram feature, or why you don't use one if you have one. My e-mail address is `ggeorges@ reallyusefulpage.com`.

TIP

When you review the images with a histogram, it may be a good time to delete those "not quite right" photos to make room on your digital photo storage media space for more photos.

USING EXPOSURE COMPENSATION

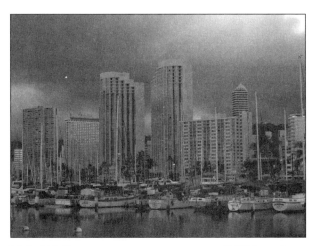

12.1 *Original image* © 2002 Gregory Georges

12.2 *Edited image* © 2002 Gregory Georges

"Waikiki Yacht Harbor" Olympus C720 Ultra 2000, hand-held, zoom set to 75mm (35mm equivalent), f/7.1 @ 1/80th, ISO 200, 1,984 x 1,488 pixels, 609KB .jpg

Automatic exposure meters in even today's least expensive compact digital cameras are impressive — they are able to get the correct exposure in more shooting environments than most of the expensive professional film cameras of just a few years back. However, all automatic exposure metering systems can make mistakes and take the wrong exposure sometimes. In this technique, you learn how to use the exposure compensation feature to either correct a bad exposure, or to get the more "creative" exposure that you want.

The photo shown in **Figure 12.1** was taken with an automatic exposure setting — no exposure compensation was used. **Figure 12.2** is the same photo after some minor adjustments were made to it using Adobe Photoshop.

DECIDING WHEN TO USE EXPOSURE COMPENSATION

The exposure compensation feature is useful when your chosen automatic metering does not get the exposure you want. Exposure compensation actually "compensates" the automatic metering based upon your judgment to get it to more accurately give you the desired exposure. Also, you can use exposure compensation to get a creative exposure to suit your artistic view. When you look at **Figures 12.3 (CP 12.3)** through **Figure 12.9 (CP 12.9)**, you can see how

much difference a small change in exposure (even 1/3 of a stop) can make to a photo. An exposure compensation feature allows you to enjoy the benefits of the subtle, but important, differences in exposure.

STEP 1: DETERMINE HOW YOU WANT THE PICTURE TO LOOK

The purpose of an automatic exposure meter is to give you a "normal" exposure. But, what is a "normal" exposure and is it what you want your photo to look like? If it isn't, then you need to modify the exposure.

12.3 (CP 12.3) © 2002 Gregory Georges

12.5 (CP 12.5) © 2002 Gregory Georges

12.4 (CP 12.4) © 2002 Gregory Georges

12.6 (CP 12.6) © 2002 Gregory Georges

STEP 2: SET APPROPRIATE CAMERA SETTINGS

When you make exposure changes with the exposure compensation feature, the camera must either make a change to the aperture setting or to the shutter speed setting to match your request. If you know what you want the picture to look like (you thought about that in Step 1, right?), then you will likely know whether keeping the aperture setting fixed and varying the shutter speed is more important, or vice versa. If you are most concerned about maintaining a specific depth-of-field, then set the shooting mode to aperture mode. If you're more concerned about stopping movement, then choose the shutter speed mode.

After you've determined which mode to use, either shutter speed or aperture mode, make sure to set the correct setting. For example, if you want to minimize camera shake as you are hand-holding the camera, choose the shutter speed mode and set shutter speed to 1/125th of a second or faster, assuming you're using a focal length of less than 100mm (35mm equivalent). Then, when you change the exposure compensation setting, the camera will automatically change the aperture setting instead of the shutter speed.

STEP 3: COMPOSE AND TAKE A PHOTO

- Compose the photo and press the shutter button to take a photo.

After taking the photo, you may want to review the histogram feature if your camera has one. The histogram is an excellent tool to use to help you understand how you have exposed a photo. To learn more about the histogram, see Technique 11.

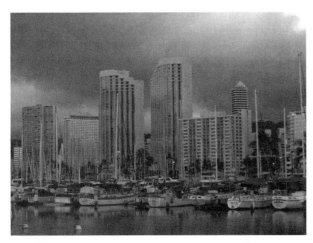

12.7 (CP 12.7) © 2002 Gregory Georges

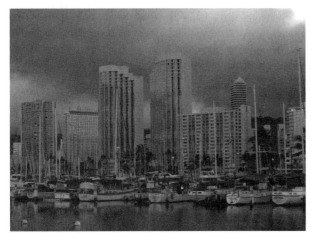

12.8 (CP 12.8) © 2002 Gregory Georges

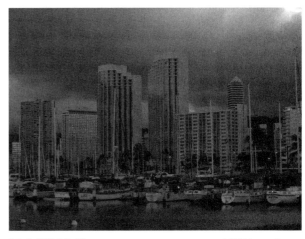

12.9 (CP 12.9) © 2002 Gregory Georges

STEP 4: CHANGE EXPOSURE COMPENSATION WITH THE EXPOSURE COMPENSATION FEATURE

■ Turn on the exposure compensation feature and make a change to the settings.

Figure 12.10 shows the LCD monitor of a Canon PowerShot G2 when the exposure compensation feature is on. Using a rocker button, the slider can be moved to the left and right to increase or decrease exposure by plus or minus two stops in 1/3 stop increments.

After making a change to the exposure compensation, go back to Step 3 and shoot again until you have taken all the shots that you want.

USING AUTO EXPOSURE BRACKETING

If you like using the exposure compensation feature, but you would prefer a more automated approach, or you need to be able to make the exposure adjustments more quickly due to shooting conditions, consider using auto exposure bracketing. Cameras that offer auto exposure bracketing usually allow you to select the amount of "bracketing" in 1/3 stop increments up to plus or minus two stops. Some even allow you to choose where the bracketing occurs. For example, you may want a slightly under-exposed image and consequently, you may choose to bracket around a –2/3 stop. After you set the bracketing amount, you simply press and hold the shutter button until three pictures are taken. **Figure 12.11** shows the LCD monitor screen on the Canon PowerShot G2 with a plus and minus 2/3 exposure bracketing setting.

12.10 © 2002 Gregory Georges

12.11 © 2002 Gregory Georges

USING EXPOSURE LOCK, METERING MODES, AND FOCAL POINTS

13.1 (CP 13.1) *Original image* © 2002 Gregory Georges

13.2 (CP 13.2) *Edited image* © 2002 Gregory Georges

ABOUT THE IMAGE

"Eagle on Hole #15" Canon PowerShot G2, hand-held, zoom set to 34mm (35mm equivalent), f/8 @ 1/320, ISO 100, 2,200 x 1,704 pixels, 1.7MB .jpg

There will be times when your digital camera's automatic exposure will not get the exposure that you want. In Technique 12, you learned how you can "adjust" the automatic exposure determined by your camera by using the exposure compensation feature. However, this feature takes time that you may not always have, and there is a faster, more intuitive way to adjust exposure. In this technique, you learn how to use exposure lock to quickly adjust exposure compensation. You also learn how to use center-weighted and spot metering to more precisely meter your scene or subject.

The example photo used in this technique is a "real-world" problem that all photographers sooner or later face. A retired friend of mine who enjoys spending his time golfing and doing digital photography likes to take photographs of various holes on golf courses where he has had a birdie (a score of one under par) or an eagle (a score of two under par). More often than not, when shooting holes on a golf course, he gets poorly exposed photos, as you can see in **Figure 13.1 (CP 13.1)**. The source of the problem is how the

automatic exposure feature reads the light in the scene and chooses the exposure. It's easy for a bright sky to fool a camera meter into thinking the subject is lighter than it is, and subsequently underexpose the shot. Using this technique, he was able get the much better photo shown in **Figure 13.2 (CP 13.2)**.

Before you get to the technique, let's first agree on the definition of a few terms. Although the terms used here are clearly defined, the documentation that came with your camera may use other terms or offer other features. However, if you understand conceptually what these terms mean, you will understand how to use the features regardless of what they are named.

METERING MODES

Almost all digital cameras have a "zone" or evaluative metering mode that is appropriate for standard shooting conditions. Although the logic of such metering modes is complex, the important thing to know is that metering modes generally work quite well *and* that they determine exposure by analyzing *all parts* of an image.

In contrast, a "center-weighted" metering mode places a greater emphasis on the *center* of the composition. For those times when you want even more precise metering, choose "spot metering" if it is available on your camera. Spot metering modes measure exposure from an area as small as a one- or two-degree view of the scene. Not all digital cameras offer these three metering modes, and some offer even more. Check the documentation that came with your camera to determine what modes your camera offers.

> **NOTE**
>
> Most manufacturers base their normal, or "evaluative" or "programmed," exposure on thousands of properly exposed meter settings that have been analyzed by computer.

FOCUS POINT

You need to understand that most auto-focus modes center around a specific focus point. The default focus point is the center of the image. However, some, but not all, compact digital cameras allow you to change the focus point between one or two or even more different points. Having more than a single center focus point allows you to select an off-center focus point to match your composition and your choice of where the camera should focus.

One additional feature on many cameras with selectable focus points is that you can also choose to have the exposure metering "area" centered around the selected focus point or have it remain centered around the center focal point. This feature is valuable for taking photos like the one shown later in **Figure 14.2** because you can focus on *and* meter off the same off-centered focus point.

If you think for a moment about having selectable focus points and multiple types of metering modes, you can have quite a few combinations to meet a variety of compositional needs. Each of these different combinations can give different exposure settings. The next six steps show you how to get the desired exposure for hole #15 — the first time, using the default metering mode and focus point. At the end of the six steps is a discussion of a few other combinations and when you may want to use them.

EXPOSURE LOCK

The exposure lock feature allows you to point your camera where you choose and lock to that exposure setting. You can then recompose and shoot using the exposure that was previously set. You can implement and use exposure lock in a variety of ways. Some digital cameras allow you to lock the exposure by pressing the shutter button half-way down — this often locks many settings such as exposure, focus, and even white balance. Other digital cameras have a button specifically for exposure lock or they may even require that a menu be accessed to lock the exposure.

Check the documentation that came with your camera to learn how to use exposure lock before doing this technique.

STEP 1: DETERMINE HOW YOU WANT THE PICTURE TO LOOK

- As always, the first step to getting a good picture is to decide how you want it to look — you've heard that before haven't you? Otherwise, you can't choose optimal camera settings.

For example, should the photo of hole #15 show a deep blue sky with wispy white clouds, a dark fairway, and dark sand trap? Or, should the photo show more detail in the fairway and sand trap at the expense of getting a washed-out sky? Sadly, this is a common trade-off, and you must make a decision or live by the defaults! As the blue sky with the wispy white clouds makes a much better photo, we want to expose to capture the details in the sky and clouds while not making the fairway too dark.

The photo shown in **Figure 13.3** shows how making a minor adjustment using Adobe Photoshop's Curves tool made much of the fairway and tree detail less visible.

13.3 © 2002 Gregory Georges

STEP 2: CHOOSE CAMERA SETTINGS

- After you've decided what you want the picture to look like, choose an appropriate metering mode and choose a focus point.

To take a good photo of hole #15, use the default metering mode (evaluative) and the default focus point (the center one). Because we want to maximize depth-of-field, choose aperture priority as the shooting mode. Enough light is in this scene if we use a low ISO setting of 100 to avoid digital noise.

STEP 3: COMPOSE THE PHOTO AND EVALUATE THE IMAGE ON THE LCD MONITOR

- After your camera settings are correct, compose the photo and evaluate the image on the LCD monitor.

In the case of shooting hole #15, you can easily see that the photo will not have any detail in the sky because it is getting washed out due to the averaging logic of the "full image" evaluative metering mode.

> **TIP**
>
> If you plan on using an image editor such as Adobe Photoshop to edit your images, you are better off compensating to avoid overexposure. Overexposure pushes near-white parts of the scene into pure white, which means there is no detail whatsoever. If you expose to show detail in the highlights, you can usually edit to recover some details in the shadows. This is because those areas that appear to be almost pure black do, in fact, have detail that you can't see.

STEP 4: REPOSITION CAMERA UNTIL EXPOSURE LOOKS CORRECT

■ To get a better exposure to show the detail in the sky, recompose your camera and point it directly at part of the subject you care most about — in this example the white clouds. Often you can move the camera just enough to eliminate the source of light or shadow that is fooling the system, and capture exactly the exposure information that will allow your shot to have the detail you desire. As you move your camera, watch the camera settings in the LCD monitor to make sure you are shooting with enough shutter speed to avoid image blur, and that the exposure does not require a shutter speed that is outside the limits of your camera.

STEP 5: LOCK EXPOSURE

■ After having found a part of the scene that appears to give the exposure you want, and before recomposing, lock the exposure setting using your camera's exposure lock feature.

> **WARNING**
>
> If you access exposure lock on your camera by pressing the shutter button halfway, make sure you understand any other settings the button may also lock. You may find that when you press the shutter button halfway that you are at the same time locking other settings, such as focus or even white balance. On the more feature-rich cameras, this is the case; however, you will also find specific buttons for exposure lock and focus lock so that you can control them separately when you want. Releasing the button resets the exposure to normal.

STEP 6: RECOMPOSE PICTURE AND PRESS SHUTTER BUTTON

■ Now recompose and take the picture.

Your camera will use the stored exposure information that it captured earlier to make this exposure, ignoring the bright sky or other elements that would have fooled it. After you get used to this process, it will only take a few seconds to do it and it will become "second nature" to you. Soon you will find it easy to handle difficult exposure situations by pointing your camera to get the exposure you want; then recomposing and shooting. After you've taken a photo, don't forget to take a quick look at the histogram.

USING CENTER-WEIGHTED OR SPOT METERING AND EXPOSURE LOCK

In the prior six steps, you learned how to use the evaluative metering mode and the center focus point to find a good exposure. Sometimes, though, you may find that the evaluative metering mode meters too large an area (the entire composition). If you want a more accurate meter reading, narrow the area where an exposure is being taken by selecting either a center-weighted or spot metering mode. Not only can you more precisely select the area where you want to meter, but some digital cameras also let you choose the focus point and where these metering modes are located on the image.

Using a smaller area of the scene to read exposure avoids many of the problems associated with the "weighing" of different areas in an image. If you were to select a center-weighted metering mode, you could point it directly at the clouds in the sky shown in the hole #15 photo to get an exposure that *may be* perfect to show the desired cloud details.

When you can use exposure compensation, spot metering, and exposure lock together, you are ready for any difficult lighting situation that you may come across.

CONTROLLING FOCUS WITH FOCAL POINT SELECTION AND FOCUS LOCK

14.1 *Original image* © 2002 Gregory Georges

14.2 *Edited image* © 2002 Gregory Georges

ABOUT THE IMAGE

"Mack Truck Bulldog Ornament" Canon Powershot G2, hand-held, zoom set to 102m (35mm equivalent), f/3.2 @ 1/200, ISO 50, 2,272 x 1,704 pixels, 1.5MB .jpg

Technique 10 covered the topic of how to take a sharply focused picture. However, the assumption in that technique was that the area of the composition on which the camera was to focus was at the center of the composition. Often, you may choose another portion of the image to use as the area where the camera should be focused. For example, the photo shown in **Figure 14.2** shows the bulldog hood ornament on an old Mack firetruck. Because the important part of the image is off-center to the right, the camera needs to be focused off-center to get a sharply focused bulldog and a soft-blurred background.

To accomplish off-center focusing, you can either use focus point selection, focus lock, or a combination of them both. In this technique, you learn how to use one, or a combination of these features to get as focused as you want!

STEP 1: CHOOSE APPROPRIATE CAMERA SETTINGS

■ After you've decided how you want your photo to look, select the most appropriate camera settings to accomplish your objectives.

STEP 2: COMPOSE PHOTO AND PREVIEW IMAGE ON LCD MONITOR

■ Compose the photo as you want it composed.
■ Determine from the image on the LCD monitor where you want the camera to focus.

If the area that you want the camera to focus on is off-center, this technique can help you to learn several different ways to handle such off-center focus photo compositions.

STEP 3: SELECT FOCUS POINT

The default focus point is the center of the image. However, some, but not all digital cameras allow you to change the focus point to one or two or even more different points. Having a choice of extra focus points allows you to select an off-center focus point to match your composition and your choice of where the camera should focus.

Vendors offer focal point selection features in many variations on different models of digital cameras. The Canon PowerShot G2 offers three selectable focus point positions, whereas the Nikon CoolPix 990 offers five selectable focus points. Some digital cameras even have automatic focal point selection where the camera, such as the Sony F717, determines what portion of an image it thinks should be selected as the area to use to focus the lens!

■ Read the documentation that came with your camera to learn how many focus points you have to choose from and how to choose one — if they are selectable.

STEP 4: AIM THE SELECTED FOCUS POINT AT THE AREA WHERE YOU WANT THE CAMERA TO FOCUS AND LOCK FOCUS

When you've determined where in the composition the camera should focus, center the selected focus point on that area and lock the camera's focus using the focus lock feature.

> **TIP**
>
> If you plan on shooting multiple photos that are composed where an off-center focus point is needed, consider selecting a different focal point if your digital camera has selectable focus points. When none of the selectable focal points match up against the area that is to be in focus, choose the closest one and use your focus lock feature as outlined in this technique.

Focus lock is implemented and used in a variety of ways. Some digital cameras allow you to lock focus by pressing the shutter button halfway down — this often locks many settings such as exposure and even white balance. Other digital cameras have a button specifically for focus lock, or they may even require that you access a menu to lock the focus. If you're lucky, your camera will allow both approaches, as does the Canon PowerShot G2. Check the documentation that came with your camera to learn how to use focus lock before doing this technique.

WARNING

If you use the shutter button to lock focus, check the documentation that came with your camera to learn whether you also lock other settings such as exposure or white balance. In most cases where you want to focus off-center, you may not necessarily want to take an exposure reading at the focus point, too!

STEP 5: RECOMPOSE

When you have locked the focus, you can recompose your photo. When viewing the final composition on the LCD monitor, you should see your image focused, as you want.

STEP 6: TAKE PHOTO

If you depressed the shutter button halfway to lock the focus, press it the rest of the way down now to take the photo. If you used a focus lock button or menu, you need to press the shutter button all the way to take a photo.

TIP

If your composition includes a subject or scene that has low contrast, is dimly lit, or has a mixture of close and far objects, you may find that your digital camera has a hard time getting focused. In such cases, look for another object that is the same distance from the camera and use that as the focus area. Then, lock focus and recompose.

USING A BUILT-IN FLASH

15.1 (CP 15.1) © 2002 Gregory Georges

15.2 (CP 15.2) © 2002 Gregory Georges

ABOUT THE IMAGE

"Paper Man & His Paper Dog" Olympus C720 Ultra Zoom, hand-held, zoom set to 56mm (35mm equivalent), f/3.2 @ 1/40th second, ISO 200, 1,488 x 1,984 pixels, 1.8MB .jpg

To flash or not to flash — that is the question. You should ask yourself that question each time you consider using a built-in flash. Unquestionably, a built-in flash serves many purposes and is an often-used feature that you can find on most compact digital cameras — even though a better alternative may exist for modifying the light than using a built-in flash. In this technique, you learn why you may or may not want to use a built-in flash and how to properly use one if your camera has one and you decide to use it.

Figure 15.1 (CP 15.1) shows a photo of a man and his dog covered in newspaper. The dog is not real, but the man is! He sits there motionless for hours every evening waiting for curious people to see whether he will move. When he doesn't move, many of them put a dollar or more in his jar for not moving, I guess. As I shot a couple of photos of him, I contributed, too. Notice how the newspaper is white as it really is, but not a bit yellow from the streetlights, as it ought to be. Also, notice how black the background street and stores are. The photo is reasonably focused. It does lack shadows, which would add dimension to the picture and so it appears very "flat." Most importantly (to me) it reads, "Taken with a flash!"

In **Figure 15.2 (CP 15.2)**, the built-in flash was turned off. To get a good exposure, the automatic shooting mode automatically changed the ISO setting to 400 ISO, the aperture to f/3.2, and the shutter speed to 1/4th of a second. The differences between this photo and the one in **Figure 15.1 (CP 15.1)** are significant. Here you can see a yellow color cast, which was caused by the street lights. The white newspaper is no longer white. The image contains lots of digital noise and it suffers from a slight blur due to the low shutter speed. Additionally, because the entire scene is evenly lit with ambient light, you can see the details of the background and shadows appear where they should appear under the chair and around the dog. These two photos illustrate the dramatic differences a low-powered built-in flash can have on a picture — both good and bad differences.

CHARACTERISTICS OF A BUILT-IN FLASH

Because a built-in flash is at most, just a few inches away from the lens, the flash unit creates a flash of light that shines almost straight from the lens to the burst of light. Although the light does light up the subject, it also reduces or eliminates any natural

shadows that help to define texture and subject detail. Notice how the leaves are further defined by the shadows that are beneath them in the photo shown in **Figure 15.3 (CP 15.3)**. Also, notice how much detail you can see in the bark because of the natural shadows coming from the low-level evening sun. This is a very three-dimensional photo with strong depth and texture.

In the photo shown in **Figure 15.4 (CP 15.4)**, a built-in flash was used. Because of the strong sunlight and the weakness of the built-in flash that was used to take this photo, there is still a small amount of natural shadow, but the flash has washed out most of it. In particular, the texture in the tree bark has been

15.3 (CP 15.3) © *2002 Gregory Georges*

considerably reduced. Just because a built-in flash was used, this photo is much less interesting than the one shown in **Figure 15.3 (CP 15.3)**.

Another disadvantage of the built-in flash is that it can and often does create the dreaded "red-eye" when it is used to take photos of people. Many camera vendors have red-eye reduction features that fire two flashes to minimize red-eye — first a pre-flash to shrink the iris, then a flash to expose the photo. Notice that the words *reduction* and *minimize* were used, because you can still get red eyes when using such features. There is also a downside to using a red-eye reduction feature, because the first of the two flashes can cause results as unsatisfactory as getting

red eyes. Many subjects blink during the pre-flash, and then the second flash catches them blinking. Or sometimes subjects think that the first flash means the photo was taken and they move and the second flash fires to capture their movement on the photo. If you were to use a detached or off-camera flash or shoot with existing light only, you would not have either of these problems.

DECIDING WHEN TO USE A BUILT-IN FLASH

So, with those previously mentioned "negatives" about built-in flashes set aside for a moment, take a look at some situations where a built-in flash can be tremendously useful.

■ **Reducing exposure range:** One of the best uses of a built-in flash is to bring your subject's exposure range down to where your camera can capture detail in both shadows and highlights. With the intent of getting a good photo of the inside of a restored Jaguar XKE, the photo shown in **Figure 15.5 (CP 15.5)** was taken with a Canon PowerShot G2 mounted on a tripod. The

15.4 (CP 15.4) © 2002 Gregory Georges

15.5 (CP 15.5) © 2002 Gregory Georges

extremely wide exposure range produced by the bright light coming in the windows contrasting with the dark shadows covering the interior of the car made for a wholly unacceptable photo.

After turning on the built-in flash, the photo shown in **Figure 15.6** was taken. This remarkable difference was made by increasing the light inside the car to more closely match the light level outside the car. With this decrease in subject dynamic range, a good photo was made. **Figure 15.7 (CP 15.7)** shows the photo taken in **Figure 15.6** after some editing was done with Adobe Photoshop.

■ **Using "fill in" flash:** If your subject has some unacceptable dark shadows, you can use fill flash to open them up and reveal details. Be careful not to wash out the texture in the parts of the picture that are lit with natural light — use exposure compensation to achieve the best balance. This approach works really well with back-lit subjects as well.

■ **Stopping motion:** The built-in flash on your camera produces its light in a super quick burst that can be very useful for freezing action. You will want to shut off red-eye reduction, because it greatly delays the moment of exposure, and makes it difficult to time the exact moment you're trying to capture. You also can experiment with "slow sync" mode, which is a long ambient exposure followed by a flash. This can capture both a blur of motion and freeze it, too.

DECIDING WHETHER A BUILT-IN FLASH IS FOR YOU

First, review the pros and cons of using a built-in flash. Using a built-in flash is extremely convenient because it is built in to the camera and is always ready to use when you need it. When you are shooting and you need more light than is on your subject, you can provide that extra light, in a flash! A built-in flash is also wonderful for taking snapshots and quick pictures in low-light environments where capturing the shot takes priority over getting a perfectly lit shot. Taking advantage of the built-in flash also means you won't have to carry extra pieces of equipment, or spend more money to buy them. If your digital camera does not have a hot-shoe (a place to attach a flash) or a synch-socket (a place to plug in an off-camera flash), then using a built-in flash is your only option.

The reasons not to use a built-in flash are numerous. Built-in flashes are not very powerful; light range is usually limited to eight to ten feet — fifteen feet at most. Because the flash comes straight from the

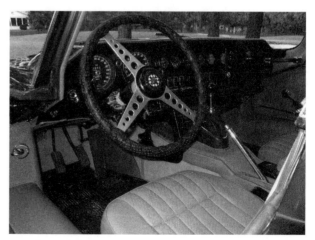

15.6 © 2002 Gregory Georges 15.7 (CP 15.7) © 2002 Gregory Georges

camera, you get a flash of light that can eliminate much of the detail and texture on your subject. This direct light can also cause red-eye when you're photographing people.

Many other reasons against using a built-in flash have to do more with the benefits of using an external flash mounted on the camera's hot-shoe or an off-camera flash. External flash units have much more power and they can cover a wider area, as well as subjects that are farther away. Many external flashes can be tilted to bounce light off the walls or ceilings to provide a much more natural-looking light than if the flash is aimed directly at the subject. A considerable number of flash modifiers are made for external flash, as you discover in Technique 20. When you take people photos, you won't have to worry about getting red-eye if you place the external flash a few feet from the camera.

The final reason not to use a built-in flash is also a reason *not* to use an external flash, too. Many photographers simply don't like the artificial quality of light that you get with any type of flash — so, they *never* use them. Admittedly, I often find that using a tripod and a long exposure with existing light is usually the way to shoot. This approach avoids the flat harsh light and black shadows that are so typical of flash shots. When there isn't enough light and I can't modify the scene with natural light, then there isn't enough light and I don't take a photo.

Enough of the pros and cons! If you want to use a built-in flash, here are the steps to get the best results.

STEP 1: TURN ON THE FLASH

Depending on the shooting mode you have selected and the light level of the scene you are shooting, your camera may or may not have already turned on the flash.

■ If your flash is not already turned on, turn it on.

STEP 2: SELECT RED-EYE REDUCTION, IF DESIRED

■ If you have chosen to use a red-eye reduction feature, turn it on now, or if you don't want to use it, make sure it is turned off!

There is no sense in leaving the red-eye reduction feature on when you don't need it, because red-eye reduction is accomplished with a pre-flash that uses up your battery power and delays the moment of exposure.

STEP 3: CHANGE THE FLASH EXPOSURE COMPENSATION, IF DESIRED

Most digital cameras use a default setting of maximum flash, when a built-in flash is used. Based upon this maximum flash "light," the camera then appropriately adjusts the aperture or shutter speed setting to get a good exposure. However, many digital cameras also allow you to adjust the amount of flash that is used via a flash exposure compensation feature. This feature is very similar to the exposure compensation feature covered in Technique 12.

When you use flash exposure compensation, you're really changing the balance between the amount of

> **WARNING**
>
> Experiment with your camera's red-eye reduction feature before using it for important people photos to see whether you like the results. If you do use it, make sure you tell your subjects that they will see two flashes and that the second flash is the important one. They must keep still until the second flash has fired, which is when the photo will be taken.

ambient or existing light and the unnatural light that comes from the flash. Flash exposure compensation can be used to get excellent results as it allows you to "open up" or make more details visible in the shadows, while minimizing the "flatness" that can occur when full flash is used and all the shadows are removed. Flash exposure compensation is a nice feature to have, but sadly, it is not available on all digital cameras. If you use a built-in flash often, check to see whether you have flash exposure compensation — using it can be a good way to minimize the negative aspects of a built-in flash while providing more light to the scene.

STEP 4: COMPOSE AND SHOOT THE PICTURE

■ Compose your picture and press the shutter button.

Remember that your flash won't light things that are too far from your camera, and it may have an excessive "light" effect on things that are close. You get the best results when working with subjects that are in the mid-ground area of your pictures — not too close and not too far away.

STEP 5: REVIEW IMAGE AND ADJUST THE SETTINGS

■ After taking a photo, review the photo on your camera's LCD monitor to see whether it is exposed correctly.
■ Check the histogram if your camera has one. To learn more about using a histogram, see Technique 11.

The techniques in Chapters 1 and 2 covered most of the material that you really ought to know to get good results with your digital camera. In this chapter, you learned about many useful features such as the histogram, exposure compensation, auto bracketing, spot metering, exposure lock, focal point selection, focus lock, and using a built-in flash. If you're serious about photography and your camera has these features, then your photography will be much better if you know how to use most of these features. They will undoubtedly make a huge difference in how you shoot and the results you get.

In Chapter 4, you learn how to choose and use some of the more common and useful accessories.

CHAPTER 4

CHOOSING ACCESSORIES

© 2002 Larry Berman

Taking better photos is the objective of every technique in this book. In this chapter you learn about some of the accessories that you may want to purchase to shoot better photographs. Getting the "right" accessories for the kinds of photos you take is as important as choosing the right digital camera and learning how to take better photos. In Technique 16 and Technique 17 you learn about tripods and tripod heads. In Technique 18, you learn all about focal length, 35mm equivalent focal length, and digital versus optical zoom factors — useful terms and concepts for discussing and comparing camera lenses. Technique 19 covers the topic of filters, and in Technique 20, you learn how to choose strobes so that you can add light to your subjects.

© 2002 Gregory Georges

CHOOSING A TRIPOD

16.1 *Original image* © 2002 Larry Berman

16.2 *Edited image* © 2002 Larry Berman

"Sunlight in Slot Canyon"
Nikon CoolPix 5000, tripod, WC-E68 wide angle accessory lens zoom set to 19mm (35mm equivalent), f/2.8 @ 1/13, ISO 100, 1,920 x 2,580 pixels, 1.5MB .jpg

You *must* have a good tripod to capture many scenes or subjects such as the Slot Canyon in Arizona shown in **Figure 16.2**. Choosing the right tripod for the kinds of photos you want to take is just about as important as choosing the right digital camera. A tripod allows you to take a slower, more deliberate, and precise approach to composing than you can get with a hand-held camera. You can also use it to minimize camera shake, maximize depth-of-field, or to shoot in low light settings.

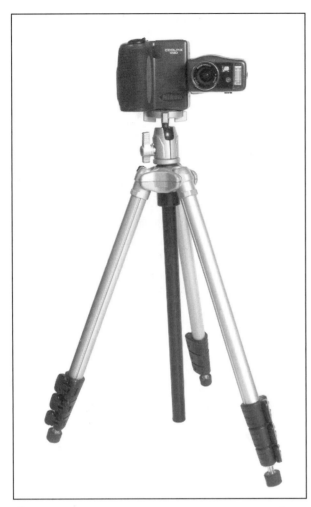

16.3 © 2002 Larry Berman

All categories of photographs — from people photos to macro photos, to landscape photos, to long exposure night photographs — are simply better when you use a "good" tripod. What is a good tripod? Admittedly, recommending the "perfect" tripod for your use is about as easy as recommending a "perfect" shoe for your feet! However, mentioning a few things that are important to consider when you begin your search for a tripod is possible. In this technique, you learn how to decide for yourself which tripod is "perfect" for you.

STEP 1: CONSIDER THE FOLLOWING QUESTIONS

Getting the right tripod for your photography is not hard providing that you take your time in making a selection and that you consider the following questions.

- **How much do you need to spend on a tripod?** You should plan to spend $80 or more to get an adequate tripod (without a head) to use with compact-level digital cameras. A few notable exceptions exist, such as the Velbon Maxi 343E (`www.web1.hakubausa.com`) shown in **Figure 16.3**, which you can purchase for around $90, including a ball head.

The Bogen 3001BPRO (`www.bogenphoto.com`), shown in **Figure 16.4** is also an excellent tripod. There are several versions of the 3001 that range from around $85 to $120 depending on which center column you choose. Another popular and solid tripod in the Bogen line is the

3221WN, shown in **Figure 16.5**. You can purchase it for $150 to $170 depending on various options. It is an excellent tripod that professional photographers have used for many years. If your budget allows and you think you may be purchasing or using a heavier 35mm digital SLR or film camera, you may want to consider getting a carbon fiber tripod like the Gitzo 3443D, shown in **Figure 16.6**. It sells for around $325.

16.4 *© 2002 Manfrotto*

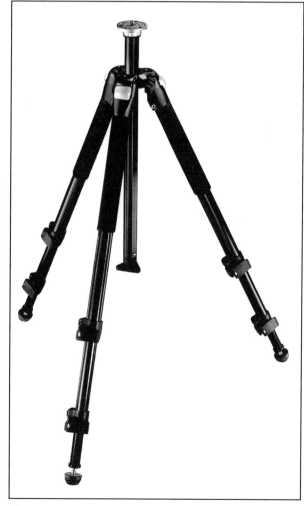

16.5 *© 2002 Manfrotto*

Although you may be tempted to spend less than $80 for a tripod and head, you are quite likely to find yourself buying a second tripod later, because inexpensive tripods are usually flimsy products that won't provide the solid support you need.

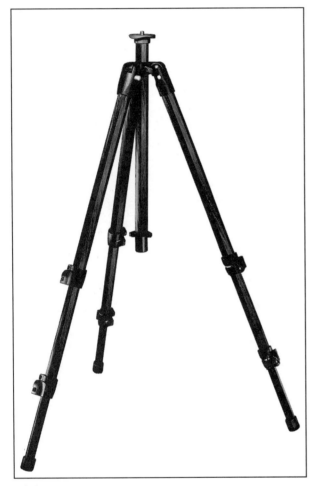

16.6 © 2002 Manfrotto

■ **What camera and focal lengths do you plan on using?** The longer the focal length of your lens, the more camera movement will affect image quality. When you shoot with a wide angle lens such as a 28mm lens (35mm equivalent), camera shake is less of an issue than if you shoot at the long end of the zoom, especially one like the Nikon CoolPix 5700, which has a 35–280mm (35mm equivalent) focal length. If you plan on adding a 2X or 3X tele-converter lens, you will want to control camera shake even more.

In Technique 32, you learn how to *digiscope* — that is, to take a photo with a digital camera by connecting it to a high-powered scope. Because of the high power of most scopes and because adding a digital camera to them adds even more focal length, you would be wise to spend $400 or more dollars on one of the best tripods you can find. Otherwise, you'll get blurred images all the time. Focal length matters that much when you are choosing a tripod!

WARNING

A surprising number of photographers have more than one tripod because the first tripod they purchased turned out to be too flimsy to offer the support they need. Therefore, choose your first tripod carefully. If you already have a flimsy tripod, you still may find some uses for it, such as using it as a short tripod (the less the extension, the sturdier a tripod is) or a light stand for holding an off-camera flash.

■ **How do you intend to use your tripod?** What kinds of pictures do you like to take? If you take lots of close-up photos of things that are within a foot of the ground, you will want something that allows you to mount your camera low to the ground. If you frequently travel and you want to carry as little as possible, a large heavy tripod that is 35 inches long when it is closed will not be a good one for you. The point here is that you must decide how you plan to use your tripod, before you go shopping for one. If you don't know yet, wait to buy one until you do.

■ **Do you need one or more tripods?** If you find that you have widely varying requirements for your "ideal" tripod, you may have no choice but to buy more than one! If you want a tripod that you can easily stick in a suitcase and use when you travel, you may want a different tripod than you ordinarily use. Likewise, those photographers who shoot macro shots of "low to the ground" subjects and landscapes have to choose wisely to get a tripod that is optimal for both types of photography. You don't have to immediately buy two or more tripods. Just consider your needs carefully and try to avoid getting one that is *not* optimal for any of the kinds of photos you plan on taking.

■ **What kinds of tripods are available?** Every year new tripods are introduced. Some tripods have extension columns whereas others don't. You can find some with lateral arms, some without lateral arms. Tripod legs come in two, three, and four

sections. A variety of materials are used, ranging from metal alloys to steel to carbon fiber. You can buy a monopod — a one-legged tripod. You can find specialty tripods like the Bogen window-mounted clamp shown in **Figure 16.7** and the

16.7 © 2002 Larry Berman

16.8 © 2002 Larry Berman

16.9 © 2002 Larry Berman

tabletop tripod shown in **Figure 16.8**. Many different kinds of tripods exist; your challenge is to pick one with the features you need, or maybe you will even want to create your own for a specific purpose using Bogen Super Clamps. **Figure 16.9** shows how a Bogen Super Clamp and ball head were used to mount a camera on the leg of a tripod for shooting close-up photos of subjects near ground level.

■ **What features are most important to you?** Like many things in life, choosing the "best" tripod for your use is a matter of making compromises. You'll face many trade-offs during the selection process. Heavier tripods are more stable, but are heavier to carry. Short tripods weigh less, but they can be more uncomfortable to use when shooting because you may have to stoop. The following are a few of the features (and trade-offs) you'll want to consider:

■ **Sturdiness:** The feature that *ought* to be most important to you is sturdiness. After all, a tripod that is not sturdy is not worth having. However, you have to pay a price for sturdiness in terms of weight and cost.

■ **Weight:** To a certain degree, the more a tripod weighs, the sturdier it is likely to be. Yet, a heavy tripod is not fun to carry all over a mountainside or for days as you tour around many cities. So, look for one tripod that matches your needs for being "not too heavy," yet heavy enough to be stable.

■ **Maximum height:** If you're over six-feet tall, and you want to point your camera up toward the tops of trees to take bird photos or toward the sky to take photos of the moon and stars, then you'll be miserable if you have to stoop down to look up. The bad news is that tall tripods weigh more and cost much more than shorter ones.

■ **Minimum height:** Minimum height may not seem like an important factor to consider

until you decide you want to take photos of a wild flower or a mushroom. Most tripods with a long center column cannot be lowered enough to take such a photo. Some vendors recognize this problem and provide a reversible center column, an optional short center column, or just a base plate, allowing the camera to be mounted very low to the ground.

■ **Minimum length when closed:** If you want to carry your tripod on a backpack or in a suitcase, you want a tripod that is compact. Consider one that has legs that extend in four sections. It will have a shorter minimum length, but it will take a bit more time to set up and adjust.

■ **Material:** Carbon-fiber tripods seem to be the rage these days. They are strong, rigid, lightweight — and expensive. Besides weighing less than comparable "metal" tripods, carbon-fiber tripods have the added benefit of being able to dampen vibration effectively. If you're willing to pay for a carbon-fiber tripod, it is an excellent choice. However, you can get an equally good and sturdy tripod for less money if you pick one that is not carbon fiber.

■ **Center column:** The sturdiness of a tripod is determined by the tripod's weakest part. When you raise the center column on many tripods, it becomes the weakest part and you may be noticeably reducing the stability of the tripod. Yet, tripods with center columns can be much easier to use than tripods without a center column. If you need to raise or lower a tripod just a few inches, raising or lowering a single center column is much easier than doing so to three tripod legs. If you have selected a tripod with a center column just to get the height you need, you may want to consider purchasing a more expensive tripod that offers more height without requiring the center column to be extended.

■ **Tripod head:** Less expensive tripods usually come with a head attached, but before you buy a tripod with a head, read Technique 17. You want to make sure that you get the right tripod *and* the right head for your purposes.

STEP 2: VIEW TRIPOD VENDORS' WEB PAGES

A great place to learn more about tripods is on the leading tripod vendor's Web pages. Some of the better tripods and heads are made by Benbo, Gitzo, Manfrotto (Bogen), Slik, and Velbon. To get a "clickable" list of tripod vendors' Web sites, visit this book's companion Web page at `www.reallyusefulpage.com/50dc`.

STEP 3: ASK ABOUT THE TRIPOD YOU'RE CONSIDERING ON AN ONLINE FORUM

There is nothing like using the power of the Internet for finding more about products and services related to digital photography. Just about everyone who is into digital photography seems to be relatively skilled in the use of computers, too! So, when you have completed some research on tripods and have thought carefully about how you intend to use a tripod, visit one of the online forums and ask for advice. When you read the replies, remember the old adage: "Free advice is often worth just what you paid for it." Although getting advice that is dead wrong is possible, most of the time you can get lots of useful comments that will help you choose the right tripod. You can find one of the best forums for this kind of question at `www.dpreview.com`. To get a "clickable" list of more photography forums, visit this book's companion Web page at `www.reallyusefulpage.com/50dc`.

STEP 4: TRY OUT THE TRIPOD YOU WANT BEFORE BUYING IT

If you haven't had first-hand experience with a few different tripods, you will find it more than worthwhile to visit a local photo store to try each of the tripods you are considering. While you can usually find a better selection of tripods at one of the local "pro" photo stores, many of the nationwide photo stores, such as Ritz Camera and Wolf Camera, do have "super" stores where they offer more choices than they do in their smaller stores, where the selection is more limited.

WHAT MAKES A TRIPOD, "PERFECT" FOR YOU?

A good tripod is sturdy and easy to use. It won't pinch your fingers. It is light and easy to carry. It is simple to adjust. It is one that you will actually carry and use when you need it. Most importantly, it is one that allows you to shoot as you want to shoot.

A good tripod will also last a lifetime, or even more. Many of us have "love and hate" relationships with our tripods; with some work and luck, maybe you will find one you love. Your pictures will be better if you do.

TIP

It costs money to stock photo gear and present it in a "bricks-and-mortar" store. Take the time to visit a store; if you get good advice from the sales people, and they have the tripod you want, ask for the best price they can give you and then buy it from them. Most stores will work with you to earn your business if you tell them what you want and tell them the cost of buying the product from an online store or from a mail order store. Without giving some of your business to the bricks-and-mortar stores, one day, we all will find that we have lost a valuable service by continuingly trying to save a few dollars on every purchase — there won't be any stores that we can visit to try products.

CHOOSING A TRIPOD HEAD

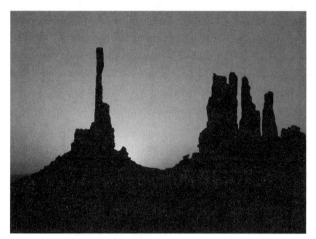

17.1 *Original image* © *2002 Larry Berman*

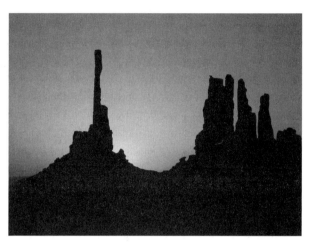

17.2 *Edited image* © *2002 Larry Berman*

ABOUT THE IMAGE

"Sunrise Behind Totem Pole"
Nikon CoolPix 5000, tripod,
85mm (35mm equivalent),
f/6.8 @ 1/363, ISO 100, 2,560
x 1,920 pixels, 1.1MB .jpg

I n Technique 16, you learned how to choose a tripod. In this technique, you find out how to choose a tripod head, which is equally important. Shooting with a good tripod and head makes taking photos fun and easy. If you get one that doesn't feel good to you, or it limits how you take photos, then you have the wrong head. There are many different types of tripod heads and ways to attach your digital camera to your tripod. This technique gives you all the information that you need to choose the right tripod head for your intended use.

STEP 1: CONSIDER THE FOLLOWING QUESTIONS

Getting the right tripod head for your photography is not hard providing that you take your time in making a selection and that you consider the following questions.

■ **How much do you need to spend on a tripod head?** You should plan to spend at least $25 or more to get a reasonably good tripod head. The

more you shoot, the more you can justify moving up to a better head, which can cost over $100 or more. Many photographers who have previously shot with a 35mm film camera, or still shoot with one, or with one of the newer digital SLR cameras, use tripods heads that cost well in excess of $300. Although these heavier and more expensive tripod heads are necessary for the heavier 35mm cameras and digital SLRs, they can also be excellent heads for the lighter-weight, compact-level digital cameras, too. So, if you already have one, you won't need a new one.

■ **What features are most important to you?** Although choosing a tripod head may initially seem easy, you will be disappointed with your purchase if you find that it doesn't allow you to shoot as you want. The following list of tripod head features will give you a good idea of what to consider when purchasing a tripod head:

■ **Sturdiness:** The feature that *ought* to be most important to you is sturdiness. After all, a tripod

head that is not sturdy is not worth having. However, you pay a price for sturdiness in terms of weight and cost.

■ **Type:** One of the first choices you'll need to make when looking at tripod heads is what type you want. The two main types of tripod heads are the pan-tilt head and the ball head. The pan-tilt head allows you to separately control each of three movements: up and down, side to side, and horizontal rotation. Ball head tripods allow you to unlock motions in all three axis with a single control. **Figure 17.3** shows an example of the Manfrotto 484 ball head, which sells for about $35. **Figure 17.4** shows the Manfrotto 3030 3-Way Pan/Tilt Head with Quick Release head, which sells for around $55.

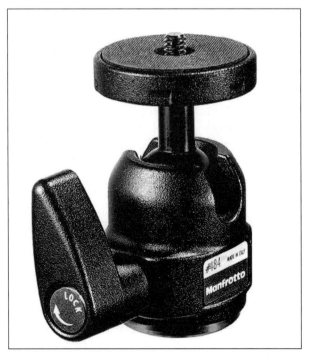

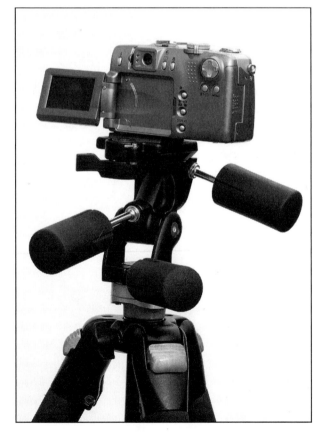

■ **Quick-release feature:** Soon after you've screwed your digital camera on and off a tripod head a few times, you'll be looking for a faster, easier way to attach your camera to the tripod head. Many tripod head vendors offer "quick release" features that enable you to remove the camera from the tripod head with a single lever or a twist of a knob. Kirk Photo (`www.kirkphoto.com`) sells a selection of plates that will fit any style of tripod head. To use this quick release feature, you also need to purchase a quick release plate that you screw to the bottom of the camera, like the CoolPix 5000 plate from Kirk Photo, shown in **Figure 17.5**, which is about $50. **Figure 17.6** shows the Kirk Photo plate mounted to the bottom of the Nikon CoolPix 5000.

■ **Ability to shoot vertically:** Being able to turn your camera 90 degrees and shoot in portrait mode (when the longer side of the image is vertical) is highly desirable. Some tripod heads have not been designed to allow a camera to be rotated a full 90 degrees. If you plan on shooting vertically, make sure to get a tripod head that allows you to do so.

■ **Ability to pan:** One of the more exciting advantages of shooting digitally is that you can use a digital camera and special "digital photo stitching" software to digitally stitch photos together into one wide or tall photo, or even into a full 360-degree movie. You can shoot photos for this use best if your tripod allows a controlled panning motion.

17.5 © 2002 Larry Berman

17.6 © 2002 Larry Berman

■ **Ease of adjustment and level of precision:**
One of the most significant differences between
the least expensive tripod heads and the more
expensive ones is how easy (or hard) adjusting
the orientation of the camera is and how pre-
cisely you can position it. Less expensive ball
heads are typically locked or not locked,
whereas the more expensive ball heads allow
you to set tension and to position the camera
smoothly without locking it completely.

■ **Bubble level:** If you shoot panoramas, having a
tripod with a bubble level can be helpful because
it makes leveling your camera easier and faster. By
leveling your tripod before you shoot your first
shot, each subsequent picture will follow the same
horizon line. A bubble level is a nice feature, but
having one is surely not essential.

STEP 2: VIEW TRIPOD VENDORS' WEB PAGES

A great place to learn more about tripod heads is to
look at the leading tripod head vendors' Web pages.
Some of the better tripods and heads are made by Arca
Swiss, Benbo, Gitzo, Kirk Photo, Manfrotto (Bogen),
Slik, and Velbon. To get a "clickable" list of tripod head
vendors' Web sites, visit this book's companion Web
page at `www.reallyusefulpage.com/50dc`.

STEP 3: ASK ABOUT THE TRIPOD HEAD YOU'RE CONSIDERING ON AN ONLINE FORUM

After you have completed some research on tripod
heads and have thought carefully about how you
intend to use a tripod head, visit one of the online
forums and ask for advice. You can find one of the
best forums for this kind of question at `www.`
`dpreview.com`. To get a "clickable" list of more
forums, visit this book's companion Web page at
`www.reallyusefulpage.com/50dc`.

WARNING

Don't spend your money on a video or fluid
head unless you plan to shoot more movies
than still photographs. You won't gain any
advantage from the extra smooth panning
motion these heads provide. Furthermore, they
cost quite a bit more and they usually don't
have the tilt control features that are necessary
to shoot still photos.

TIP

Make sure the screw threads on the bottom of
the tripod head match the threads on your tri-
pod. The two standard sizes are 1/4 and 3/8 inch.
The more sophisticated tripods sometimes have
a reversible screw in the top where the head
screws on so they can be used with any head.
You can also buy an adapter if you have two dif-
ferent size screw threads.

STEP 4: TRY OUT THE TRIPOD HEAD
YOU WANT BEFORE BUYING IT

If you haven't had first-hand experience with a few different tripod heads, you will find visiting a local photo store to try each of the tripod heads you are considering more than worthwhile. While you can usually find a better selection of tripod heads at one of the local "pro" photo stores, many of the nation-wide photo stores, such as Ritz Camera and Wolf Camera, do have "super" stores where they offer more choices than they do in their smaller stores, where the selection is more limited.

In addition to the two Manfrotto (Bogen) heads shown in **Figure 17.3** and **Figure 17.4**, you may also want to consider the more solid and expensive Manfrotto 488RC2, shown in **Figure 17.7**, which sells for about $90. Notice that it has a separate lever for controlling the panning and it also has a graduated scale to use when shooting photos for panoramas. An even more expensive pro ball head is the Arca-Swiss Monoball B1 Ballhead with independent panning

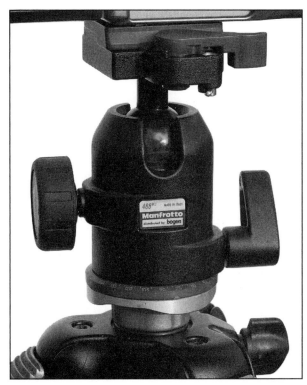

17.7 © *2002 Manfrotto*

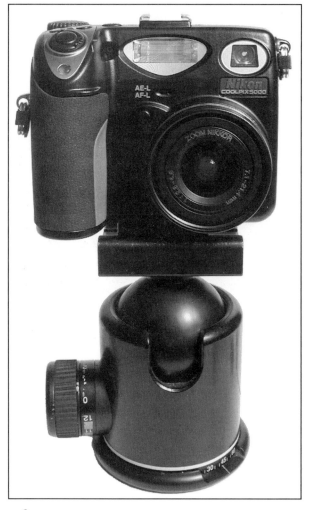

and lock & quick release, shown in **Figure 17.8**, which costs around $400. While this is an unreasonable amount to pay to use only with a compact digital camera, it is the ball head of choice for those using a digital SLR or film camera. It works well for most compact digital cameras. One of the newer and more innovative tripod heads is the Novoflex "The Small" tripod head, shown in **Figure 17.9**. It costs around $135.

Reputable manufacturers make all of these excellent heads with good warranties and support. Although these are "recommended" heads, they may not be the right ones for you; consider these and others carefully before choosing one for your intended uses.

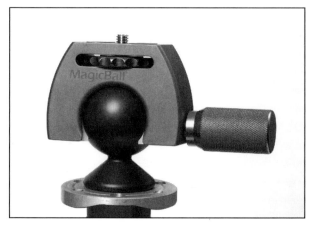

17.8 © *2002 Larry Berman*

17.9 © *2002 Gregory Georges*

SELECTING SUPPLEMENTAL LENSES

18.1 *Original image* © 2002 Larry Berman

18.2 *Edited image* © 2002 Larry Berman

Auxiliary lenses are lenses that you can attach to compact digital cameras to "modify" the focal length and angle of view of a camera's built-in lens. An example of the use of a Nikon FC-E8 fisheye lens on a Nikon CoolPix 4500 zoomed for a full frame image is shown in **Figure 18.2**. Digital camera vendors and third-party vendors offer a wide range of auxiliary lenses, including telephoto, wide-angle, fisheye, and close-up lenses. Choosing one is not difficult, but understanding exactly what you will get when it is attached can be more than a bit confusing. In this technique, you learn about focal length, 35mm equivalent focal length, and digital versus optical zoom factors — all useful concepts when choosing auxiliary lenses and digital cameras with their built-in lenses.

Before you begin reading the content in this technique, be warned that it is quite technical if you have experience with 35mm film cameras and are of the technical type who wants to understand more about focal lengths and the resulting view you will get with your built-in lens and any supplemental lenses you choose to add. If you are not inclined to care about such matters, please skip this technique and move on to the next technique.

Before you learn some important terminology, first take a look at the effects of attaching a few auxiliary lenses. The photos in **Figure 18.3** show

Photographs taken with a Nikon CoolPix 4500
(built-in lens is 38-155mm [35mm equivalent])

.63 Wide-angle supplemental converter
24mm (35mm equivalent)

Built-in wide zoom setting
38mm (35mm equivalent)

Built-in telephoto zoom setting
155mm (35mm equivalent)

2x Telephoto supplemental converter
310mm (35mm equivalent)

3x Telephoto supplemental converter
465mm (35mm equivalent)

5x Telephoto supplemental converter
775mm (35mm equivalent)

the results of using a Nikon CoolPix 4500 with a wide-angle lens, and a 2X, 3X, and 5X telephoto lens. If you wanted to explain to someone else what lens you used to take each photo, you would have to get into a discussion about focal length. You might say that the first photo was taken with a wide-angle lens with a .63 focal length factor — but, what would that really mean? You would also have to tell him that the lens was added to a Nikon CoolPix 4500, which has a focal length zoom range of 7.85–32mm. Again, that's not much help either, you'll find out! Throw in the size of the image sensor — 1/1.8" (0.556") inches, and that the 35mm effective focal length is 38–155mm and you have all the information needed to speak intelligently about the lens — but that information is still not very user-friendly!

USE THE 35MM FOCAL LENGTH REFERENCE TABLE

So, the question is how do you compare and discuss the angle of view you get with a specific camera and specific camera lens? Because so many owners of digital cameras have previously used 35mm cameras, camera vendors like to use the term "35mm focal length equivalent." But, what is that? **Figure 18.3** shows *true* 35mm focal lengths and the corresponding angle of view. **Table 18.1** breaks all the lenses down into six types: fisheye, super-wide, wide, normal, telephoto, and super telephoto. This table is a good reference when you know what the 35mm effective focal length is for any lens and camera you want to discuss or compare.

Because each digital camera has it own multiplier factor, the true focal length written on the camera is not a good one to use when comparing one lens with another, or with the view that many of us have etched into our mind — the views associated with 35mm film camera focal lengths. To make it easy to compare images and lenses, a 35mm equivalent focal length ought to be used. You'll notice that there is a photo at the beginning of each technique throughout this book. The shooting data listed for this photo is in the "About the Image" box, and it shows a 35mm equivalent focal length. This allows you to compare what you get with your camera to the photo in each technique.

TABLE 18.1 35MM LENSES AND ANGLE OF VIEW

TYPE OF LENS	35MM FOCAL LENGTH	ANGLE OF VIEW *
Fisheye	6mm–16mm	170–220 degrees
Super Wide	13mm–20mm	94–118 degrees
Wide	24mm–35mm	53–84 degrees
Normal	45mm–55mm	42–46 degrees
Telephoto	85mm–300mm	6–23 degrees
Super Telephoto	Over 300mm	Under 6 degrees

*Angle of view varies slightly depending on the manufacturer's specifications. Additionally, an overlap exists in focal length between fisheye and super wide-angle lenses. Super wide lenses are rectilinearly corrected (no distortion if oriented properly), whereas the fisheye lenses are designed to curve to see more.

FOCAL LENGTH

So, where does all the confusion come from? If you're confused about focal length measurements, focal length multipliers, and zoom factors — all of which determine the angle of view you get — don't feel bad. Camera vendors have historically used lens focal length to describe a lens's angle of view, but comparing focal lengths and angles of view only works when the film or light sensors in the cameras that the lenses are attached to are the same size. Today's digital cameras use a multitude of sensor sizes, so comparing the *actual* focal lengths of the lenses on different digital (or film) cameras is meaningless. In an attempt to relate lenses to standards that many photographers already know, most digital camera makers now refer to *35mm film camera equivalent focal lengths.*

Technically, focal length is the distance in millimeters between the optical center of the lens and the image sensor or film plane when the lens is focused on infinity. A larger focal length (for example, 200mm) gives a narrower view than a smaller focal length (for example, 28mm), which has a wide-angle view. Why do we care about focal length as a measurement? We care because historically it has been used to describe the "angle of view" that we can see and record with a lens. However, the angle of view that you get with a specific focal length is *also highly dependent* on the size of the image sensor or film that the lens focuses its image on!

This means that a 100mm lens on a 35mm film camera has a different angle of view than a 100mm lens has on a digital camera with an image sensor that is larger or smaller than 35mm film! The point is that focal length is not really a good measurement to use for determining what the angle of view will be because it is so dependent on the image sensor size or film size. So, any confusion you may have had is well founded.

DIGITAL CAMERA LENSES AND FOCAL LENGTH MULTIPLIERS

Unfortunately, camera vendors continue to label their lenses with focal length measurements. But, that is okay if you understand how to determine a focal length multiplier and use it. Because compact-level digital cameras have image sensors that are smaller than 35mm film, you need to multiply the focal length by a number called the "focal length multiplier" to get an equivalent 35mm focal length.

For example, the numbers printed on the Canon PowerShot G2 lens barrel are "7–21mm." If you're familiar with the views you get with a 35mm film camera, you may think, "Wow — that is a very wide-angle zoom lens!" But it actually isn't. If you look inside the Canon G2 manual, you find that the 35mm film equivalents are 34–102mm. You can use these two sets of numbers to determine the "focal length multiplier" for the Canon PowerShot G2. You can either divide the wide-angle, 35mm-equivalent focal length (34mm) by the wide-angle focal length of the Canon PowerShot G2 lens (7mm), or the telephoto 35mm-equivalent focal length (102mm) by the telephoto focal length of the Canon PowerShot G2 (21mm) to get a focal length multiplier of 4.86 (34mm/7mm = 4.86 or 102mm/21mm = 4.86).

After you have a focal length multiplier for your camera, you can use it in many ways. If you use the EXIF data that is included in your image files, you will find that the focal length of the lens is shown for each shot. But it is the focal length of the lens — not a 35mm focal length equivalent. Using the multiplier, you can determine the 35mm focal length equivalent, which makes it easy to compare with other digital and 35mm film cameras and lenses.

Knowing the 35mm focal length equivalent also helps you determine the view you will get if you add a supplemental lens. For example, if you add a Canon

WC-DC58 Wide Converter to a Canon PowerShot G2, you multiply the actual focal length by the multiplier for this camera (4.86) then by the wide-angle adapter factor of .8 to determine the 35mm film camera equivalent angle of view. This means that the 7mm wide-angle lens on the Canon PowerShot G2 becomes a 27mm (35mm focal length equivalent) lens with the WC-DC58 Wide Converter attached ($7mm \times 4.86 \times .8 = 27.2mm$).

THE "X" FACTOR

Most compact-level digital cameras have zoom lenses; that is, their lenses have variable focal lengths. When you read that a lens is a "2X" or "3X" zoom, it simply means that the longest focal length setting is two or three times the focal length of the shortest (or widest angle) setting. Using the Canon PowerShot G2 as an example once again, the 7–21mm zoom lens is actually a 3X lens ($3 \times 7mm = 21mm$).

You will also find that tele-converters (an add-on lens that increases focal length) and wide-angle converters (an add-on lens that decreases focal length) also use X factors. For example, Canon's WC-DC58 Wide Converter has a lens factor of 0.8X. When you use it with the Canon PowerShot G2's 7–21mm lens, you then have a 5.6mm–16.8mm (7×0.8 to $21 \times .8$) zoom lens (actual focal length) or a 23.7–81.6mm ($5.6 \times 4.86 = 27.2mm$ to $16.8 \times 4.86 = 81.6mm$) 35mm equivalent focal length!

DIGITAL VERSUS OPTICAL ZOOM

One last zoom factor to consider is digital zoom. Digital zoom is produced by digitally increasing the size of the center portion of the image by using a mathematical algorithm. Photos taken with digital zoom are very much inferior to those taken only with optical zoom. If you want the best picture, plan on only shooting with optical zoom.

WARNING

Many people suffer from the "bigger is better" mentality. When they see a camera with a 2X or 3X or even 10X zoom, they automatically think the camera with the larger magnification is the better camera. However, these same people may find out after they purchase a camera that they can shoot only in the telephoto range and that they cannot shoot a small group of people for a group photo because they do not have a wide enough wide-angle lens. Before purchasing a digital camera, carefully consider how you want to use it and buy one with a lens that will work for your intended use.

Now that you understand a few terms and important concepts, you're ready to choose a supplemental lens. Or if you haven't yet purchased a digital camera or you're looking to purchase a new one, you can do so with confidence that you will get a lens that suits your needs.

I'm pleased to see you made it this far! With an understanding of the terms and concepts you've just covered, you should now take a few minutes and shoot a few photos using minimum and maximum focal lengths (assuming you have a zoom lens). Then compute your focal length multiplier and shoot a few more photos with any supplemental lenses you have so that you have a clear understanding of the view you will get with each combination of focal length and supplemental lens.

CHOOSING FILTERS

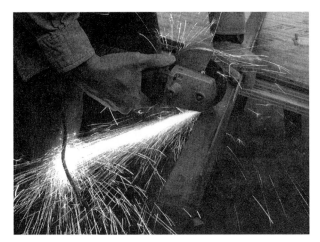

19.1 *Original image* © *2002 Larry Berman*

19.2 *Edited image* © *2002 Larry Berman*

If you're into digital photography and are skilled at using an image editor like Photoshop, you may feel that you no longer need lens filters because you can get similar or better results by digitally editing your images. However, many good reasons exist for considering using a few filters, including a protective filter to prevent damage to your lens in harsh environments, like the one used to take the photo in **Figure 19.2**. In this technique, you learn about four filters that you're likely to find useful: the protective filter, neutral density filter, polarizing filter, and infrared filter. All of these filters are shown in **Figure 19.3**.

TIP

Most of the damage done to camera lenses occurs when they are improperly cleaned. If you decide not to purchase and use a protective lens filter, use a soft clean cloth to clean the lens. Old cotton t-shirts make excellent cleaning cloths. If you clean your lens often, consider buying a lens cleaner kit that has a soft cloth plus a small bottle of cleaning liquid. Avoid "scrubbing" the lens because you can remove or scratch the coating on the lens.

STEP 1: DECIDE IF YOU SHOULD USE A PROTECTIVE FILTER (UV OR SKYLIGHT)

Protective filters are primarily designed to protect the front element of a camera lens from dust, moisture, scratches, and breakage. The two most common protective filters are the UV-absorbing filter and skylight filters. There are two schools of thought on using "protective" filters. Some feel strongly that you should always protect the lens on your digital camera (or any camera) with a protective filter such as a UV or skylight filter. Others feel equally strong about not

adding extra glass to a lens that could possibly degrade the quality of the image. If you take good care of your camera and you avoid using it when and where the lens could get damaged, you may not need a protective filter. If you use your camera in harsh environments where the lens could get damaged or where the lens frequently gets wet or dirty and needs to be cleaned often, you may want to buy and use a UV or skylight filter.

STEP 2: CONSIDER WHEN YOU SHOULD USE A POLARIZER

One of the more valuable and tricky-to-use filters is the polarizer. You can use polarizers to reduce reflections and to make richer colors — sometimes. Admittedly, the successful use of a polarizer requires some knowledge and a bit of luck. Because a polarizer's effect varies depending upon your camera's angle to the sun, you have to have chosen a place to shoot where the camera's orientation allows you to "polarize" the light — and you have to know how to adjust the polarizer.

19.3 © 2002 Larry Berman

WARNING

Too much polarization can increase contrast and color saturation in a photograph so much that it can look unnatural and even posterized. Until you've gained some experience with a polarizer, shoot the same picture with varying amounts of polarization so that you end up with a photo you like.

You can buy two types of polarizers: circular and linear. Your best choice is a circular polarizer because some digital cameras may not work with a linear polarizer. To view the effect of a polarizer, you must look on your camera's LCD monitor because you won't be able to see the change through an optical viewfinder. Be aware that your camera may also compensate for the darker skies by increasing exposure, which causes clouds to lose valuable detail, so you will want to take a quick look at the histogram (if your camera has one) to make sure your exposure is correct.

The strongest effect from a polarizer occurs when you shoot at a right angle to the sun. As you turn more toward or away from the sun you gain less benefit from the polarizer, and the polarizer blocks less light to your camera's image sensor. A polarizer can cut down on the amount of light to your camera's image sensor ranging between one and two stops.

Besides being able to control reflections, you can also use a polarizer to enhance or deepen the intensities of colors such as a blue sky, red and orange leaves, or green trees and plants. **Figure 19.4 (CP 19.4)** shows the results of using a polarizer. **Figure 19.5 (CP 19.5)** is the same scene without polarization.

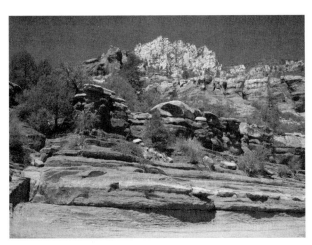

19.4 (CP 19.4) © 2002 Larry Berman

19.5 (CP 19.5) © 2002 Larry Berman

Notice the richer blue of the sky, and the colors in the red rocks. This is a good example of when a polarizer's effects should be used sparingly. Overdarkening the sky would have been easy to do in this situation, giving the scene an unnatural appearance.

Another good use for a polarizer is to reduce or eliminate glare from reflective surfaces like water or glass. **Figure 19.6 (CP 19.6)** shows a photo of the reflections of fall colors in a shallow stream. When a polarizer is used to eliminate the reflections, you can see the bottom of the stream as is shown in **Figure 19.7 (CP 19.7)**. Similar results may be obtained if you want to shoot through a glass window and remove the reflections.

STEP 3: CONSIDER WHERE YOU MIGHT USE A NEUTRAL DENSITY FILTER

Neutral density filters are designed to reduce the amount of light that gets to the image sensor in your digital camera without affecting the color. Although this may seem contrary to the way you usually work, where more light helps you use a low ISO setting and a fast shutter speed for sharper pictures, you will soon find that neutral density filters can be some of the most useful filters you can buy.

If you have ever seen a photo of a waterfall where the water looks like a silky stream of fog rolling down the rocks, then you're likely to have seen the results of a

19.6 (CP 19.6) *© 2002 Gregory Georges*

19.7 (CP 19.7) *© 2002 Gregory Georges*

photograph taken with a neutral density filter. Also, because of the mathematics behind the optics in compact digital cameras, achieving shallow depth-of-field in bright light is very hard. Using a neutral density filter, you can not only slow action down enough to get soft blurred water coming down a waterfall, but you can also improve the background blur behind your subject — a highly desirable feature for many photographers.

Most neutral density filters are labeled in logarithmic units, with each .3 equaling one stop of light-blocking ability. A filter labeled as .9 blocks three stops of light, and allows you to extend your exposure time by three stops. Some vendors label these same filters with a 2x (one stop), 4x (two stops), and 8x (three stops) filter factor notation. The effects are the same, only the labeling is different.

Generally, when you use a neutral density filter, you also need to use a tripod because you will be shooting with slow shutter speeds. The longer your exposure time, the smoother the water flow and the longer the camera must be perfectly still. Experiment with shooting water, plants blowing in the wind, and different moving objects. Capturing subjects in motion with a neutral density filter can often yield exciting results. Get one and experiment with it — you're more than likely to get results you would not be able to get without one.

Figure 19.8 (CP 19.8) shows flowing water without the benefit of a neutral density filter. **Figure 19.9 (CP 19.9)** shows the result of using a .9 neutral density filter to slow down the shutter speed by three stops, which smoothes the flowing water.

19.8 (CP 19.8) © 2002 Chris Maher

19.9 (CP 19.9) © 2002 Chris Maher

STEP 4: DECIDE IF YOU WANT TO USE AN INFRARED FILTER

Some people like the effects seen in infrared photos but are discouraged by the difficulty of working with infrared film. If you ever were interested in infrared images, now is the time to buy an infrared filter! Used with the right digital camera, an infrared filter can produce some outstanding photos, and infrared photos are easy to shoot digitally compared to shooting with infrared film in a film camera. Seeing the world bathed in infrared light, right on your LCD screen, can be pretty exciting. Trees and plants appear to glow, skies become jet-black, and skin often radiates with a strange glow. **Figure 19.10 (CP 19.10)** shows a scene that was shot with an infrared filter. **Figure 19.11 (CP 19.11)** shows the same scene without a filter.

If you are interested in taking digital infrared photos, read Technique 46 to learn how to determine whether you can use your digital camera for shooting digital infrared. Technique 46 also offers lots of other useful information about digital infrared photography.

STEP 5: PURCHASE FILTER ADAPTORS IF THEY ARE NEEDED

If you decide to purchase a filter, you may also need a filter adaptor. **Figure 19.12** shows a variety of adaptors. Filter adaptors allow you to attach a filter to a camera when they don't have the same thread sizes. For example, if your digital camera has 28mm threads and you want to use a filter that has 37mm threads, you can buy a step-up adaptor to attach the filter. Some of the most common thread sizes are

19.10 (CP 19.10) *© 2002 Chris Maher*

19.11 (CP 19.11) *© 2002 Chris Maher*

37mm and 52mm. If you have more than one digital camera, you can often use the same filters on cameras with different thread sizes by purchasing an adaptor.

What do you do if your camera doesn't have threads? Some digital cameras, such as the Nikon CoolPix 5700, do not have filter threads on the front of the lens. To be able to use third-party filters, you need to purchase a third-party filter adapter made for "threadless" cameras, or you can try using gaffers tape or electrical tape — either will work. To learn more about filters and adaptors, visit `http://bermangraphics.com/gallerydigicam.htm`.

19.12

> **WARNING**
>
> Many filters can cause *vignetting,* a darkening of the corners caused by the rim of the filter blocking the lens's angle of view. If you use more than one filter at a time (generally not recommended), vignetting can be a real problem. To avoid vignetting, use a step-up adaptor so that you can use a larger filter.

CHOOSING PHOTOGRAPHIC LIGHTS

20.1 *Original image* © 2002 Gregory Georges

20.2 (CP 20.2) *Edited image* © 2002 Gregory Georges

Without the right quality of light, taking a good picture is hard. Although you can have too much light, the most common problems are that you have too little light, the wrong quality of light, or you need to be able to shoot in an environment where you can have complete control over the light. In each of these cases, you need to choose some kind of photographic lights and light modifiers to get the photos you want. If you routinely use a digital camera to shoot photos for products to sell, like the computer monitor stand shown in **Figure 20.2 (CP 20.2)**, or you have a passion for shooting still life, or you want to be able to shoot better portraits in a controlled-light environment, this technique can help you get started using photographic lights.

DIFFERENT TYPES OF PHOTOGRAPHIC LIGHTS

Before looking at why you would want to choose one type of light over another, first take a quick look at a few different types of photographic lights:

■ **Built-in camera flash:** Many compact digital cameras have a built-in flash. Although built-in flashes are simple to use and convenient, they rarely produce light that flatters the subject. Built-in flashes are mostly used for "snapshot" photos. It provides harsh, flat light that can wash out your subjects, produce strong black shadows behind your subjects, and cause red-eye if you photograph people.

■ **Hot shoe–mounted camera flash:** Some compact digital cameras have a *hot shoe*, a place for mounting an "accessory" flash unit made by the camera vendor or a third-party vendor such as Vivitar, Sunpak, or Metz. **Figure 20.3 (CP 20.3)** shows a Canon Speedlite 550EX mounted on a hot shoe on a Canon Powershot G2. These larger flash units not only produce more light with more control, but they often can also be directed at a ceiling to give a softer "bounced" light. Another benefit is they won't drain your camera's batteries, because they have their own source of power.

■ **Hot shoe camera flash located "off camera" on a light stand:** If you have a hot shoe flash like one of the Canon Speedlites, you can either mount it on the camera's hot shoe, or you can mount it on a stand "off the camera." To fire an off-camera flash, you need to use a connector cord called a *sync cord*. Or you can fire the flash wireless via a control unit that is attached to the camera, which helps to avoid having to worry about tripping over a wire. Taking the flash unit off the camera entirely gives you the chance to use even more effective light modifiers such as umbrellas, which spread soft directional light across your subject, as shown in **Figure 20.4**. The flash unit has been attached to a standard tripod using the Bogen umbrella swivel adapter.

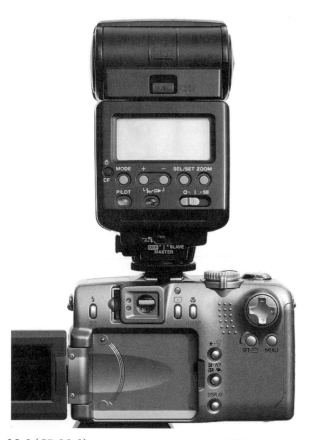

20.3 (CP 20.3) © 2002 Gregory Georges

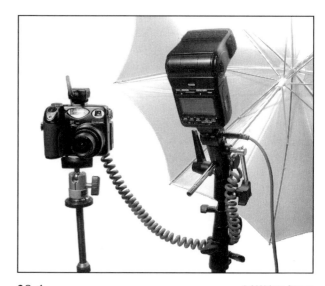

20.4 © 2002 Larry Berman

Unfortunately, there are lots of "gotchas" when you begin using a third-party vendor's flash with another vendor's digital camera. Sticking with the same vendor is usually best (and more expensive). Canon offers a wide range of flash equipment, and so does Nikon for their respective cameras. The best part of using either of these vendor's products is that they also work with many of their film cameras and their newer digital SLR cameras, so your investment is protected if you later move up to a digital SLR (same brand) or want to use the flash on a film camera (same brand), too.

■ **Off-camera slave flash triggered by flash:** Besides hot shoe–style flash units, you can find some very fun and exceedingly useful flash units, like those made by The Morris Company. The Morris Mini Slave Flash Plus, shown at the right in **Figure 20.5**, is a small compact flash that contains its own batteries and can be fired either by your camera's hot shoe or it can be fired remotely by sensing the light from another flash. **Figure 20.5** also shows the Maxi Slave Flash (on the left), which has more power and two power levels as well as a detachable wide-angle adapter. **Figure 20.6** shows the Morris Universal Infrared Sender mounted on a Canon G2. This infrared unit can also be used to trigger the Mini and Maxi Slave Flash. These inexpensive Morris lights are wonderful supplemental lights to use to add light to places not covered by other lights. They are especially useful for lighting up the side or back of a subject. The authors of this book find these Morris lights to be wonderfully fun and easy-to-use lights to get creative shots not normally possible with many of the other more expensive types of photographic lights.

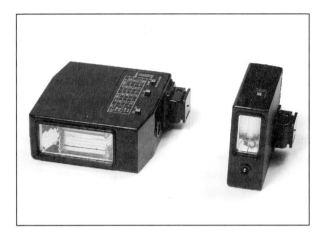

20.5 © 2002 Gregory Georges

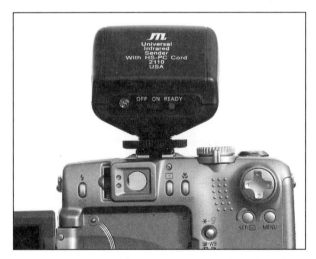

20.6 © 2002 Gregory Georges

■ **Studio strobe (flash):** If you need more light and control than you are getting from flash units that have been designed to be mounted on a camera's hot shoe, you need a studio strobe. These lights are not only more powerful lights, but they usually have modeling lights and advanced controls. A modeling light shines on your subject so you can see how the flash will light your subject when the flash fires. Modeling lights also make using your camera's auto-focus easy for you because they stay on except during the exact moment of exposure.

Many, many companies make studio flash kits. However, not many of them make them with the power and features at the prices that are offered by AlienBees (`www.alienbees.com`). The entire AlienBees line of studio strobes is affordable, and they are excellent lights. You can purchase single lights or complete kits with stands and umbrellas. Considering that some of the top-of-the-line camera flash units offered by the major camera vendors can cost more than $350, the price of an AlienBees B400 StudioFlash, a general-purpose 10-foot stand, and a 32-inch Brolly Box (shown in **Figure 20.7 (CP 20.7)**), is an exceedingly good value at just under $300. **Figure 20.8** shows the control panel on the back of the AlienBees B400 Studio Flash.

If you need two studio strobes, you can buy two B400 Studio Flash Units, two LS3050 general-purpose 10-foot stands, one U48TWB 48-inch shoot-thru umbrella, one U48SB 48-inch silver/white umbrella, and a carrying bag for $600 direct from AlienBees.

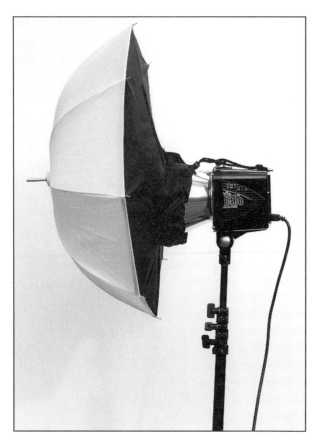

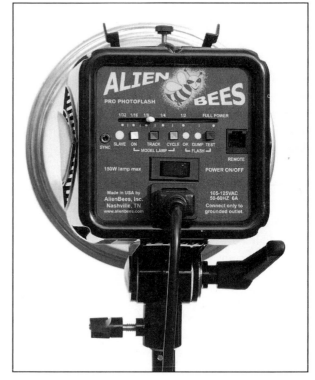

20.7 (CP 20.7) *© 2002 Gregory Georges* **20.8** *© 2002 Gregory Georges*

■ **Hot lights:** Hot lights are unlike strobes in that they are "hot" to work under because they don't flash; rather, they are continuous lights that remain on until you turn them off. Many of the powerful tungsten lights are rated at 500–600 watts. They are simple to use but they consume lots of power, while putting out lots of heat. Smith Victor lighting kits, such as the Q60-SGL, are available for about $250.

■ **Other non-photographic lights you can use:** The previously listed types of lights are all specifically designed for use as photographic lights. However, you can use lights designed for other purposes as photographic lights, too! Some of the most useful lights for shooting small items like jewelry are swing arm halogen desk lights. You can illuminate larger subjects with the quartz lights designed for construction work, which you can find at most building supply stores. The light from these lights is not as even as with true photographic lights, but by bouncing the light off walls and ceilings, a strong even light can be had for very little cost.

ARE FLASH UNITS OR HOT LIGHTS BEST?

Now you get into the process of deciding which light is best for your purpose. First, let's compare flash units with hot lights (continuous lights). Flash units put out light that has a color balance that is very close to daylight. This means that colors, especially blues, will be captured in a more accurate way than under incandescent lights. Second, they send a very short burst of light, so you don't have to worry about subject or camera motion the way you do with hot lights. Finally, they are much cooler to work under; your subjects won't feel like they are in a sauna while you shoot. The cool light also means you can use more kinds of light modifiers, like umbrellas or soft boxes, without worrying about setting your house on fire.

Hot lights have advantages, as well. First, they are generally less expensive than comparable studio strobes. This can be a big factor if you're on a budget. Second, they work with any digital camera, even those without a hot shoe or synch cord features, because no special synchronization is needed. This alone can be the deciding factor, unless you're planning to buy a new camera soon! Finally, if you shoot any video, you can easily use your hot lights to light up your movie scenes, something that flash units can't do.

WHAT IS THE DIFFERENCE BETWEEN A STUDIO STROBE AND A FLASH UNIT?

Why would you choose a studio strobe over a flash unit or vice versa? Studio units have modeling lights, which are a decided advantage in those cases where you want to be able to "preview" the light or to avoid turning lights on and off while you work. Modeling lights automatically turn off when the actual strobe fires so they will not affect your photograph. This makes setting up and adjusting your lights before you take your first shot much easier. Without modeling lights you would have to shoot multiple tests and review them on your LCD monitor before you would know what to expect from your flash units. Some studio units also put out much more light than standard camera flash units, and they use regular household current, not expensive batteries as a power supply.

So which type of light is best for you? Read on to decide for yourself.

STEP 1: THINK ABOUT YOUR SUBJECTS

If you primarily take people pictures, strobes are the best way to go. Not only are they more comfortable to work under, but their quick bursts of light prevent any blurring if your subjects move while you shoot. If you shoot still life or product shots, either incandescent lights or strobes can do a good job. If color is critical, studio flash units will yield truer colors.

STEP 2: CHECK TO SEE WHETHER YOUR CAMERA CAN WORK WITH EXTERNAL STROBES

This step is critical, because some digital cameras just can't be used with external flash units. Sometimes a workaround exists, like using the on-camera flash to trigger slave units, but other times there just is no practical way to make it work. Read your camera manual to learn more about any flash synch features your camera may have. If your camera has a hot shoe, you can use an adaptor to connect it to a studio flash unit. The Wein Safe Sync (`www.saundersphoto.com/html/wein.htm`) is an adaptor that both connects your flash to your camera, and protects your camera from potential damage from the flash unit's trigger voltage.

STEP 3: CONSIDER YOUR BUDGET

Not too many years ago, a good set of studio strobes would have been prohibitively expensive. Now, the same advances that are driving down costs and making digital cameras better and cheaper are also bringing down the costs of high-quality studio flash units. One-piece strobe lights, like the AlienBees units (also called mono lights), have the power supply and flash tube in the same package and are remarkably affordable. They are available as part of an inexpensive kit, with quality light stands and umbrellas. Of course, *inexpensive* is a relative term. Professional units with separate power packs and flash heads cost many thousands of dollars. You can purchase a starter kit of two AlienBees flash units, umbrellas, and stands for under $600.

Traditional tungsten halogen lighting kits like the Smith Victor Q60-SGL are available for about $250. These consist of a pair of 600-watt lights with barn doors and light stands. Umbrellas, soft boxes, and other light-control devices are extra.

STEP 4: DECIDE BETWEEN STROBE OR HOT LIGHTS

If your evaluation of your digital camera in Step 2 showed your camera to be incapable of synchronizing with external flash units, your decision is an easy one. Incandescent lights will work with your camera, whereas external flash units won't. Of course, if you have been thinking of buying a new digital camera, this could be an additional motivating factor to get one sooner rather than later. But assuming you're happy with the quality of the images you're getting from your digital camera, it's time to go shopping for hot lights.

If your camera can synchronize with strobes, you can choose from several options. Of course, hot lights are still a possibility. They are simpler to work with, and can cost less than studio strobes. You also can work with a pair of hot shoe flash units, mounting them on light stands and pointing them into umbrellas. This option is attractive if you already have one or more hot shoe flash units or you plan on buying them for other purposes. The primary downside to these flash units is the lack of modeling lights, which will make it difficult to see the effect of the lighting without shooting test shots. If you're really serious about shooting indoor pictures, and you have the budget, buy some studio strobes like those offered by AlienBees.

STEP 5: SHOP FOR LIGHTS AND ACCESSORIES

When you've decided what to buy, you should visit a local "pro" camera store if one is nearby. Otherwise, you can get good advice and reasonable prices from a large mail-order dealer like B&H Photo Video in New York (`www.bhphotovideo.com`) or Calumet Photographic (`www.calumetphoto.com`) in Chicago.

> **WARNING**
>
> Cameras trigger flash units by momentarily completing an electric circuit. Check to see what the limit of this "trigger voltage" should be before connecting any external flash units. Exceeding the rated voltage could damage your camera's internal circuits. If you're not sure, or if your flash units exceed the camera's rating, you can use a "safe sync" type module, such as the Wein Safe Sync, to keep the higher voltage from hurting your equipment.

You need at least two lights for most studio type pictures. A third light gives you added flexibility, but you can add more lights later if budget is a consideration. In addition to the lights themselves, you need light stands, and light modifiers such as umbrellas. If you are buying strobes, you also need synch cables and an adaptor to match them up with your camera. Some flash units come with cables, others do not. Check when you order, and ask about the connectors on the cables. You may also need an adaptor for your camera so that you can connect it to the synch cables. Without these important parts, you won't be able to use your lights when they are delivered.

Studio strobes, like those from AlienBees, have a built-in "slave" sensor, which fires the flash when any other flash unit is triggered. This means you only have to connect one light to your camera; the others will automatically trip when the connected one fires. If you're working with a pair of regular flash units, you will have to connect them all together. For example, Nikon CoolPix cameras without a hot shoe use Nikon SC-18 and SC-19 flash cables, and they connect directly to the Nikon flash units. But they need the Nikon AS-10 hot shoe adaptor to mount the flash on a light stand or tripod. Nikon CoolPix cameras that do have a hot shoe use the Nikon SC-17 cord to connect to a Nikon flash unit off camera.

LIGHT MODIFIERS

If you use a flash unit like one of the Canon SpeedLites or Nikon SB lights, you may want to consider getting either a Sto-Fen Omni Bounce (`www.stofen.com`), shown in **Figure 20.9**, or a LumiQuest Pocket Bouncer (`www.lumiquest.com`), shown in **Figure 20.10**, for about $20. You can use these products to soften, enlarge, or redirect light from flash units with a minimum of light loss.

BACKDROP CLOTH

One last accessory you're likely to want to consider purchasing is a black drape. You can use black drapes to black-out light coming from a window or doorway,

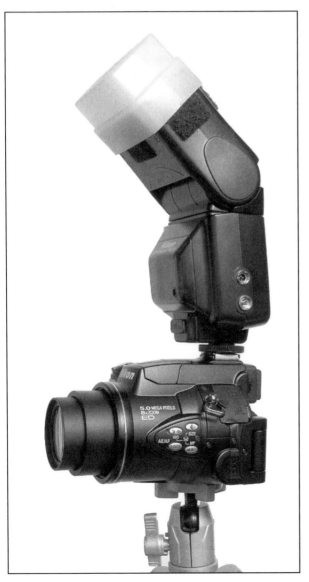

20.9 © 2002 Larry Berman

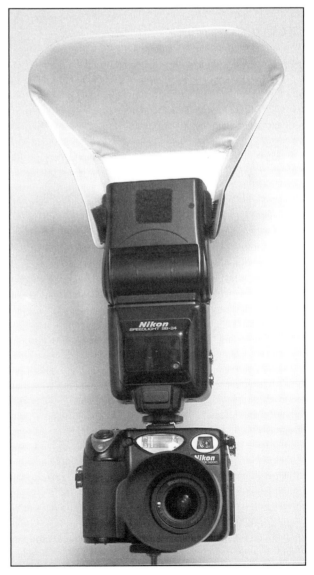

20.10 © 2002 Larry Berman

or use them as a background for your subjects. Although purchasing a variety of black cloth from a local fabric store is possible, some companies offer select materials specifically for use as black-out cloth or as backdrops. One such company is Backdrop Outlet (`www.backdropoutlet.com`) in Chicago. They offer an 8 foot x 16 foot Economy Black Solid Color cloth for $70. They also have a very good 10 foot x 21 foot Black Out Cloth for $170, and a Super Soft Black for $140. The more expensive Black Out Cloth is a richer black and is a good choice if your budget allows the extra expense. You'll also need to buy some wide tape to remove lint and pet fur if a pet is nearby because these cloths are lint and hair magnets!

Good studio lighting techniques take time to learn. Fortunately, your digital camera will allow you to quickly experiment with very little cost other than your time. Review your photos constantly, and you soon will get a feel for the way each light affects your subject. As you will be in complete control of your subject and the light that falls upon it — you will learn a lot quickly! When you get results you like, take notes so you can reproduce the quality of light when you need to shoot a similar subject. Make a little sketch of light placements, including distance measurements.

Granted, this is nearly a "too quick" overview of photographic lights, but it is sufficient to help you get started, and you will quickly learn whatever else you need to know as you go. In the next chapter, you find out how to take people pictures with and without photographic lights.

5

TAKING PEOPLE PICTURES

© 2002 Larry Berman

A very high percentage of all photos taken are people photos. In this chapter you find seven techniques that will help you to take better people photos. In Technique 21, you learn how to take portraits for business use. Taking good snapshot photos of kids is the topic of Technique 22. Techniques 23 and 24 show you how to take a family portrait in existing light and photos of friends having fun. If you like "window-lit" portraits, then you'll enjoy Technique 25, as you will learn how to use just the light from a window to light your subject. Technique 26 shows you how to shoot silhouettes, and Technique 27 covers the topic of getting sports action photos. If you like to shoot people pictures, you'll enjoy this chapter.

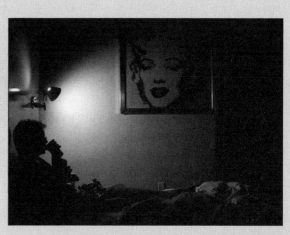

© 2002 Larry Berman

© 2002 Larry Berman

TAKING A PORTRAIT FOR A BROCHURE

21.1 *Original image* © *2002 Larry Berman*

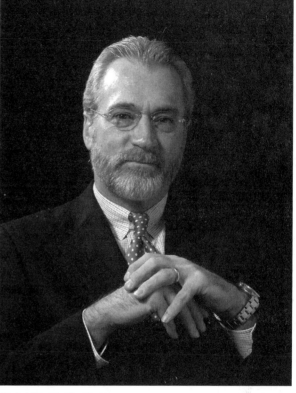

21.2 (CP 21.2) *Edited image* © *2002 Larry Berman*

"Financial Advisor Portrait"
Nikon CoolPix 5000 on tripod, zoom lens set to 74mm (35mm equivalent), f/7 @ 1/1000, ISO 100, 2,560 x 1,920 pixels, 1.3MB .jpg

There may be a time when you will want to shoot a formal portrait that can be used on a Web site or for a company brochure. The keys to getting good results are control of the lighting and a friendly, engaging manner with your subject. You won't need a lot of equipment to take a professional quality portrait like the one shown in **Figure 21.2 (CP 21.2)**, which was taken with a simple two light setup. The purpose of the shot was to produce a black and white portrait for a company brochure.

STEP 1: PLAN THE SHOT

Begin by communicating with your subject. Learn exactly what is expected from the portrait session, and how the pictures you shoot will be used. Next, find out about the setting that you will be shooting in ahead of time. This will guide you in your choice of lights and background materials. The photograph you see here was made in a conference room because the office that we had originally planned to shoot in was too small for our lighting setup. Finally, arrange ahead of time the kind of clothing the subject will wear. It's best if they avoid pure white or black; very light or dark clothing can make lighting much more difficult.

STEP 2: SET UP THE LIGHTS AND BACKGROUND

In addition to your camera, you will need some lighting equipment. This can be as simple as a couple of off-camera flash units with umbrellas, or a couple of tungsten lights. If you are unsure about what kind of lights would be best for your needs, read Technique 20. In addition to the lights, you will also need a tripod and a background cloth.

If you are shooting a busy executive, you may want to have someone else stand in while you adjust your lights and test your initial exposures. As shown in **Figure 21.3**, set your main light at a 45-degree angle, and bounce it into a white umbrella. Set a second light up behind and to one side of your subject. This light will give your subject some definition against a dark background. Use a fill card on the opposite side

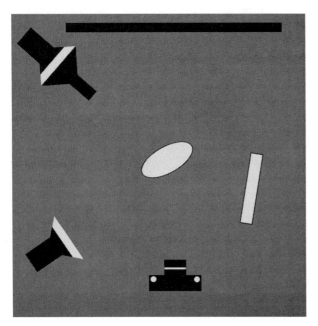

21.3 © *2002 Larry Berman*

> **TIP**
>
> Understand that no matter how technically good your photographs can be, the chemistry between the photographer and the subjects is more important. The best people photographs capture the essence of the person. Whether it be the interaction between a family, or a group of friends, or just a simple portrait by window light, it's the magic of the moment that can make a photograph good or just ordinary. Proper camera technique and lighting come second. Understanding that can help you take better people photographs.

of the main light to balance the light on the subjects face but keep the ratio of light between the main source and the fill uneven for a more interesting portrait. If the background is distracting, hang a black cloth several feet behind where the subject will sit. Test your exposures, adjust the power output of your strobes, and shoot a few frames.

STEP 3: ADJUST YOUR CAMERA

If you are using flash units, you will need to set up your camera to synchronize with them. For the portrait shown in **Figure 21.2**, we decided to work with both the flash and camera on manual, letting the photographer make all the exposure decisions. Switch your flash units to manual mode and turn off your internal flash. Choose a fast shutter speed to minimize any effect of ambient (room) light, and adjust your aperture to give a good exposure. This will be a function of the amount of light your flash units put out; reviewing a few test shots should show you the correct exposure. Be sure to set your color balance to match the electronic flash.

If you are using incandescent (hot) lights, adjust your color balance to match those lights. Set your camera to aperture priority mode, and choose a starting f-stop one stop down from wide open.

If your camera has a portrait mode, you should experiment with that too. If your camera allows you to alter the degree of sharpening, use the normal or soft mode.

STEP 4: POSE THE SUBJECT

Engage your subject in a conversation as you work. Evaluate the person's look, and compensate with your lights and the camera angle you choose. For example, if a person has a very thin face, have them look straight into the camera, while if they have a round face, try a 3/4 pose, and lift your camera angle a bit. If they have a lot of wrinkles, use softer wrapping light by bringing your umbrella closer. A large nose can be minimized by having it face directly into the camera with the chin raised slightly. A small nose can be given more emphasis with a side view. Watch out for reflections on eyeglasses, have them turned away from the lights, or raise your lights until the reflection goes away.

STEP 5: TAKE THE PHOTOGRAPH

Be sure the focus is sharpest on the eyes. That's the first place people look when examining a portrait. If your camera lets you zoom in when you are in review or play back mode, you can use that feature to check for sharp catch lights in the eyes. Catch lights are reflections of the light source that give life to the person's eyes and make the portrait look natural. If you can think of any humorous stories, share them as a natural smile can add warmth to a formal portrait. Review your images as you work, and make sure you have good expressions as well as good exposures before you end the session.

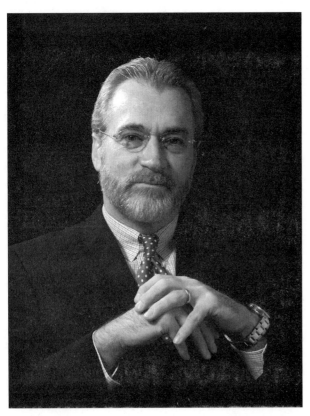

21.4 (CP 21.4) © *2002 Larry Berman*

STEP 6: CONVERT COLOR PHOTO TO BLACK AND WHITE

Once you have the photos you want and have downloaded them to your computer, use an image editor like Adobe Photoshop 7 or Adobe Photoshop Elements 2.0 to convert the color images to black and white images. **Figure 21.4 (CP 21.4)** shows the result of converting the photo in **Figure 21.2** to a black and white photo.

TAKING GREAT KID PHOTOS

22.1 *Original image* © 2002 Larry Berman

22.2 *Edited image* © 2002 Larry Berman

Watching kids is a great source of wonder. They grow up so fast! Pictures are the best way to capture each moment of their development, and they give you something to treasure forever. And good photos give you the chance to share those moments with family and friends, no matter where in the world they are. The interaction of siblings, like those in **Figure 22.2**, can also make for a wonderful family picture to hang in the family room. Great kid pictures can happen at any time, so try to always be prepared.

DIFFERENT AGES, DIFFERENT APPROACHES

Every age is a great age to shoot kids. When they are young you can use squeaky toys and play peek-a-boo to elicit great expressions; as they get a bit older, playing dress up or acting out movie roles can be fun. Photographing kids playing with their friends works well at almost any age. Photographing them engaged in activities, like sports, as in Technique 27, can capture lasting memories.

22.3 (CP 22.3) © 2002 Larry Berman

22.4 (CP 22.4) © 2002 Larry Berman

WORKING WITH PROPS

Toys are a big part of a child's life, and taking a picture of a kid on a bike or with a favorite doll is a good way to relax and involve the young one in the fun of photography. Most boys at any age are drawn to sports equipment, even when they're not dressed for it, as seen in **Figure 22.3 (CP 22.3)**. Even an obscure prop like a magnifying glass can hold a child's interest and make for an interesting photograph like in **Figure 22.4 (CP 22.4)**.

STEP 1: DECIDE WHAT KIND OF PHOTO(S) YOU WANT

■ Begin by thinking about the opportunities that are available to you. Kids are constantly changing, and so are your picture possibilities. You will never run out of inspiration when you photograph kids! You can shoot pictures of kids when they are sleeping peacefully, or howling because something didn't go the way they expected. You can ask them to pose for you, or just watch while kids play with each other and quietly shoot them from a distance. Each of these approaches gives you a different kind of shot.

STEP 2: CHOOSE A TIME AND PLACE TO SHOOT

■ Select a time of day when the light will show your subjects to good advantage. Outdoors, that will probably mean mornings or later in the afternoon, when the sun is lower on the horizon. The light for indoor shots varies quite a bit from room to room, depending on the window light. Of course, you can choose to shoot with a flash, but that will make getting candid shots very difficult.

Think about the setting for your shot. A picture of a child in a messy bedroom may seem to show a side of family life you would rather do without,

but think about how much fun it would be to look back and share the picture with that same child in 15 to 20 years!

STEP 3: KIDS AND THEIR CLOTHES

■ Choose outfits that are appropriate to the kind of activities you will be shooting. Avoid white; it can be very difficult to photograph well (and tough to keep clean!). Your choice of clothes will be influenced by what you decide in Steps 1 and 2. Bright colors can really work on an overcast day, while softer pastels can be more effective in sunlight. You may have difficulty convincing teenagers to dress as you want, but they may become motivated if you offer to provide a digital file of the best shots, so they can e-mail the photograph to friends.

STEP 4: GET PREPARED TO SHOOT

■ Check that your lens is clean and your batteries are fresh. If you are shooting in low light, a tripod

TIP

Today's digital cameras are so simple to use on full automatic that kids can become photographers as soon as you point out where the shutter release is. You may be amazed at what a wonderful view you have of the child's day if you send a camera along with them to school. The pictures they will bring home of friends and teachers can bring you into the world that they spend a great amount of young life in. Of course, the kids should be old enough to hold on to the camera and know not to drop it or bang it around. You might even consider buying an inexpensive digital camera for your child.

can help, but usually kids move around so much that a hand-held camera will give you more spontaneous results. Take a few test shots, just to be sure all is working well.

STEP 5: SET UP THE CAMERA AND CHOOSE SETTINGS

■ Switch into your camera's menu mode, and set up your camera for the pictures you have planned. If you plan to shoot without drawing attention to yourself, then turning off any sound effects is a good idea. This goes doubly for flash; if you can avoid using your camera's flash, you will get much more natural pictures. If you don't have much light to work with, try raising the ISO speed. This gives you faster shutter speeds, although it does so at the cost of some increased "digital noise." You may need to experiment to see what works best.

STEP 6: COMPOSE AND TAKE PHOTOS

■ Anticipate and be ready! Kids are most enthralled when something interesting or exciting first happens. They can become distracted easily or even bored as time progresses. At an amusement park, for example, the first 15 seconds of a ride sparks wonderful looks of joy, but as the moments slip by, the young riders become more serious. So be ready! Plan your shots ahead of time, and shoot quickly, taking full advantage of the wonderment that comes with new experiences.

Sometimes being just outside the group, looking in from a distance, is best. Long zoom lenses or supplemental telephoto lenses let you capture intimate close-ups of the kids being themselves, lessening the chance they will feel like they are on stage. Close-up shots of the wonder on a child's face preserve a memory for a lifetime. Long lenses have another advantage — they can easily eliminate

cluttered backgrounds and focus attention on your subject.

When taking photos of babies and really young children, have someone else help with the job of entertaining the child. They can also help by distracting the child from you and your camera. Squeaky toys and bright objects can capture a look of focused attention that may be difficult to achieve otherwise. The mother of a very young child is often the helper of choice, but sometimes that closeness can actually be a disadvantage. Be flexible and willing to experiment. Also, try to avoid shooting around naptime; things can get ugly in a hurry with a tired little one.

STEP 7: REVIEW AND CONFIRM YOU HAVE WHAT YOU WANT

■ Check your LCD monitor as you shoot, making sure you caught the expression you were hoping for. Digital cameras can be slow on the shutter release; if you miss a shot, take two more! Your camera may pre-focus if you partly squeeze the shutter release, which can cut the time it takes to release the shutter for your next shot.

SHOOTING A FAMILY PORTRAIT
IN EXISTING LIGHT

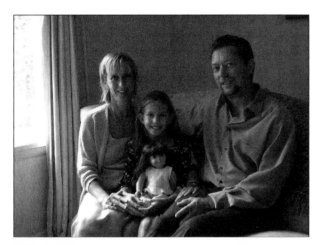

23.1 *Original image* © 2002 Larry Berman

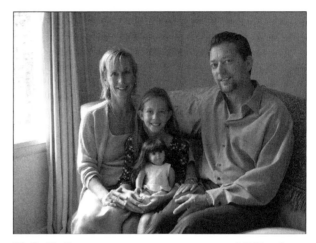

23.2 *Edited image* © 2002 Larry Berman

One of the most treasured family possessions is a good family portrait. Aren't you overdue to have one done now? You can certainly find plenty of portrait photographers around to take your money and give you quality photographs. With their expensive settings, backdrops, flash equipment, and "pro" camera gear, they most certainly can take "technically" better photos than you if you are shooting with a consumer-level digital camera in your own home — *but* — never underestimate the quality of family portraits you can get! Take a close look at the photo in **Figure 23.2**. Don't take this challenge as a substitute for professionally taken family photos. Just try taking a few and you may find that you can have more family portraits more often, and that is good!

In the next seven steps, you learn how the photo shown in **Figure 23.2** was taken. Seven steps may seem like a lot, but you have probably not shot thousands of family portraits in a familiar setting like most professional photographers. Hopefully, these steps will help you to quickly gain the experience to shoot like a pro.

WHAT CAMERA GEAR DO YOU NEED?

The camera gear you need is dictated by your expectations and by the size of image you want. Chances are that the new digital camera you just got is at least a 3.3 megapixel camera, which is more than enough resolution for an 8 × 10-inch print.

If you want a good family portrait, you definitely want to use a tripod. Without one, you will more than likely have camera movement and be frustrated in not having any sharp photographs to print. That's it — your digital camera and a tripod are all that you need to take great family portraits in existing light. To learn more about shooting people with a flash, see Technique 21.

If you have teenage kids who are not happy about being photographed, try getting someone else to take the shots for you. Just having another non-family member in the room is likely to minimize the "messing about" that can occur.

STEP 1: CHOOSE A TIME AND PLACE TO SHOOT

■ Choose a setting for its ambiance and the quality of light that illuminates it. The light will vary throughout the day, so choose a time when it will be at its best. In the example shown earlier, the best light comes in through the living room in the morning, so a morning shoot was scheduled. Fortunately, it turned out to be a rainy day, which diffused the light coming in the window. If it had been a sunny day, covering the window with some sheer fabric to diffuse the light might have been necessary. Avoid locations that have uneven or excessively high contrast light, like direct sun outdoors.

STEP 2: GET THE FAMILY DRESSED FOR A PHOTO

■ Use the information you've learned in earlier techniques to help the family choose what to wear.

Keep in mind the problems that can occur when you shoot a photo of a subject that is white when it is bathed in bright light. You also learned about other conditions that make it hard to get a sharply focused or well-exposed photo. All that information can now be used to help choose what the family should wear. The best colors for the family members to wear are not only ones that go with the room or with their face tones, but also (and more importantly) ones that coordinate with each other. Originally the father put on a white shirt, but I asked him to change to a blue shirt for two reasons: to match the outfits his wife and daughter were wearing, and to avoid anything that wouldn't hold detail in the window light.

STEP 3: GET PREPARED TO SHOOT

■ As much as you can, try to get your camera's settings ready by practicing on whoever is ready first. Because the father was dressed quickly, he was used to check camera settings and lighting, and therefore not waste the family's valuable time and energy. You must respect the time and effort that it takes for your subjects to sit and pose comfortably. Too long a time will cause them to start fidgeting, so being prepared and ready to shoot is a great advantage.

TIP

When selecting camera settings for portrait photography, be sure to lengthen the amount of time it takes for the camera to shut itself off, because you might miss the decisive moment if the camera goes to sleep and has to be turned back on to take a shot.

STEP 4: LOCATE CAMERA

■ Decide where to put the camera. The placement of the camera defines the relationship between you, the photographer, and your subjects and whatever else will be visible in the photograph. The wider the zoom setting, the more of the room will be in the picture and the more depth-of-field you'll have. I chose a placement of about six feet from the subjects with a zoom setting of approximately a 40mm lens (35mm equivalent), as shown in **Figure 23.3**.

I chose to set the camera on the tripod horizontally (landscape) knowing that I would still have enough resolution to crop vertically (portrait) if I wanted to after reviewing the photographs. In the end, I did choose to rotate and crop the picture of the mother and daughter for better composition, as shown in **Figure 23.4**.

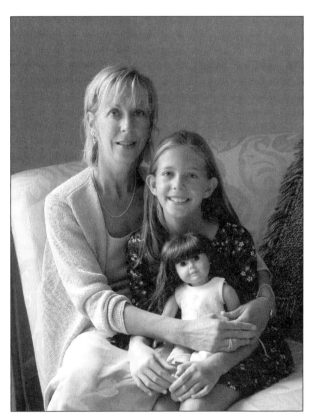

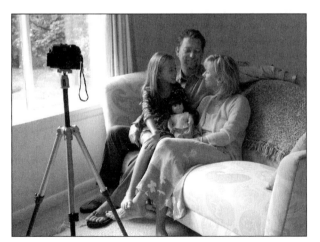

23.3 © 2002 Larry Berman

23.4 © 2002 Larry Berman

STEP 5: CHOOSE CAMERA SETTINGS

■ If you're not already using it, set your camera on the lowest ISO setting it has. Using this setting ensures the least amount of digital noise. Also, set your camera on the highest-quality image file possible. Using these two settings, you'll be able to capture the best quality portrait possible.

Unless you have a specific idea on how to choose your settings, shoot the first few test frames in your default camera setting and then make setting modifications after reviewing the test. The test of the father from Step 3 was shot in program mode. Those photos came out perfect, so I stayed with those settings. Checking the EXIF data told me that my settings were 1/4 second at f-stop 3.2. Using a tripod to support the camera eliminated my worry of camera movement. And my subjects' willingness to pose eased my mind about subject movement. As it goes, everything worked out in the end. Even though my settings might be construed by some to be non-conducive for shooting a family portrait, the end result was three good photographs worthy of being displayed on the family picture wall.

TIP

To shoot to get a "best quality" image, set your camera to ISO 100 and the highest-quality jpeg setting. Also, set your camera to single-shot auto-focus, which may reduce the time and effort the camera will take to hunt for focus between pictures. These three settings, along with disabling the built-in flash, can be used for basic everyday settings as they are a good starting point when entering into most photographic situations.

TIP

If you choose to use available light for your portrait, the in-camera flash may need to be disabled. See Technique 21 to learn more about shooting people with a flash.

WARNING

You shouldn't use a "best shot selector" mode for portraits as it might throw away the best facial expressions when it deletes all but the sharpest image.

STEP 6: COMPOSE AND SHOOT PHOTOS

■ Now that you've made decisions about camera placement and settings, subject placement, and colors, it's time to shoot. Because the camera is set up on a tripod, you can pay careful attention to the chemistry, body language, and facial expressions of your subjects. Shoot and shoot some more. The more pictures you take, the better your chances of getting a winning portrait. For the three pictures you've seen as the examples for this technique, I took about 60 photographs.

If it's your family and you are supposed to be in the photo, consider either getting someone else to trip the shutter, or using the camera's self-timer to make the exposure. Some cameras, such as the Nikon CoolPix 5000 series, actually allow you to pivot the LCD screen so it can be seen from the front of the camera. A feature like this can be very helpful when you want to be in the shot. You will lose a bit of control by not standing behind the

camera, and the timing may not be quite as you would like, but a quick review of the image on the LCD monitor should show you and your subjects just how good everybody looks.

STEP 7: REVIEW AND CONFIRM THAT THE PHOTOS ARE GOOD

■ Take advantage of your camera's capability to display a photo on an LCD monitor. After you've taken a few photos, show them to your subjects. After you have taken enough to be fairly sure you have some everyone will like, have everyone take a break while you download them to your computer. After they've been downloaded, show them to your subjects again and make sure they are happy with one or more of them.

> **TIP**
>
> Be prepared to do good work at the beginning of the shoot as the subjects are fresh and into it. You can take some of the best pictures then. Also watch for moments of spontaneous inter-action, as shown in **Figure 23.5**, because it can make for wonderful natural portraits.

> **TIP**
>
> During the review phase is when you learn how important taking lots of photos is when you shoot more than just one person. It can be rather humorous when you find twenty almost perfect photos, but not a single one where every person was smiling or was not caught during an eye blink.

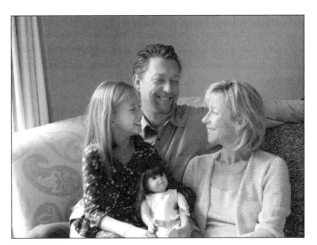

23.5 © 2002 Larry Berman

TAKING SNAPSHOT PHOTOS OF FRIENDS

24.1 *Original image* © 2002 Larry Berman

24.2 *Edited image* © 2002 Larry Berman

"Hair Day" Nikon CoolPix 990, hand-held, zoom set to 38mm (35mm equivalent), f/3.1 @ 1/81, ISO 100, 2,048 x 1,536 pixels, 1.1MB .jpg

Friends are fun to be around. You can relax, be who you are, and share your feelings, knowing your thoughts are understood and appreciated. And anytime friends meet, picture-making opportunities will happen. In **Figure 24.2,** you can see how the girls totally ignored the camera. People who are relaxing and having fun in a comfortable environment have natural smiles on their faces, not just the kind that are put on for the camera. Having good pictures of your friends helps those feelings last, and lets you show them how much you appreciate them, too.

WHAT KIND OF CAMERA IS BEST FOR SHOOTING FRIENDS?

Why, the one you have, of course! While that is true, this is an application where small "shirt pocket" cameras really shine. You can have it with you all the time, and pull it out whenever a photo opportunity presents itself. If your camera is a bit too big for your shirt pocket, perhaps you can get a small nylon belt pouch for it. Don't use flash if you can help it. That can be too attention getting, and spoil the relaxed atmosphere.

WHEN IS IT MOST APPROPRIATE TO TAKE SHOTS OF FRIENDS?

Anytime you are having fun is a great time to shoot. That can be while you are going to a concert, or just sitting around a table in your friend's kitchen. And if your friends see you taking pictures all the time they will be less likely to put on a special face for you when you point the camera at them. Sharing what you just captured by showing a quick preview on the viewfinder makes it fun for everyone.

GET IN THE PICTURE

Here's where you get to join in the fun. You can use your camera's self-timer and a small table-top tripod to join your friends on the other side of the lens. If you don't have a little tripod, look around for a few books you can prop your camera against and take a quick test shot to check the composition. You don't want your friends to think that you're unwilling to be part of the scene, do you? And having you in the pictures makes your shots that much more of a record of your friendships.

STEP 1: DECIDE WHAT KIND OF PHOTO(S) YOU WANT

- Think of all the chances you have to photograph your friends! When you meet after work to relax, you can grab shots of your friends in their work-day clothes. If you're going out on the town, you can take some great fashion shots. Think about the next chance you will have to be with the people you care for, and plan some pictures.

STEP 2: CHOOSE TIME AND PLACE TO SHOOT

- Look around and really notice the kind of light that is illuminating your friends. Look at the shadows, and notice the background behind people. If you get in the habit of noticing those details, you will be that much more prepared when you want to grab a shot or two. You can even suggest that your friends move closer to a window, or sit a bit differently if you feel it might make a difference.

STEP 3: GET PREPARED TO SHOOT

- Casually take some test shots and check the light quality on your LCD monitor; it may suggest a new perspective or different angle to take advantage of the kind of light that you have to work with.

STEP 4: SET UP THE CAMERA AND CHOOSE SETTINGS

■ Switch into your menu mode, and choose a center-weighted metering. If there is much backlight from windows, you may need to use exposure compensation to adjust. Don't use a passive image stabilization mode like Nikon's "best-shot selector;" it just shoots several shots in a row and throws all but the sharpest out, possibly causing you to miss the best expression. If you're in a low-light situation, zoom out to the widest focal length, use the aperture priority mode, and set your lens wide open. These settings allow your camera to use the highest shutter speed it can for the light available. You might even experiment with fill flash, such as in the photo in **Figure 24.3.**

STEP 5: COMPOSE AND TAKE PHOTOS

■ Compose your shot vertically if you are shooting individuals or couples. For groups and for shots that show a lot of the surroundings, use a horizontal composition.

24.3 © 2002 Larry Berman

A quick group shot is somewhere between a spontaneous shot and a formal picture. People stop what they are doing, perhaps put their arms around each other, and smile at the camera, waiting for you to take the picture. You can do better than just telling them to "say cheese." Try to capture them laughing, or at least genuinely happy. You should try some silly poses, or you can ask everyone to try a different expression. Be ready to grab shots as people are interacting with each other; don't just wait for folks to hold still.

Remember that the place that the picture was taken will be increasingly important as time goes by, and the little thing like the table lamp or the couch that is in the picture will bring back memories many years hence. Look for a balanced composition, don't put the faces in the center of the picture, but remember to compose the picture using the "Rule of Thirds" you read about in Technique 7.

STEP 6: REVIEW AND CONFIRM YOU HAVE WHAT YOU WANT

■ Check your LCD monitor and review your work as you shoot. Showing friends your good shots is definitely part of the fun.

TIP

Practice with your camera till you can shoot quickly and accurately. Think of yourself as a gunslinger in the old West, and practice pulling out your camera, turning it on, and shooting things as quickly as you can. Pay attention to composition and exposure, but act as quickly as you can. Review the image you captured, then put the camera down and look for something else to shoot. Repeat this until you are fast and effective with your quick shots.

TAKING "WINDOW-LIT" PEOPLE PHOTOS

25.1 *Original image* © 2002 Larry Berman

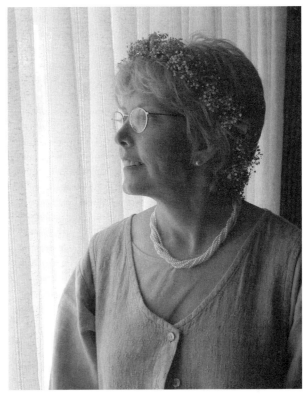

25.2 *Edited image* © 2002 Larry Berman

Shooting indoors with existing light, like in the photo shown in **Figure 25.2,** is fun and easy to do. Windows are a great source of ever-changing light, and are a natural source of illumination for people photos. You may choose to incorporate part of the window as an element in the image, or crop the window so it is not seen. This technique shows you how to take advantage of soft window light, and even explains how to modify it if you need to.

STEP 1: DECIDE WHAT KIND OF PHOTO(S) YOU WANT

■ Begin by thinking about the kind of photo you want to create. If you want a nice framed portrait of a person in formal dress, window light can provide beautiful illumination. Thinking about a casual shot? Again, window light can do a great job.

STEP 2: CHOOSE THE TIME AND PLACE TO SHOOT

■ Walk around your house and really look at the way the light affects the objects in each room. Things closer to the window are naturally brighter than those farther away, and direct sunlight has a radically different quality from the diffused light that comes from a window facing open sky. The character of the light coming in a window constantly changes as the day goes on. Artists have long appreciated the clear light that comes through north-facing windows. But in truth, variables such as the time of day, the weather, and even the time of year will make such a large difference that the best window to shoot with may change by the hour. Note what windows in your home offer light you would like to work with, and the factors that contribute to that light. This helps you plan ahead and be confident that your light will work for you when you need it.

STEP 3: GET THE SUBJECTS DRESSED APPROPRIATELY

■ Think of the goal you set in Step 1, and suggest that your subjects dress with that in mind. Choose colors that complement the surroundings by the

window you have chosen. Avoid white because holding any detail in the white fabric closest to the window light will be difficult. Black also can be a problem, as it may blend too well with shadows in the background.

STEP 4: GET PREPARED TO SHOOT

■ Choose the gear you will use to make the shot. A tripod will be really helpful here, as your exposures may be fairly long.

STEP 5: SET UP THE CAMERA AND CHOOSE SETTINGS

■ A window-lit situation is usually handled very well with the automated program modes on your camera, but check your LCD monitor and your camera's histogram to make sure. If you include any of the window or other light source in the picture, the bright window may cause your subject to be underexposed; conversely a dark background can lead to overexposure. You can adjust your exposure with your cameras exposure compensation over- and under- settings. Choose a midpoint in your zoom range, as wide angles used up close can distort facial features. If you are shooting a head shot, a moderate telephoto lens will give you pleasing results.

STEP 6: MODIFY THE LIGHT

■ If your window is not quite giving you the light you want, modify it. A couple of spring clips and a few yards of sheer material can do wonders to create both an interesting backdrop and an effective

light diffuser. A white sheet of paper or foam core board can act as a reflector to bounce light back to your subject and fill in the darker shadows. Experiment with the possibilities.

STEP 7: COMPOSE AND TAKE PHOTOS

■ Move in close enough to eliminate any distracting elements that might be in the picture. Be aware of items in the background that might draw attention away from your subject, and eliminate them by changing your angle, or physically moving them out of the shot. Shoot some test shots to check for balance, perspective, and exposure.

■ After you have the right light, the right perspective, and a pleasing setting, you need to do the most important thing — encourage your subject to relax and enjoy being photographed. Expressions are fleeting, so be sure to catch them when they first light up your subject's face. It's not unusual for some people to be uncomfortable in front of a camera, so do whatever you can to make the person relax and enjoy being photographed. Take

lots of pictures, and experiment with the light as it changes.

STEP 8: REVIEW AND CONFIRM YOU HAVE WHAT YOU WANT

■ Check your results as you shoot. Show your subject the camera's LCD review when you capture a good expression. This process often helps make a subject feel more comfortable, which in turn makes getting more good pictures easier.

TIP

You can buy sheets of 32 × 40 mat board at a local art supply store to act as large inexpensive reflectors. If you want to warm up the light, buy a gold- or warm-toned board. The back of the board will still be white, so you can use it for neutral-toned images, as well.

SHOOTING SILHOUETTES

26.1 *Original image*

© 2002 Larry Berman

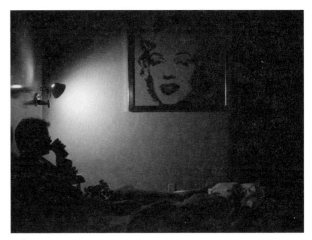

26.2 *Edited image*

© 2002 Larry Berman

Silhouettes have a long history in art. The low-tech version can be cut out of black paper; the high-tech version can be made with your digital camera. There is something anonymous and yet very defining about showing someone's profile as a shadow. The following steps show you how to get great results with the modern version of this old portrait technique, as shown in **Figure 26.2**.

STEP 1: CHOOSE THE TIME AND PLACE TO SHOOT

■ Look for a fairly bright background to contrast your subject with. It can be a uniformly lit window or a wall that is washed with an even source of illumination. A single light in a room can provide the light source for a silhouette. The trick is to not let the light spread into the foreground, or it can light up the side of the subject's face that the camera sees, spoiling the effect. In a room with white walls, preventing that kind of back scattering of light can be difficult, so you may want to choose a space that has walls or drapes that absorb light.

STEP 2: GET THE SUBJECTS DRESSED APPROPRIATELY

■ Ask your subject to dress in dark clothing. Light-colored clothes can spoil the effect as they may reflect light into the foreground, reducing the needed constrast. Even your clothes, if they are light colored, can bounce light back onto the shadow side of your subject, so you, too, need to dress dark for the best effect.

STEP 3: GET PREPARED TO SHOOT

■ Place your subject in front of a window with the room lights turned off, and position him or her so a clear profile is visible. Keep the foreground dark, perhaps by spreading out a dark cloth to absorb any backscatter. You can also try this shot at night. Turn a lamp so it shines on a white wall behind your subject, but don't let any light spill onto the ceiling or foreground.

STEP 4: SET UP THE CAMERA AND CHOOSE SETTINGS

■ Adjust the exposure to make your subject completely dark. Unlike any other shot, you want to have your camera's exposure set to read the light source, not the subject. You want to deliberately underexpose the foreground, turning it black. Also set your camera's sharpening and contrast at a higher level, which accentuates the edge between the light and the dark. Check the exposure on your LCD monitor, and if necessary, use exposure compensation or manual mode to further reduce the exposure so no detail exists on the side of the subject that faces the camera.

STEP 5: COMPOSE AND TAKE PHOTOS

■ Now ask your subject to give you a profile view and experiment with different compositions. Next ask her to move her hands into the shot, and experiment as she moves them for you. If the window has Venetian-type blinds, experiment with the strips of light and shadow you can produce by partly closing them.

STEP 6: REVIEW AND CONFIRM YOU HAVE WHAT YOU WANT

■ Check your LCD monitor and adjust your exposure if needed. You can clean up minor amounts of spill light in an image-editing program like Photoshop or Adobe Elements.

TAKING SPORTS ACTION PHOTOS

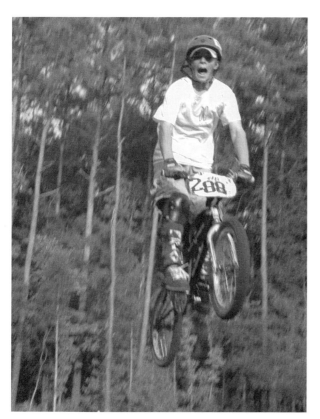

27.1 *Original image* © 2002 Gregory Georges

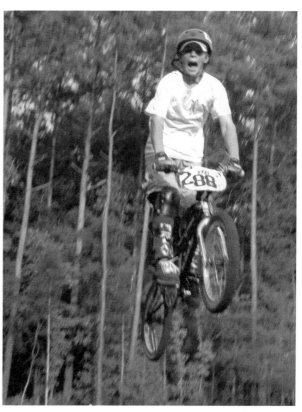

27.2 *Edited image* © 2002 Gregory Georges

ABOUT THE IMAGE

"Doing a Jump BMX Style" Nikon CoolPix 950, hand-held, zoom set to 60mm (35mm equivalent), f/5.4@ 1/94, ISO 100, 1,600 x 1,200 pixels, 780KB .jpg

The more that people are involved in sports either as a player, parent, friend, or spectator, the more they want to have or to take good sports action photos. The sad truth is that compact digital cameras are not the best type of camera to use to get good sports action photos. Does that mean you can't get them? No — but it will take some planning, skill, and lots of luck to get good ones. In this technique, you learn a few tips and tricks to help you get a few good sports action photos like the one shown in **Figure 27.2**.

STEP 1: DECIDE WHAT KIND OF PHOTOS YOU WANT

■ Before you begin shooting, decide on what kinds of photos you want. Are they to be printed out as 8 × 10-inch prints? Do you plan on printing them vertically, or is a horizontal shot okay, too? Will a Web page–sized photo be acceptable? Do you want action shots or just good player photos? Do you want a full-frame shot?

Getting a full-frame shot for an 8 × 10-inch print will certainly be challenging. However, you can easily crop an image to a Web page–sized image, and doing so allows you to make a small part of an image fill the entire image when it is displayed on a computer screen.

The best sports action photos are of players or competitors who are just about to make a key play or goal, or set new records. They also should show the face and a ball, if one is being used, along with one or more competitors or opposing team members. Getting a sharply focused player against a soft, blurred background is also often the goal of pro sports photographers. You can find a good example of such a photo in Technique 50 — one that was taken with a professional digital SLR camera and an expensive 300mm f/2.8 lens.

Can you get such a photo with a compact digital camera? It is not likely. But with some work, you still should be able to get some reasonably good photos that you'll enjoy sharing. The problem with compact digital cameras is the excessively long lag time between when you press the shutter button and when the picture is taken. You'll also find that getting a properly focused photo is somewhat difficult as well. However, with some practice, the correct camera settings, and some good luck, you can get a few photos you'll be proud of.

STEP 2: CHOOSE AN EVENT TO SHOOT

■ Because most sporting events are scheduled on a specific day and at a specific time, you will not have much choice as to when you get to shoot. If your goal is to get a couple of good photos from the season's play, you can choose to be more aggressive in your shooting on those days that have the best light. Avoid days where the sun is really bright or there is a white or bright sky. The best days are slightly overcast days or days with a deep blue sky. The worst days are when a few dark clouds are moving quickly over an otherwise bright sky, causing dramatic changes of light levels.

STEP 3: CHOOSE WHERE TO SHOOT

■ Every sporting event has good places to stand to shoot and not-so-good places to stand. The best place depends on the game, the speed of the players or competitors, the focal length of the lens that you are using, and your luck that day. If you have a short focal length lens and you are shooting a field game like soccer or lacrosse, try to determine which part of the field has the most play, then

> **TIP**
>
> One good way to get good sports action photos is to shoot during warm-up or after a game when you can walk onto the field. Before doing this, make sure you have the permission of the coach and that you do not make any of your subjects uncomfortable by being on the field and pointing your camera at them.

position yourself there and wait for the play to come your way. If luck is not in your favor, you may find that the play is on any part of the field that you are not close to — it happens sometimes!

STEP 4: CHOOSE CAMERA SETTINGS

■ Many compact digital cameras have a "sports" shooting mode; if your camera has one, try it because it will choose the most important settings for you. If not, choose shutter priority mode and set the shutter speed to be 1/400 or 1/500, if possible, to stop the action. As long as you're shooting in sunlight, you should be able to use these shutter speeds and keep the ISO setting set to the slowest setting (for example, 50 or 100 ISO).

If you're not shooting from a sports shooting mode, you also want to see whether your camera has an

TIP

If you find that you're getting blown-out highlights on white jerseys and white balls, try setting the shooting mode to manual. Set the shutter speed to 1/400 or 1/500, if possible, to stop the action. Then, experiment by adjusting the aperture until you get a well-exposed image of a nearby player with a light or white jersey. After you determine a good exposure, you can then shoot all the photos using this setting. Believe it or not, many pro photographers shoot in manual mode more often than not to get the best results when shooting frame-filling images of dark and light jerseys.

option for continuous focusing and continuous shooting to minimize the time interval between shots. A continuous shooting mode or high-speed shooting mode allows you to keep shooting as long as you have the shutter button pressed.

Unless play is very near you, you want to set the zoom to maximum telephoto. Any camera lens that has less than a 100mm (35mm focal length equivalent) focal length will be hard to use to get an action photo. In this case, you may want to consider purchasing a tele-converter auxiliary lens. See Technique 18 to learn more about choosing auxiliary lenses.

If you decide in Step 2 that you will use images for a Web page instead of making large prints, you can decrease the time lag between photos by choosing a smaller image size. The disadvantage to this approach is that you won't be able to crop a small image without loosing a great deal of quality. Large images can be cropped in on, essentially letting you "zoom" in on the subject when you are viewing the images on a computer screen.

STEP 5: PRACTICE TAKING PHOTOS

■ Due to the shutter lag that most digital cameras suffer from, you need to practice shooting in order to learn when you should press the shutter button relative to when you want a picture to be taken. Anticipation of when you should shoot is the key to getting a good photo with a compact digital camera! When you get ready to shoot, press the shutter button half-way down to begin auto-focusing. As the play gets nearer to you or nearer to when you want a photo, press the shutter button all the way down to take a photo. You may find that you have to press the shutter button as much as a second or more before you want to take a

photo. You may be able to further reduce shutter lag by switching into a manual focus mode. As you probably have assumed, to get a good shot, you ought to shoot as often as you can because the more shots you take, the more you are likely to get a good shot.

STEP 6: COMPOSE AND TAKE PHOTOS

■ When you have your camera settings correct and you've had a few practice shots, keep on shooting. Because taking photos with a digital

TIP

Try to time your exposures to peaks in the action. For example, a basketball player jumps to make a shot. At the top of his (or her) leap is that moment where time stands still and you can capture the action even with a slower shutter speed. Anticipating that moment requires some knowledge of the sport and lots of practice.

camera is free, shoot as often as you can until you get one or more photos you like. Also, try slowing down the shutter speed to as slow as 1/60 of a second and pan the camera with the player. You'll find that you can sometimes get a nice blur in the background with a somewhat blurred subject, which makes a good photo, much like the photo of the BMX biker shown in **Figure 27.2**.

STEP 7: REVIEW AND CONFIRM YOU HAVE WHAT YOU WANT

■ After you've taken a few photos, look at them on your camera's LCD monitor. If your camera has a histogram feature, check it out to see whether you have properly exposed your shots and that the highlights are not badly blown out. Delete some of the photos you know are not good to make more room to try again. Keep shooting, and you'll get something good!

If you become more serious about taking sports action photos and you have a budget of $2,000 for a camera and $2,000 for a lens, consider moving up to one of the digital SLR cameras. You can learn more about shooting with one in Technique 50.

CHAPTER 6

PHOTOGRAPHING NATURE

© 1999 Gregory Georges

Frogs, flowers, birds, cats, dogs, and elephants — these are just a few of the thousands of subjects that nature offers that you can photograph. Taking photographs of living things in their natural or captive environments can be tremendously rewarding. If you're into photographing nature, you'll enjoy these techniques. In Technique 28 you learn how to get good photos of pets and in Technique 29 you learn how to take photos of animals in a zoo. Then you learn how to get good close-up photos of flowers in Technique 30. Technique 31 shows how to use macro mode to shoot small amphibians, such as a frog. In Technique 32, you learn how to *digiscope* — that is, take photos with a compact digital camera through a spotting scope to get some great bird photos. These techniques will get you successfully shooting in one of the most rewarding areas of photography — nature photography.

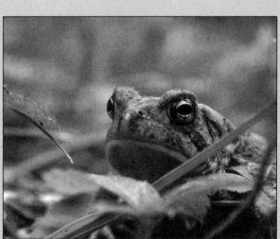

© 1999 Gregory Georges

THE FLAG.
TEN TEN

PHOTOGRAPHING PETS

28.1 *Original image* © 1999 Gregory Georges

28.2 (CP 28.2) *Edited image* © 1999 Gregory Georges

Many people are so attached to their pets that they consider them to be members of the family, but because pets are usually animals of one kind or another, this technique was put in the nature chapter rather than the people chapter. However, in many ways, taking a pet portrait *is* rather like taking a people portrait. You can shoot tightly and just show part of your pet, like the face of the cat shown in the photo in **Figure 28.2 (CP 28.2)**. Or you can shoot it doing something that it enjoys, like sleeping, chasing a ball, or perching on a bird stand (if it is a bird). You can also work to bring out a facial expression that is "just so them." In this technique, you learn how to get a good pet portrait that you will enjoy taking and viewing.

STEP 1: DECIDE WHERE TO SHOOT

■ The first step to getting a good pet portrait is deciding where to shoot. Sure, you can put the pet on a chair or table in front of a black drape and shoot the subject with strobes just as you would a people portrait. However, you can get much more interesting photos of pets if you shoot them in their natural surroundings doing things they enjoy doing. If your pet is a cat, try catching it napping in the sunlight in front of a favorite window. Or, you can shoot pets outdoors playing with a ball or chasing children.

Once again, you should be aware of how important it is to have good light. An attempt at shooting a black Labrador in dark shade will be challenging. Likewise, when shooting a white poodle in bright sun, getting a well-exposed photo will also be hard. Yet, if you place the same white dog in an area of your yard where overhead trees soften the bright sun, you can easily shoot against a shady background to get a photo like the one shown in **Figure 28.3 (CP 28.3)**. The quality of light makes or breaks a photo — so choose a day, time, and place where you have good light.

If you have a small pet like a bird, mouse, or snake, having someone hold the pet in his hands or on a comfortable perch held near a window can provide both a good source of light and a way of controlling the pet's movement. Think about ways to involve your pet that will result in some good facial expressions. A "meow" sound made the poodle in **Figure 28.3 (CP 28.3)** turn his head and look curiously at the owner, who was standing directly behind the photographer. With a cat, a string or a bit of twine can work wonders. For a horse, it might be a carrot or a lump of sugar or maybe you can get a good photo just by shooting it in the stall, like the horse shown in **Figure 28.4 (CP 28.4)**. Be creative, and experiment!

Remember, a great pet shot doesn't have to be a formal shot. Next time your pet is fast asleep, with legs up in the air, and has a silly expression on its face, quietly grab your camera and take a few shots. Many of the best photographic opportunities just happen — they aren't created.

STEP 2: CHOOSE FOCAL LENGTH

■ Depending on the length of the zoom lens on your camera, you may want to use a supplemental telephoto lens when taking a pet portrait. Longer

28.3 (CP 28.3) © 2002 Gregory Georges

lenses allow you to be farther away from your subject, which can be helpful if your pet is uncomfortable with too much attention. A little extra distance can also be helpful if your pet is a real attention hog, as you can reduce your pet's activity by being a bit more distant and aloof. **Figure 28.5** shows how a telephoto lens made it easy to shoot the cat sleeping in the sun on the car hood.

STEP 3: CHOOSE CAMERA SETTINGS

■ If you are planning to shoot outdoors, select aperture priority mode and open your lens to its

28.4 (CP 28.4) © 1999 Gregory Georges

maximum f-stop. Depending on the amount of available light, the maximum f-stop setting will ensure that you are getting the fastest shutter speed you can, which helps stop any movement and helps keep your pet sharply focused. Try to use at least 1/250th of a second as the shutter speed if your pet is moving quickly. Next, enable fill, or forced flash. Outdoor fill flash allows you to capture detail in shadows, and is especially helpful if your pet has dark or black fur.

■ If you plan to shoot indoors, you have to evaluate the amount of available light to decide whether or not to use flash. If you have a cat that likes to sit on a window ledge, your primary concern will be getting a good exposure by metering for the cat, not the bright window. Use your camera's exposure compensation feature, or spot metering with exposure lock to ensure that your subject is properly exposed. Shooting in a darker part of the room may work for sleeping pets (which can actually make some very good pictures), but if you have an active animal, you need to use supplemental lights. See Technique 20 for help on choosing lights.

28.5 © 2001 Lauren Georges

STEP 4: GET YOUR PETS READY

■ Because shooting a pet can be more or less challenging depending on whose pet it is, what kind of pet it is, and how manageable it is, decide who ought to be working with the pet and who ought to be behind the camera taking photographs. Some of the most manageable pets, such as a well-trained dog (you cannot really train a cat, can you?), can still be challenging unless you can get them to mind and to look like you want them to look.

■ Getting your pet's attention, getting the right composition, and taking pictures all by yourself is sometimes tough, so, if possible, have an assistant who can either engage your pet or take pictures. If you plan to use an assistant, choose someone who has a good relationship with your pet and knows how to control it. A family member or a close friend who knows the pet would be a good choice.

■ In addition to your camera gear, make sure that you have a plentiful supply of the pet's favorite treat. Food is a good motivator and reward, and it helps to get your pet to do what you want. Other useful tools for getting attention are noise makers, like squeakers and clickers. For animals that are fascinated by movement, like cats, a string or bit of yarn can be useful to attract their attention. If your pet has a favorite toy, use it to keep the pet posed for good photographs.

STEP 5: COMPOSE AND TAKE PHOTOS

■ Look critically at the light, and choose your angle based on its direction. While the obvious orientation is to have the sun shine toward the subject, you should also try some shots with the sun behind your subject, and fill the shaded face with light from your flash. If your camera has an automated fill flash mode, try it first. If not, you may need to move closer or farther away to achieve the correct balance between flash and existing light. You won't be able to shoot from too far away, because built-in flash units are only effective at close range. Getting the exposure correct may take a few tries, but backlit and sidelit shots can do wonderful things with fur. Be sure to review your results on your LCD monitor as you shoot to ensure that you're getting the right exposure, and that you are not picking up any red-eye from the flash. If your pet has dark fur, you may need to shoot with the sun behind you to get the detail you need.

■ When you are composing a picture of a pet, be sure to get the eyes in focus. If the eyes are in focus, your mind fills in the rest of the detail, and overall, it makes for a more pleasant portrait. The same technique applies for photographing people. A catch light (reflection of the light source) in the eyes gives your portrait more life — try to shoot to get one.

■ Also try shooting close to the ground so you're shooting level to your pet, as that perspective is

much better than one where you are looking down at it. To a small kitten, grass may be like a jungle, and you can shoot through the blades of grass to capture a unique perspective. Turn off your flash if it lights up too much of the foreground. Be aware of the background, and try to keep it simple. Indoors, choosing an angle that allows the background to go dark will be relatively easy; when you're shooting outdoors, try to keep the background plain or out of focus.

TIP

Shoot many pictures because expressions on pets come and go quickly. Try to capture a moment of focused attention; it can be a great way to show the personality of your pet. This may be difficult with some pets, but not impossible. In most animals, cocked ears, a focused gaze, and an alert body posture are the signals of a happy pet, and happy pets make great photos.

STEP 6: EVALUATE SHOTS AND CHANGE SETTINGS IF NEEDED

- Once you've taken a few pictures, take time to carefully evaluate your results to see that they are well-composed, that they are in focus, and that they are properly exposed. Use your LCD monitor to look at the overall composition, and if your camera review has a zoom feature, use it to zoom in on the subject's face to see if the eyes and face are in focus. Likewise, if your camera has a histogram, take a quick look to evaluate exposure.
- Although obviously some differences exist between photographing different kinds of pets, great pictures of any kind of pet share a surprising number of similarities. First, the animal's attention will be focused. When a horse's attention is focused, its ears are pricked forward, both pointing in the same direction. With a snake, it could be indicated with a fixed stare of one eye, and a flick of the tongue. No matter what size your pet is, its eyes should be alive and bright, and your pet should be shown in a setting that is free of distracting elements.

TAKING PHOTOS AT A ZOO

29.1 *Original image* © 2002 Larry Berman

29.2 (CP 29.2) *Edited image* © 2002 Larry Berman

The zoo is a great place to take your digital camera. Not only does it offer a wide variety of interesting subjects, but you can also relax and learn about your camera as you patiently observe the animals and watch for a great shot to present itself. Patience is a key part of getting good animal pictures, whether you are shooting in the wild or in a controlled environment like the zoo. Moreover, time spent observing an animal's behavior prepares you for the key moment when great expression or interaction happens, such as the moment caught between the two elephants shown in **Figure 29.2 (CP 29.2)**. In this technique, you learn how to take good photos of the animals in a zoo.

STEP 1: PLAN YOUR VISIT

■ It's best to arrive when the zoo first opens and preferably on a weekday when fewer visitors are around. Morning light offers better modeling qualities than the flatter light of midday, and the animals are more likely to be active in the early part of the day than they will be later in the day, especially if it is a hot sunny day. Sunny and cloudy days each have advantages, so the weather should not have a major impact on your shooting. Plan to spend the day, because different areas will have better light and various levels of activity throughout the day.

STEP 2: GET YOUR EQUIPMENT READY

■ Clean your camera's lens and LCD monitor, and pack a supplemental telephoto lens if you have one. An external flash that will synchronize with your camera is very handy for fill flash at a distance and for adding a catch light to the eyes of your subject. Also, pack extra batteries, and clear your flash memory cards so you have plenty of room.

Your camera's zoom lens will be tested when you shoot at a zoo. In general, the longer the focal length, the better close-ups you will be able to get. One of the keys to great animal pictures in a zoo is to eliminate or minimize the surroundings that look like a zoo. Tight cropping is easy when your telephoto can zoom right in on your subject. If your camera's maximum zoom is less than the 35mm equivalent of 200mm, you will find that getting full-frame photos of most animals will be difficult.

■ Bring a tripod with you. Because you will be shooting mostly with the telephoto end of your zoom, the stability of a tripod will really help the sharpness of your images as well as make it easier to get a more precisely composed photo. If you have an external flash unit (see Technique 20), its more powerful output helps fill shadows and give your subject's face and eyes more life. Be sure to bring extra batteries for your flash.

STEP 3: VISIT THE ZOO OFFICE

■ When you first arrive, pick up a map and inquire about feeding times for the animals. Knowing when the keepers feed various animals will ensure you get some good shots of active animals. Also, ask about any special programs that might allow you greater access to the animals. Sometimes zoos have entertaining and educational programs that are well worth attending if you plan on taking pictures.

STEP 4: CHOOSE CAMERA SETTINGS

■ Set your camera on aperture priority mode, and open your lens to its maximum aperture. These settings cause your camera to use as fast a shutter speed it can for the light that is available. Working with a wide-open lens also helps limit your depth-of-field, and keeps the focus on your subjects, the animals, and not on the background, which not surprisingly may look like one from a zoo. A fast shutter speed also helps minimize the effects of camera and animal movement that will

be amplified by the use of a long telephoto. Be prepared to turn on your flash, using the forced flash mode, when shooting animals with faces covered in shadow.

STEP 5: EXPLORE THE ZOO

■ Begin by walking around the zoo and observing the different animals' activities. If you are visiting a very large zoo, see whether there is a tram or other ground transportation that will allow you to quickly and easily get around. Note the quality and direction of the light for various animals' enclosures. If you see a photo opportunity, stop and shoot it. However, your first quick trip around the zoo should be a scouting expedition where you note the quality of light and activity levels of the animals.

STEP 6: SHOOT

■ After you've decided which animals to shoot and when to shoot them, set up your tripod, and follow the animal with your lens. Look for eye contact, or interesting expressions, or just plain entertaining shots, like the elephant tails shown in **Figure 29.3**. When you first walk up to an exhibit, be prepared to shoot right away, because you're more likely to be given attention when you first arrive. After the animal knows you're not a source of food or a threat, you'll be ignored.

■ If the light is coming from behind a furry animal you can get a wonderful backlight effect, but

you will probably need to use fill flash to open up the shadows. Shooting with your lens wide open, a high shutter speed, and your flash on maximum power may work if the distances are not too great. Review your shots on your LCD monitor to see whether your flash is creating the desired effect.

■ If you see a zookeeper, ask for more information about the specific habits of the animal you are photographing. Not only can you learn whether there is a better time of day to shoot that particular animal, but your association with the keeper may also be noticed by the animal, and it may well pay you more attention! Many kinds of zoo animals are quite curious about their surroundings, and although they know that most of the people walking by mean little to them, their keepers are actually central to their lives. You can benefit from that association.

29.3 *© 2002 Larry Berman*

■ Experiment with your composition. If you are photographing a flock of flamingos, try zooming in on a single bird, like the one shown in the photo in **Figure 29.4 (CP 29.4)**. If you see two giraffes interacting with each other, concentrate on them, and not the whole herd. Look for telltale signs of the zoo environment, such as feeding or watering bowls, fences, or signs, and change your composition to eliminate them. Concentrate on capturing the animal's personality. In good animal pictures, the animals have interesting expressions.

■ Don't spend too much time waiting in front of an animal's enclosure if it is inactive. You have plenty of subjects to explore; just make a note to come back later if you want a photo of that particular animal. Speaking of subjects, you can shoot much more than animals at zoos. Appreciate and shoot the plants and flowers as well; you just might come home with pictures of much more than just zoo animals.

One of the challenges of taking photos in a zoo is to get a good photo when shooting through glass enclosures. To get a good photo when shooting through glass, put your camera lens against the glass and shoot at an angle to the glass that minimizes or eliminates reflections. **Figure 29.5 (CP 29.5)** shows a photo of a monkey that was taken through glass.

29.4 (CP 29.4) © 2001 Gregory Georges

29.5 (CP 29.5) © 2002 Gregory Georges

TAKING CLOSE-UP FLOWER PHOTOS

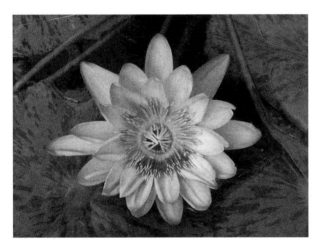

30.1 *Original image* *© 2002 Gregory Georges*

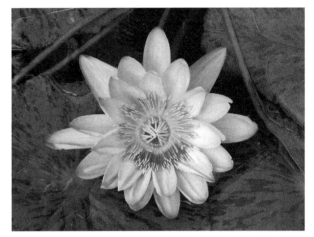

30.2 (CP 30.2) *Edited image* *© 2002 Gregory Georges*

ABOUT THE IMAGE

"Pink Water Lily and Pads"
Canon PowerShot G2 mounted on a tripod, zoom set to 71mm (35mm equivalent), f/8.0 @ 1/200, ISO 200, 2,272 x 1,704 pixels, 2.3MB .jpg

Taking flower photos can be as rewarding as it can be challenging if you shoot them in their natural environment. When you shoot flowers outdoors, you usually face two challenges — how to minimize movement caused by wind, and how to shoot in good light. In this technique, you learn how to take a strong close-up photo of a flower, like the pink water lily shown in **Figure 30.2 (CP 30.2)**.

STEP 1: CHOOSE DAY AND TIME TO SHOOT

■ Yeah — right — choose day and time to shoot when the conditions are excellent. You have heard this advice several times before in this book, but what if you don't have a choice of which day and time you can shoot, which is frequently the case? What if the shooting conditions for a specific flower you want to shoot are never good?

The pink water lily, found in Hawaii, was in the shade most of the day, and the trade winds that *always* blow on the Hawaiian Islands kept it continuously moving. If you want to take a photo in these or similar conditions, you must learn to adjust your camera settings and use flash, if needed, to get the best shot you can. To do so, you must learn to balance the trade-offs between low ISO setting and digital noise, aperture opening and depth-of-field, and shutter speed and image blur caused by subject movement.

STEP 2: DECIDE HOW YOU WANT THE PHOTO TO LOOK

■ Deciding how you want a photo to look before taking a photo is always an important step. Because the water lily was in the middle of a pond, shooting it was not possible without getting into the pond. Because being in the pond made shooting straight down on the lily possible, the decision was made to get a photo that showed the whole flower surrounded by the lily pads and to have everything in the photo be sharply focused.

STEP 3: SET UP TRIPOD AND CAMERA

■ Set up your tripod and attach the camera to the tripod. While the available light allowed shooting at f/8.0 and 1/200th of a second, a tripod was still used to reduce camera shake and to get more precise control over composition.

STEP 4: SELECT CAMERA SETTINGS

■ Start with the camera settings that will give you the best image quality with the most depth-of-field. Choose the lowest ISO setting your camera offers (for example, 50 or 100 ISO) to minimize digital noise. Use an evaluative or matrix metering mode to meter the entire composition. Select automatic focusing and choose a focus point centered on the flower. Select the aperture priority mode, choose the maximum aperture (for example, f/8.0), and let the camera select the shutter speed.

STEP 5: COMPOSE AND TAKE PHOTOS

■ With the appropriate camera settings chosen, you can now compose and take one or more photos. Align the camera so that it is directly over the flower and make sure the face of the lens is parallel to the surface of the water or to the flower to keep as much of the flower in focus as possible. Take a few photos while slightly varying the exposure by using exposure compensation.

STEP 6: EVALUATE PHOTOS AND SHOOT AGAIN

■ After you've taken a few photos, look at the images on the LCD monitor and check the histogram, if your camera has one. After evaluating the photos, make any additional changes to your camera settings that you want and shoot a few more photos to get the ones you want.

If there is no way to control the wind, and you do not want to use a higher ISO setting, but you need to use a faster shutter speed, you can use a built-in flash or a macro ring light flash like the Canon Macro Ring Lite MR-14EX, shown mounted on a Canon PowerShot G2 in **Figure 30.3**, or other external flash to help stop the movement. To learn more about using a macro ring light read Technique 47.

If you have used a 35mm camera with a macro lens to shoot subjects like flowers, you may be aware how depth-of-field is severely limited. This is usually not the case with compact digital cameras due to the

small size of their image sensors and the interrelated mathematics of optics and sensor size. This means that using the smallest aperture to get maximum depth-of-field may not be as important as you think. **Figure 30.4** and **Figure 30.5** are photos of the same water lily shown in **Figure 30.2**, except the settings are 50 ISO, a maximum aperture of f/8.0 @ 1/50, and 50 ISO, a minimum aperture of f/2.2 @ 1/500, respectively. If you open the full-size original images that you can find in the **/chap06/30** folder on the companion CD-ROM, you will not be able to notice much difference (if any) in depth-of-field.

TIP

If you're not sure whether you have a sharply focused subject, use your camera's image review zoom feature to zoom in on the image using the LCD monitor. You may need to check the documentation that came with your camera to see whether your camera has such a feature.

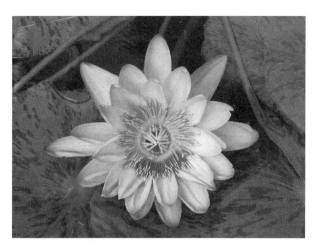

30.4 © 2002 Gregory Georges

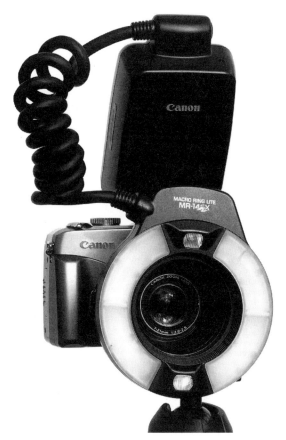

30.3 © 2002 Gregory Georges

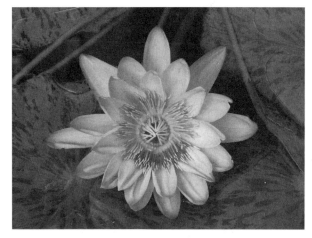

30.5 © 2002 Gregory Georges

USING MACRO MODE TO TAKE CLOSE-UP PHOTOS

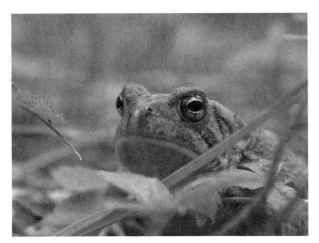

31.1 *Original image* © 1999 Gregory Georges

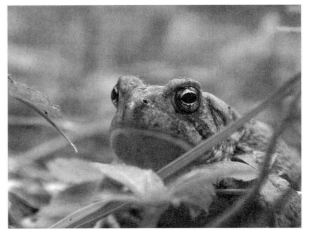

31.2 (CP 31.2) *Edited image* © 1999 Gregory Georges

The world of digital macro photography is full of opportunity and surprise. You can make small things look large. Tiny things you ordinarily never see or notice can be presented in a photo that will grab your attention; so get your camera, put it in macro mode, and go exploring for fun subjects to shoot, like the frog shown in **Figure 31.2 (CP 31.2)**. In this technique, you learn about the challenges that you'll face when shooting close-up photos, and you learn how to use macro mode to get great photos that you'll enjoy sharing with others.

First, let's cover a few terms. Many people use the phrases "macro photography" and "close-up photography" interchangeably, but they shouldn't. Technically, macro photography is taking photographs that are life size or larger. In other words, the actual image on the image sensor (or film if you are using a film camera) is 1:1 with the subject or larger. Close-up photography is merely taking photographs "close-up" to the subject — generally, between a couple of inches and a few feet — depending on the focal length

of the lens you use. However, a macro mode on compact digital cameras simply enables the lens to focus on a subject closer than if the camera were not in macro mode. Strictly speaking, using a macro mode doesn't necessarily mean that you are taking macro photos, but depending on the distance between your camera and the subject and the focal length of the lens you are using, you could be taking macro photos!

When you shoot within a few inches to a foot of your subject, depth-of-field will be limited at these close-focusing distances. Depending on your camera and lens, depth-of-field can be as shallow as 1/8 inch. Notice how the right eye of the frog is clearly in focus in **Figure 31.3**, but the left eye is slightly out-of-focus.

Because of the shallow depth-of-field, one of the challenges of close-up photography is to get enough of your subject in focus to realize your vision of the photo you want. Quite often you will not have sufficient depth-of-field and you will have to focus very carefully on the most important part of your subject. The photo shown in **Figure 31.2 (CP 31.2)** was taken after a tiny adjustment in focus on the frog was made. Notice how the left eye is now in focus and the right

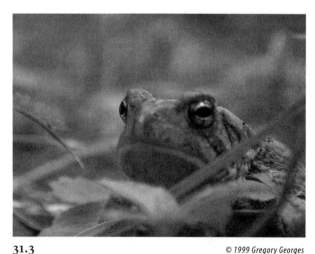

31.3 © 1999 Gregory Georges

eye is slightly blurred. This tiny difference made one photo good and the other unacceptable.

In Technique 10, you learned that aperture determines the amount of depth-of-field you will get — a larger aperture number (for example, f/8.0) setting results in less depth-of-field than a smaller aperture number (for example, f/2.2). Because aperture size and shutter speed are tightly interrelated, a small aperture setting (that is, good depth-of-field) requires a slow shutter speed to get adequate exposure. Anytime you shoot with a shutter speed under 1/60th of second or less, you have to be much more concerned about camera shake and subject movement if you want to avoid getting blur in the photo.

One other challenge you'll face when taking close-up photos is getting enough light where it is needed. When you are within a foot or so of the subject, blocking light with your body or camera is possible. In addition, because many close-up subjects like the frog are usually found in shaded environments, the use of a slow shutter speed is almost a given. Factor in a little wind with the previously mentioned factors and you will get a good idea why close-up photography is a challenge which is quite rewarding when you get it right!

STEP 1: READ YOUR CAMERA MANUAL

■ As macro modes vary widely between camera models, take a few minutes now and read the documentation that came with your camera to learn all that you can about your camera's macro feature, if it has one. The macro mode on most compact digital cameras enables the lens to focus closer to a subject than it can without using macro mode, thus allowing the image to fill up more of the frame or magnifying the subject more than when the camera is not in macro mode.

■ Also look up the minimum and maximum distance that you can shoot when in macro mode. If you completed the Digital Camera Features/Specification Checklist in Technique 1, you already have the information you need. For example, when using the Canon PowerShot G2's macro mode, you can shoot close-ups of subjects in the range of 2.4 inches to 2.3 feet at maximum wide angle, and 7.9 inches to 2.3 feet at maximum telephoto. Some of the Nikon CoolPix cameras can focus to under one inch when set on macro.

STEP 2: DECIDE HOW YOU WANT THE PHOTO TO LOOK

■ Pre-visualize the photo you want before setting up to take a photo. Do you want a tight image showing just your subject, or do you want to show the subject with some of the surrounding area, too? Should the whole subject be clearly in focus, or is part of your design to blur part of the subject and all the background?

The intention of the photographer taking the frog photo was to place the camera on the ground and shoot up at the frog to make the small one-inch-long frog look huge. The intent was also to make the background as blurred as possible so that the image looked more dramatic with just the big bright frog eyes being in focus.

STEP 3: SELECT CAMERA SETTINGS

■ Depending on how you want your photo to look, you can choose aperture priority mode, select an appropriate aperture setting, and let the camera select the shutter speed. Alternatively, you can choose shutter priority mode and choose the shutter speed to minimize or show subject movement; then, let the camera choose the aperture. In either case, you may find that the camera-chosen settings are outside the limits of your camera or ones that you will accept. In that case, you can consider changing the ISO setting, add light with a flash, or reconsider how you want the photo to look.

STEP 4: COMPOSE AND TAKE PHOTOS

■ Once you have selected the desired camera settings, compose and take a few photos. One of the great things about shooting with most compact digital cameras is you don't have to press your eye right against a viewfinder to compose a shot. Instead, you can place the camera where needed to get the best shot, then look at the LCD monitor. If your camera has a swivel LCD monitor like many of the Nikon CoolPix or Canon cameras, it is even easier to see what you are shooting without having to be a gymnast to get the shot you want. When pressing the shutter button, be careful to minimize camera movement, which robs sharpness from your pictures.

TIP

When it suits your vision of the photo you want, try to keep the plane of the image sensor parallel with your subject to keep as much of the subject in the area of focus as possible.

STEP 5: EVALUATE PHOTOS AND SHOOT AGAIN

■ When shooting close-up photos, carefully evaluate the results on your LCD monitor and with the histogram if your camera has one. You may also want to use a zoom review feature, if your camera has one, to zoom in on an image to see whether the subject is in-focus, as you want it. However, be aware that a small LCD monitor can mislead you into thinking you have the photo you want — when in fact, the subject is poorly focused, or there is image blur due to camera or subject movement. The best thing to do is shoot many photos so that you can choose from more than one when you download them to your computer and look at them on a large computer monitor.

TIP

If you want even more magnification of tiny subjects, you may want to consider purchasing a close-up filter. Close-up filters are supplemental lenses designed to allow even closer focusing than is ordinarily possible with your camera's lens even when it is in macro mode. Close-up filters screw onto the camera's filter ring. Depending on your camera's macro capability, you may never need one of these filters, or it could allow you to get the extra close details that your camera could get no other way.

TAKING BIRD PHOTOS USING A DIGISCOPE

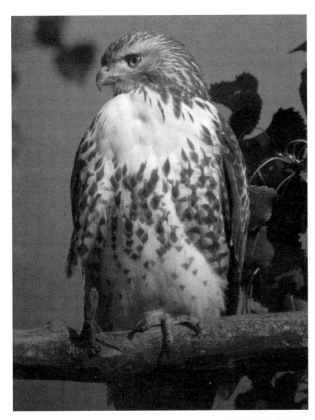

32.1 *Original image* © 2002 Melissa Whitmire

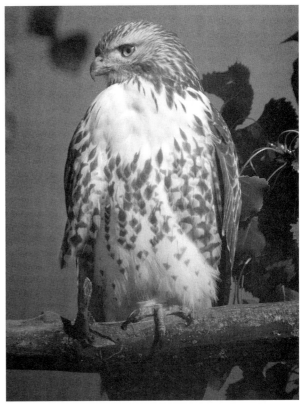

32.2 (CP 32.2) *Edited image* © 2002 Melissa Whitmire

ABOUT THE IMAGE

"Immature Red-tailed Hawk" Nikon CoolPix 5000 on Swarovski 65HD spotting scope with 20X x 60X eye-piece, f/4.8 @ 1/123, ISO 100, 1,600 x 1,200 pixels, 712KB .jpg

Not too long after digital cameras were introduced, a few birders (Laurence Poh may have been the first) found that they could use a compact digital camera to take bird photos through their spotting scope — a small compact telescope designed for viewing things that are too far away to use binoculars. Before long, digiscoping became a widespread practice and more and more birders started taking and enjoying photographs like the one of the immature red-tail hawk taken by Melissa Whitmire in **Figure 32.2 (CP 32.2)**. In this technique, you learn how to use a compact digital camera and a spotting scope to take bird photographs.

185

First, why might you want to take a digital picture through a spotting scope? The answer is almost unbelievable magnification. Depending on the spotting scope, eyepiece, and digital camera you use, you can get an equivalent 35mm focal length of up to and even over 4,000mm! With the right techniques, good equipment, and a solid tripod, you can turn sharply focused images into printed photographs.

If you are a birder and you digiscope, you will be able to take photos of rare and unusual birds, or of birds that you need help identifying. You also can take photos of any birds to enjoy later and to share with others. The best part is you can get good photos of many birds that are exceedingly hard to photograph even when you have $12,000 or more of professional camera equipment, including a long telephoto lens.

To digiscope, you need the right combination of compact digital camera, spotting scope, tripod, tripod head, and possibly an adapter to connect the camera to the scope. More specifically, you need a spotting scope that can be coupled to a compact digital camera with minimal distance between the front lens of the digital camera and the glass of the eyepiece on the spotting scope. If there is as much as or more than 1/8-inch distance between the glass of the scope and the camera, severe *vignetting* (a darkening of the outside edges of the picture) will occur. The design of many spotting scopes makes using them as a digiscope difficult or impossible. Other spotting scopes, such as some of the models made by Swarovski and Kowa, are ideal for digiscoping. **Figure 32.3** shows Melissa holding a Nikon CoolPix 5000 on a Swarovski 65HD spotting scope with a $20 \times 60X$ eyepiece.

Because you can end up with an exceedingly long focal length when digiscoping, you need a very, very solid tripod and head to avoid having even the slightest bit of camera or scope shake, as it will ruin a photograph. Because scopes and compact digital cameras weigh so little, make sure you buy a tripod that is way overrated for the weight of the scope and camera together in order to get solid support. Some of the

more expensive carbon fiber Gitzo (`www.gitzo.com`) tripods are excellent for digiscoping.

Many digiscopers get good photos without physically attaching their compact digital cameras to their scope — they merely insert them and carefully hold them by hand to take a photo, as is shown in **Figure 32.4 (CP 32.4)**. Other digiscopers would not consider shooting in this manner. These more compulsive digiscopers either make their own "attachment device" or they purchase one from a vendor. There are definite advantages and disadvantages to both approaches.

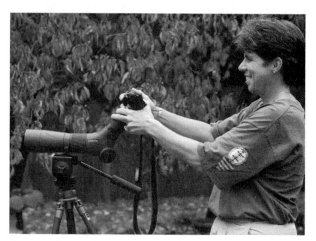

32.3 © 2002 Gregory Georges

32.4 (CP 32.4) © 2002 Gregory Georges

STEP 1: CHOOSE DAY AND TIME TO SHOOT

■ Anytime you plan on taking a photograph, consider the quantity and quality of light. If you are trying to shoot an owl hidden in a heavily shaded part of a tree, you just won't get a good shot. Likewise, if you are shooting bright white egrets on water glistening from bright sunlight, you can't expect to get a good shot either. The best way to get a good photograph (if you have a choice) is to choose the right day and time to shoot.

■ Besides shooting in good light, you must also shoot from a place where you have light on the bird you are shooting — on the side you are shooting from. Unless your goal is to shoot a silhouette, you want to set up your camera where the bird is not backlit. A dark bird between you and the sun is usually not going to make a very good photograph.

STEP 2: SET UP TRIPOD AND SCOPE

■ After you determine where you want to shoot and you're in the best place possible to take advantage of the available light, set up your tripod and attach your scope. It is essential that you use a solid tripod and tripod head to avoid camera shake, which will result in a blurred image.

WARNING

Many birders who don't have photography experience try digiscoping and get poor results because they don't recognize the importance of having light on the side of the bird they are shooting. Admittedly, you won't always have an opportunity to shoot a bird with good frontlight, but be aware that a backlit bird will not result in a particularly good photograph.

STEP 3: CHOOSE CAMERA SETTINGS

■ Set your camera to maximum zoom if your camera has a zoom capability. If there is enough light, you want to select 100 ISO. You can try using an automatic shooting mode such as shutter priority and choose the fastest shutter speed you can. Or you can use the manual mode and take a few practice photos until you get a good combination that results in a good exposure (providing you have the time to do so). Generally, you are better off using automatic focus. If you do not get the results you want, try setting your camera to manual focus and set it to focus on infinity.

STEP 4: LOCATE BIRD IN SCOPE

■ After you have selected the appropriate settings on your camera and you're ready to shoot, locate the bird or birds that you want to photograph in your spotting scope. One of the advantages of not having your compact digital camera attached to your scope is that you can use the scope as you normally would without having to look at the LCD monitor on your camera. When you find a bird, you can simply slip the compact digital camera's lens in the eyepiece to take a photo. This method can make finding a bird in the scope much easier. The downside of this approach is you may miss many good photos.

If you are just getting started using the combination of a digital camera and a spotting scope,

TIP

Choose an exposure setting that avoids blowing out highlights, as you can usually lighten shadows to bring back detail; however, getting detail from overexposed highlights is usually not possible.

try shooting a large bird like the heron shown in **Figure 32.5**. Large birds like a heron usually stand very still while fishing. A large, still subject will be easier for you to get used to making the adjustments you need to make and to get some good photos, too.

STEP 5: COMPOSE AND TAKE SEVERAL PHOTOS

■ When you have set up your tripod, scope, and camera and have a bird in view, take a quick picture before taking too much time to adjust camera settings and the scope. If the bird quickly flies away, you may be glad you at least got a photo,

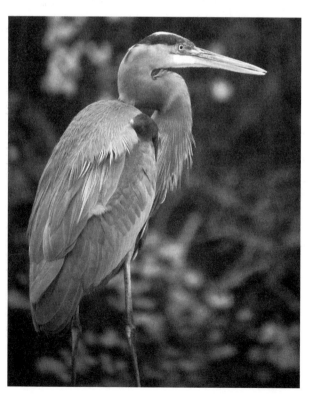

32.5 © 2002 Melissa Whitmire

even if it is not a good photo. If time allows, you can take a few more photos. Because birds move very quickly, shooting lots of photos when you have a bird in view is better than waiting until you have the perfect photo opportunity, which may never happen. Taking photos with a digital camera does not cost you anything, and the more photos you take, the better chance you'll get one you really like.

STEP 6: EVALUATE RESULTS AND CHANGE SETTINGS IF NEEDED

■ After you've taken a few photos, check your camera's LCD monitor to see whether you have a good exposure. Check the histogram if your camera has a histogram feature, then make any changes to settings that are needed.

You can use your digital camera and a scope to shoot subjects other than just birds. **Figure 32.6 (CP 32.6)** shows a photo taken of a butterfly that was just within the close-focusing range of the Swarovski 65HD scope. An advantage to using a digiscope to shoot subjects like dragonflies and butterflies is that you can shoot far enough away not to scare them off. Using a digiscope, you may get reasonably good photos of subjects that you ordinarily would never get with a camera.

> **NOTE**
>
> Finding a tiny bird in good light with a powerful spotting scope is not easy. Taking a photo of a tiny bird in good light with a compact digital camera coupled to a spotting scope is even more difficult. Do not plan to get good photos of every bird you see when digiscoping or you will probably be severely disappointed.

Although this technique provides enough information to help you get started with digiscoping, it covers only a few of the many tips and techniques that you will want to know to get good photographs. You can learn more about digiscoping from the excellent Internet-based resources noted in the following list. After some practice and more reading on the topic, you may even be able to get a photograph of a "difficult-to-shoot" owl, like the one shown in **Figure 32.7 (CP 32.7)**.

- Check out Laurence Poh's Web site (`www.laurencepoh.com`); he was one of the first to digiscope and is one of the leading experts on the topic.
- George Raiche's excellent Web site, (`www.digibird.com`), has information on high-magnification digital bird photography.
- The Digiscoping Links page (`www.angelfire.com/pe2/digiscoping/digiscoping_links.htm`) is a good Web site that lists some of the best links on digiscoping.
- EagleEye Optics (`www.eagleeyeuk.com`) offers many useful products for digiscopers.

- Wildbirds.com (`www.wildbirds.com`) is a good Web site to learn more about attracting birds to your backyard and how to feed them. It also has an excellent page that lists some of the best bird Web sites on the Internet.

If you have questions or would like to join an e-mail group for digiscopers, the digiscopingbirds group on `www.groups.yahoo.com` is an excellent one. To join, send an e-mail message to digiscopingbirds-subscribe@yahoogroups.com.

The end of this technique is also the end of this chapter. In the next chapter, you learn how to take a variety of landscape photos.

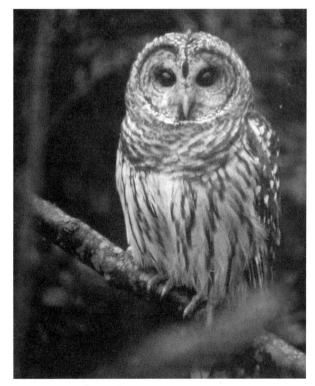

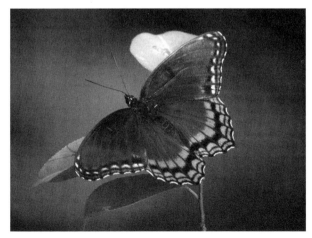

32.6 (CP 32.6) *© 2002 Melissa Whitmire*

32.7 (CP 32.7) *© 2002 Melissa Whitmire*

CHAPTER 7

"SCAPE" PHOTOGRAPHY

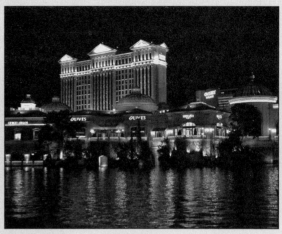

This chapter covers the topic of shooting "scapes." First, you'll learn how to photograph cityscapes in Technique 33. In Technique 34, you learn how to capture dramatic skyscapes in all colors. Photographing country landscapes with barns and farmhouses is the topic of Technique 35. If you have always wanted to be able to capture a beautiful panoramic view that exceeds your camera's widest angle view, Technique 36 will show you how to shoot multiple overlapping photos in a series that can later be digitally stitched to make a panoramic photo. Technique 37 gives you insight on how to take night or low-light photos. Taking "scape" photographs is great fun, as there can be so much variety in each scene as the sun moves across the sky and as weather conditions change.

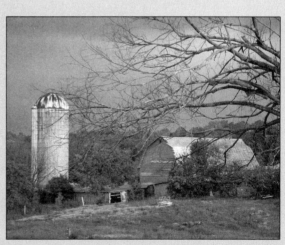

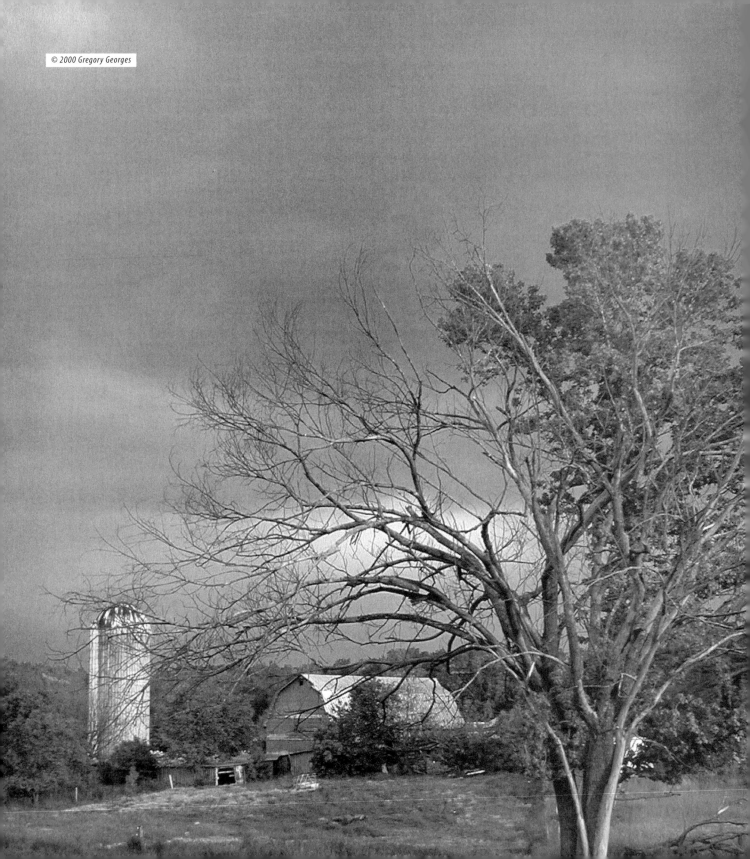

PHOTOGRAPHING CITYSCAPES

33.1 *Original image* © 2002 Gregory Georges

33.2 (CP33.2) *Edited image* © 2002 Gregory Georges

ABOUT THE IMAGE

"Waikiki Beach" Nikon CoolPix 950 mounted on tripod, zoom set to 111mm (35mm equivalent), f/4.0 @ 1/7, ISO 80, 1,600 x 1,200 pixels, 735KB .jpg

Cityscapes are constantly changing subjects that can be photographed at all times of the day and night. In early morning and late evening light, you can often get a photo of a city that glows due to the sun reflecting off the glass in the buildings, like the photo shown in **Figure 33.2 (CP33.2)**. During the day, you can shoot cityscapes filled with the bustle of traffic and people. Late at night, you can shoot with a slow shutter speed and record the bright trails of automobile lights as they move on the roads, as shown in the photo of Honolulu in **Figure 33.3 (CP33.3)**. Some cities, like Las

193

Vegas, have so much colorful light that when you shoot them at night, you get spectacular night colors like the rich reflected colors shown in the water in the photo shown in **Figure 33.4** (**CP33.4**). In this technique, you learn how to decide when to shoot cityscapes and how to get good photos of them.

STEP 1: CHOOSE DAY AND TIME TO SHOOT

- Depending on the city you choose to photograph, quite likely you can get successful photos no matter what time of day or night you shoot.

33.3 (CP33.3) © 2002 Gregory Georges

Generally, you will find that midday sun offers the least attractive light. As with all subjects, you want to consider carefully when the sun will provide the best light from your chosen vantage point. Some of the best views of a city may be seen from one direction only. If the sun sets behind a city (from your chosen vantage point), you may find that the best time to shoot that city is during daylight in the morning when the sun will be shining on the city — not from behind it, which would cause the buildings to be covered in shadows. Because many cities are often covered in haze (a nice word for pollution), you may get some excellent photos if you shoot right after a rain because rain clears the air and possibly provides a rich blue sky, too.

TIP

Sometimes a photograph taken with the sun behind the skyline can make a great silhouette, especially if the skyline is distinctive enough to be recognizable.

33.4 (CP33.4) © 1999 Gregory Georges

STEP 2: SET UP THE TRIPOD AND CAMERA

■ Choose a good place to set up your camera and tripod. When you've determined the city you want to shoot, decide what vantage point you want. Consider shooting from a balcony in a high-rise building, or from a bridge, as was done to get the photo of the city of Pittsburgh shown in **Figure 33.5**. A different vantage point from the more obvious vantage points will result in a more unusual photo.

STEP 3: CHOOSE CAMERA SETTINGS

■ Select the slowest ISO speed your camera offers (possibly ISO 80 or ISO 100). Choose aperture priority mode and set the aperture to its smallest setting (for example, f/8.0) to provide the greatest depth-of-field. Use automatic focus and try using a "matrix" or "evaluative" metering mode to meter the entire image.

STEP 4: CHOOSE FOCAL LENGTH

■ Generally, you want to use the widest-angle setting your camera offers when shooting city-scapes. However, you can take many successful cityscapes with a telephoto lens as well. If you are some distance back from the city you want to shoot, you can select one small portion of the city to shoot with a telephoto lens. Technique 48 shows a good example of using a telephoto lens to shoot landscapes.

STEP 5: COMPOSE AND TAKE PHOTOS

■ Use the composition tips offered in Technique 7 and look for creative ways to compose your photos in new ways. A beautiful city, perfect light, and the right camera equipment can all result in a not-so-good photo if your composition is not good. **Figure 33.6** shows a photo of a tall hotel in Las Vegas. To fill the frame, the camera was tilted to get the entire hotel in the frame. Experimentation is good.

33.5 © 2002 Larry Berman

33.6 © 1999 Gregory Georges

STEP 6: EVALUATE RESULTS AND MAKE SETTING CHANGES

■ As you shoot with a digital camera, take advantage of your camera's histogram (if your camera has one). Use the histogram in addition to the image on the LCD monitor to see whether your images are properly exposed. Varying the settings slightly, especially by bracketing exposure, is always a good idea to give you a choice between images when you later download the photos to your computer and view the images on a large computer monitor.

SHOOTING DRAMATIC SKYSCAPES

34.1 *Original image* *© 2002 Gregory Georges*

34.2 (CP34.2) *Edited image* *© 2002 Gregory Georges*

Many poets have sat and watched sunrises and sunsets and have been inspired to write award-winning poetry about what they witnessed. For centuries, great painters have painted with the rich colors of early morning and late evening sky. Now you can capture all the brilliant colors that are found in dramatic skyscapes. You simply have to press the shutter button on your digital camera to take a photo of a sky with rich blue colors, like the one shown in **Figure 34.2 (CP34.2)**, or

one with pinks and blues, like the photo shown in **Figure 34.3 (CP34.3)**. In this technique, you learn how to photograph dramatic sunrises and sunsets to get photos that will make excellent prints.

STEP 1: CHOOSE DAY AND TIME TO SHOOT

■ Many factors contribute to, or take away from, the beauty of a sunrise or sunset. Clouds are often the key to having a beautiful skyscape as they can reflect the glow from the sun in very stunning ways. Clouds can be so deep and low on the horizon that they can completely block a sunrise or sunset. The best time to shoot a sunrise can vary from twenty minutes before sunrise to an hour or two after sunrise. Likewise, some of the best sunsets occur in the range between an hour or two before sunset to twenty or thirty minutes after sunset.

As you gain experience in watching sunrises and sunsets, you'll learn that you must have time and patience. More often than not, photographers will leave a sunset scene just as the sun dips below

the horizon — what a mistake that can be! You can get some of the most beautiful sunset photographs by capturing the afterglow that can occur up to twenty or thirty minutes after sunset, like the one shown in **Figure 34.4 (CP34.4)**, where the sun had long before dipped below the horizon line in Maine. As the tide was out, the wet muddy bottom of the water reflected the brilliant colors of the sun adding even more color to an already colorful photo.

34.4 (CP34.4) © 2002 Gregory Georges

34.3 (CP34.3) © 2002 Gregory Georges

If you're in an unfamiliar place, or if you're in an area where seeing the sunset is hard due to trees or other visual barriers, you may want to purchase a compass to help you find a good place to shoot the sunrise and sunset. Trying to find where the sun will set can be surprisingly difficult when you're driving around in the middle of the day. If you have a compass, you can know well in advance of sunset exactly where the sun will drop, and you can be in the right place at the right time.

STEP 2: SET UP THE TRIPOD AND CAMERA

■ A sturdy tripod is required to shoot sunrises and sunsets. When you've decided when and where to shoot, set up your tripod and camera early so you're ready to shoot when the sky gets painted in rich colors.

> **TIP**
>
> If you want dramatic sunrise and sunset photos, you must choose the best days, get up early, be ready to shoot the sunrise 20 minutes before it is scheduled to come up, shoot often, and have patience. Depending on where you plan on shooting, good sunrises or sunsets may be rare or common. When you travel to shoot sunrises or sunsets, visit a Web site like `www.weather. com` to get a forecast for sunrise and sunset. You'll then know when to set your alarm so that you don't miss the sunrise and you will know the exact time for when you ought to be in position to take photos of the sunset.

STEP 3: CHOOSE CAMERA SETTINGS

■ Select the slowest ISO setting (for example, 80 or 100 ISO) your camera offers. Use auto focus and select auto white balance. Select aperture priority, then set the aperture to the smallest aperture (for example, f/8.0) and allow the camera to choose the shutter speed. If you don't normally use an image review feature (see Technique 4), you should turn it on when shooting sunrises and sunsets because doing so enables you to monitor how well you've exposed each shot.

STEP 4: COMPOSE AND TAKE PHOTOS

■ Use the tips you learned in Technique 7 to compose your sunset photos. Consider shooting both horizontally and vertically. **Figure 34.5** shows the same sunset shot in horizontal mode that was shot in vertical mode, shown in **Figure 34.4** (**CP34.4**).

If objects like trees are nearby, consider shooting to capture foreground items as a silhouette, as

34.5

© 2001 Gregory Georges

shown in **Figure 34.6**. To get the best silhouettes, you may have to experiment with the exposure by using exposure compensation. **Figure 34.7 (CP34.7)** shows the same trees and sunset shot in horizontal mode. Notice how much the sun lights the clouds from below in this picture. What was strange is that the sun had dropped below the horizon ten or fifteen minutes before this strong under-lighting of the clouds occurred. If I had left when the sunset dropped below the horizon, this shot would have been missed.

34.6 © 2001 Gregory Georges

> **TIP**
>
> If you take a photo every sixty seconds or so without moving your camera or changing composition, you can create an animation for a Web page that shows an entire sunset or sunrise by using layers and an image editing program like Adobe's ImageReady, which comes with Photoshop 7.

34.7 (CP34.7) © 2001 Gregory Georges

Technique 2
Choosing Image Quality Settings

Choosing the optimal image quality settings before taking photos is an important first step to get the photo that you want. Key settings include image resolution, file format, compression level, ISO setting, and file numbering.

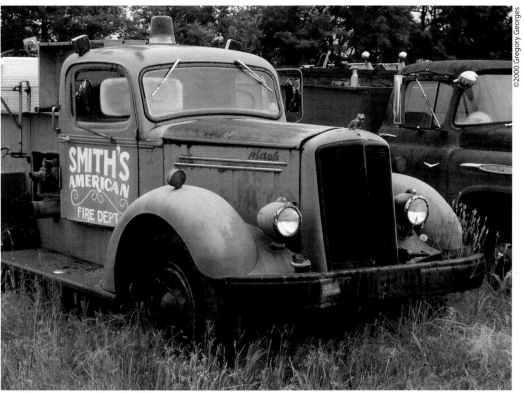

CP2.2

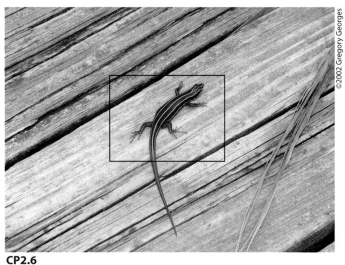

CP2.6

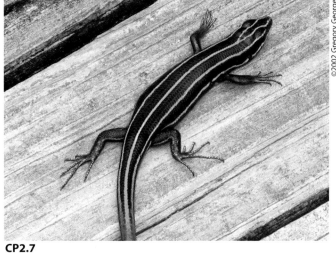

CP2.7

Technique 4
Taking and Reviewing Photos

Being able to take a photo and review it instantly is one major advantage digital cameras offer over film cameras. By choosing the right "preview" or "review" features, you can assess the technical and compositional aspects of your photos to see if you need to change settings and shoot again.

©2002 Gregory Georges

CP4.2

©2002 Gregory Georges

CP4.3

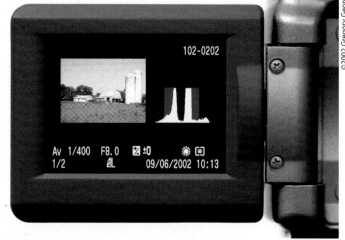

©2002 Gregory Georges

CP4.4

Technique 5
Changing Critical Settings Quickly

The best photo opportunities often come and go quickly. By learning how to check and change important settings (such as white balance) quickly you will get better photos taken at the perfect moment—more often.

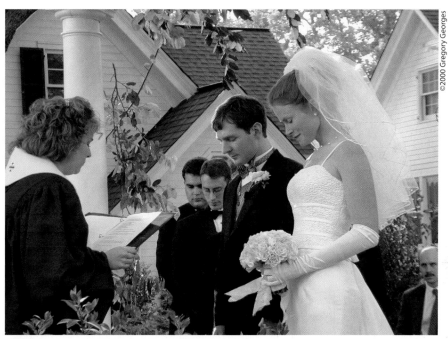

CP5.1

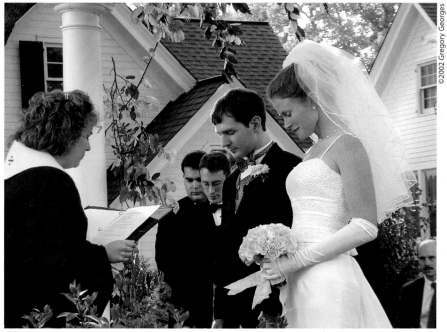

CP5.2

Figuring Out What To Shoot

Getting good photographs in common places is simply a matter of learning how to "see".
Look around for new and unusual subjects that will capture viewers' interest.

CP6.2

CP6.5

CP6.6

CP6.8

Composing Your Shots

The vision, which is the start of a good photo, is what is really important—the camera is merely the tool to get the photo—and composition is how the vision is presented.

CP7.2

CP7.3

CP7.7

CP7.12

Technique 9
Getting the Exposure You Want

One of the most frequent complaints about photos is that they are not properly exposed. Learn six steps that will help you get the "right" exposure—as often as is possible.

CP9.2

CP9.5

CP9.7

CP9.8

Using the Histogram

Does your camera have a histogram? If it does and you are not using it, you are missing out on a valuable tool to help you get a good exposure.

CP11.1

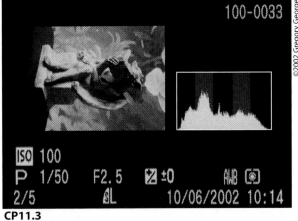

CP11.3

CP11.4

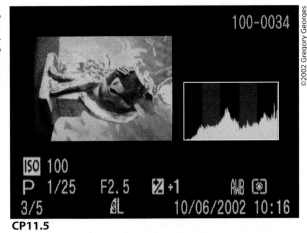

CP11.5

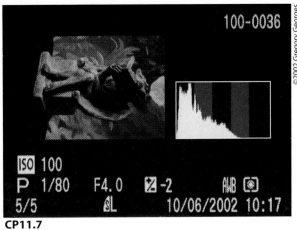

CP11.6

CP11.7

Technique 12
Using Exposure Compensation

Today's digital cameras have highly capable automatic metering systems. However, they don't always expose "correctly" or as you want. When that happens, exposure compensation is the feature to help you get the photo you want.

CP12.3

CP12.4

CP12.5

CP12.6

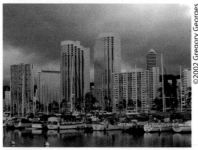

CP12.7

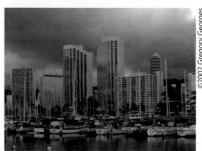

CP12.8

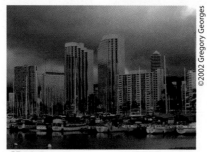

CP12.9

Using Exposure Lock, Metering Modes & Focal Points

Shooting a scene with a bright sky and a dark foreground is always a challenge. Learn how to use exposure lock, different metering modes, and focal point selection to get the exposure you want.

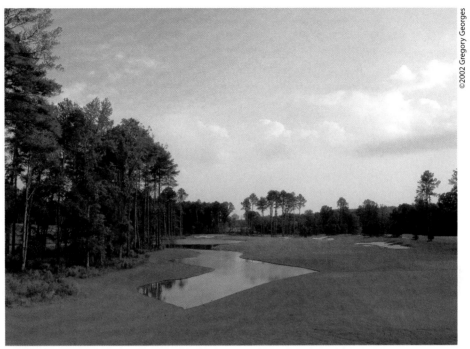

©2002 Gregory Georges

CP13.1

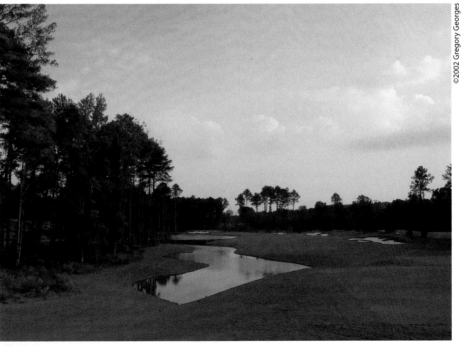

©2002 Gregory Georges

CP13.2

Using a Built-in Flash

A built-in flash has benefits and drawbacks as can be shown in these three sets of images. Learn when you should and should not use a built-in flash and your photos will improve dramatically.

CP15.1

CP15.2

CP15.3

CP15.4

CP15.5

CP15.7

Technique 19
Choosing Filters

If you use a digital image editor like Adobe Photoshop, you may not need many filters. However, protective filters, neutral density filters, infrared filters, and a polarizer can offer results you'll find worthwhile.

CP19.4 ©2002 Larry Berman

CP19.5 ©2002 Larry Berman

CP19.8 ©2002 Chris Maher

CP19.9 ©2002 Chris Maher

CP19.10 ©2002 Chris Maher

CP19.11 ©2002 Chris Maher

CP19.6 ©2002 Gregory Georges

CP19.7 ©2002 Gregory Georges

Technique 20
Choosing Photographic Lights

In order to get enough of the right kind of light, you may need to supplement the existing light with one of the many kinds of strobes. Learn how to choose one to suit your purposes.

©2002 Gregory Georges

CP20.2

©2002 Gregory Georges ©2002 Gregory Georges

CP20.3 **CP20.7**

Taking a Portrait for a Brochure

Do you need a good portrait for business purposes? Learn how to use flash and a dark background for a professional-looking portrait like these two photos.

©2002 Larry Berman

CP21.2

©2002 Larry Berman

CP21.4

Taking Great Kid Photos

Great kid photos are undoubtedly some of the most valuable of all photographs. Learn how to take good ones and they will be even more valuable.

CP22.3

CP22.4

Technique 28
Photographing Pets

When shooting family portraits—don't forget to shoot the pets—they are family too! Learn how to shoot all kinds of pets including the hard-to-shoot white dogs and black cats.

©1999 Gregory Georges

CP28.2

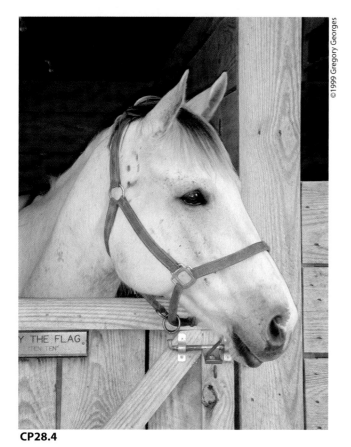

©1999 Gregory Georges

CP28.4

©2002 Gregory Georges

CP28.3

Taking Photos at a Zoo

Even though animals in zoos are often behind glass or in zoo enclosures, you can still get good animal photos. Learn how to get photos you can enjoy and share with others.

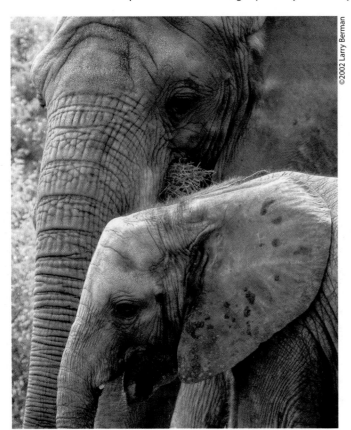

CP29.2

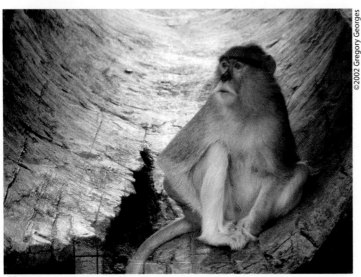

CP29.5

CP29.4

Using Macro Mode to Take Close-up Photos

Taking close-up photos with macro mode is both challenging and rewarding. Learn how to get the most from the macro mode on your camera and get awesome photos.

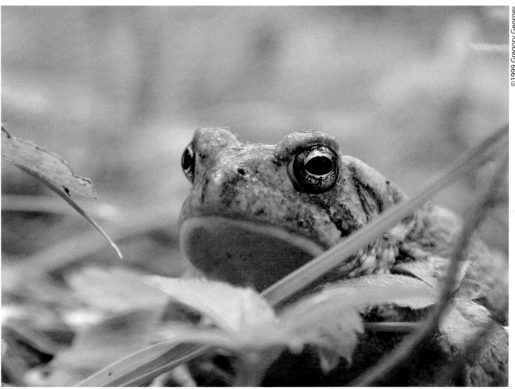

CP31.2

Taking Bird Photos Using a Digiscope

Did you know you can shoot some digital cameras through some birding scopes to get extremely long telephoto shots? These are a few photos that show you what you can get when you use a digiscope.

©2002 Melissa Whitmire

CP32.2

©2002 Melissa Whitmire

CP32.6

©2002 Melissa Whitmire

CP32.4

Photographing Cityscapes

Some cities are beautiful and their character changes as the sun moves from one side of the sky to the other. Try taking photos of cities near you during the day and the night.

CP33.2

CP33.3

CP33.4

Technique 34
Shooting Dramatic Skyscapes

With the right clouds and light conditions, you can get amazing photos of skyscapes. The photos shown here are good examples of the wide range of colors and clouds that can be photographed.

©1999 Gregory Georges

CP34.2

©2002 Gregory Georges

CP34.3

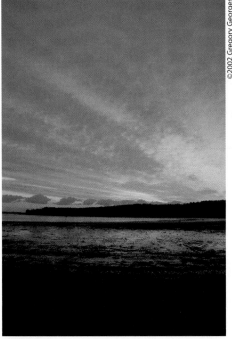

©2002 Gregory Georges

CP34.4

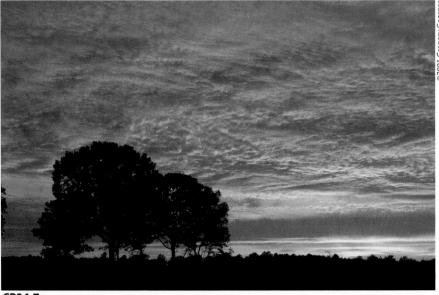

©2001 Gregory Georges

CP34.7

Technique 35
Photographing Country Landscapes

Finding the perfect landscape to photograph can result in many excellent images if you know how to compose them. These four photos show how a zoom lens was used to get four entirely different compositions.

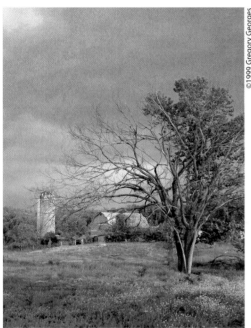

CP35.2

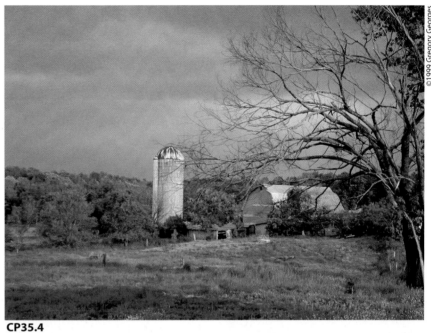

CP35.4

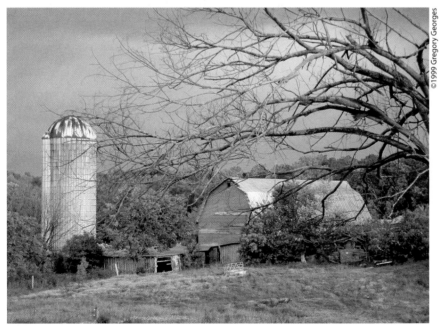

CP35.5

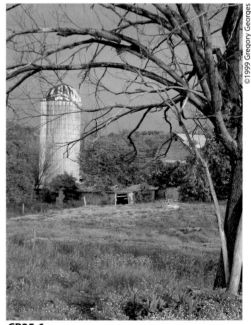

CP35.6

Technique 36
Taking Photos to Make Panoramic Landscapes

Have you ever looked with awe at a magnificent landscape scene and then wondered how you could capture the full expanse of the scene? Read this technique to learn how you can shoot multiple overlapping images and digitally stitch them into one wide panoramic photograph.

CP36.1a

CP36.1b

CP36.1c

CP36.1d

CP36.1e

CP36.1f

CP36.1g

CP36.1h

CP36.1i

CP36.2

Taking Night Photos

Some of the newer digital cameras are capable of getting night photos like the two shown here. Grab your tripod and camera and head out into the night to shoot night exposures—you may get photos you'll really like!

CP37.2

CP37.4

Making Photos for Online Auctions

Do you have things you'd like to sell on one of the online auction sites such as eBay? If so, this technique will show you how to get photos that will help you sell your products for "top dollar."

©2002 Larry Berman

CP39.2

©2002 Larry Berman

CP39.4

Taking a Photo of an Automobile

Are you proud of your car or do you need to have a photo for an online auto auction site? If so, this technique will show you how to get good photos of an automobile that will present your car in the best possible way.

CP41.2

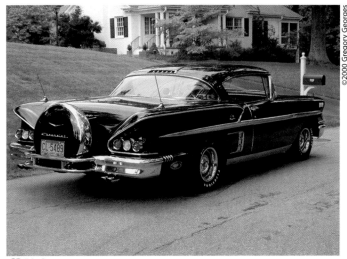

CP41.4

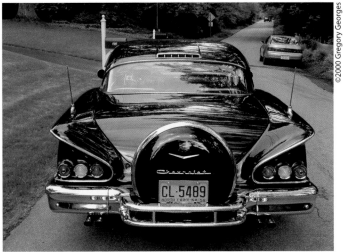

CP41.6

Technique 42
Shooting with Candlelight

If you have an hour or so and you want to take a few photos inside—try shooting still life with just the light of a candle or two. These photos show a few examples of what you can do if you use a tripod and just the light from a candle.

CP42.2

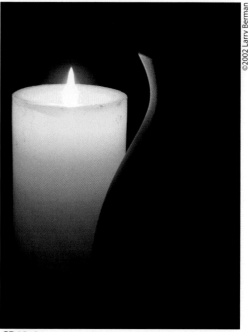

CP42.4

CP42.5

Technique 43
Taking Photos for Digital Manipulation

Once you step into the world of digital photography, you don't always have to think of shooting each and every photo to be realistic. Sometimes, you can shoot a subject or a scene to be later digitally manipulated with an image editor to get an entirely different kind of image.

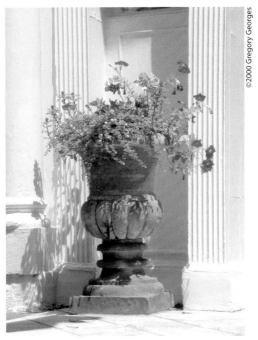

©2000 Gregory Georges

CP43.1

©2001 Gregory Georges

CP43.2

Technique 44
Shooting Colorful Still Life Photos

Are you creative and do you have some paint and a few cool "found objects"? Larry has a whole collection of found objects, which his wife paints to be used for props for their popular still life photographs that are sold at art shows. Get out the paint and try this technique—you'll maybe get hooked on doing painted still life!

©2002 Larry Berman

CP44.2

©2002 Larry Berman

CP44.3

©2002 Larry Berman

CP44.4

Shooting High-key and Low-key Photos

Two familiar techniques to professional photographers are the "high-key" and "low-key" lighting set-ups. Learn a few tips on how to take both of these kinds of photos with your digital camera.

CP45.2

CP45.3/45.7

Technique 48
Shooting Landscape Photos with a Telephoto Lens

Next time you are looking at a wonderful landscape—consider using a telephoto lens to capture just a tiny piece of the landscape instead of using a wide-angle lens. This photo of a country farm was taken with a polarizer to deepen the blue sky and to increase contrast. It even makes a good black-and-white photo.

CP48.2

CP48.4

Technique 49
Isolating a Flower from Its Background

Isolating a flower from its background is a technique that can be used to create wonderful impressionistic images like the one shown here. Learn how to choose the right camera settings and how to set up your camera to get photos like this one.

CP49.2

Technique 50
Photographing Sports Action

Getting good sports action photos can be challenging with today's compact-level digital cameras. These photos, which were taken with a digital SLR and a 300mm lens are good examples of what can be done with the more capable "prosumer" digital cameras.

CP50.2

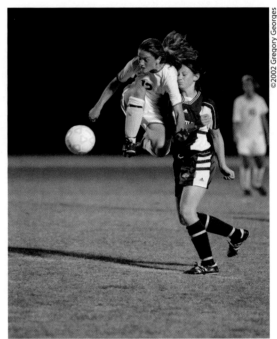

CP50.4

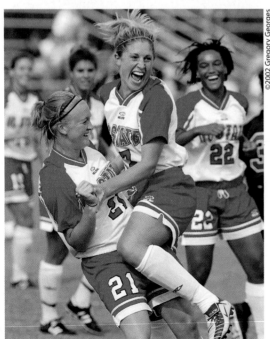

CP50.3

STEP 5: EVALUATE RESULTS AND MAKE SETTING CHANGES

■ Because sunrises and sunsets can often mislead the automatic metering systems found on digital cameras, which can result in a poor exposure, make sure that you check exposure when you shoot by looking at the images on the LCD monitor or by using the histogram. In those cases where you need to make an adjustment, use exposure compensation. You can learn more about exposure compensation in Technique 12. Slightly underexposing can make the colors of a sunrise or sunset richer than if they were overexposed.

WARNING

The most beautiful part of a sunrise or sunset may only last for less than a minute or even just a few seconds. Be careful not to be caught short of space on your digital photo storage media when you are shooting a quickly changing sunrise or sunset or you may miss the best part.

TIP

Metering the sky at sunrise or sunset can be difficult. A good starting place is to meter the sky near, but not including, the sun, and use that as a starting point for bracketing (exposure variations). If your camera has an auto bracket feature, this would be a great time to experiment with it.

PHOTOGRAPHING COUNTRY LANDSCAPES

35.1 *Original image* © 2000 Gregory Georges

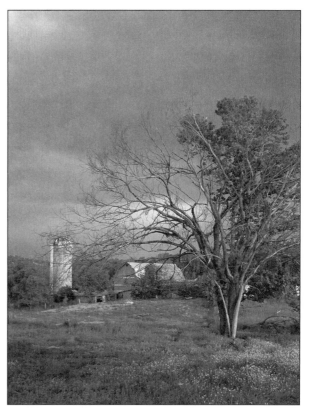

35.2 (CP35.2) *Edited image* © 2000 Gregory Georges

Barns, grain silos, rolling hills, plowed fields, tractors, and grassy fields make excellent subjects for photos. When you have a few hours, take a drive out to the countryside to take a few photos. If you're there at the right time, you may be able to shoot in the "golden glow" that is frequently found out in the country around sunset, as shown in the photo in **Figure 35.2 (CP35.2)**. Not only will you have a pleasant drive, but chances are good that you'll also get some good photos. In this technique, you discover how to take photos of the countryside that you'll be proud to share with others.

203

STEP 1: CHOOSE DAY AND TIME TO SHOOT

■ More often than not, you can get the best photos of the countryside a few hours before sunset to twenty minutes or so after sunset. Sunlight coming in from a low angle often casts a wonderful warm golden glow to the surrounding area. Besides shooting toward the sunset, remember to turn around and shoot behind you, too, because that is where the warm light will be shining.

Part of the challenge in getting a good countryside photo is knowing where you ought to be and what you should shoot — and being there when the best light occurs. When you find a good place to shoot, have patience, set up your tripod and camera, and wait for the light. You can easily find yourself driving all around and then not being near a good place to shoot when the light gets good. When possible, make your trip to the countryside when the weather is changing or when there are rich blue skies and many white clouds.

The days where you are likely to get the least good landscape photos are days where the sun is bright or you have bright white skies. Unless you're able to shoot without including the bright sky in the photo, you will be better off to wait and shoot on a day where you have blue sky or blue sky and white clouds, as shown in the photo in **Figure 35.3**.

STEP 2: SET UP THE TRIPOD AND CAMERA

■ After you determine what you want to shoot, then decide where to set up your tripod and camera. If you just pulled your car off to the side of the road, where it was safe and convenient to park, you may not be in the best place to take photographs. Grab the camera gear you need and walk if a better place to shoot is nearby. Many amateur photographers take photos within a hundred feet of the roadside where they parked their car, and they miss getting a better photo because they were too eager to shoot or too lazy to walk to a better place.

■ Also consider setting up your tripod and camera where you can include some foreground in the photo; notice how the tree in the foreground

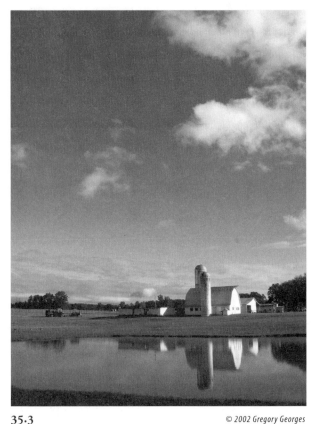

35.3 © 2002 Gregory Georges

shown in **Figure 35.2 (CP35.2)** helps to frame the image. Without this tree, the photo would be much less interesting. If a tree isn't nearby, consider shooting tall weeds or part of a wooden fence to give your photo some depth and scale.

STEP 3: CHOOSE CAMERA SETTINGS

■ When shooting landscapes of any kind, you usually want to use the slowest ISO setting your camera offers. Use auto focus and "matrix" or "evaluative" metering. Choose auto white balance unless the sky is full of dark clouds; then choose a white balance for shooting under cloud cover. Choose aperture priority and set the aperture to the smallest setting (for example, f/8.0) and allow the camera to choose the shutter speed.

■ After the camera has chosen the shutter speed, decide whether you can shoot without a tripod. If you're shooting in bright sun and the camera has chosen a shutter speed that is faster than 1/200, you can *maybe* get by without setting up a tripod. After you get used to using a tripod for all your landscape shots, you will find your photos are more sharply focused and better composed. Lazy photographers generally get fewer good pictures.

STEP 4: CHOOSE FOCAL LENGTH

■ When you're out in the country and looking at a wide expanse of land and trees and sky, the natural tendency is to shoot with your camera lens set to the widest angle. However, you can also get good landscape photos with focal lengths that are

longer than the minimum focal length that your camera offers. If you have a reasonably long telephoto lens, try selecting a small portion of the landscape to shoot. Technique 48 shows you how to get a wonderful landscape photo with a telephoto lens. Be creative and experiment.

STEP 5: COMPOSE AND TAKE PHOTOS

■ As you compose your photo, pre-visualize the effect of all of its elements. Consider the foreground, midground, and background. Note how objects such as trees, barns, and fences relate to each other. Composition is extremely important, and poor composition can ruin an otherwise beautiful scene. To learn more about composition, read Technique 7. Should you shoot vertically or horizontally? Should you zoom in or should you

> **TIP**
>
> Traveling to a good location to shoot photos takes time and money. Because it does not cost anything to shoot many photos when you are using a digital camera, shoot as many as you need when you are there. Many amateur photographers think they have one or two good photos and they leave the site only to find out later that they really did not get the photo they wanted. Try composing in many different ways and vary the exposure settings to ensure that you'll have a choice of photos and improve your chances of having a perfect one.

use maximum wide angle? These questions are just a couple that you'll need to answer as you compose and take photos. **Figures 35.4 (CP35.4), 35.5 (CP35.5),** and **35.6 (CP35.6)** show three variations of the same dairy farm shown in **Figure 35.2 (CP35.2)**. Which one do you like best?

STEP 6: EVALUATE RESULTS AND MAKE SETTING CHANGES

■ After you've taken a few photos, look carefully at the images on your camera's LCD monitor and review the histogram if your camera has one to make sure you are getting a good exposure. If you need to alter the settings and you are using an automatic exposure setting like aperture priority, try making the needed adjustments using the exposure compensation feature. To learn more about using exposure compensation, read Technique 12.

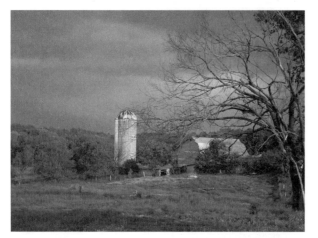

35.4 (CP35.4) © 1999 Gregory Georges

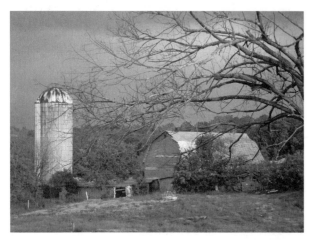

35.5 (CP35.5) © 1999 Gregory Georges

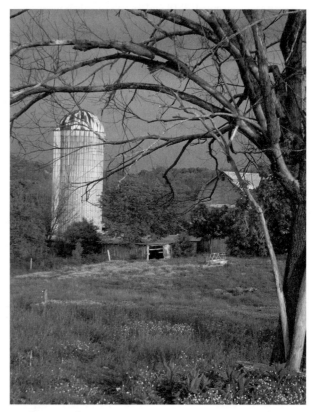

35.6 (CP35.6) © 1999 Gregory Georges

TAKING PHOTOS TO MAKE PANORAMIC LANDSCAPES

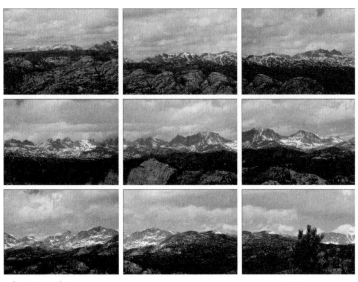

36.1 (CP36.1) *Original image* © *2000 Gregory Georges*

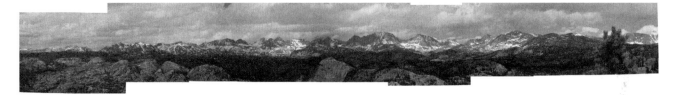

36.2 (CP36.2) *Edited image* © *2000 Gregory Georges*

One of the most exciting things about working with digital images is that you can digitally stitch them together using special "stitching" software to create vertical or horizontal panoramic photos. The nine photos shown in **Figure 36.1 (CP36.1)** were taken with a Nikon CoolPix 950 digital camera and then digitally stitched to make the photo shown in **Figure 36.2 (CP36.2)**. The resulting image is 9,520 × 1,499 pixels in size and it makes a wonderful 40 × 6.24-inch print at 240dpi — way beyond what you could get shooting with a 35mm film camera or a wide-angle lens. If you haven't made a panorama yet, try making one soon — it is great fun!

STEP 1: SET UP THE CAMERA AND TRIPOD

■ When you've decided where you want to shoot, set up your tripod and mount your camera. When shooting panoramas, having a tripod head that allows you to pan the camera without the possibility of moving in the other two axes is nice. If you have a pan-tilt head, and you plan to shoot many panoramic photos, you may want to consider getting a panoramic base for your head. Alternatively, you can purchase a ball head that has a separate panning control like the Manfrotto 488RC2 Midi Ball Head, shown in **Figure 36.3**. The lever on the right locks the panning motion.

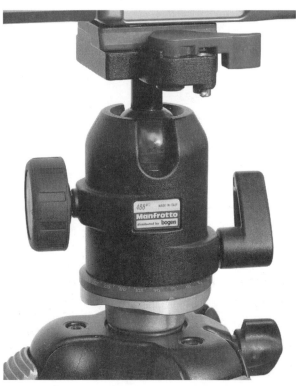

36.3 © 2002 Gregory Georges

STEP 2: CHOOSE CAMERA SETTINGS

■ If you are using a camera that has a zoom lens, you can set it to any focal length that you desire to get the composition that you want. However, if you are using a lens that has some distortion, choose a focal length that is not distorted (maybe a mid-range focal length). Avoid using extremely wide-angle focal lengths and fisheye lenses.

> **NOTE**
>
> Although it's much easier to make a panorama from images shot on a tripod, you still can get good results without one if you use the right camera settings, take care to hold the camera carefully, and shoot from the same position. A tripod was not used to take the nine photos shown in Figure 36.1, because one was not available. However, great care was taken to shoot the camera from the same place and to hold it steady to avoid blurring the image. One disadvantage to handholding a camera is that it is likely that the image will have to be cropped to make it rectangular, which can considerably reduce the size of the image.

> **TIP**
>
> Getting your camera level to shoot a series of images for a digitally stitched panoramic photo can be challenging. To make the process of leveling the camera easier, consider purchasing the Hama camera spirit level, shown in **Figure 36.4**. While it is a costly product at $40, it takes the hassle out of leveling the camera — just insert it into your camera's flash shoe, if your camera has one — and use the two bubbles to level the camera.

Depending on your camera, you may be able to take either of two different approaches when shooting photos for panoramas. If your camera has a panorama mode, you can select it, and the camera will choose the rest of the settings for you. Many cameras that have a panorama mode allow you to see how much you are overlapping images by showing the previous photo on the LCD monitor next to the one you are currently composing. Such a feature makes shooting a series of overlapping images easy. For example, the Canon PowerShot G2 has a Stitch Assist Mode that not only helps you overlap images, but also has different settings for taking photos horizontally in either direction, or vertically in either direction, as well as clockwise if you want to overlap photos in a 2 × 2 square.

The other approach is to choose the manual shooting mode so that each photo has the same exposure. This approach is more challenging, but it can yield excellent results.

■ After choosing the lowest ISO setting (to avoid digital noise), set the aperture to the smallest setting to maximize depth-of-field. Now look across the area that you will shoot and determine an area that has an average exposure. For example, in **Figure 36.2 (CP36.2)**, the middle portion of the image is the average exposure. The right side is slightly darker than the extreme left side. After you find an area with a good average exposure, compose a photo on that area and adjust the shutter speed until you get the exposure you want. Because you are shooting in manual mode, this exposure setting will be used for the entire set of photos.

If you don't use manual mode or a mode that has been created especially for taking panoramas, and there is variance in light levels across all the images, stitching software may not be able to blend the photos — one image may be noticeably darker than the image next to it. This is also the reason you want to find an average exposure and lock it in before shooting the series. Otherwise, you may start by underexposing the first part of the panorama and end up with an overexposed part as you get to the opposite end.

STEP 3: COMPOSE AND TAKE PHOTOS

■ After your camera is set up and you're ready to shoot, begin by composing your first shot from the left. If you start from the left, your image files will be numbered in the order that you shot, which makes picking out the images that you took for a panorama easier.

When shooting, overlap each image by 15% to 40% so that the stitching software has sufficient image to use to align one image with the next image. If the images overlap by more than 40%, the blends may not be as good as they would be if there were less overlap. You also should compose the photos (when possible) so that the overlapping areas have distinctive items in them, such as a tree or a rock. These items make matching the images easier for the software. After you have taken one photo, do not change the focal length by zooming. If you do, the images will not be able to be stitched.

36.4

STEP 4: EVALUATE RESULTS AND MAKE SETTING CHANGES

■ After you have taken all the photos in a series that you want, take some time to look back over them to see whether they are properly exposed and that they overlap as they should. If you have enough empty space on your digital photo storage media, you may want to vary the exposure setting slightly and shoot the series again. Shooting again won't take much time compared to the amount of time you took to set up.

WARNING

When shooting photos to be digitally stitched together, be mindful of the fact that if parts of the scene are moving, the movement may make combining the images difficult for the stitching software, or the movement may result in less-than-perfect images. Fast-moving clouds or waves on a seascape are good examples of things that can make stitching images together difficult or impossible for stitching software.

STEP 5: USE DIGITAL STITCHING APPLICATION TO CREATE PANORAMA

■ After you have taken a series of photos and have downloaded them to your computer, you're ready to stitch them together to create a panoramic photo. Quite a few software applications exist for digitally stitching images. Adobe's Photoshop Elements 2.0 has a feature called Photomerge, which can stitch images together all the way up to a full 360 degrees.

Many digital cameras come with a stitching application. Canon, for example, ships PhotoStitch with many of its cameras including the Canon G2. **Figure 36.5** shows a screenshot of the nine photos of the Wind River Mountain range just after they were merged using PhotoStitch.

If you want to learn more about creating panoramas, James Riggs has created an excellent Web site dedicated to "photographers interested in panoramic photography achieved by manipulating a sequence of pictures taken with a conventional (non-rotating) camera." It includes lots of useful tips, software reviews, and galleries. You may visit his site at www.panoguide.com.

If you want larger digital photos, you may not have to buy a camera with more pixels. Consider taking several photos and digitally stitching them into one image. **Figure 36.6** shows a screenshot of Photoshop Elements 2.0's Photomerge feature. The four photos of fall leaves were taken with a Canon PowerShot G2 and then stitched together using Photoshop Elements

2.0. The resulting file is 3,266 × 2,499 pixels. This is the equivalent of a file from an 8 megapixel camera! You can find this file in the **/chap/07/36** folder on the companion CD-ROM. It is named **4photos.tif**. Open the file and see whether you can tell where the images were joined.

36.5 © 2002 Gregory Georges

36.6 © 2002 Gregory Georges

TAKING NIGHT PHOTOS

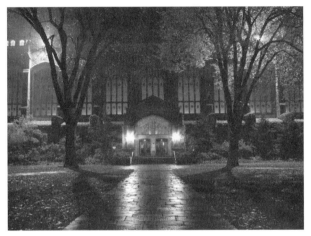

37.1 *Original image*

© 2002 Chris Maher

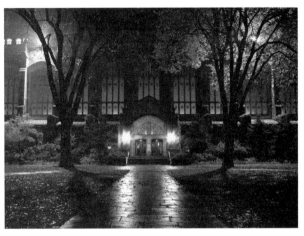

37.2 (CP37.2) *Edited image*

© 2002 Chris Maher

It is a different world when the sun goes down. Streetlights come on and windows begin to glow with inviting warmth as is shown in the photo in **Figure 37.2 (CP37.2)**. Don't put your camera away at the end of the day; instead, take it out into the night and shoot time exposures. Ordinary subjects such as cars and trees will be bathed in light of unexpected colors, and the light sources themselves will become brilliant spots of light. Using a digital camera, you can instantly review the result of each shot to make sure your exposure is just right, and you can take advantage of the intriguing color shifts that the different light sources provide.

WHAT EQUIPMENT DO YOU NEED?

First on the list of equipment you need is a digital camera that allows you to take long exposures. Earlier digital cameras tend to create "digital noise" when exposures became too long. Their CCD or CMOS sensors would record large numbers of colored or light pixels in dark areas of the pictures.

Many of the newer digital cameras have noise-reduction technologies built in, such as dark frame subtraction and luminance control. With dark frame subtraction, the camera immediately records a second exposure after the first, but without opening the shutter. The camera then subtracts the values of all the noisy pixels, yielding a remarkably clean night shot. This process takes double the time it takes to make a picture, but the results are well worth the short delay.

One particularly good digital camera for taking night photos is the Sony Cyber-shot DSC-F717, which is a 5-megapixel camera that incorporates several superior technologies for shooting in low light. It has Clear Color and Clear Luminance Noise Reduction, as well as dark frame subtraction. It also has a NightFraming mode that projects a holographic infrared pattern to focus in total darkness (the picture is then exposed with the on-camera flash), and a NightShot infrared illumination system for exposing infrared pictures, which can be taken using no visible light at all!

You also need a good tripod to keep your camera steady during the long exposures that you will be making. An off-camera flash can yield some interesting effects as well. Bring extra batteries for your camera, because long exposures and constant viewing of your LCD monitor will use plenty of power. Carrying a small flashlight can be useful for seeing your camera's dials and buttons in the dark.

STEP 1: CHOOSE LOCATION

■ Choose a location where you might find some interesting night shots. A downtown area offers plenty of artificial lights, neon colors, and reflective surfaces. If you shoot after a rain, the sidewalks and roadways can become rivers of reflected color. A quiet walk down deserted streets can be a source of great discovery. You can also get night photos shooting in a country setting, too. Nearby towns light up the distant sky, and a quiet graveyard at night can be the scene for many powerful images. Try shooting in the light from a full moon when the sky is clear. You'll be surprised at how much light the moon will provide in a country setting.

STEP 2: SELECT CAMERA SETTINGS

■ Set your camera to manual exposure mode, and set your f-stop to about the middle of its range. Your shutter speed will widely vary; begin at a one-second exposure for the first test. Many cameras will automatically turn on noise reduction when exposures are long. If you have to manually turn on noise reduction, do so now. Set the ISO setting to the slowest speed to minimize digital noise. Also, begin by setting white balance to auto; you can adjust that setting later when you see how your camera reacts to different kinds of light. If your camera has a hard time focusing, you can switch your camera to manual focus.

STEP 3: CHOOSE INTERESTING SUBJECTS

■ Look for a strong composition, because each of the light sources that appear in your picture will vie for the viewer's attention. If key parts are in shadows, you may want to use an off-camera flash to "paint" some light into the dark areas. Watch out for areas of extreme contrast — you won't be able to capture detail in brightly lit windows and in deep shadows, so compose accordingly. Moving objects, such as cars, will leave streaks of light as they go by — red from their taillights, and white from their headlights. People won't show up if they are moving through the frame during a long exposure; if they stop, they may look like ghosts.

Figure 37.3 and Figure 37.4 (CP37.4) show two photos that were taken on a college campus at night. Notice the eerie colors that appear around the statue in the first photo, and how the bright lights contrast with the otherwise extremely dark building in the second photo.

STEP 4: SHOOT TEST EXPOSURES

- Shoot a few test exposures, beginning with a full second exposure and f-stop set midway. If the photos are underexposed, increase the length of time the shutter is open and open the lens a stop or two. Alternatively, if your first shot is way overexposed, close the aperture down to f/8 or more if your camera allows, and reduce the shutter speed. Getting the right exposure may take several attempts, but shooting, checking the image on the LCD monitor, and trying again is the process that will get good results. If you reach the maximum exposure time your camera is capable of, and still need more light, you can increase the ISO speed of your camera. However, don't always try for the shortest exposure time; long exposures give you more freedom to experiment with light painting and allowing motion to have an effect on your subjects.

37.3 © 2002 Chris Maher

STEP 5: EXPERIMENT WITH DIFFERENT SETTINGS

- Adjust your color balance setting and see how it affects the pictures you take. There is no one right setting, because you will be shooting subjects that are lit by multiple light sources, and the sodium vapor and mercury vapor streetlights may put strong color casts in your picture no matter what camera settings you've used. However, changing the color balance can have an effect, and you can judge which settings work best in each unique shot. You can also experiment with slow shutter

37.4 (CP37.4) © 2002 Chris Maher

synchronization with your flash. This setting fires your camera's flash unit at the end of a long exposure and can give some interesting effects when people are walking by.

STEP 6: SHOOT MORE PICTURES

■ Let your experience guide your initial exposures after you finish testing, and put more of your thought into the creative aspect of your images. Try walking into one of your shots as it is exposing, and holding a pose for a percentage of the shot. You will be a semi-transparent ghost! Use some colored cellophane or colored light gels to color your flash and add some saturated color to the scenes you compose. Review each shot on your LCD monitor after you take it, and then adjust your exposure and composition as needed.

<div style="border:1px solid black; padding:10px;">

TIP

One of the fun things you can do when you shoot long exposures at night is to "paint" light into your picture. Just take a flashlight and, after your exposure begins, shine the beam around areas you want to lighten up; the cumulative exposure will brighten those areas. If you cover your light with a deeply colored filter, you can add rich, saturated accents, as well. You can also add light with a flash unit — just walk around during your long exposure, and manually pop it at parts of your scene — each flash will be recorded in the long exposure. Amazingly, you can even walk around in full view of your camera's lens during a long exposure adding light here and there, and if you wear dark clothes, you won't even show up in the final picture! Lightly colored cellophane or lighting gel material will let you add a touch of color wherever you choose to shine your colored light.

</div>

CHAPTER 8

TAKING STILL-LIFE, ART, AND AUCTION PHOTOS

© 2002 Larry Berman

S till-life photography can be used to sell products or it can be seen as art in its own right. If you enjoy being able to control light, arrange objects, and select backgrounds to create your own still-life photographs, then read Technique 38 to find out how to shoot still life on a table. If you sell things on an online auction site like eBay, then Technique 39 will be useful for showing you how to take good product shots. Technique 40 covers the tips and techniques you need to know to get good shots of flat fine art. Technique 41 is for those who want to capture the beauty of a fine automobile.

© 2000 Gregory Georges

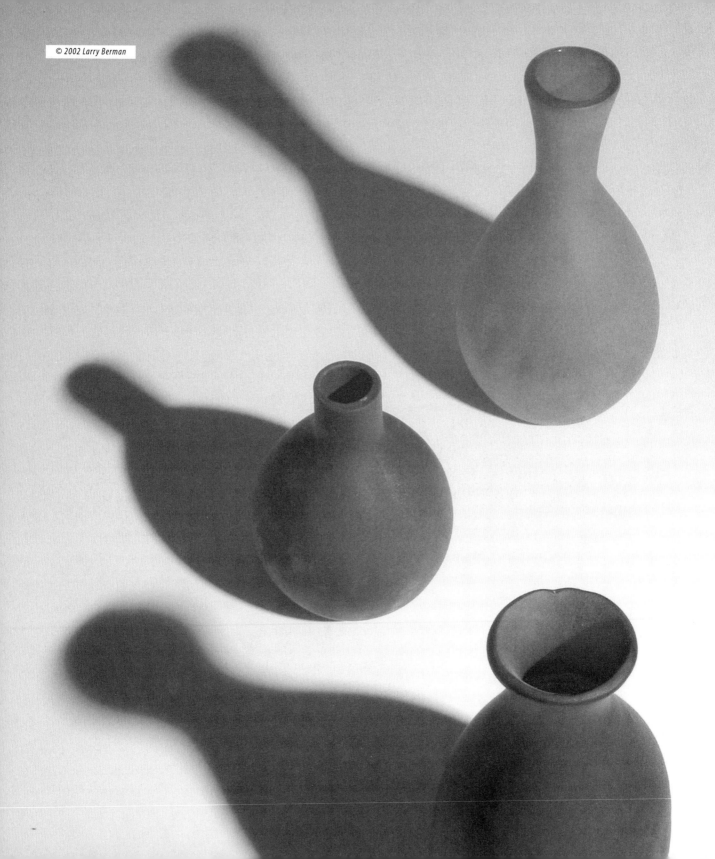

USING OFF-CAMERA FLASH FOR STILL-LIFE PHOTOS

38.1 *Original image*

© 2002 Larry Berman

38.2 *Edited image*

© 2002 Larry Berman

It won't take more than a few shots with your camera's built-in flash for you to note that the quality of light it produces is harsh and flat. Built-in flash also has the tendency to overexpose foregrounds and underexpose backgrounds, as well as create strong unpleasant shadows behind subjects. In this technique you learn how you can greatly improve the effects of artificial light by using a flash that is independent and removed from the camera. You can easily modify the light output, either by bouncing it into a white umbrella, off a white reflective surface like foam board, or even off a wall or ceiling. Controlling the direction off-camera light is simple, and you can use it to emphasize the

subject's colors, shape, and texture as is shown in **Figure 38.2.** Moving the flash to any number of positions relative to the subject is also possible; experiment to see how each direction change affects the dimensionality of your subject.

In the following steps you learn how to create a basic shooting "set" to photograph a simple still life using a single flash unit on one side. Find a couple of glass bottles or fancy wine glasses and experiment with the light as you follow these steps.

STEP 1: CREATE A BASIC SHOOTING SET

■ Begin by creating a set on which to photograph your still life. Move a table next to a wall. Lay a piece of white mat board or foam board on the top of the table. This board will become your shooting platform. Place an additional board up against the wall. Now position the camera and adjust the zoom lens so the viewfinder just covers all the white area.

If you plan to shoot objects that are tall, consider constructing your set on the floor instead of a table. This height allows you to work at a more comfortable and better shooting angle than if you had to extend your tripod and maybe even stand on a chair to see the LCD monitor.

TIP

A simpler but more costly way to create a background is to purchase a roll of *53" or 107"* wide white "seamless" paper at a camera store. Tape or tack it to the wall behind the table and let it roll down and across the table, leaving a gentle curve so there is no rear edge line where the wall and table meet.

STEP 2: POSITION OBJECTS TO PHOTOGRAPH

■ Now you can get creative. Place the objects on the set, taking into account the way the shadows will fall and the relationship of objects to each other. Refer to Technique 7 to review some basic composition tips.

STEP 3: SET UP A LIGHT

In Technique 39, you learn how to use a two-light setup for shadowless product illumination. However, for this side light technique you will work with only a single light source.

■ Begin by mounting the flash on a light stand and set it to the side of your table. You can use an adaptor like the Bogen Swivel Umbrella Adapter #2905 (`www.bogenphoto.com`) shown in **Figure 38.3,** which costs about $30, to attach an inexpensive white umbrella and your flash to a light stand.

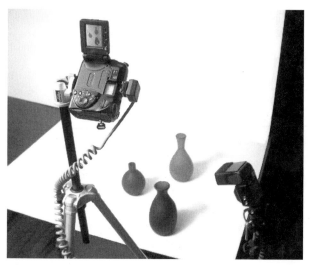

38.3 *© 2002 Larry Berman*

■ Next, connect your flash unit to your digital camera. Some manufacturers, like Nikon, make proprietary connectors that require special adapters or flash cords. For example, Nikon's cords are the SC-17, SC-18, and SC-19, and the shoe adapter is the AS-10. Check your user manual, or the Web site of the company that made your camera, to see which cords and adapters are needed for the particular model of camera you own.

STEP 4: POSITION THE CAMERA AND SELECT CAMERA SETTINGS

■ Attach your camera to your tripod. Adjust the height and angle to eliminate any background and keep the composition simple. If the camera has an LCD monitor that folds out, adjust it so you can clearly see the composition as you move your camera. If the LCD monitor does not move independently of the camera body, you may have to stand on a stool or chair to get a good look at it as you work to create a balanced composition.

■ Adjust the camera's exposure mode, choosing manual exposure. This exposure allows you to modify the exposure to match the light being produced by the flash unit. Select a high shutter speed setting, like 1/1000 of a second. This setting reduces the effect of any ambient light in the room. Next, adjust the aperture setting to a middle f-stop, such as f/5.6. You will be opening up or closing down the aperture depending on the results of the first few test shots. If you are shooting very small items, or need to get in close for good composition, you may want to shoot in macro mode.

If your flash has adjustable output settings, you will have much more control over the depth-of-field (the area that will be in sharp focus) in your picture. Reducing the light output allows you to use a wider aperture (smaller numbered f-stop), letting you selectively focus on a specific part of your subject and allowing other parts to be softly out of focus. Increasing the amount of light from your flash unit allows the aperture to be closed down (larger numbered f-stop), which increases the depth-of-field.

STEP 5: SHOOT AND REVIEW

■ Now shoot a few test photos. Because you are shooting in manual exposure mode, bracket the exposures by adjusting the f-stop or flash output power level, using flash exposure compensation. To get the best review of your photos, download the image files to a computer and check the composition, focus, and exposure.

STEP 6: REPOSITION SUBJECT, LIGHT, AND CAMERA FOR EXACT COMPOSITION

■ After reviewing the images, make adjustments where deemed necessary. Make changes to your composition by moving the objects on the set

> **NOTE**
>
> Unlike film cameras with focal plane shutters, most consumer digital cameras with electronic shutters can synchronize with a flash unit at any shutter speed. The advantage of using a high shutter speed with a flash unit is that it reduces or eliminates any effect the ambient (available) light in the room may have on the picture.

and adjusting the light. For example, to keep the shadow from falling outside the frame, raise the light slightly. Doing so shortens the shadow and possibly improves the composition. If you are shooting more than one object and their shadows are overlapping, separate them slightly and shoot again. If the color of the objects is too dark, adjust the exposure either by changing the f-stop or the power setting on the flash. Again, check your pictures on the LCD monitor. For a more precise check, download them to your computer for review. You may make a few trips back and forth between your shooting set and your computer, but with each set of photos, you should see continued improvement.

STEP 7: TAKE YOUR FINAL SHOT

■ When all the camera settings are correct and you like the position of the objects, the camera, and the light, take your photo — and that's it! You will have created a fine still-life photo and will be on the way to even more interesting pictures.

MAKING PHOTOS FOR ONLINE AUCTIONS

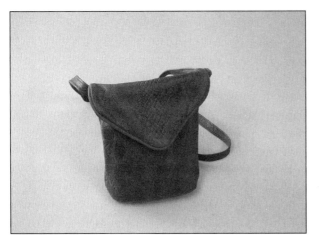

39.1 © 2002 Larry Berman

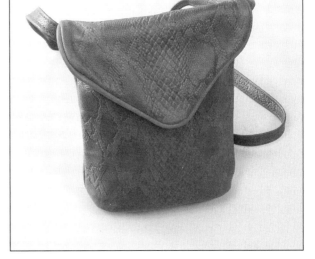

39.2 (CP39.2) © 2002 Larry Berman

ABOUT THE IMAGE

"**Leather Handbag**" Nikon CoolPix 990 mounted on a tripod, zoom set to 51mm (35mm equivalent), f/3.0 @ 1/120, ISO 100, 2,048 x 1,536 pixels, 1.2MB .jpg

Online auction sites like eBay are enjoying increasing popularity. Some people earn a good living by buying and selling things on online auctions. Everyone has something that is taking up room in the house that could be sold online for quick cash. How about those old-fashioned film cameras you have lying around?

What makes some auctions successful, while others don't get a single bid? The overwhelming evidence suggests that the most successful auctions all have one thing in common — they all have good pictures. If you enjoy online auctions and would like to be a more effective seller, this technique is for you. You will learn each step that you need to take photos that make your items stand out from the others so that they appeal to buyers.

WHAT CAMERA GEAR DO YOU NEED?

You can get reasonably good product photos with an inexpensive digital camera, a tripod, and a plain white background. However the quality of your photos can dramatically be improved if you use reasonable quality lighting equipment. A two-light setup is versatile. It allows you to create clear crisp pictures without distracting shadows, while presenting important texture and details of the items you are shooting.

To get the photo of the leather purse in **Figure 39.1**, which was photographed for `www.leatherstuff.com`, two Nikon SB24 flash units, two light stands, two white umbrellas with swivel adapters, and

> **TIP**
>
> The Set Shop (`www.setshop.com`) is a New York store that has a comprehensive catalog of set-building resources on its Web site.

> **WARNING**
>
> When considering a purchase of a flash *not* from the manufacturer of your digital camera, be careful that the trigger voltage doesn't exceed the specified limit of your camera. Paramount Cords (`www.paramountcords.com`), the largest manufacturer of flash-to-camera sync cords, has a lot of good information on its Web site, including a link to a Web site that lists the trigger voltage of the most common flashes.

Nikon's proprietary connecting cords were used. **Figure 39.2 (CP39.2)** shows the results of the photo after some image editing was done with Adobe Photoshop. **Figure 39.3** shows the lighting set up used.

Although your camera manufacturer may have flash units that are designed to work optimally with your digital camera, you may want to investigate flash units made by companies such as Vivitar (`www.vivitar.com`), Sunpak (`www.sunpak.com`), or Metz (`www.bogenphoto.com/webmetz.htm`). These companies offer less expensive flash units than those sold by the leading digital camera vendors, but they still offer lots of features and power for the money. Also check out low-cost studio flash units from Alien Bees (`www.alienbees.com`). Studio strobes are more powerful than camera mounted flashes. They have highly adjustable output and they have modeling lights that allow you to see the effect of your lighting changes before you take a shot.

> **TIP**
>
> Generally, you can find most of the lighting equipment you need to set up your product shot from an online auction like eBay. Besides saving a substantial amount of money by avoiding purchasing all new gear, you can also learn what it is that you notice about seller's photographs that entice you and make you feel comfortable buying. Please note that the quality of the items and the reliability of online auction vendors vary — you can find yourself unhappy with your purchase with no recourse.

WHAT MAKES A GOOD PRODUCT SHOT?

Before beginning this technique, first consider what it is that makes a good product shot. A good product shot shows the details of the object quickly and clearly without the distraction of shadows or backgrounds to divert the viewer's eye away from the product that is being offered for sale. To accomplish this, use a plain background, such as white paper or a sheet of foam board. Using a white background has the added benefit of acting as a reflector, bouncing light under and around your object. Of course, if the item you are shooting is very light or white, you should consider using a darker background to add some contrast and make the item stand out.

Besides choosing a simple background, your choice of light quality is also critical. Soft diffused light can add depth while controlling contrast and revealing detail in shadow areas. Umbrellas are an inexpensive way of producing this quality of light.

STEP 1: SET UP THE SHOOTING TABLE

■ Create a place to take product photos. The exact size of this space depends on the size of the items you will be shooting. For the purposes of this technique, let's assume you will be photographing items that can fit on a tabletop. Move a table against a wall. Lay down a piece of white mat board or foam board on the top of the table. This board will become your shooting platform. Place an additional board vertically at the back of the table up against the wall. Position the camera and adjust the zoom lens so your viewfinder frames the white background.

STEP 2: POSITION THE PRODUCT

■ Center the product on the shooting surface. After you set up and position the lights and tripod, shoot a few test photos and reposition the product if necessary.

> **TIP**
>
> If you plan to shoot objects that are tall, consider constructing your set on the floor instead of a table. Doing so enables you to work with a more comfortable shooting angle than if you had to extend your tripod and possibly stand on a chair to see your camera's LCD monitor.

> **TIP**
>
> A simpler but more costly way to create a background is to purchase a roll of white "seamless" paper available in *53" or 107" widths in various colors* at most professional camera stores. Tape or tack it to the wall behind the table and let it roll down and across the table, leaving a gentle curve so there is no rear edge line where the wall and table meet.

STEP 3: SET UP LIGHTS

■ Mount the flashes on the light stands and attach the umbrellas. You can use an adaptor like Bogen's Swivel Umbrella Adapter # 2905 or a similar connector, as shown in **Figure 39.4 (CP39.4)**. Next, connect the flash units to your digital camera. In this case, Nikon's proprietary connectors and adapters were used. Check the documentation that came with your camera, or visit your camera vendor's Web site to see which cords and adapters you need for the particular digital camera you own.

■ Use white umbrellas to help soften the light and give it a more "wrapping" quality. Angle the umbrellas so they point down at approximately 45 degrees to the object. Move the light stands so that one light is to the left and the other is to the right of the camera, as shown in **Figure 39.3**.

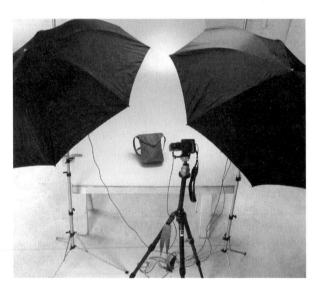

39.3 © 2002 Larry Berman

STEP 4: SET UP THE CAMERA

■ Attach the camera to a tripod, and position it so the object fills the frame and is centered inside the frame. A simple composition is best. If your camera has an LCD monitor that folds out, adjust it so you can clearly see the composition as you move the camera.

■ Now adjust your camera's exposure mode, choosing manual exposure. This mode allows you to modify the exposure to match the light being produced by the flash unit. Select a high shutter speed setting, such as 1/1000th of a second. This setting reduces the effect of any ambient light in the room. Next, adjust your camera's f-stop, choosing an aperture in the middle of the range to start. Open up the aperture or close it down depending on the results of the first few test photos. If you are shooting small items, you may want to choose macro mode if one is available on your camera.

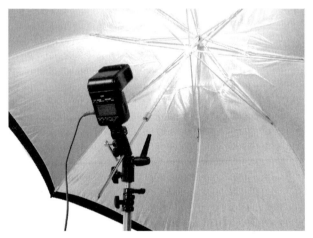

39.4 (CP39.4) © 2002 Larry Berman

This mode prevents your camera from needless "hunting" for focus. To learn more about using macro mode, read Technique 31.

STEP 5: COMPOSE AND TAKE PHOTOS

■ Adjust your zoom lens and angle of view. All the important details of the item you are shooting should be in the photograph. If the item has several sides your customers may be interested in seeing, rotate the item and photograph it again. Later you will be able to move in and shoot close-ups of specific parts of the item that show the quality or condition of the item you are auctioning. But for now, concentrate on getting the camera and lights adjusted for a good exposure and strong initial composition.

TIP

If your flash has adjustable output settings, you will have much more control over the depth-of-field (the area that will be in sharp focus) in your picture. Reducing the light output allows you to use a wider aperture (smaller f-stop numbers), letting you selectively focus on a specific part of your subject and allowing other parts to be softly out of focus. Increasing the amount of light from your flash unit lets you close your aperture down (larger numbered f-stop) and greatly increase the depth-of-field.

■ If you are shooting in manual exposure mode, bracket the exposures by adjusting the f-stop (or use flash exposure compensation). If you are shooting with one of the "auto" shooting modes such as program mode, use exposure compensation to bracket your exposures.

■ If your item is off-center, check to make sure the focus is correct. You may want to use off-centered focusing as was covered in Technique 14. You can also try manual focus, although focusing accurately with most consumer-level digital cameras is hard, due to the low resolution of the LCD monitor. After you've taken a few shots you are happy with, download the image files to your computer and look at them carefully on your computer monitor for composition, focus, and exposure.

STEP 6: REVIEW AND MAKE ADJUSTMENTS

■ After reviewing your images, make adjustments as needed to get the best product photo you can. Remember that the goal is a clear descriptive image

TIP

If your subject has reflective areas, you can reduce the glare using a small amount of hair spray or "dulling" spray, which you can buy at art or photo stores. Use these sprays sparingly because you don't want to change the character of the item, nor do you want the item damaged by the spray or later when you have to clean it off.

that will entice people to bid on your product. If the color of the objects is too dark, adjust the exposure either by changing the f-stop or the power setting on the flash.

STEP 7: SHOOT THE FINAL PHOTOS

■ After you have a good exposure setting, move the camera and the item around to capture different sides and shoot some macro shots that will show potential bidders the closer details of the product. Who knows, because taking good product photos is so easy and fun, you may get rid of unused items faster than you thought — leaving you with money to spend, too!

TIP

When you're happy with your results, make notes about the camera settings that you used so you can easily replicate your setup. If your camera has the ability to remember "user settings," you can use that feature to store and quickly recall later the camera settings you use for product shots. Make a lighting diagram and record the distances and power settings of your lights. This diagram may take a few minutes, but it can save you hours of trial and error next time you want to shoot a product.

SHOOTING "FLAT" FINE ART

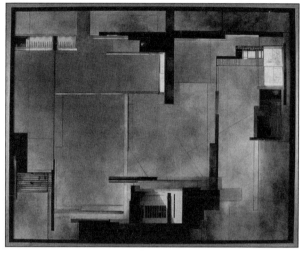

ABOUT THE IMAGE

"Ginny Herzog Painting" Nikon CoolPix 990 mounted on a tripod, zoom set to 39mm (35mm equivalent), f/7.4 @ 1/60, ISO 100, 2,048 x 1,536 pixels, 1.2MB .jpg

Photographing a painting or drawing seems deceptively simple. Just hang it on the wall and snap a picture, right? More than likely you will be disappointed with the results if you try that approach. If your camera is not aligned with the art, or illumination is uneven in color or intensity, the pictures you take will not show the art as it really is. In this technique, you learn how to get great photographic copies of your artwork that you can use to make prints, put on the Internet, or even turn into slides for showing on a slide projector or light box. The painting in **Figure 40.2** was photographed for www.herzogart.com.

WHAT MAKES A GOOD FLAT ART PHOTO?

A good photo of any kind of art should have the same color, tone, and appearance as that of the original work. One of the challenges of flat art is to make sure it is evenly lit and that the color is true to the original art color. The art should stand out from any background (if there is one) so as

not to distract the viewer's eye. If the art has texture, such as brush strokes or palette knife marks, the light should show them as a viewer would see them on the original — not too light, nor too pronounced. If the photo is a good photo, it will look *like* the original art!

WHAT EQUIPMENT DO YOU NEED?

Ideally, you will have a matched pair of off-camera flash units or incandescent "hot" lights (special photographic "white" lights) and the necessary equipment to allow you to position the units or lights where they need to be. To use flash units, your camera must have a sync socket for synchronizing the flash of light with the exposure. Because incandescent hot lights stay on all the time, no synchronization with the camera will be needed.

A camera tripod can support either type of light if you purchase special brackets made for that purpose. Or, you can purchase light stands that are made for supporting and adjusting lights.

If you are using flash units, you will get better, more evenly lit art if you have some light modifier such as a soft box or white umbrellas. Soft boxes or umbrellas are excellent for washing artwork with a soft, directional source of light.

If you do not have all that, relax; you can substitute incandescent lights for the strobes if you do not have a camera that will synchronize with external flash units, and you can get by without umbrellas or other light modifiers if your lights put out fairly even illumination.

If you have no lights at all to work with, you can shoot your work outdoors. Choose an overcast day when the light will be flat and even. Position your work to minimize glare, and be sure your camera is properly aligned with the art. Adjust your camera's color balance so the photograph captures the true color of the artwork. Hang your work in such a way that you do not include any distracting background elements, like trees or grass. You will not be able to achieve the same level of consistency as you would if you controlled the lighting as you can indoors, but you can achieve acceptable results if you are careful and pick the right time and day to shoot.

Most building supply companies sell relatively inexpensive tungsten work lights that are mounted on adjustable stands. If you remove the glass and any glass protector from the face of the light to avoid causing shadows on the artwork, you can get all the quality light you will need. However, you will still need two separate lights on independent stands so that you will have flexibility in your light placement.

STEP 1: DECIDE HOW THE PHOTO WILL BE USED

- Decide how the photographs will be used. If you're not sure, shoot at the highest resolution and set your camera for minimal compression and maximum detail. These settings give you the largest file size and the most flexibility to use your pictures for any purpose you may need in the future. If you will only be using the photo to create a small image for e-mailing, or for an image that will be used on the Internet, a smaller size file will be fine. Even an older one- or two-megapixel camera can take great pictures of artwork for the Internet, but cameras with higher pixel counts will give you a more detailed file that you can use to make very good prints or slides.

> **TIP**
>
> If your art is smaller than 8.5 × 11 inches or it can fit on a flatbed scanner, you probably will get good results just by scanning it on a flatbed scanner. However, if your artwork is larger, you want to follow the steps in this technique to get a quality photograph.

STEP 2: CHOOSE A PLACE TO WORK

■ Choose a room large enough to hang the work on a wall and set up lights on either side at a 45-degree angle.

■ Leave a reasonable amount of distance between the artwork and your camera. Of course, the exact distance will vary with the size of the painting. Do not count on a wide-angle lens to shoot all of a large painting because it may result in an image with barrel distortion.

■ If you shoot during daylight, darken the room to eliminate stray light that can affect your color balance or cause glare. Or you can simplify the process by just shooting at night.

STEP 3: PREPARE ARTWORK

■ If the artwork is framed and you don't want to photograph the frame, then remove it. Because glass is exceedingly difficult to shoot through without picking up reflections or glare, removing any glass or other clear protective material is best.

STEP 4: HANG ARTWORK AND ALIGN CAMERA

■ Hang the art on a wall and set the tripod directly in front. Move the camera in and out until you fill the frame with your subject without having to use a wide-angle lens at or near minimum focal length, where you may end up with some distortion.

■ Center your lens on the middle of the art. Make sure the front of the camera lens is parallel to the surface of the artwork, not slightly tilted up or down or sideways. If your camera is tilted even a small amount, your artwork will not be square in the frame. It will appear to be *keystoned*, or fore-shortened on one end or a side.

TIP

If for some reason you must shoot through glass, or your art is naturally reflective, you can do a couple of things. First, you can buy several yards of black velvet and hang it as a drape in front of the camera. Black velvet is amazingly good at absorbing light; regular black cloth will not be nearly as effective. Cut a small slit in the middle to let the camera lens peer through from behind the velvet, and be sure the drape is large enough to block all reflections. The larger your art, the larger the drape needs to be.

Another option is to cross-polarize the lights and camera lens. You need a large sheet of polarizing material for each light. Align them so they are horizontally polarized. Put a polarizing filter on your lens and adjust it to be vertically polarized. This cross polarization can be quite effective at reducing glare, but the cost of the material is considerable.

TIP

Check your artwork hanging on the wall with a small level; when it is level, then you can use the level to align your camera, too. Place the level against the lens ring and adjust the tripod until the camera is level on the vertical axis. Although using a level for this kind of precision is not as important for smaller artwork, it can be very useful when you shoot large artwork. The level helps to take the "guess work" out of setting up the camera.

STEP 5: SET UP LIGHTS

■ Set up two lights that have exactly the same output on each side of the picture, and point each to the opposite side of the artwork at a 45-degree angle. Use a tape measure to make sure your lights are equally spaced from the art and share the same distance from the wall.

When the lights are set up correctly, the artwork should have a flat, even wash of light with no hot spots or shadowed areas. If the lights are too bright, or they are uneven, try moving them farther away from the artwork, or adjusting the angle in or out. **Figure 40.3** shows the setup that was used to shoot the photo in **Figure 40.2**.

STEP 6: SHOOT A FEW TEST PHOTOS

■ If you are using flash units, set your camera on manual. Setting shutter speed to a high setting, like 1/500 or 1/1000th of a second, reduces the effect of any ambient light in the room. You need

to adjust the f-stop by opening or closing it down depending on the amount of light the flash puts out. If you are using hot lights, like photofloods or lamps with halogen bulbs, your meter may give you an accurate reading. If not, bracket by adjusting the exposure up or down as needed. This is a good time to use your camera's histogram if you have one. Adjust the aperture until you get a histogram centered in the graph.

■ Choose the most appropriate color balance setting on the camera to match your light source. Just about all digital cameras have a choice of sun, incandescent, flash, or florescent light. If your camera offers a manual white balance setting, you may get the best results by using that feature. Setting color balance manually is as easy as shooting a white card and using that image to set the custom color balance. Check the documentation that came with your camera to learn whether it has a manual color balance setting and how to use it, if it has one. A custom setting often gives you the best results.

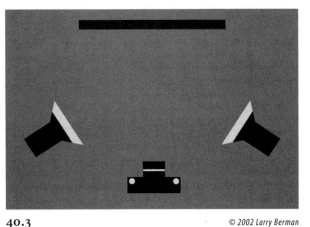

40.3 © 2002 Larry Berman

WARNING

If you made changes to the color balance setting, make sure to change it back to your everyday setting when finished. Many good photos have been ruined by inadvertently shooting with the wrong color balance setting. The best practice after changing to a custom or other "specific" light setting is to change back to the automatic color balance setting as soon as you are finished shooting.

STEP 7: TAKE THE FINAL PHOTO

■ After you have your lights set up properly, the camera located where it should be, and have taken a few test photos to set the exposure, take the final photo. You may want to bracket the final shot by 1/3 of a stop, which gives you a couple extra photos, but will also give you slightly different exposures to choose from.

Because everything is set up to take photos of flat art, if you have more art, now is a good time to shoot it. Just move your camera in and out to adjust for the different sizes; your exposure will not change as long as your lights do not move.

TIP

If you want to make slides from the digital files you have just shot, you can send your files to a service bureau that has a film recorder. A film recorder exposes regular slide film from your digital file. One such service bureau is Slides .com (www.slides.com). Check its Web site for pricing and submission requirements.

TAKING A PHOTO OF AN AUTOMOBILE

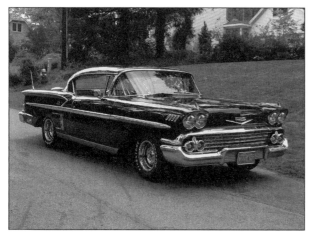

41.1 *Orignal image* © 2000 Gregory Georges

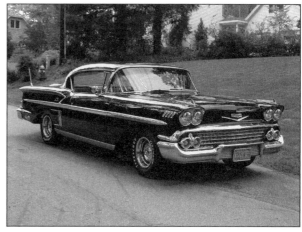

41.2 (CP41.2) *Edited image* © 2000 Gregory Georges

ABOUT THE IMAGE

"'58 Chevrolet" Nikon CoolPix
950 hand-held, zoom set to
57mm (35mm equivalent),
f/3.0 @ 1/119, ISO 80, 1,600 x
1,200 pixels, 670KB .jpg

Many reasons exist for why you may want to take a photograph of an automobile. Maybe you want to sell it online or create a sales flyer and you need a good photo. Or maybe you are as attached to your car as some people are to family members or their pets, and you just want some cool photos of it. Whatever your reasons are, this technique shows you how to take good photos of automobiles for any purpose you might have. **Figure 41.2 (CP41.2)** shows a photo of a 1958 Chevrolet.

STEP 1: CHOOSE A GOOD PLACE TO SHOOT

■ Finding a good place to take photos of a car is an important step to getting a good photo. Look for an appropriate setting for the car that you are shooting. After deciding that the 1958 Chevrolet shown in **Figure 41.2 (CP41.2)** ought to be parked in front of a 1950s style home,

an hour was spent driving around a few older neighborhoods to find the perfect house and yard with good light. This particular spot was chosen because of the house style, because there were no trees that would cause shadows, and because there would be excellent contrast between the car and the background.

STEP 2: PICK A TIME AND DAY WITH GOOD LIGHT

■ Because altering the light for an "object" as large as an automobile is very hard, make sure you pick the right time and day to shoot. After you have determined where you want to take photos, consider when you can take a photo when the light will be good.

TIP

If you want a good automobile photo, there may be days where you ought to *not* even waste your time taking photos. Having an opportunity to shoot a burgundy Jaguar XKE, on the *wrong* day, I spent an hour shooting without getting a single good photo. **Figure 41.3** shows the results of an attempt to block the bright sunlight by placing the XKE under some pine trees. The pine straw and the dark color of the car in the shade made for a horrible photo of what is my favorite car of all time. The moral of the story: If the light isn't right, pick another day if you can.

The best time to shoot is late morning or early to late afternoon, when the sun is at a low level, but it has not yet slid low enough to cast an orange color to the shooting environment.

Generally, the worst time to shoot is in the middle of the day when the sun is directly overhead. This time of day reduces most shadows that add depth to your photo. You also want to avoid taking photos when the sun is bright and the sky is bright white. Most cars have too much chrome and shine for you to shoot them in bright sunlight. The best day to shoot is a lightly overcast day where the clouds soften the light.

STEP 3: CHOOSE THE CAMERA ANGLE AND SET UP THE CAMERA

■ Choose the best angle to shoot from; for most cars it is from directly in front and to the side so that both the front and side are in full view, as shown in **Figure 41.2 (CP41.2)** or directly from behind and to the side as is shown in **Figure 41.4 (CP41.4)**. If the car you are shooting has another remarkable view, choose an angle to show that

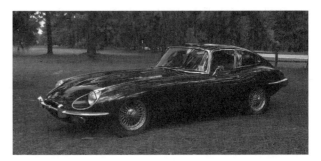

41.3 © 2002 Gregory Georges

view. The 1948 Packard is a long graceful car, so a good shot of that car is one that shows mostly the side of the car, as shown in **Figure 41.5**.

STEP 4: CHOOSE CAMERA SETTINGS

■ Set your camera to aperture priority and choose an aperture setting of f/8.0 to maximize depth-of-field.

When the photo shown in **Figure 41.1** was taken, the shooting mode was initially set to aperture priority mode and the aperture was initially set to f/8.0 to maximize depth-of-field. Later on, the aperture was set to f/3.0 because the larger opening was necessary to get a properly exposed shot using a low ISO setting (80 ISO) and a shutter speed of 1/120 to minimize blur due to camera shake. A better option would have been to use a tripod and shoot using an f/8.0 aperture

setting and to use whatever shutter speed was required; however, a tripod was not available at the time.

STEP 5: SELECT FOCUS POINT AND SHOOT

■ Choose the focus point to ensure that the entire car is in focus. To shoot the photo shown in **Figure 41.2 (CP41.2)**, a focus point was selected just above the left-front tire. After setting focus, take a photo.

STEP 6: CHECK EXPOSURE, ADJUST, AND SHOOT FINAL SHOTS

■ After you take a photo, review the image on the LCD monitor to evaluate it. Besides looking at the image, also consider using a histogram feature if your camera offers one, because it can help you to

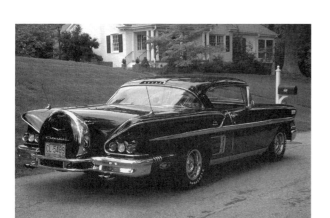

41.4 (CP41.4) © 2002 Gregory Georges

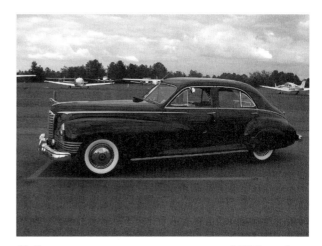

41.5 © 2002 Gregory Georges

determine how well the photo was exposed. Also, make sure to look for any "blinking highlight alerts" if your camera has that feature. The blinking highlights are most likely to appear on the chrome or shiny surfaces where light shines back toward the camera.

■ After you've made the appropriate camera adjustments, if any were needed, shoot a few more bracketed photos to make sure you have one that you will like. It's okay for the brightest reflections off chrome to have no detail, but watch out for other areas.

STEP 7: VARY THE ANGLE

■ If you get too much glare from the sunlight, vary the angle slightly. Or maybe you want to vary the angle to show a slightly different view of the car, as shown in **Figure 41.6 (CP41.6)**. Take a few more pictures and your job is complete!

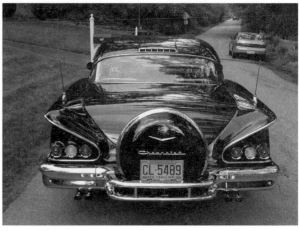

41.6 (CP41.6) © 2002 Gregory Georges

9

CREATIVE PHOTOGRAPHY

© 2002 Larry Berman

Y ou can take photos of people. You can take photos of things to sell on eBay. Or maybe you enjoy shooting flowers, insects, or even mushrooms to get "specimen" photos. Whatever you generally like to shoot, keep shooting — but take some time to shoot creatively! The digital camera is an incredible tool for exploring your creativity; both in terms of how you shoot and what you shoot. In Technique 42 you find out how to shoot with just candlelight. You learn how to shoot photos to be digitally edited in Technique 43, and you learn to shoot colorful still life in Technique 44. Technique 45 covers the more traditional methods of shooting high-key and low-key photos. Technique 46 shows you how to take infrared photos with your digial camera. These techniques ought to get you started thinking about your own ways you can shoot creatively!

© 2002 Chris Maher

SHOOTING WITH CANDLELIGHT

42.1 *Original image* © *2002 Larry Berman*

42.2 (CP42.2) *Edited image* © *2002 Larry Berman*

ABOUT THE IMAGE

"Side-lit Bottle" Nikon CoolPix 5000, tripod, zoom set to 85mm (35mm equivalent), f/6.3 @ 1/2, ISO 100, 2,560 x 1,920 pixels, 825KB .jpg

Taking photos of objects with just the light from one or more candles can result in outstanding photographs. Candles provide a warm light source that can create a romantic ambiance that is hard to achieve any other way. After you begin shooting, you can produce many interesting shots in just a few minutes.

A digital camera can be a more creative tool than a film camera. It really is true. The instant feedback and no-cost-to-shoot aspect sets you free to create as never before. Creativity can happen at the least predictable moments.

For example, the photograph in **Figure 42.2 (CP42.2)**, taken with only the light from a single candle, is the result of a late evening inspiration. From inspiration to finished piece it took less than half an hour. After shooting a few photos, they were downloaded to a computer where the results could be examined. After a quick look at the images and the camera settings in the EXIF data, the photographer took a few more photos, resulting in three good shots. The same picture ideas shot on film might have taken days to complete between the shoot, feedback, and the shooting of the final pictures. The goal of this technique is for you to learn how to shoot using candlelight and to learn how to compose when you have complete control over the composition.

STEP 1: BUILD A STILL-LIFE SET

■ Using any table or desktop as a base, you can easily make a set to shoot with candlelight. If possible, use a top surface that is a dark wood or has a dark color, as shown in **Figure 42.3**. If the surface

42.3 © *2002 Larry Berman*

isn't dark, you can cover it with a dark fabric or even a dull black poster board. Making a candle-lit set is even easier if you shoot at night when you won't have to work to eliminate other light sources such as sunlight coming in a window, under a closed door, or around the sides of a window with drawn shades.

As long as you are shooting in a dark room, you may not even need to worry about the background. If you find you do have a distracting background, hang a dark cloth or place a dark poster board behind your set to cover the distracting background. The farther away you place the background from your camera, the larger it will have to be to block out the background, but the softer it will appear.

STEP 2: ARRANGE ONE CANDLE AND A SINGLE OBJECT

■ When your set is ready, arrange a candle and a single object. Polish any objects, such as glass or metal, that have a shiny surface before taking photos. Move the object you are shooting close enough to the candle so that the candlelight becomes the only light on the object. Make adjustments in placement so that the object is dark except for the side nearest the light. Remember that simple compositions are often the best ones. Although you can have more than one candle or one object to your scene, try keeping it as simple as possible to start.

The photo shown in **Figure 42.4 (CP42.4)** is a variation that includes the candle in the photo. Notice how there is a more mysterious feel to the candle as the side of the bottle on the opposite side disappears into the black surrounding negative space. *Negative space* is space not being occupied with the subject in a photograph; however, it is an important element of composition.

After you have a few simple shots with one candle and one object, you can try several different candles

and a variety of different glass objects, such as vases, bottles, or glasses. Some wine bottles, or exotic crystal wine glasses, or even well-designed olive oil bottles have wonderful glows, shapes, and reflections.

STEP 3: SET UP THE CAMERA

■ Now is the time to set up your camera. As you have probably already assumed, you must have a tripod or some kind of camera support because of the low level of light and the necessary long exposure times. Set up your camera to be close enough to the objects that you can shoot just a part of the object or the entire object, but not much more. If you have a zoom lens, use it so you can more easily change composition without having to move the camera and tripod to do so.

42.4 (CP42.4) © 2002 Larry Berman

STEP 4: CHOOSE CAMERA SETTINGS

■ Now choose your camera settings; to do that, you must first decide how your photo is to look. Assume you want to have as much of the candle and object you are shooting in focus; choose the aperture priority setting and close the f-stop all the way down (around f/8.0). If you want to have one object in focus and the other blurred, you would still choose the aperture priority setting, but you would select a wider aperture, such as f/2.5. Remember that aperture numbers are actually the denominator of a fraction with 1 as the numerator. So, f/2.5 (1/2.5) is a wider aperture than f/8.0 (1/8). You can also use a program mode if your camera has one; it allows the camera to change aperture settings for you. Check to make sure you are using a low ISO setting, such as 50 or 100, for less digital noise in the photo.

If color accuracy is not a concern, you can set white balance to auto. Or you can experiment and try using the incandescent, sunlight, or other white balance settings and see what you get. You'll notice that you can get a "cooler" photo with an incandescent setting. For warmer pictures, try using the sunlight setting.

One challenge will be to see whether your camera can focus using auto-focus on soft edges and in low light. If the camera can't lock in to the edge of the bottle, you need to use manual focus. Or you can turn on some lights and use automatic focus and

> **TIP**
>
> Any time you are doing night photos or you are shooting in a room with little light, you may find that reading the camera settings and finding some camera controls is difficult. Consider purchasing a small flashlight that you can keep with your camera.

focus lock; then turn off the lights and shoot again. To learn more about using focus lock, see Technique 14. If you are shooting within a foot of the bottles or candle, you may need to select macro mode if your camera has one. Macro mode also helps prevent your camera from "hunting" to get the right focus by limiting the range where it seeks to find focus.

That's about it! Your camera should be mounted solidly on a tripod, and the objects should be arranged for the first shot. You've selected an appropriate shooting mode and aperture setting. Your camera will automatically select the shutter speed. You now understand the effects of different white balance settings and how to control focus and how to experiment with them.

STEP 5: SHOOT A FEW PICTURES

■ Take pictures of the light coming through a glass object, then try some shots showing the way the light glints off the sides of an object. Try including the candle in the picture, and try compositions that only show a single object, surrounded by darkness. Experiment — over and over again!

As you shoot, look at the exposure settings and the image on the LCD monitor to determine whether you need to make any exposure compensation as covered in Technique 12. This is also an excellent time to use the histogram if your camera has one. To learn more about using and reading histograms, see Technique 11.

TIP

Low-light photos can often make excellent "grainy" photos. Consider changing the ISO setting from 50 or 100 ISO to 200 or even 400 ISO. The increase in ISO setting may dramatically increase the amount of digital noise (grain) you will get in the image as shown in **Figure 42.5 (CP42.5)**.

STEP 6: REVIEW AND MAKE SETTING ADJUSTMENTS

■ After you've taken a good number of photos, download them to your computer and review them on a computer monitor to get the best view. Look to see how you can improve the composition, exposure, and focus. When you have a good understanding of the light and exposure settings, you can try using manual exposure mode to tweak the camera settings and push exposures to the extreme.

When you review the images on your computer, don't forget to use an application that shows the EXIF data (camera settings information). Being able to read the shutter speed, exposure mode setting, f-stop, and other settings is a good way to learn how to get the shots you want. It also helps you learn about the limits that you have with your camera and the light you have.

42.5 (CP42.5) © 2002 Larry Berman

TAKING PHOTOS FOR DIGITAL MANIPULATION

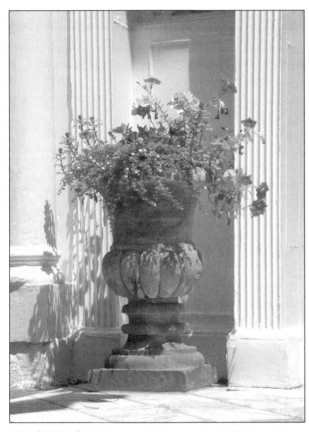

43.1 (CP43.1) *Original image* © 2000 Gregory Georges

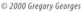

43.2 (CP43.2) *Edited image* © 2001 Gregory Georges

"Flowering Urn in Charleston, South Carolina" Nikon CoolPix 950, zoom set to 90mm (35mm equivalent), f/10 @ 1/114, ISO 80, 1,200 x 1,600 pixel image was cropped and converted to a 1,152 x 1,600 pixel, 5.8MB .tif file

The moment you open up a digital photo in an image editor such as Adobe Photoshop, you open yourself up to a whole new world of creative possibilities. Understanding what you can do with an image editor before you take photos will help you to see everything differently. You can take a fantastic blue sky with puffy-white clouds from one photo and put it in another photo that has a less interesting sky. You can insert and remove people in a group portrait. Adding the texture or color from one photo to another is also possible, as are an infinite number of other possibilities. After you understand what is possible, you can begin taking photos specifically to be manipulated digitally.

In this technique, you learn how to take the digital photo of the urn shown in **Figure 43.1 (CP43.1)** and transform it into the watercolored "pen and ink" sketch shown in **Figure 43.2 (CP43.2)**. The point of this technique is that a photo is no longer just a photo; rather you can use it as a starting point or as just a piece of an entirely new creative process, way beyond what was possible in the traditional darkroom.

In the next six steps, you first make the photo of the urn look like a watercolor painting; then you turn a second copy into a pen-and-ink sketch. In the end, you combine these two images into a watercolored pen-and-ink sketch. Although the technique was originally done using Adobe Photoshop Elements 2.0, you can easily complete it with any of the other Adobe Photoshop products, too. If you do not already have a copy of Photoshop Elements 2.0, you can install a 30-day trial version from the companion CD-ROM.

STEP 1: OPEN FILE

- After opening Adobe Photoshop Elements 2.0, choose **File ➤ Open** (**Ctrl+O**) to display the **Open** dialog box.
- Double-click on the **/chap09/43** folder to open it and then click on the **43.1.tif** file to select it.
- Click **Open** to open the file.

STEP 2: MAKE A COPY OF THE IMAGE TO BE USED FOR THE WATERCOLOR PAINTING

- As both a watercolor painting and a "pen and ink" sketch are needed, duplicate the image by choosing **Image ➤ Image Duplicate**.
- When the **Duplicate Image** dialog box appears, type in **pen-ink** to name the image, as shown in **Figure 43.3**, then click **OK**.

STEP 3: TRANSFORM ONE IMAGE INTO A WATERCOLOR PAINTING

Adobe Photoshop Elements 2.0 does have a watercolor filter, but in most cases, I find that it makes the images too dark with too many odd-looking brush strokes. Therefore, let's try another approach.

- Click on the **urn-before** image to make it the active image.
- Choose **Filter ➤ Artistic ➤ Dry Brush** to get the **Dry Brush** dialog box. Click in the preview window and drag the image around until you can see a few flowers. Begin experimenting with the settings for **Brush Size**, **Brush Detail**, and **Texture**. I used **2**, **8**, and **1**, as shown in **Figure 43.4**. Click **OK** to apply the settings.

To soften the brush strokes and make them look more like a watercolor wash, try using a blur filter:

- Choose **Filter ➤ Blur ➤ Smart Blur** to get the **Smart Blur** dialog box. Try using a **Radius** of **10** and a **Threshold** of **50**, as shown in **Figure 43.5**. Also, make sure you have **Quality** set to **High**, and **Mode** set to **Normal**, before clicking **OK** to apply the settings.

For this particular image, these few steps produce a realistic-looking watercolor. After using many images and trying many different techniques to create watercolor paintings, I've concluded there are many variables and settings for each of many different techniques; what works on one image may work poorly

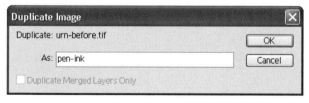

43.3 *© 2002 Gregory Georges*

on another. In general, these steps work well on images that are about 1,600 × 1,200 pixels in size and have been taken with a digital camera.

On larger files, and when photographs have been scanned with a flat-bed scanner or negatives or slides have been scanned with a film scanner, the same techniques work well if you first apply a light **Gaussian Blur** to the image. The larger the files, the better this technique seems to work, provided that the image is a good-quality image with minimal grain. Sometimes, you may also find that you can make an image look more like a watercolor painting if you apply some of these filters more than once. Experimentation is the key to getting what you want.

STEP 4: TRANSFORM SECOND IMAGE INTO A PEN-AND-INK SKETCH

The next step is to turn the second image into a "pen-and-ink" sketch. Although many digital imagers use and recommend the Find Edges filter to make line drawings, I find I get much better results with a hidden option in the Smart Blur filter. The results, as you'll see, can be quite outstanding.

43·4　　　　　　　　

43·5

- Click on the **pen-ink** image to make it the active image.
- Choose **Enhance** ➢ **Adjust Color** ➢ **Remove Color** (**Shift+Ctrl+U**) to remove all color.
- Select **Filter** ➢ **Blur** ➢ **Smart Blur** to get the **Smart Blur** dialog box shown in **Figure 43.6**. Set **Quality** to **High**, and **Mode** to **Edge Only**.

Finding settings that show the vertical lines on the columns while not adding too many lines around the flowers is important. To do this, click in the preview box inside the **Smart Blur** dialog box and drag the preview image until you see the column, as shown in **Figure 43.6**.

- Try setting **Radius** to **25** and **Threshold** to **35**. Click **OK** to apply the settings.
- You may be surprised to see what now looks like white lines on a black ink scratchboard as shown in **Figure 43.7**, but this is okay; choose **Image** ➢ **Adjustments** ➢ **Invert** (**Ctrl+I**), and you will see black lines on a white background sketch.

STEP 5: COMBINE IMAGES

At this point, you have learned two techniques and you have two entirely different images made from the same digital photo — a watercolor-like image and a "pen-and-ink" sketch. Now you can combine these two images:

43.6 © 2002 Gregory Georges

43.7 © 2002 Gregory Georges

- Click on the **urn-before.tif** image to make it active, then choose **Select** ➢ **All** (**Ctrl+A**), then choose **Edit** ➢ **Copy** (**Ctrl+C**) to copy the image into memory.
- Click on the **pen-ink.tif** image to make it active; choose **Edit** ➢ **Paste** (**Ctrl+V**) to paste the image as a new layer.
- Looking at the **Layers** palette in **Figure 43.8**, you can see two layers. Click once on the **Layer 1** thumbnail in the **Layers** palette to make sure it is the active layer, and then set the **blend** mode to **Multiply** and **Opacity** to **100%**.

STEP 6: MAKE FINAL COLOR ADJUSTMENTS AND ADD YOUR SIGNATURE

- Choose **Layer** ➢ **Flatten Image** to flatten the layers into one.

You have lots of filters for adjusting color, such as **Levels**, **Color Cast**, and **Hue/Saturation**.

- To lighten the image, choose **Enhance** ➢ **Brightness/Contrast** ➢ **Levels** (**Ctrl+L**) to get

the **Levels** dialog box. Set **Input Levels** to **0, .75,** and **160,** as shown in **Figure 43.9**.
- Click **OK** to apply the settings.

The final step is to adjust the colors, as you would like them. As I have both Adobe Photoshop and an artistic license to create, I decided to make the image turquoise, purple, and green with yellow flowers, as shown in **Figure 43.2 (CP43.2)**!

- Click **Enhance** ➢ **Adjust Color** ➢ **Hue/ Saturation** (**Ctrl+U**) to get the **Hue/Saturation** dialog box. Set **Hue**, **Saturation**, and **Lightness** to **100**, **20**, and **0**, as shown in **Figure 43.10**.

43.9

43.8

43.10

If you aren't into turquoise, purple, and green, use **Hue/Saturation** or **Color Variations** to get the colors you want. Creating something out of the ordinary is great fun, and if you like it, then do it! If not, then make adjustments to suit your taste. You may find a more reasonably colored image on the companion disc in the **/chap09/43** folder — it is a file named **urn-after2.tif.**

Also, don't forget to add your signature — it adds a nice touch to your painting. If you want, you could also hand-paint more of the flowers yellow. Some of them seem to be lacking a bit of color on the left side of the image. A good tool for painting the flowers is the **Brush** tool. You also might want to put a soft edge on the image by using a soft eraser. Save your file, and it is ready to be printed.

Although this image looks reasonably good on a computer screen, it *really* does look exceptional when printed on a fine-art watercolor paper with a photo-quality inkjet printer. I used an Epson 1280 printer and Waterford DI Extra White CP watercolor paper distributed by Legion Paper Corporation (`www.legionpaper.com`). Printing on quality fine-art paper is essential to getting a print that you'll be proud to frame.

This is just one example of how you can digitally edit photos and make something entirely different than what you started with. The point of this technique is that you can begin to shoot with an entirely new view of what you want to get!

If you're interested in more techniques like this one, fifty more are available in the book *50 Fast Digital Photo Techniques* and another fifty in *50 Fast Photoshop 7 Techniques*; both written by Gregory Georges, one of the authors of this book.

SHOOTING COLORFUL
STILL LIFE PHOTOS

44.1 *Original image* © *2002 Larry Berman*

44.2 (CP44.2) *Edited image* © *2002 Larry Berman*

ABOUT THE IMAGE

"Painted Coffee Pot" Nikon CoolPix 5000, tripod, zoom set to 79mm (35mm equivalent), Macro setting, f/4.6 @ 1/121, ISO 100, 2,560 x 1,920 pixels, 1.5MB .jpg

When you think of a still-life photograph, do you think of a dull, uninteresting arrangement of fruit on a table, or maybe some flowers in a vase with a few surrounding props? Well, get ready to have some serious fun with this technique. In it, you discover how to really jazz up your still-life sets with brightly painted props that look wonderful in your photos.

When you create a still-life photo, you get to control all the elements that make up the picture. Using this technique, you not only control the composition, lighting, and perspective, but the color of each component as well. If you don't consider yourself much of a painter, you might want to collaborate with someone who will enjoy that aspect of this creative process with you. Larry is fortunate to have a creative wife who enjoys painting, and she helped prepare the props for the photo shown in **Figure 44.2 (CP44.2)**.

STEP 1: COLLECT PROPS

■ Visit your local thrift store or a flea market to find interesting objects. Don't worry about the color of any object because you can paint it to be the color you want. The older and more worn things are, the more character they will have in your pictures. You probably will only need to spend a few dollars to pick up a bunch of potentially interesting items. Think about shapes and how they will go together and complement or contrast with each other. **Figure 44.3 (CP44.3)** shows the extensive collection of props, both painted and unpainted, that Mary and Larry have in their basement.

STEP 2: PREPARE THE PROPS

■ Prepare your props by giving them a new color and texture. You can purchase acrylic paints for a few dollars from craft stores. Choose bright colors that will contrast or complement each other. Home improvement stores sell brushes and rollers that are designed to add texture to wall painting, and you can use them to make wonderful textured backgrounds. Use colors that are fun and bright, and be willing to experiment!

STEP 3: BUILD THE STILL LIFE SET

■ Construct a set similar to the ones Techniques 38 and 39 showed how to set up. If you're using

44.3 (CP44.3) © 2002 Larry Berman

props that will fit on a table, set your table up against the wall so you can lean your background against the wall. If your props are too large for a table, set them up on the floor. You might find that you need a color-coordinated background to complete your still-life setting. If so, consider painting a piece of plywood, an old door, or shutters in color-coordinated colors. If that's too much work, try using a colored piece of mat board from an art supply store, or colored fabric.

STEP 4: SET UP LIGHTS

- Start by setting up two lights on light stands and bouncing them into white umbrellas for soft wrapping light. Or set your items up by a window and use the soft window light to illuminate your props. To learn more about choosing lights and setting them up, see Techniques 38 and 39. You might even try setting up the set outside and use available light. As you shoot, be creative and experiment with the light. Try experimenting with more direct lighting and side lighting.

STEP 5: SET UP THE CAMERA AND CHOOSE SETTINGS

- After you have created a set and your props are in place, you are ready to set up your camera. Mount it on a tripod so that you can precisely compose the image and minimize camera shake while maximizing depth-of-field. Make sure you are shooting with the lowest possible ISO setting (50 or 100 ISO). Set shooting mode to aperture priority so that you can easily adjust the aperture setting. Close the aperture down to the smallest opening, such as f/8.0 or less, to ensure your camera has a smaller setting to ensure that all the props are in focus. Make sure you use an appropriate white balance setting. Use the flash setting if you are using a flash, and set white balance to sun if you are outside.

STEP 6: SHOOTING THE STILL LIFE

- Start by taking pictures of your composition. If you're working with more than one object, experiment and include more or less in the frame. You may find that just a close-up will be the winning photograph. Bracket your exposure to lighten or darken the image.

STEP 7: REVIEW AND SHOOT AGAIN

- Review your images on the computer and decide whether the composition and exposure can be improved. Change your composition, exposure, and maybe even the placement of the props until you arrive at a photograph that fits your vision.

Figure 44.4 (CP44.4), Figure 44.5, and **Figure 44.6** show three more of Larry and Mary's painted still-life photos. They make photographic prints of still-life shots like these and sell them at juried art shows.

44.5 © 2002 Larry Berman

44.4 (CP44.4) © 2002 Larry Berman

44.6 © 2002 Larry Berman

SHOOTING HIGH-KEY AND LOW-KEY PHOTOS

45.1 *Original image* © *2002 Larry Berman*

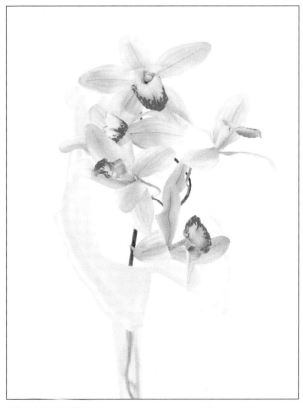

45.2 (CP45.2) *Edited image* © *2002 Larry Berman*

ABOUT THE IMAGE

"High-key Flowers in Glass Vase" Nikon CoolPix 5000, tripod, TC-E2 telephoto accessory lens, Macro setting, zoom set to 128mm (35mm equivalent) due to the accessory lens, f/7.1 @ 1/2000, ISO 100, 2,560 x 1,920 pixels, 1.6MB .jpg

S hooting "high-key" and "low-key" photos are two of the more traditional approaches to making creative photographs. If you've seen a photo that is almost all white or very light, then you've seen a high-key photo. A typical example might be a vignette of a face on a white background featuring a very soft light-toned portrait. In sharp contrast, you may have seen a portrait of an orchestra conductor holding his baton. If all you can see is the lit conductor and baton against an otherwise black or very dark background, you've seen a low-key photo. In this technique, you learn how to take photos using both of these approaches.

Getting either a good high-key or low-key photo can be a challenge. The best way to learn how to successfully create these kinds of photos is to create a still life and place it on a set where you have complete control of the light. After you've mastered the techniques in these controlled conditions, you can experiment in more difficult environments.

Silk flowers were chosen as the still life for this technique, along with a frosted glass flower vase (for the high-key look) and dark oil can (for the low-key look). The results of the high-key approach are shown in **Figure 45.2 (CP45.2)** and the low-key approach in **Figure 45.3 (CP45.3)**. As you can see, the same subject (silk flowers) can be portrayed in an entirely different manner when photographed using these two different approaches.

STEP 1: BUILD SET FOR HIGH-KEY PHOTO

■ Create the same set as described in Technique 39, which showed how to create a white background set for shooting products to be displayed and sold online on an auction site such as eBay. That's exactly the same set you'll need to create a high-key photo. The difference is that you will be pointing the second flash directly at the white background, using a black card (known as a gobo) to prevent that light from hitting the subject, as shown in **Figure 45.4**.

STEP 2: CHOOSE AND ASSEMBLE PROPS

■ High-key photographs require light-colored or white props. Take a quick look around your house or studio and see what you have that might work. If you have a white vase or pitcher, put some flowers in it. If you have some light-colored fabric, wrap it around something to give it shape. If you have some interestingly shaped objects that would make good subjects, but they are too dark, consider buying a can of white spray paint and painting them.

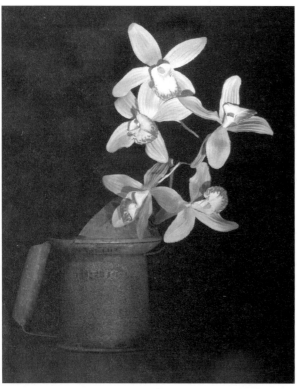

45.3 (CP45.3) © 2002 Larry Berman

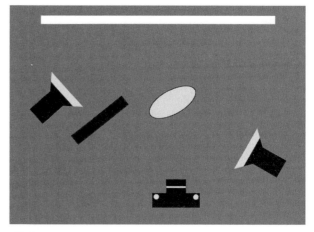

45.4 © 2002 Larry Berman

STEP 3: SET UP LIGHTS

■ Begin by working with one light to light the props. Position your objects and experiment with the position of the light until you're happy with the way the set looks.

■ Next, you need to light the background with a second light so it shines only on the white back-drop or background; the goal is to light it up so that it becomes pure white. If light from this second flash spills onto the main subject, you can use a black card to shield the subject. If you have a small slave flash unit, like the Morris Mini Strobe (`www.themorriscompany.com`), shown in Technique 20, you can hide it behind your subject pointing back toward the white background.

STEP 4: SET UP CAMERA

■ Look critically at your still life and move in for the best composition. Set your camera on a tripod and frame your subject. Connect your sync cords if you are using strobes and adjust your camera to work with them, disabling the internal flash. Manual mode gives you the most control, and makes bracketing your exposure easy. Set your shutter speed high enough that ambient (avail-able) light won't affect the exposure. Use your f-stop in coordination with your flash output to achieve correct exposure. You may choose to bracket by adjusting either the flash output, or by changing your camera's f-stop.

If you are working with hot lights, you can adjust your f-stop and shutter speed to give a good exposure on the flowers then move your background light in closer until the background goes completely white.

Be careful not to let any of the background light spill onto the subject. You won't be able to use auto or pro-gram mode here, as the camera will try to compensate for the white background, causing underexposure.

■ Shoot some test shots, and find the exposure that will make the background go white, but not overexpose your subject. Be sure to adjust the white balance of the camera to match your light source, or your whites won't be clean.

STEP 5: TAKE PHOTOS

■ After you have balanced your lights and are get-ting a clean high-key effect where you have a near white background and soft colored subject, you might want to experiment with different composi-tions. Leave your camera mounted on the tripod and experiment with the placement of the flowers. Look very critically at your whites; they should have hints of detail that define the shape of your vase without drawing too much attention to it.

STEP 6: REVIEW AND SHOOT AGAIN

■ After you've shot a few pictures, download your photos to your computer so that you can carefully view the results. The subtle shades of white that make up a successful high-key photo are difficult to see on a small LCD monitor, so you need to view them on a full-sized computer monitor before making critical exposure judgments. After a careful examination of the image, review the camera settings and make any needed tweaks to the composition, lighting setup, or exposure. You also may want to look at the histogram if your

camera has one. High-key and low-key photos have very distinctive histograms. **Figure 45.5** and **Figure 45.6** show the histograms of the high-key and low-key silk flower photos, respectively.

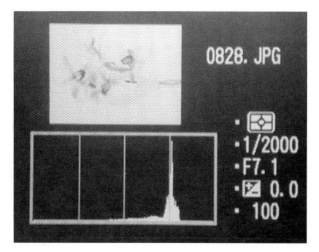

45.5 © 2002 Larry Berman

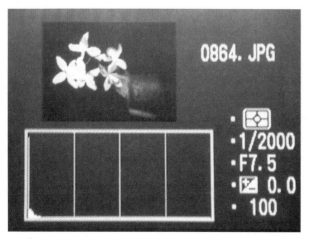

45.6 © 2002 Larry Berman

If possible, leave your camera set up in its exact position when removing the digital photo storage media to review the images. This allows you to insert the media back into the camera, make the necessary changes, and hopefully get the intended results. If you don't get them the first time, don't worry — even professional photographers can spend hours getting their lights and sets just right.

- After you review the images at a larger size on your computer, make notes on lighting placement and exposure, and shoot again.

When you've successfully accomplished a high-key photo, you should try shooting a low-key photo. Admittedly, making a low-key photo has its own challenges, as you need to keep the light on the objects and completely off the background. Depending on your props and set, this can be more difficult than merely shielding the subject from the background light used to make the high-key background white.

As the goal is to have a mostly dark photo with good detail defining the subject, consider choosing an appropriate subject that will look good set against an all black background. **Figure 45.7 (CP45.7)** shows the results of using the same silk flowers that were used in **Figure 45.2 (CP45.2)**, but changing the background and tabletop to black. To fit the mood of the low-key image, an old, dark oil can was used to hold the flowers instead of the white-frosted flower vase.

An easy way to set up a black background is to use a black fabric such as velvet or a backdrop made especially for photographers like those sold at www.backdropoutlet.com. Black velvet does an excellent job of absorbing light. A few yards will come in handy for lots of different picture-taking situations.

You can generally find several black fabrics to choose from at any well-stocked fabric store.

The most significant change from a high-key set to this low-key set is that you will only need a single light for the object as opposed to the two or possibly three lights for the high-key shot. Point the single light at the subject while being careful not to illuminate the background because you want it to go dark.

To produce the directional light needed to illuminate the subject and isolate it from the background, as shown in **Figure 45.8**, studio photographers use a *snoot*, or an elongated hood with a small opening, on the front of their light source. If you are using a conventional flash, you can design your own hood by covering the front of your flash with an opaque paper and taping an empty toilet paper roll in the center pointing at your subject. Make sure to leave room between the dark paper and the flash to let the heat escape.

Using a tripod when doing a low-key photo is just as important as when doing a high-key photo. Connect your sync cords if you are using a strobe and adjust your camera to work with it, disabling the internal flash. Manual mode gives you the most control and makes bracketing easy.

45.7 (CP45.7)　　　　　　　© 2002 Larry Berman

45.8　　　　　　　© 2002 Larry Berman

SHOOTING DIGITAL INFRARED PHOTOS

46.1 *Original image*

© 2002 Chris Maher

46.2 *Edited image*

© 2002 Chris Maher

Photos taken with only infrared light are magical. Plants can appear to glow with internal light, skies can turn black, and people can take on an ethereal luminescence. Otherwise ordinary scenes become captivating with their supernatural appearance, as you can see in the photo shown in **Figure 46.2**. In this technique, you learn what it takes to shoot digital infrared photos and how to take good ones.

You also learn why shooting infrared — digitally — is so much better than shooting with a film camera and using infrared film. Not only can you create true infrared pictures with superior tonality to film, but you will be able to use your camera's LCD monitor to see the world as it appears in infrared light *before* you take your picture. For anyone who has shot with traditional infrared films, being able to preview a scene in infrared before shooting is an amazing thing; no more guessing about exposure times and later finding out you missed getting what you wanted entirely.

WHAT IS INFRARED PHOTOGRAPHY?

Infrared photographs are made using invisible infrared light only. Technically, the spectrum of infrared light that most digital cameras can record is called *near infrared*. It is composed of the frequencies just longer than visible red light, starting at a wavelength of around 700nm. These frequencies are absorbed or reflected quite differently than visible light. Most noticeable is the way that the internal cell structure of leaves strongly refracts near infrared light. The resulting brightness is dependant on the type of leaf and its health. Other things, such as still water or wrought iron, absorb infrared, and thus appear very dark. Some animals absorb infrared (reptiles especially), while others reflect it. Skies go dark because the longer wavelengths don't scatter in the atmosphere like shorter wavelengths of light do (that, by the way, is why the sky is blue).

Part of the magic of infrared photography is you're not sure what you get until you shoot. Then, when you shoot — what you get looks so different from the actual scene it can be amazing. Infrared can transform the ordinary into a very interesting photo.

WILL YOUR DIGITAL CAMERA CAPTURE INFRARED LIGHT?

The light-sensing image sensors in digital cameras are quite responsive to infrared light. In fact, they are so sensitive that manufacturers have to add internal infrared blocking filters in front of the image sensors or the cameras would not capture a scene as we see it with our eyes. Even with an internal blocking filter, many digital cameras *can still* produce wonderful infrared photographs that are far superior to anything that you can produce with traditional infrared films.

To determine whether your camera can be used for digital infrared photography, point an invisible infrared source at the camera and check the camera's LCD monitor to see it; do not look through the viewfinder because it won't show there. Use a TV remote control as the infrared source. Point the control at the lens, and push any button on the remote control down while you look at your camera's LCD monitor. If your camera is letting infrared light in, you will see the invisible infrared light from the remote control light up the digital camera's LCD monitor like a flashlight bulb.

One of the best cameras to use for digital infrared is the Nikon CoolPix 950 because you can shoot with relatively fast shutter speeds when shooting in bright sun. The Nikon CoolPix 4500 is also good but it doesn't have the infrared sensitivity that the CoolPix 950 does, and requires longer exposure times. In bright sun, you will find that you need approximately 1/2 second when shooting with the CoolPix 4500 as compared to 1/15th of a second with the CoolPix 950. Some Sony digital cameras like the Sony DSC F707 and F717 have a night-shot mode, which pulls the infrared block away, allowing the camera to be used to shoot unblocked infrared. The Canon Pro 90 IS is also good for infrared photography as it allows 1/8th second exposures in full sunlight, plus it offers image active stabilization that helps to reduce camera shake.

TIP

If you aren't familiar with infrared photography, you may want to take a few minutes now to visit Chris Maher's digital infrared Web page at www. InfraRedDreams.com. His wonderful Web site will give you a good idea of what infrared photos look like and inspire you, too! Not only can you view many of his black-and-white infrared galleries, but you can also see a few color infrared galleries, and find lots and lots of useful information on digital infrared photography. Also check out Larry Berman's color infrared galleries at www.alternatephoto.com.

[handwritten: Will Harrison & Harrison 1835 Thunderbolt Dr #E Porterville, Ca 93257 1-877-213-6787 559-782-0121]

WHAT DO YOU NEED TO SHOOT DIGITAL INFRARED PHOTOS?

To shoot infrared photos with a digital camera, you need a digital camera that can record infrared light; you just learned how to check whether yours will work. You also need an infrared filter to block out all visible light and pass only infrared. You *must* also have a good solid tripod. Because most digital cameras require considerably long exposures when *[handwritten: WILLIAM]* shooting infrared, a solid tripod is a necessity to minimize camera shake. *[handwritten: 39.85]*

The most common opaque infrared filters are the 87, 88-A, or 89-B. Any one of them will work well, and you can order them from Harrison and Harrison, 1835 Thunderbolt Drive, Unit E, Porterville, CA 93257-9300, phone (559-782-0121). These filters appear to be black glass to our eye, but transmit the infrared light that your camera can see. **Figure 46.3** shows the Harrison and Harrison 87 filter. You can find other sources for infrared filters on Chris's Web site at www.InfraRedDreams.com on the InfraredResources page.

Now, if you've tested your camera, and it can record infrared light, and you have an infrared filter, then you're ready to shoot a few infrared photos.

[handwritten: 89B 689 Nanameters Block]

46.3 © 2002 Larry Berman

STEP 1: ATTACH INFRARED FILTER

■ Screw your infrared filter onto your camera's lens. If your camera does not have threads to use to attach a filter, you can buy a 3 × 3-inch square infrared Wratten gelatin filter and cut it to fit over your lens and attach it with tape.

STEP 2: FIND A SCENE TO SHOOT

■ Earlier you learned that infrared records differently than film and that the resulting photos will look entirely different than the scene you are shooting! Therefore, to determine what you are shooting, carefully walk around looking at the LCD monitor while pointing the camera at the scene you are considering shooting. Be careful not to trip.

After you learn how common things look when shooting with infrared, you'll be better at judging what will make a good photo without having to look at the LCD monitor. **Figure 46.4** is a good example of how a simple scene of a few stairs in a garden can look so different from the actual scene.

As exposure times can be long and because blown-out highlights aren't as offensive as they can be when

46.4 © 2002 Chris Maher

shooting with visible light, it is best to shoot on a bright sunny day. Before taking the time to set up your camera on your tripod, take a few test pictures using the program or automatic shooting mode. Point your camera so it has some green plants and trees in the frame, and include some blue sky if you can. Take a few photos of people, too, while focusing on eyes and skin areas.

STEP 3: SET UP YOUR CAMERA AND TRIPOD

■ After you find something that you want to shoot, attach your camera to a solid tripod and compose your photo. If you have a hard time seeing your camera's LCD monitor in bright sunlight, consider buying an LCD hood and magnifier such as the Xtend-a-View (`www.photosolve.com`) that is shown in **Figure 46.5**. This inexpensive hood makes it easy to see your LCD monitor in very bright light, plus it has the added benefit of magnifying the image, which can be very useful if you later find you have to focus manually.

46.5 © 2002 Larry Berman

STEP 4: CHOOSE CAMERA SETTINGS

■ Set the shooting mode to program mode or auto mode, or if you like using aperture mode, that is a good choice, too. If, after pressing the shutter button halfway down, your LCD screen is still too dark, you may have to switch to manual mode and manually set the aperture to the largest opening (for example, f/2.2 or f/2.8) and choose a longer shutter speed.

You might now be wondering how long the shutter needs to be open. This depends on your camera. Manufacturers are always trying to improve the color fidelity of their digital cameras, and greatly reducing the infrared light that gets to your camera's image sensor is one step they take. A camera like the CoolPix 950 is quite sensitive to infrared, with average exposures of about 1/15 of a second. Cameras like the Sony DSC-F707 and F717 can pull the hot glass out of the light path, allowing faster exposures when in their infrared, or Night Shot, mode. To learn what shutter speed you need for your camera, you just have to shoot and experiment.

Some digital cameras have a hard time focusing with an infrared filter. If this is the case with your digital camera, you may have to switch to a manual focus mode.

> **NOTE**
>
> Some Sony digital cameras have Night Shot mode. This mode is designed to go into a true infrared mode only in low light, so you need a neutral density filter to reduce the amount of light available from bright sunlight. You can learn more about neutral density filters in Technique 19.

STEP 5: COMPOSE AND TAKE PHOTOS

■ Now compose and take a few photos. As you shoot, you can make adjustments to exposure by using the exposure compensation feature if you have one. As most exposure compensation features only allow for a plus or minus two stop compensation, you may have to switch to manual shooting mode to make further adjustments in exposure.

If your camera requires a long exposure (more than 1/30th of a second), you can minimize camera shake caused by your pressing the shutter button by using an electronic cable release. If you don't have one, you can get the same results by setting the shutter release timer to two or more seconds. The camera can then trigger the shutter automatically.

TIP

If you find that most of the visible light is blocked and your exposures are very long, consider increasing the ISO setting to the camera's highest setting. Traditional infrared photographs are often grainy, so adding a bit of digital noise is okay.

There is plenty of infrared light in bright sun and even a fair amount on a cloudy day. Indoors, incandescent lights produce a fair amount of infrared output, but they are quite dim compared to sunlight. Fluorescent lights put out almost no infrared at all.

Auto-focus may not work well when you shoot with infrared. To avoid problems with close-up shots, try increasing the depth-of-field or use manual focus.

STEP 6: EDIT IMAGES ON A COMPUTER

■ Download your digital photos to your computer, and review them. You probably will find that the tones are pretty muddy. You may even see a strange color cast. Rarely will digital infrared photos have a full tonal range right out of the camera. There is rarely a true white or solid black. Using an image editor like Adobe Photoshop 7 or Adobe Photoshop Elements 2.0, you can convert the off-color infrared image to black and white and greatly improve the photo by doing the following:

■ Adjust the tonal range by selecting **Auto Levels**. This setting generally makes a dramatic improvement in the image.

■ To convert the color image to a black-and-white image, you can either convert to Grayscale or Desaturate, or you can use one of the more sophisticated approaches to converting color to black and white — you can use **Channel Mixer**, or convert to LAB mode and then convert to grayscale using the Lightness channel. Both of these last two methods require a full version of Adobe Photoshop — not an Elements version.

■ To make any final adjustments in the tonal range, use Adobe Photoshop 7's **Curves** tool. Adobe Photoshop Elements 2.0 does not offer **Curves**.

You an also use Adobe Photoshop to produce other classic infrared film effects. Kodak High Speed Infrared Film was quite grainy and had no anti-halation backing. This caused the highlights to flare and glow with a soft, dreamlike effect. You can add both these effects to your digital images using Adobe Photoshop's Diffuse Glow filter.

If you decide to keep your infrared photos as color infrareds, but they have too much red in them (a common problem with some digital cameras), use Adobe Photoshop to minimize the red using **Levels** on only the Red channel. Likewise, if your images are too dark, use **Levels** or **Curves** to lighten the photo to suit your taste.

Now that you see how easy it is to get great infrared effects, go looking for subjects that will look extraordinary when photographed using infrared. Slight wispy clouds can be extremely dramatic against a darkened sky, as can the leaves of a plant or tree. People's complexions can be amazingly clear, and occasionally a network of small veins can be seen just beneath the surface. Eyes can be quite spooky, as the iris can absorb or transmit infrared in unexpected ways. Bodies of water can reflect infrared if the surface is in motion, but will tend to absorb it if it is still. Cityscapes can be richly varied, as buildings reflect and absorb different amounts of infrared, and overall image clarity is often dramatic, as atmospheric scattering of near infrared wavelengths is generally quite low. But best of all, you will see all theses effects on your LCD monitor before you shoot them, so go out and see the world differently and capture it with your digital infrared camera!

CHAPTER 10

MOVING UP TO A DIGITAL SLR

© 2002 Gregory Georges

Using many of today's under-$1,000 compact digital cameras, you can get outstanding photos. However, as you get more serious about digital photography, you may decide you want to move up to a digital SLR camera (a digital camera similar to 35mm film cameras with interchangeable lenses) to enjoy the many benefits you get from these more expensive and capable cameras — especially if you already have one or more 35mm camera lenses.

In this final chapter, you learn how to take photos with a digital SLR. Technique 47 shows how to use a macro ring light to take flower photos. You learn how to take a landscape photo in Technique 48 using a telephoto and a polarizer. In Technique 49, you find out how to isolate a flower from its background. Technique 50 briefly covers the challenging topic of getting good sports photos.

© 2002 Gregory Georges

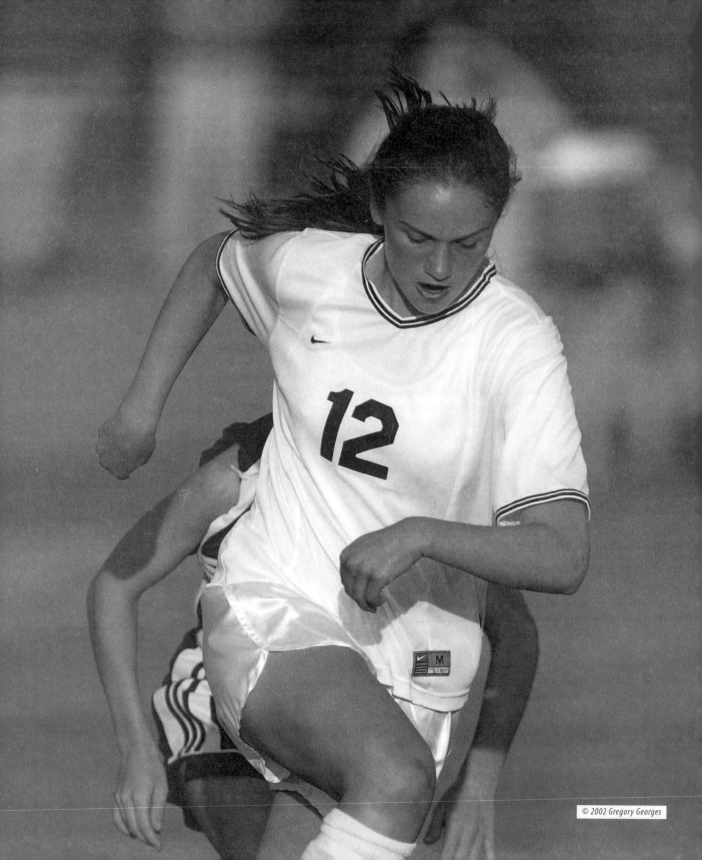

PHOTOGRAPHING FLOWERS WITH A MACRO RING LIGHT

47.1 *Original image* © 2002 Gregory Georges

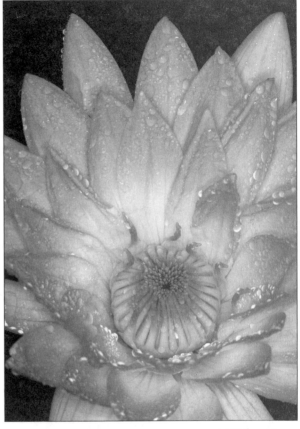

47.2 *Edited image* © 2002 Gregory Georges

ABOUT THE IMAGE

"General Pershing Day-Blooming Tropical Lily" Canon EOS D60 mounted on tripod, Canon 100mm f/2.8 Macro, Canon Macro Ring Lite MR-14EX, f/9.0 @ 1/200, ISO 100, 2,048 x 3,072 pixels, 2.0MB .jpg

A ny time you shoot close to a subject, you're likely to have lighting problems. You, the camera and lens, part of the subject, or a combination of the preceding are likely to cast shadows or block some or all of the available light. Although using an external light source may be possible, nothing is as useful as a macro ring light for shooting close-up photos. In this technique, you learn how to shoot flowers with a macro ring light to get a well-lit flower against a black background.

WHAT IS A MACRO RING LIGHT?

A macro ring light is a ring-shaped flash tube that fits on the front of a camera lens. Macro ring lights have been designed specifically to add an even amount of light to subjects that are very close to the camera. To avoid the unnatural-looking results of flash, some macro ring lights have two light tubes that can be controlled independently, allowing the photographer to create a more natural light effect by controlling how much light comes from each of the light tubes. **Figure 47.3** shows the twin light tubes on the Canon Macro Ring Lite MR-14EX, which costs $450. Notice the two small modeling lamps that can also be used for focusing in low-light conditions.

Another excellent macro ring light is the Nikon SB-29 TTL Macro Speedlight, which also costs around $450. Canon and Nikon macro ring lights offer considerable control over the light from the twin lights via a control panel like the one on the Canon MR-14EX, shown in **Figure 47.4**. These highly capable flashes will take you some time to learn how to use correctly, but learning how to use them effectively will result in excellent photos.

WHY WOULD YOU WANT TO USE A MACRO RING LIGHT?

Although you may prefer using natural light, especially when shooting nature subjects, many subjects are often covered in shade, or are so small that getting quality light to them when a camera is located within a foot or less of the subject is difficult. Also, the challenge in getting good macro shots is to get enough of the subject in focus as 35mm camera optics provide limited depth-of-field. To maximize depth-of-field, you need to use a small aperture, which requires a slow shutter speed. If there is any wind or subject movement, a slow shutter speed is not desirable

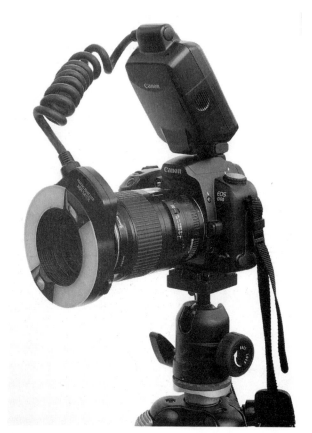

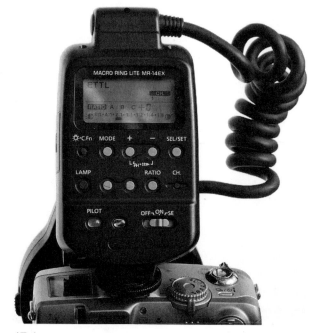

because you will end up with a blurred subject. If you must hand-hold your camera to shoot fast-moving subjects such as butterflies or dragon flies, being able to use a fast shutter speed is a must.

A macro ring light solves all of these problems while providing you with sufficient controls to create a more natural light than you would get with other external flash. If you routinely shoot macro or close-up photos, you may want to consider getting a macro ring light. They are excellent for taking photographs of insects, flowers, jewelry, or other small items, as this technique shows you.

STEP 1: CHOOSE DAY AND TIME TO SHOOT

■ To avoid the problems caused by shooting in bright daylight, choose a day and time when there is a soft cloud cover, or plan on having an assistant hold a light modifier of some kind to minimize these problems. Bright-colored flowers and white or light-colored flowers can be very difficult to shoot in bright sunlight. Bright sunlight causes two problems: blown-out highlights and a "too-wide exposure range" caused by very bright highlights and deep black shadows found in the backgrounds.

The photo shown in **Figure 47.2** was taken on a day where fast-moving clouds periodically turned the sun's bright light into soft light that was excellent for shooting with a macro ring light.

STEP 2: DECIDE WHAT KIND OF PHOTO YOU WANT

■ Choose from one of the many different approaches you can take when shooting flowers. You can shoot perfect specimen photos by using a small aperture to get a fairly deep depth-of-field. You can shoot more artistic photos by using selective focus, shooting with a large aperture and from an angle that provides a soft blurred background,

like the photo shown in Technique 49. You can choose to use a telephoto lens and get fantastic background blur while also getting sufficient depth-of-field to allow the entire flower to be sharply focused. Or you can try any one of many other approaches, too!

The goal of the photographer for the lavender water lily photo was to use a combination of a small aperture, a fast shutter speed, and a macro light to allow the flower to be lit and the background to turn black due to the quick shutter speed and the quick drop-off of light from the macro light. The macro light also added some sparkle to the drops of water on the lily's leaves.

STEP 3: SET UP TRIPOD AND CAMERA

■ Position the tripod, camera, and yourself in the best location for the shot. One of the major differences between amateur photographers and pro photographers is that pro photographers are more apt to get "down and dirty" to get a good photo. When you plan on shooting, wear clothes that allow you to comfortably lie on the ground to get a good shot when it is needed. If you want to shoot lilies in a pond, consider getting in the water so that you can get the camera positioned in the ideal place, as is shown in **Figure 47.5.**

47.5

STEP 4: SET UP MACRO LIGHT AND CHOOSE SETTINGS

■ To attach the Canon Macro Ring Lite MR-14EX to the Canon 100mm Macro lens, first screw a Canon Macro Lite Adapter 58c onto the lens. Then attach the Macro Lite to the adapter by pressing the two attachment buttons and pushing the light onto the lens. You can rotate the macro light to control how the lights are oriented relative to the subject. Attach the macro light control unit to the hot shoe on the camera.

■ If you have used flash for macro photos taken with a film camera, you can understand how difficult getting a perfectly exposed photo is. However, using a digital camera, it is considerably easier. Even though the Canon Macro Ring Lite can automatically determine exposure, setting it on manual mode allows you to have complete control over the light.

STEP 5: SELECT CAMERA SETTINGS

■ Choose the aperture shooting mode so that you can choose the exact aperture setting you want. Even though the Canon D60 has a close up shooting mode, the goal of the photo was to show as much of the lavender water lily in focus as possible, so the aperture was set to f/9. The resulting shutter speed was 1/200.

STEP 6: COMPOSE AND TAKE PHOTOS

■ To make sure you get the focus as you want, you may want to use manual focus for your close-up photos; you will get well-focused pictures more often. After manually focusing, compose your shot and press the shutter button to fire the flash and take a photo.

STEP 7: EVALUATE PHOTOS AND SHOOT AGAIN

■ After you take a photo, look at the image on the LCD monitor and then look at the histogram. If you need more light, make an appropriate manual adjustment to the flash and shoot again, until you get the exposure you want. After two or three photos and adjustments, you should have a perfectly exposed flower photo.

USING MACRO RING LIGHTS WITH COMPACT DIGITAL CAMERAS

You can use the macro ring lights made by Canon and Nikon with many digital cameras made by various vendors when you use the appropriate adapters. For example, you can use the Canon Macro Ring Lite MR-14EX with the Canon PowerShot G2 when using a Canon Conversion Lens Adapter LA-DC58 and a Canon Macro Lite Adapter 58c, which together cost around $45. If you have a choice, use a macro ring light made by the same vendor that made your camera.

SHOOTING LANDSCAPE PHOTOS WITH A TELEPHOTO LENS

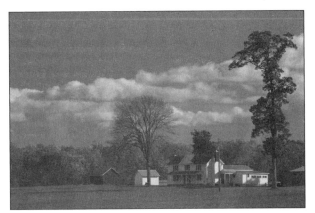

48.1 *Original image* *© 2002 Gregory Georges*

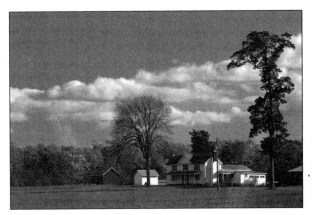

48.2 (CP48.2) *Edited image* *© 2002 Gregory Georges*

When most people think of taking a landscape photo, they usually think of using a wide-angle lens to get an "all-encompassing" shot like some of the photos shown in the techniques in Chapter 7. However, you can use a zoom telephoto such as a 70–200mm lens to get excellent landscape photos when you use it to capture a part of the scene that is a good distance away. In this technique, you learn how the photo shown in **Figure 48.2 (CP48.2)** was taken. You also learn how a polarizer was used to make what might have been an ordinary photo into a much better photo.

STEP 1: CHOOSE DAY AND TIME TO SHOOT

■ Rather than choose a day and time to go shoot photos regardless of the weather, look for changes in weather — you're likely to get much more dramatic lighting and better photos. Skies are usually much clearer and bluer after rain, and when everything has been washed in rain, the color tones can be richer.

The day the farmhouse photo was taken, the weather forecast was moderate morning rain and an afternoon with clear skies, which was a significant change from the three prior days of heavy rain — the perfect time to get a good photograph!

STEP 2: DECIDE WHAT KIND OF PHOTO YOU WANT

■ When you look at a landscape, decide what kind of photo you want before you pull out your camera, lens, and tripod. Does the scene lend itself to a horizontal or a vertical photo, or both? Is a wide-angle lens needed, or can you select a part of the landscape to make a good landscape photo with a telephoto lens? Also, look to see where the sun is and how it shines on the part of the landscape you want to shoot. Is the desired portion of the landscape bathed in good light or is part of it covered in undesirable shadows? If clouds are in the sky, what kinds are they and how fast are they moving? Will they periodically block some of the sun? Taking all of these factors into consideration helps you decide what kind of photo you want to get and what photographic gear you need.

STEP 3: SET UP TRIPOD AND CAMERA

■ As it is nearly always wise to use a tripod for landscape photos, especially when shooting with a telephoto lens, set up your tripod and attach your camera. To maximize depth-of-field, a small aperture of f/16 or less is usually desirable, which generally results in a slow shutter speed. Also, in this example, because the D60 has a 1.6 multiplication factor and a 70–200mm telephoto zoom was chosen, the 35mm equivalent focal length could be between 112mm and 320mm — long enough to necessitate a tripod.

■ When you're deciding where to set up your tripod, look around to see whether there is a place where you can capture some interesting foreground, such as a tree, fence, or other feature that will add to your photo. Lazy photographers rarely take the best photos. Even though getting out of your car and shooting is easy, you can often get much better photos by walking to a better place.

STEP 4: ADD POLARIZER AND ADJUST

■ If you have a polarizer, consider using it if the conditions are right to increase contrast and color saturation. When shooting the farm photo, a polarizer was used to increase contrast between the clouds and the sky, and the trees with the buildings. The sun was at a right angle to the orientation of the camera. This angle enabled the polarizer to dramatically alter the photo. **Figure 48.3** shows the result of taking a photo without a polarizer. Compare this photo to the one shown in **Figure 48.1** where a slight amount

of polarization was used. To learn more about polarizers, see Technique 19.

STEP 5: CHOOSE CAMERA SETTINGS

■ Because a smaller aperture is generally preferred for most landscapes, close your lens down to between the middle and the smallest aperture. To minimize digital noise, set the ISO setting to 100. Try using an evaluative (matrix) metering mode and auto-focusing. If adjustments to exposure are needed, use the exposure compensation feature.

STEP 6: COMPOSE AND TAKE PHOTOS

■ The challenge now is to find one or more parts of the entire scene surrounding you that would make a good photo. The interesting part of the

48.3 © 2002 Gregory Georges

scene shown in **Figure 48.2 (CP48.2)** is the red barn, white farmhouse, and the wonderful contrast between the trees, the white clouds, and blue sky. Using the Canon 70–200mm lens's zoom capabilities, the scene was composed using the "rule of thirds" mentioned in Technique 7. The large white building was located toward the right third of the image and the horizon was located on the bottom third of the composition. Extra care was taken to make sure the composition was level.

STEP 7: EVALUATE RESULTS AND SHOOT AGAIN

■ Although you can judge exposure reasonably well by looking at the image on your camera's LCD monitor, look at the histogram (if your camera

WARNING

Many good landscape photos are either ruined or they must be cropped to fix an "out-of-level" composition, which can substantially reduce the size of the image. To avoid this problem, always take extra care to make sure your camera is level when you take a landscape photo. Although some tripods have bubble levels, they often don't work well with some tripod heads, such as many of the ball heads. Kaidan (`www.kaidan.com`) and Kaiser (`www.kaiser.com`) make two-way bubble levels that fit into your camera's hot shoe, which are very useful for leveling your camera.

has one) to get a more accurate view, especially if your LCD monitor is washed out from bright sunlight. Because of the amount of sunlight in this scene, the evaluative metering exposed more for the sky than the trees and buildings, and the histogram indicated the need for exposure compensation. To increase detail in the trees and foreground, exposure compensation was set to +2/3. To learn more about using exposure compensation, read Technique 12.

You can often use landscape photos that have been taken with a polarizer to make excellent black-and-white images when you convert them with an image editor such as Adobe Photoshop (www.adobe.com) or a Adobe Photoshop-compatible plug-in like The Imaging Factory's Convert to B&W Pro (www.theimagingfactory.com). **Figure 48.4 (CP 48.4)** shows the result of using the Convert to

B&W Pro plug-in on the image shown in **Figure 48.2 (CP48.2)**.

Next time you want to shoot a landscape photo, consider doing so with a telephoto lens and a polarizer — you're bound to like the results you get!

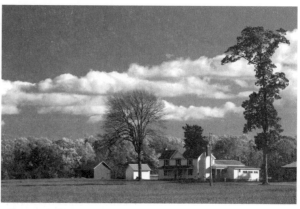

48.4 (CP48.4) © 2002 Gregory Georges

ISOLATING A FLOWER FROM ITS BACKGROUND

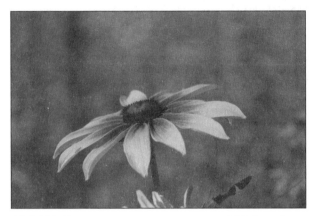

49.1 *Original image* © 2002 Gregory Georges

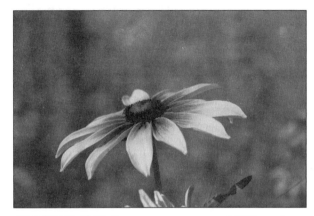

49.2 (CP49.2) *Edited image* © 2002 Gregory Georges

Depending on the effects you want, one of the significant advantages of shooting with a digital SLR camera is that the combination of its larger imaging sensor and greater choice of lenses allows you to take advantage of a technique called *selective focus*. Cameras of this design have much greater control over the exact zone of focus — much more so than what you get with a compact digital camera. In this technique, you learn how to control background blur to add drama to a subject, such as the yellow flower shown in **Figure 49.2 (CP49.2).**

STEP 1: CHOOSE DAY AND TIME TO SHOOT

■ Even though you undoubtedly can shoot flowers any day and any time as long as you have enough of the right light or the right equipment, getting great flower photos requires great natural light! Therefore, you can't always choose when and where you want to shoot. If your

277

schedule allows, watch how light changes over the day and learn to pick the best days and time to shoot — you'll get better flower photos if you do.

The best days to get good flower photos are days when there is a light cloud cover, which results in a soft light that is excellent for taking flower photos. Another major issue to consider when shooting flowers is wind. If you try taking sharply focused flower photos on a windy day, you will go crazy. Sure, you can try all kinds of tricks like using holders and wind blockers, and you can wait for a lull in the wind, but your productivity will be low and results will be less than if you shoot when there is no wind.

STEP 2: DECIDE WHAT KIND OF PHOTO YOU WANT

■ Once you've decided when and where to shoot — you must decide how you want your photo to look. As you learn more about your camera and are able to control it to get the photos you want, you will find yourself looking at the LCD monitor for something as simple as the yellow flower shown in **Figure 49.2 (CP49.2)** and thinking of a dozen or more ways to take photos. This pre-visualization of what you want is important. In this example, the decision was made to pick one perfect flower and to isolate it from all the other flowers.

STEP 3: SET UP TRIPOD AND CAMERA

■ Once you've decided what flower to shoot, you can decide where to set up your tripod and camera. If you are using a zoom lens, you can more easily set up your tripod than if you are using a fixed focal length lens like the Canon 100 Macro that was used to take the photo in **Figure 49.2**

(CP49.2). A zoom lens allows you much greater compositional control without requiring that the tripod be moved. In order to isolate a selected flower from other flowers, a place needs to be chosen for the tripod where there is considerable distance between the chosen flower and any other flowers behind it in line with the camera and flower.

STEP 4: SELECT CAMERA SETTINGS

■ Select your camera settings as applicable to your objective. Once again, the objective in this example was to control the depth-of-field, so the shooting mode was set to aperture priority and the aperture initially to f/2.8 to get a minimum depth-of-field and to maximize background blur. To get an image with the least digital noise, an ISO setting of 100 was used. The evaluative metering mode was selected and a center focal point to be used with auto-focusing.

> **TIP**
>
> Many state road systems have undergone roadside beautification programs that include the planting of large fields of wildflowers. Not only do these flowers make driving on the roads more enjoyable, but they are also wonderful places to get lots of wildflower photos, like the one shown in **Figure 49.2 (CP49.2)**. If you decide to stop your car to shoot flowers along the roadside, be careful to park legally and avoid taking risks that could result in an automobile accident. Also, be careful where you pull off as it is easy to find that you have driven into soft mud and your car can get stuck — my own experience has shown this to be true!

STEP 5: COMPOSE AND TAKE PHOTOS

■ Move the tripod and adjust the height to get the best view of your subject. As you get pickier about composition, you will fully appreciate the value of a good tripod and head. Much of the work that went into composing the flower photo had to do with moving the tripod and adjusting the height to get the best view of the flower and to make sure that the background had color. Also, I had to make sure that I was sufficiently far away from the background flowers to make a good blurred background. When you are happy with your composition, press the shutter button and take a photo.

■ Because you cannot always tell how much depth-of-field you have when looking at a small LCD monitor, shoot several additional photos using different aperture settings so you have a choice when you view them on a large computer monitor. Usually, you'll be glad you have a choice. In this case, it was a good thing to do because there was a small amount of wind, and the larger aperture settings resulted in a better-focused flower.

STEP 6: EVALUATE PHOTOS AND SHOOT AGAIN

■ After you've taken a few photos — take some time to evaluate them. In this example, a quick look at the histogram indicated that the exposure was correct. However, the depth-of-field was too shallow to allow the entire yellow flower to be in focus. So, I selected several other apertures and took more photos until it looked just right at f/6.3.

BACKGROUND BLUR AND COMPACT DIGITAL CAMERAS

One of the most significant differences between compact digital cameras and digital SLR cameras is the amount of background blur you can get from each type of camera. If you are a nature photographer who enjoys getting good specimen photos of butterflies, dragonflies, or other insects, you'll love the extreme depth-of-field you get with many of the compact digital cameras. When you take photos of the same subjects with a digital SLR camera, you have considerably less depth-of-field and the challenge is often how to get the entire subject in focus. The corollary here: Getting a narrow zone of focus with a compact digital camera is as challenging as getting sufficient depth-of-field to get a well-focused close-up subject using a digital SLR camera!

CONTROLLING BACKGROUNDS

You can control backgrounds in your photos in many ways. If you use flash, like the macro ring light flash that was used in Technique 47, you can make the background very dark or even black. When a fast shutter speed is used, the background receives so little light from the quickly falling off flash that the background becomes dark or black. You can also control the background by changing the aperture — the larger the aperture, the fuzzier the background will be because the depth-of-field will be shallower.

> **TIP**
>
> Remember that when you shoot digitally, shooting a few more photos doesn't cost anything. When you take time to set up a tripod and camera, shoot a few pictures more than you think you need just to make sure you get a perfect one. Try using manual focus. Use different aperture settings and exposure compensation. Usually, you will be glad you did when you are sitting comfortably at your computer reviewing the images on a large monitor.

The distance between your subject and the background also directly impacts how the background looks. The farther away the background is from the subject, the more likely it is to be soft and out of focus. Finally, you can gain considerable control over background by shooting with a long telephoto. The longer the telephoto is, the narrower the field of view will be. A narrow field of view allows you to move your camera one way or another so that you can pick the background that will be behind your subject. **Figure 49.3** shows the results of using a telephoto to place the seeding plant directly in front of a dark background to add contrast to the subject. If the camera were moved a few inches to either side, the plant disappeared into the bright background.

49.3 © 2002 Gregory Georges

PHOTOGRAPHING SPORTS ACTION

50.1 *Original image* © 2002 Gregory Georges

50.2 (CP50.2) *Edited image* © 2002 Gregory Georges

ABOUT THE IMAGE

"Sterling Heading Toward the Goal" Canon EOS 1D mounted on monopod, Canon EF 300mm f/2.8L IS with 1.4X tele converter (546mm effective focal length), f/4.0 @ 1/600, ISO 200, 1,648 x 2,464 pixels, 1.2MB .jpg

G etting a good sports action photo is exciting for everyone — the players in the picture, the friends and family of the players, and the photographer! Of all the different types of photography, sports action photography involves more skill *and* luck than just about any other kind of photography. In this technique, you learn some tips and techniques to help improve your chances of getting lucky and getting a great sports action photo.

Two of the most frequently asked questions on many of the online photography forums are "Can you shoot sports photos with a compact digital camera?" and "What kind of digital camera is best for photographing sports action?" With the growing popularity of digital cameras and of photographers being involved in sports as a player or spectator, these seemed like good questions to answer in this book, which was primarily written for those using compact digital cameras.

The answer to the first question was answered in Technique 27. This technique answers the second question. As prices of the more expensive digital SLR cameras continue to drop, they will become a viable option for a growing number of photographers as the photographers look to move up from compact digital cameras.

WHAT KIND OF DIGITAL CAMERA IS BEST FOR PHOTOGRAPHING SPORTS ACTION?

In Technique 27, you learned that it was possible to get lucky (after taking lots and lots of photos) and get a reasonable sports action photo, but if you want to get lots of good sports action photos, you learned you would need a digital SLR camera. Two categories of digital SLR cameras can be used for sports action photos. First are the lower-end "prosumer" digital SLR models like the Canon D30 or D60 ($2,200), and the Nikon D100 ($2,000). These prices are just for the body (no lens included). For the ultimate sports action photos, you need to spend more money and get a Canon EOS 1D ($4,500) or Nikon D1H ($3,700) — both specifically designed for photojournalists and sports photographers. These pricey but excellent cameras take wonderful sports action photos!

WHAT LENS SHOULD YOU HAVE?

The ultimate lens for shooting sports action photos depends on the sport you are shooting and the kinds of shots you want. Many pro sports photographers use two or more different lenses during a game — one for when the action is close and one or more for shooting when the action is farther away.

If you want to shoot games on playing fields like soccer, lacrosse, and football, a 300mm, 400mm, or even 500mm lens is excellent. However, it is not just the focal length that is important. Having a fast-focusing lens and one with a large, maximum aperture is also important. The large aperture lenses (for example, f/2.8) allow more light in, which makes it easier to use faster shutter speeds to get photos when little light is available, as you will find in night or evening games. The large aperture also makes shooting photos of players who are perfectly focused against a soft blurred background possible. Fast long telephoto lenses can cost anywhere from $2,000 to over $8,000. However, you can get good 200mm or 300mm lenses for $650 to $1,200 that enable you to get good sports action photos.

STEP 1: DECIDE WHAT KIND OF PHOTOS YOU WANT

■ Once again, you must decide what kind of photos you want before choosing a lens, camera settings, and where you will stand to shoot. Are you looking for full-frame photos of players for large prints? Do you want team photos, or photos showing five or more players at the same time? Or do you just need a few good photos for a Web page?

■ After you decide what kinds of photos you want, you also need to decide how realistic you are about getting them. Important things to consider have to do with the amount of available light, the focal length of your lens, and the camera you are using.

When shooting sports events, remember that it is an event — not just a game between competitors. Look for good shots of spectators, cheerleaders, happy or sad fans, coaches, and players celebrating on and off the playing field. **Figure 50.3 (CP50.3)** shows two players celebrating after one of them got an important goal. This photo is much more exciting than the photo in **Figure 50.2 (CP50.2)** of the player kicking the ball in the goal.

STEP 2: SET UP CAMERA AND MONOPOD

■ Depending on the weight of your camera and lens, the focal length of your lens, and your strength, decide whether you want to shoot with a monopod or hand-hold your camera and lens. In most cases, when you use a lens with an effective focal length over 200mm, you ought to be shooting with some kind of support.

STEP 3: CHOOSE CAMERA SETTINGS

■ Choose your camera settings based on the following variables: the sport you are shooting, available light, camera, lens, distance to action, jersey color, and so on. Choosing camera settings to shoot sports action is a major topic of debate

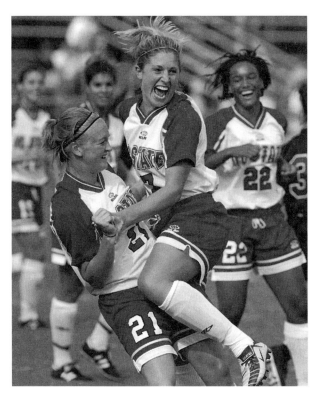

50.3 (CP50.3) © *2002 Gregory Georges*

among sports photographers. There are two basic approaches. You can use an automatic exposure setting — either aperture priority so that depth-of-field is set, or shutter speed priority to stop action. Or you can use the manual shooting mode and set both the shutter speed and aperture. The manual approach works effectively when you're shooting players with bright white jerseys playing against a team with dark jerseys. To determine a good exposure when using the manual mode, you can either use a hand-held light meter, or you can shoot a few players and use the camera's histogram to decide how much to adjust the setting.

STEP 4: DECIDE WHERE TO SHOOT

■ Deciding where to stand to shoot is one of the most important decisions you can make after you've chosen your camera settings. Being in the right place at the right time to get the shots you want is what sports photography is all about. There are lots of photographers who shoot sports; however, there are far fewer *good* sports photographers. The difference between the two is knowing where and when to shoot, and how to choose the optimal camera settings for the light and the intended results. The only way to become a good sports photographer is to know how to read the game you shoot and to practice. The more you study the game and the more you shoot, the better you will become.

Where should you stand? Once again, it depends on the game. Assuming you are shooting a field sport such as soccer, lacrosse, or football, you want to shoot where the play occurs, where you can shoot the faces of the players, and where you have a good background behind the players as often as possible. And you should avoid shooting when possible when the sun is behind the players. Otherwise, you will be shooting into the sun, the player's face will be covered in shadow, and you

will risk lens flare from light striking the front of the lens.

When the game has been underway for a few minutes, you will have a better idea which part of the field the game will be played on. If you have permission and are allowed to move around the field during the game, you want to keep moving depending on where the players are and the state of the game (that is, one is whipping the other team, or it is a tightly fought game that occurs in the middle of the field).

STEP 5: COMPOSE AND SHOOT

■ When the players are in range of your lens, watch their eyes, the ball, and the defending players. In soccer, you can get excellent shots when the players jump up to head the ball after a goal kick, as shown in **Figure 50.4 (CP50.4).** Often you can sense which player will get the ball by watching the eyes and facial expression as the player braces himself to get a ball or take a bump from another player. Another good soccer play to watch is a corner kick. Keep your camera on the players in front of the goal and wait for the ball to get to them.

In lacrosse, you can get some awesome shots as a player runs around the back of the goal and comes toward you in line with the goal. The offensive player will usually be facing you while being tightly guarded by one or more defensive players. If you're in luck, you can get a shot of this action with the goalie showing behind the action with his stick extended, ready to stop a shot. Each sport is different. Getting good shots takes time and experience.

STEP 6: EVALUATE RESULTS

■ Use the camera's histogram to make sure you're getting a good exposure and that you're capturing the action you want. This is the best part of using a digital camera — you can look at what you just shot, make adjustments, and continue shooting.

SHOOTING NIGHT AND INDOOR GAMES

Shooting night and indoor games is very challenging to both the photographer and to the equipment. If

50.4 (CP50.4) *© 2002 Gregory Georges*

you are not shooting with a lens with an aperture of f/2.8, you're not likely to be able to shoot even if you can set the ISO setting to 3200! If you are using a lens with an aperture of f/2.8, you will be just able to stop action at 1/250 using ISO 1600.

WHY MOVE UP TO A DIGITAL SLR FOR SPORTS?

If you're intent on shooting sports action, there are four driving reasons to move to a digital SLR: focus speed, minimal or no shutter lag, three to eight frames per second shooting speed, and choice of fast lenses. If you want more information on shooting sports action, consider becoming a member of Sports Shooter at www.sportsshooter.com. This active Web site has all the information any sport shooter would want on cameras, playing fields, and techniques for an annual fee of $20.

The end of this technique is the end of Chapter 10 and the end of the book. The fifty techniques in this book cover a wide range of tips and methods to help you take better photographs; learning them will make you a better photographer. Photography is a wonderful hobby that can grow into a lifetime of enjoyment. As you become a better photographer, you'll enjoy it more, shoot more, and get even better! Our hope is that you get caught up in this circle of digital photography and spend as much time capturing the light as possible! Get out there and shoot — maybe we'll see you out there.

APPENDIX A
WHAT'S ON THE CD-ROM

This appendix provides you with information on the contents of the CD-ROM that accompanies this book. For the latest and greatest information, please refer to the ReadMe file located at the root of the CD-ROM. Here is what you will find:

- System requirements
- CD-ROM installation instructions
- What's on the CD-ROM?
- Troubleshooting

SYSTEM REQUIREMENTS

Make sure that your computer meets the minimum system requirements listed in this section. If your computer doesn't match up to most of these requirements, you may have a problem using the contents of the CD-ROM.

FOR WINDOWS 9X, WINDOWS 2000, WINDOWS NT4 (WITH SP 4 OR LATER), WINDOWS ME, OR WINDOWS XP:

- PC with a Pentium processor running at 120 MHz or faster
- At least 128MB of total RAM installed on your computer
- Internet Browser such as Netscape Navigator or Microsoft Internet Explorer
- 350MB of available hard drive space
- A CD-ROM drive

CD-ROM INSTALLATION INSTRUCTIONS

To install a particular piece of software, open its folder with My Computer or Internet Explorer. What you do next depends on what you find in the software's folder:

To install the items from the CD to your hard drive, follow these steps:

1. Insert the CD into your computer's CD-ROM drive.
2. A window will appear with the following options: Install, Browse, eBook, Links, and Exit.
 Install: Gives you the option to install the supplied software and/or the author-created samples on the CD-ROM.
 Explore: Allows you to view the contents of the CD-ROM in its directory structure.
 eBook: Allows you to view an electronic version of the book.
 Exit: Closes the autorun window.

If you do not have autorun enabled or if the autorun window does not appear, follow the steps below to access the CD.

1. Click Start ➢ Run.

2. In the dialog box that appears, type *d:\setup.exe*, where *d* is the letter of your CD-ROM drive. This will bring up the autorun window described above.

3. Choose the Install, Browse, eBook, or Exit option from the menu. (See Step 2 in the preceding list for a description of these options.)

To install individual software programs from the CD, select "Explore" from the CD interface and follow the steps below:

1. First, look for a ReadMe.txt file or a .doc or .htm document. If this is present, it should contain installation instructions and other useful information.

2. If the folder contains an executable (.exe) file, this is usually an installation program. Often it will be called Setup.exe or Install.exe, but in some cases the filename reflects an abbreviated version of the software's name and version number. Run the .exe file to start the installation process.

WHAT'S ON THE CD-ROM

The following sections provide a summary of the software and other materials you can find on the CD-ROM.

THE 50 TECHNIQUES' PHOTOS

You can find one or more unedited "original" photo(s) and edited image(s) for each of the 50 techniques. Minor editing has been done to the "original" photos using Adobe Photoshop Elements 2.0 to improve image contrast and exposure, and to remove any unwanted color casts, and these edits are shown in the "edited" image.

APPLICATIONS

The following applications are on the CD-ROM:

■ Internet browser-based slide show featuring "original" and "edited" images. To run the show, use Windows Explorer to locate the folder **/show**. Double-click on **index.htm** to run the slide show in your Internet browser. You can also view this slide show online at `www.reallyusefulpage.com/50dc/show`.

■ 30-day "trial" version of Adobe Photoshop Elements 2.0 — digital image editing software for editing digital photos.

■ 30-day "trial" version of Cerious Software's ThumbsPlus, an image management application.

■ 30-day "trial" version of E-Book Systems' Flip Album — software for creating photo albums for sharing photos on Web sites and on removable storage media.

Shareware programs are fully functional, trial versions of copyrighted programs. If you like particular programs, register with their authors for a nominal fee and receive licenses, enhanced versions, and technical support. *Freeware*

programs are copyrighted games, applications, and utilities that are free for personal use. Unlike shareware, these programs do not require a fee or provide technical support. *GNU software* is governed by its own license, which is included inside the folder of the GNU product. See the GNU license for more details.

Trial, demo, or evaluation versions are usually limited either by time or functionality (such as being unable to save projects). Some trial versions are very sensitive to system date changes. If you alter your computer's date, the programs will "time out" and will no longer be functional.

EBOOK VERSION OF 50 FAST DIGITAL CAMERA TECHNIQUES

The complete text of this book is on the CD-ROM in Adobe's Portable Document Format (PDF). You can read and search through the file with Adobe Acrobat Reader (also included on the CD-ROM).

TROUBLESHOOTING

If you have difficulty installing or using any of the materials on the companion CD-ROM, try the following solutions:

- **Turn off any anti-virus software that you may have running.** Installers sometimes mimic virus activity and can make your computer incorrectly believe that it is being infected by a virus. (Be sure to turn the anti-virus software back on later.)
- **Close all running programs.** The more programs you're running, the less memory is available to other programs. Installers also typically update files and programs; if you keep other programs running, installation may not work properly.
- **Reference the ReadMe:** Please refer to the ReadMe file located at the root of the CD-ROM for the latest product information at the time of publication.

If you still have trouble with the CD-ROM, please call the Customer Care phone number: (800) 762-2974. Outside the United States, call 1 (317) 572-3994. You can also contact Wiley Customer Care by e-mail at `techsupdum@ wiley.com`. Wiley will provide technical support only for installation and other general quality control items; for technical support on the applications themselves, consult the program's vendor or author.

APPENDIX B
COMPANION WEB SITE

A companion Web site has been created especially for this book at `www.reallyusefulpage.com/50dc`. On it, you can find the following:

- Updates and corrections to this book.
- "50 Fast Digital Camera Techniques" Readers' Photo Gallery: View the work of other readers and share your best work, too! If you have created an outstanding photo that you would like to share with others, please e-mail a .jpg file version to `curator@reallyusefulpage.com`. Make sure that the images that you e-mail fit within a 640×640-pixel space and that they are under 75KB. Future editions of this book may contain images submitted to this gallery. Permission will be requested and credit will be given to those who submit images.
- Useful lists of online photography and image-editing resources, including Adobe Photoshop plug-ins.
- FAQ (Frequently Asked Questions) section for getting answers to common questions.
- Recommended book "reading list" to further your skills.
- List of online galleries that you might like to visit.

JOIN AN ONLINE FORUM

Gregory Georges, one of the authors of this book, has created and hosts an online forum at Yahoo! Groups for readers of his books, as well as anyone else who has an interest in digital photo editing. To join, visit `http://groups.yahoo.com/group/digital-photo-editing`.

Subscribe to the e-mail service to participate. You can post images and share tips and techniques with other readers of this book. You will even be invited to an occasional online chat session.

CONTACT THE AUTHORS

Gregory Georges welcomes comments from readers. He may be contacted by e-mail at `ggeorges@reallyusefulpage.com`, or occasionally on AOL Instant Messenger using the Screen Name: DigitalGregory. His Web site is at `www.reallyusefulpage.com`. Although he reads all e-mail, the heavy volume makes responding to all messages impossible.

You can contact Larry Berman by e-mail at `larry@larryberman.com`. His Web page is at `www.BermanGraphics.com`.

You can contact Chris Maher by e-mail at `chris@chrismaher.com`. His Web page is at `www.ChrisMaher.com`.

INDEX

Continued

Z

ABOUT THE AUTHORS

Gregory Georges has been an active and passionate photographer who has shot with medium format, 35mm, and digital cameras for more than 25 years. He has also been a long-time user of computers both personally and professionally ever since his first computer class in 1969. In 1999, he left the software industry to pursue his passion for photography full-time and to use his computer skills to become a leading expert on digital photography and digital imaging.

He is the founding author of the "50 Fast" series and is the best-selling author of *50 Fast Photoshop 7 Techniques*, *50 Fast Digital Photo Techniques*, and *Digital Camera Solutions*. He is also a contributing writer for eDigitalPhoto and Shutterbug magazines, and he provides photographs and written content to a growing list of Internet sites, magazines, and commercial clients. His popular Web page, www.reallyusefulpage.com is a *really useful page* for learning more about digital photography. His favorite photographic subjects are architecture, birds, farms, sports, old rusty cars, and flowers — especially iris and exotic water lilies.

Larry Berman has been selling his photographs professionally for over 30 years. His career began in the 1970's as a sports photographer, becoming the staff photographer for the ABA New York Nets. His commercial photography has been sold worldwide through The Image Bank stock agency. For the past 30 years he has been selling his fine art photography at juried art shows throughout the country. In the last three years his photography has gone entirely digital and lately he's been shooting commercial assignments with the CoolPix 5000. You can see his latest bodies of work in the photo galleries at www.BermanGraphics.com and on his color infrared Web site at www.AlternatePhoto.com.

Chris Maher began his photographic career with a degree in Photographic Illustration from Rochester Institute of Technology. After working for Eastman Kodak for five years, he left their advertising division for graduate school at Southern Illinois University. His Masters degree in Visual Communications led him to the art world where he has earned a living selling his fine art photographs for more than 25 years. An early adopter of computers, he has been online since 1985 and, along with Larry Berman, developed Web sites for more than 100 photographers, artists, and creative people. Chris shut down his 30-year-old darkroom and has been shooting exclusively in the digital realm since 1999. You can see his latest passion, fine art created with digital infrared imaging, online at www.InfraRedDreams.com.

For the past four years Larry Berman and Chris Maher have been partners in a Web design business, www.ArtWebWorks.com, where they specialize in creating image-intensive Web sites for photographers and artists. They also share a byline by writing articles for eDigitalPhoto and Shutterbug magazines. Their Web site at www.BermanGraphics.com is a resource for photography, digital imaging, and the art show industry that they're both veterans of.

COLOPHON

This book was produced electronically in Indianapolis, Indiana. Microsoft Word 97 was used for word processing; design and layout were produced using QuarkXPress 4.11 and Adobe Photoshop 5.5 on Power Macintosh computers. The typeface families used are: Chicago Laser, Minion, Myriad, Myriad Multiple Master, Prestige Elite, Symbol, Trajan, and Zapf Dingbats.

Vice President & Executive Goup Publisher: **Richard Swadley**
Vice President & Publisher: **Barry Pruett**
Editorial Manager: **Rev Mengle**
Acquisitions Editor: **Mike Roney**
Project Editor: **Amanda Peterson**
Technical Editors: **Larry Berman and Chris Maher**
Copy Editor: **Paula Lowell**
Permissions Editor: **Carmen Krikorian**
Production Coordinator: **Nancee Reeves**
Cover Art: **Gregory Georges and Larry Berman**
Production: **Beth Brooks, Sean Decker, and LeAndra Johnson**
Proofreading and Indexing: **Laura Albert, Laura L. Bowman, and Johnna VanHoose**